Prague 1900 Poetry and ecstasy

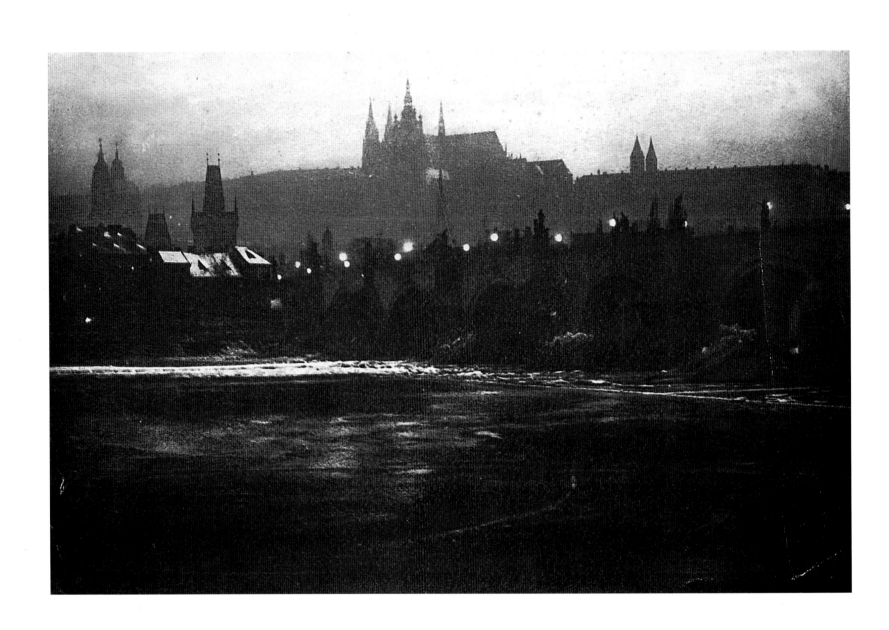

Prague

1900

Poetry and ecstasy

Editors

Edwin Becker
Roman Prahl
Petr Wittlich

Authors

Michael Huig
Iva Janáková
Luboš Merhaut
Marta Ottlová
Sylva Petrová
Alena Pomajzlová
Roman Prahl
Petr Wittlich

Van Gogh Museum, Amsterdam
Museum of Applied Art, Frankfurt am Main
Waanders Uitgevers, Zwolle

Lenders

France
Musée d'Orsay, Paris

Czech Republic
Moravian Gallery, Brno
Museum and Gallery, Hořice
Museum of Modern Art, Hradec Králové
East Bohemian Museum, Hradec Králové
Bohemian Forest Museum, Kašperské Hory
Museum of Glass and Jewellery, Jablonec nad Nisou
North Bohemian Museum, Liberec
Regional Museum, Liberec
Art Gallery, Litoměřice
Museum of Art, Olomouc
Museum of Fine Art, Ostrava
West Bohemian Gallery, Pilsen
Mucha Trust
Waldes Collection, Prague
President's Chancellery, Prague
Gallery of the City of Prague
National Literary Museum, Prague
Národní galerie v Praze, Prague
Czech Savings Bank, Prague
Uměleckoprůmyslové museum v Praze, Prague
College of Decorative Art, Turnov

and all the lenders who wish to remain anonymous

Contents

Foreword

After the successful exhibitions *Glasgow 1900. Art & design* (1992-93) and *Vienna 1900. Portrait & interior* (1997) in the Van Gogh Museum it was a logical step to consider the subject of *fin-de-siècle* Prague. Just as Viennese art owes a great deal to the Scottish designer Charles Rennie Mackintosh, the influence of the Vienna Secession and the Wiener Werkstätte on Czech art is unmistakeable.

Curator Edwin Becker's personal fascination with Prague art and culture also played a major role in the decision to organize an exhibition on this theme. Together with Roman Prahl and Petr Wittlich, who have both published important works on *fin-de-siècle* Prague, and assisted by Iva Janáková, who is attached to the Uměleckoprůmyslové museum v Praze (Museum of Decorative Arts) and Alena Pomajzlová, who works in the Národní galerie v Praze (National Gallery, Prague), he assembled a team of authors who produced a representative survey of a diverse range of arts in Prague circa 1900.

'Poetry' and 'ecstasy' proved key concepts which characterized the various trends during this period. Although the lyric impressionism and symbolic poetic works of artists such as Maxmilián Švabinský and Jan Preisler predominated initially, these were increasingly replaced by expressionist influences: artists such as Josef Váchal and Jan Zrzavý not only dissected the human soul but also portrayed the dark and ecstatic sides of human existence.

A special word of thanks is owed to the translation team for their work on the catalogue: to Kees Mercks for the translation into Dutch, Michèle Hendricks who coordinated the English edition and Sabine Rieger for the German version; they were always prepared to find a solution for various dilemmas. The editors also had recourse to Michael Huig for all art-historical queries.

The exhibition would not have been possible if museums and private collectors had not been willing to loan us their works. We are extremely grateful to all the lenders. We should also particularly like to thank the following individuals: Jaroslav Anděl, Petr Beránek, Naděžda Blažíčková-Horová, Vladimír Bukač, Kaliopi Chamonikola, Alois Čvančara, Jaroslav Fatka, Jiří Gregor, Marie Halířová, Martin Herda, Vladimír Horpeniak, Miroslav Horyna, Milan Knížák, Helena Koenigsmarková, Věra Laštovková, Henri Loyrette, Kim Massij, Petr Meissner, Anne Mommens, John and Geraldine Mucha, Odile Nouvel, Oldřich Palata, Jana Potužáková, Ivana Quilezová, Anna Rollová, Tomáš Rybička, Jaroslava Slabá, Dagmar Šefčíková, Jan Štíbr, Otto Urban, Oldřich Theodor Uttendorfský, Libor Veselý, Vít Vlnas, Eva Wolfová, Helena Petrusková, Alena Zapletalová, Pavel Zatloukal, Jiří Zemánek, Martin Zlatohlávek, Václav Žatečka, who were always ready to advise and assist.

John Leighton
Van Gogh Museum, Amsterdam

James Bradburne
Museum of Applied Art, Frankfurt am Main

The exhibition has been organized in close cooperation with
Národní galerie v Praze (National Gallery, Prague)
Uměleckoprůmyslové museum v Praze (Museum of Decorative Arts, Prague)

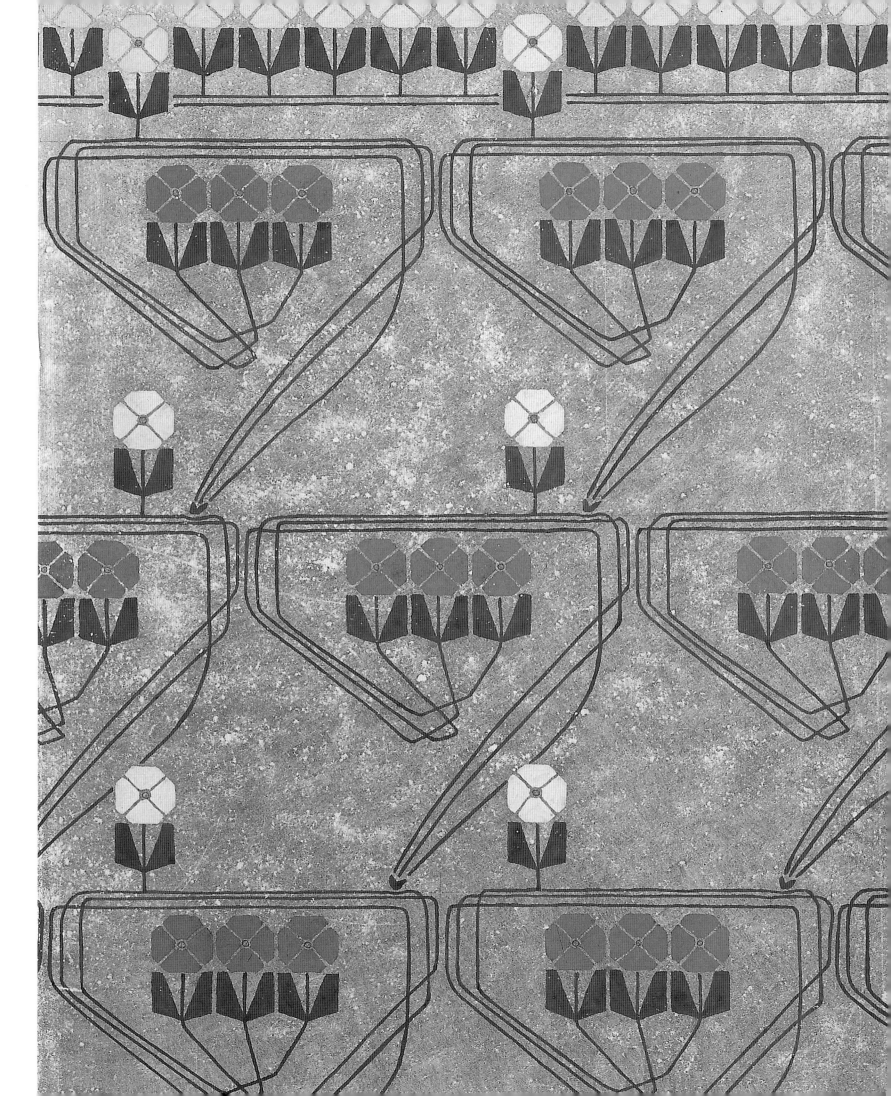

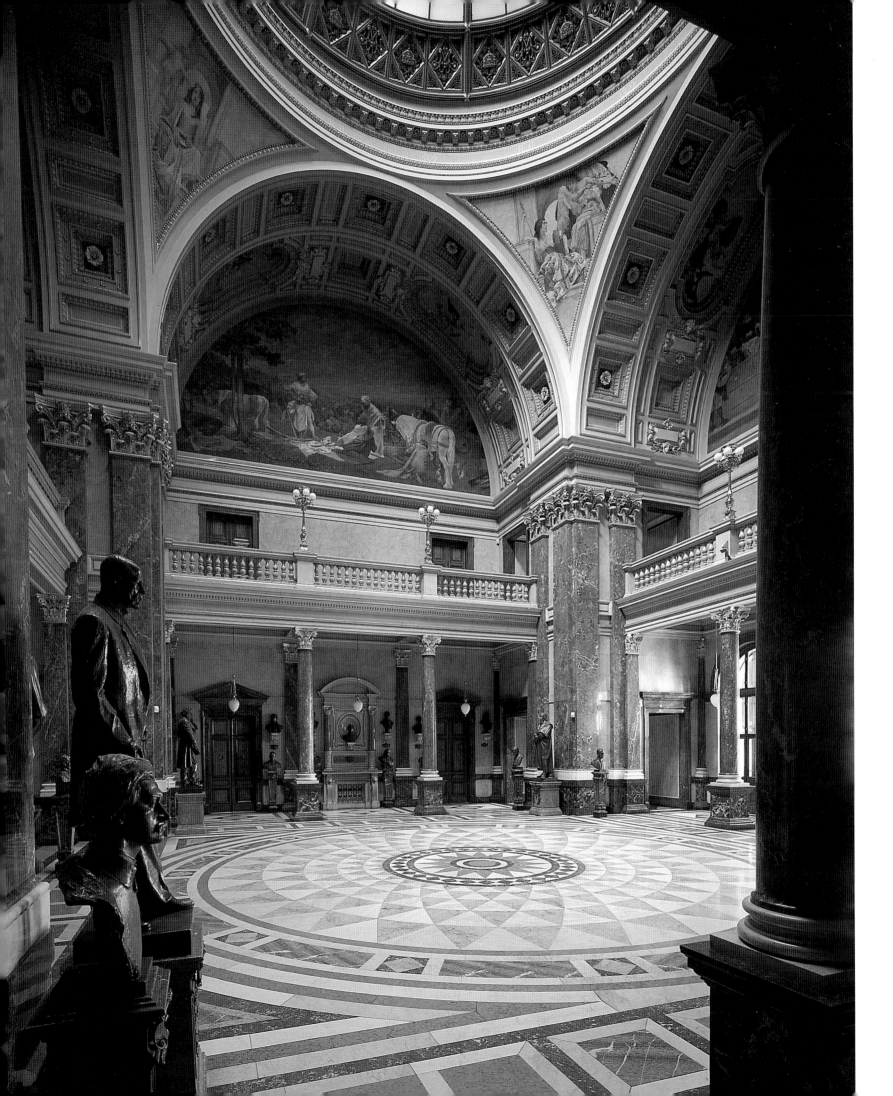

From provincial capital to metropolis

Michael Huig

Few turns of the century have been as frequently and extensively discussed as the transition from the nineteenth to the twentieth century. Major cities have provided a convenient frame of reference for this discussion as here the transition appears to have been particularly abrupt and intense. Moreover, urban society is presumed to reflect a truer image of the origins of twentieth-century social and cultural issues than an entire country. Although cities shared a common culture there were considerable differences, as a review of Prague circa 1900 will show.

Like Vienna and Budapest, Prague lay within the Austro-Hungarian Empire, which was ruled by a Habsburg monarch. Vienna was the capital of Austria and Prague the capital of the ancient kingdom of Bohemia. However, Prague was continually overshadowed by Vienna, for Bohemia was regarded as a province of Austria. Despite this subordinate status, Prague possessed a culture which was anything but inferior to that of Vienna even though Prague's social and historical background was so different it marked all branches of cultural life.

Vienna needs little introduction, since a well-rounded portrait of 'Vienna 1900' has already been drawn. Gustav Klimt, Egon Schiele, the Vienna Secession, the Wiener Werkstätte (Vienna Workshops), Arnold Schönberg, Sigmund Freud and Gustav Mahler all represented a new generation who rebelled against the old, ossified order. Rebels who consciously rejected any culture associated with the past. Although this new beauty was offset by a

Pantheon

A pantheon, a gallery of honour for illustrious individuals, is a concept that dates from classical antiquity. It was revived in Europe during the eighteenth century when many countries founded their own national pantheons. Ideas for a Slavic, Czech or Bohemian pantheon began to circulate in the early years of the nineteenth century. Although many attempts to found such an institution never got further than the drawing board, a pantheon was finally accommodated in the National Museum (1891–1895).

A huge hall, crowned by a dome, housed portrait busts and statues of outstanding Czechs, Slavs and Bohemians. The four wall arches were painted with scenes designed by Václav Brožík and František Ženíšek: The *Election of Přemysl*, *Methodius completes the Slavic translation of the Bible in Rome*, *Charles IV founds the University of Prague*, *Comenius presents his didactic works to the council of Amsterdam*. The painting shown here is the mythological *Election of Přemysl* (1900–1903) from a design by František Ženíšek. The galleries are decorated with allegorical paintings by Vojtěch Hynais (1899–1902).

1
Pantheon, interior of the National Museum on Wenceslas Square, Prague, 1891-95

9

harsh reality – political extremism, social problems and the rise of political mass movements – the enduring image of Vienna, capital of an ancient multi-racial state, is that of a cosmopolitan city, free from excessive nationalism. In a study of Vienna circa 1900, author Stefan Zweig wrote that 'every inhabitant of this city was unwittingly brought up as a supranationalist, cosmopolitan citizen of the world'.[1]

Prague resembled Vienna in major respects. Both cities were undergoing radical modernization: Prague was developing from a modest provincial capital into a metropolis. During the second half of the nineteenth century rapid population growth had already forced Prague to expand beyond its original walls, while the inner city had been subject to major refurbishment since 1893 (fig. 2). In Prague, as in Vienna, there was a sudden movement towards artistic modernity. This movement forms the subject of the present essay.

The major difference between the two cities was that Prague was immersed in a clash of nationalities, while Vienna was not. The success of the Czech national Revival in the nineteenth century had resulted in Prague's increasing emergence as capital of the Czech nation. This provoked conflicts with the German minority, who held social and economic power, and with Austria who ruled both Czechs and Germans. No one could ignore these tussles. Although public life was conducted in Czech and German, with the government issuing communications in both languages, there was no question of peaceful coexistence. Czechs and Germans wrangled almost constantly, despite efforts to encourage rapprochement. At the turn of the century this clash between the two national groups extended to all sections of society and also had a firm hold on cultural life.

National Revival

The most important factor in Czech culture was the belief that the nation was living through a time of Revival. This notion had developed from romantic memories of the independent medieval kingdom of Bohemia, Moravia and Silesia. At the beginning of the seventeenth century this kingdom had fallen into cultural and political decline, and been forced into a subordinate position, as a result of the Counter Reformation and the Habsburg lust for expansion.

At the end of the eighteenth century rich aristocrats and scholars became interested in the old Czech language and literature; moreover they wished to restore something of Bohemia's past splendour. To this end they founded patriotic societies whose task was to promote the arts and sciences in Bohemia. At the beginning of the nineteenth century this patriotism found support amongst wider sections of the population, spreading to the intelligentsia and middle classes. Ideas became more radical: what had started as a fitting occupation for the genteel classes now developed into a national movement which became increasingly important during the course of the nineteenth century.

Although there were similar developments elsewhere in Europe, the unity of the Habsburg empire, being a conglomerate of small countries and nations, was particularly threatened by the force of national movements. During the nineteenth century the Habsburgs' subjects became conscious of their national identity: they founded theatres, created their own literature and called for education in their own language. Above all they demanded political self-determination.

The monarchy endeavoured to ward off these threats by pursuing a domestic policy in which central government presented itself as an impartial agency wherever possible. At the same time the Habsburgs tried to play one region against the other, and thus preserve the monarchy.

During 1848, the 'year of revolutions' whose effects were felt in Vienna, Prague and Budapest, the Czechs and Hungarians emphatically demanded political self-determination. Ten years of firm neo-absolutism repressed the spirit of national independence, but the victory of more liberal forces in 1861 breathed new hope into these dreams. Moreover, the Habsburg monarchy could not continue to ignore its subjects' aspirations without prejudicing internal stability. One of their solutions was to create the Austro-Hungarian (double) monarchy when Austria was split in 1867, and to formally re-establish the independent kingdom of Hungary. From that moment the monarchy was divided into two separate countries which shared only a sovereign, foreign policy and defence.

The independence thus acquired by the Hungarians had long been an ambition of the Czechs. The *Ausgleich*, the 1867 compromise reached between Austria and Hungary, therefore marked the beginning of a period of deep Czech frustration. In 1848 the Czechs had already sought a degree of independence, requesting the restoration of the ancient kingdom of Bohemia. Their aim was to transform the Habsburg empire into a kind of federation of kingdoms, in which the Habsburg ruler would retain his own Austrian lands and become king of Bohemia and Hungary. In 1867, as in 1848, there were various reasons why the Habsburgs would not accede to Czech demands.

2

Josefov, from the western
river bank, c. 1906

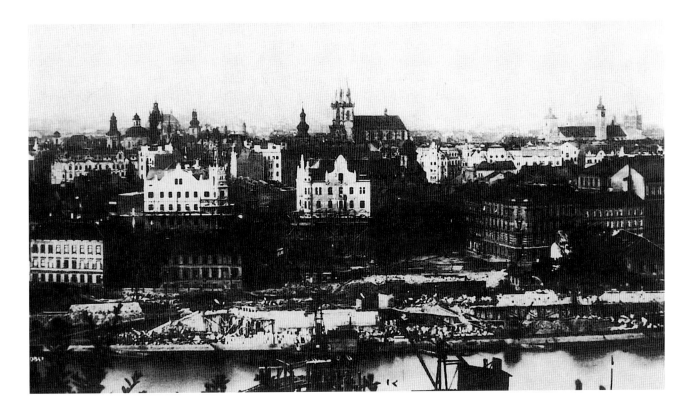

Josefov

In 1893 a law came into force which provided for the 'sanitisation' (*Asanace/Assanierung*) of the worst medieval districts in the centre of Prague. The city authorities deemed such wretched hygiene and miserable social conditions to be completely out of place in a modern city. Blocks of houses were demolished, streets widened and the street plan tidied up. New apartment complexes were built in historicist 'neo' styles. Houses constructed after 1900 increasingly incorporate Art Nouveau elements, particularly in the ornamentation.

In the Bohemian lands the Czechs formed a clear majority over the second major ethnic group, the indigenous Germans. The Germans therefore feared that restoration of the kingdom of Bohemia might threaten their own privileged status. The Habsburg monarchy had relied on an ubiquitous German class of public officials since Germanisation of the Austrian bureaucracy at the end of the eighteenth century. German was the Austrian lingua franca and the language of the upper classes. Restoration of the kingdom of Bohemia was also unthinkable as the Habsburgs considered the region to be an inseparable part of their territory.

The Czechs' response to the 1867 Austro-Hungarian compromise must be viewed against this background. Czech politicians decided to employ 'passive resistance' and began a boycott of the imperial parliament in Vienna which lasted many years. Czechs increasingly focused on developing their cultural identity, an endeavour that the Austrian state had permitted and even encouraged from the beginning of the nineteenth century. Thus the Revival was largely a cultural renaissance, intended to compensate for Czech lack of political influence. When the first stone was laid for the Czech National Theatre in Prague in 1868, one year after the *Ausgleich*, this was not an impulsive response to a rebuff, but the culmination of years of preparation, which fortunately coincided with political reality.

The Golden Chapel

Construction of the National Theatre (1867–1883) was undoubtedly the most important event in the history of the Czech Revival. This was a purely Czech enterprise; the building itself would also serve exclusively as a venue for Czech drama and music. A national demonstration lasting three days was also arranged to coincide with the laying of the first stone. This was entrusted to a series of Czech notables which included the historian František Palacký, who was regarded as the father of the nation, the politician František Rieger and the composer Bedřich Smetana. Delegations in traditional costume or association uniform poured into Prague to attend the ceremonies. The broad national basis for the theatre was

literally expressed in the foundations which comprised blocks of stone hewn from the principal mountains of Bohemia and Moravia. The theatre, built on the east bank of the river Vltava, was given some significant nicknames, such as the 'Golden Chapel' and 'Cathedral of the Revival'. The theatre's motto, *národ sobě* (the theatre given by 'the nation itself'), was even more explicit.

The building and its decorations were intended to embody an ideal synthesis of all the arts. Architecture, sculpture and painting were amicably deployed in the service of music, opera and drama. Although the political aspirations which lay behind the project were not explicitly expressed in the architecture and decorations, they were implied.

The theatre was designed by Czech architect Josef Zítek and built in the then popular Neo-Renaissance style. On the roof personifications of the Nation and the Arts were drawn in chariots by two three-horse teams; the exterior of the building was decorated with many references to classical comedy and tragedy.

The mental illness and untimely death of artist Josef Mánes, regarded as the founder of Czech art, were much regretted as these excluded him from contributing to the interior decorations. Mánes's importance as a Czech artist was based on the fact that he delivered his nation's art from the shadow of European models, drawing his inspiration for style and subject from national interests. Mánes's oeuvre is not characterised by the large-format historical scenes at which his contemporaries liked to try their hand, but by relatively small-format, intimate works, remarkable for their light and elegant treatment of subjects.

Contemporaries prized the style of Mánes's best work, such his illustrations of the Old Czech Manuscripts, for its 'classical' qualities (fig. 7); this style continued to influence the generation of painters who started work on the theatre interior after 1880. The lunettes, walls and ceilings in the corridors and foyer were decorated with Czech and Slavic themes by Mikoláš Aleš, František Ženíšek and Josef Tulka who derived their style and choice of subject from Mánes's artistic legacy (fig. 35).

Although the National Theatre mixes a Neo-Renaissance style with late nineteenth-century interpretations of national medieval themes, and thus appears a monumental anachronism to modern eyes, contemporaries viewed the building from a very different perspective. Having praised the classical qualities in Mánes's work, believing they were experiencing a rebirth of the Czech nation, it seemed only reasonable to combine national history with stylistic elements from classical antiquity and the Renaissance.

The National Theatre was completed in 1881. The writer Jan Neruda, a passionate patriot who had been closely involved in the building process, wrote that 'from now on there is a peerless monument to Czech awakening on the banks of the Vltava, a cathedral for future art, a university for the Czech spirit, built by the Czech people and the Czech genius!'[2]

A fire soon damaged the building which was reopened in 1883. The Smetana opera *Libuše* was performed for both openings. The curtain by Vojtěch Hynais was regarded at the theatre's crowning glory. It comprised a large number of allegories, with various figure groups showing how Czech people from all stations of life had built and rebuilt the theatre.

The liberal dream

Although the National Theatre spread the idea of a wide-ranging unity, supported by the entire nation, only a relatively small group with political and economic power were able to present themselves as a national movement. This was the reality behind most national movements in the nineteenth century: although nationalist principles gained popularity in increasingly broad layers of the population, only a fraction of these were in a position to make themselves heard politically. In Austria too, all kinds of electoral thresholds kept the vast majority of people out of politics.

Since the beginning of the 1860s the leading political and cultural circles in Prague had consisted of German and Czech liberals who had acquired their wealth

Záboj and Slavoj

Although the younger artists and Myslbek's students distanced themselves from him and the School of Fine Art at the turn of the century, they admired their teacher's early studies, particularly for the dynamic qualities of his designs. They were inspired, for example, by Myslbek's pair of four sculptures to decorate the new bridge over the Vltava close to the Vyšehrad hill, Prague. The sculptures, for which Myslbek had won a competition in 1881, include a bard and a warrior from the Old Czech Manuscripts. These bridge sculptures are a reference to Vyšehrad as the legendary seat of the original Czech Přemyslids dynasty. They are also a modern counterpart to the monumental Baroque statues on the Charles Bridge.

3
Josef Václav Myslbek, **Záboj and Slavoj**, 1882, Národní galerie v Praze, Prague

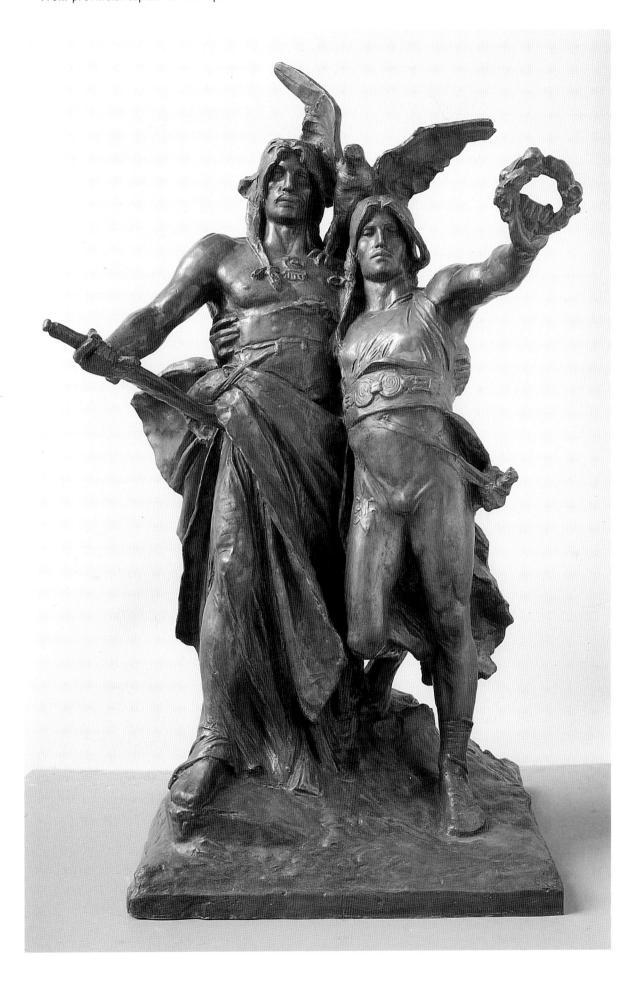

The National Theatre,
Prague, 1868-83

through industrialization. Although this new liberal order competed with the old aristocracy, they were often united by a shared patriotism and a common goal: to expand Prague for the greater glory of the fatherland, and adorn the city with exemplary architecture which would house institutions and thus enhance the city's prestige.

The Ringstrasse in Vienna was the major Central European model for city refurbishment and beautification. In 1860 the Vienna city authorities began to lay out impressive boulevards on a wide strip of wasteland between the old city centre and the more recent suburbs. A number of notable buildings were constructed along these boulevards, such as the parliament building, the city hall, the university and the Burgtheater. Ringstrasse architecture was characterised by a variety of 'neo' styles: the city hall was Neo-Gothic, the parliament building Neo-Classicist while the Burgtheater and the university were both Neo-Renaissance, although of a very different stamp. In Prague during the same period similar efforts were made to construct exemplary new buildings, although the scale was considerably smaller and the overall plan less ambitious.

Between 1885 and 1890 the National Museum, which was intended to house archaeological and natural history collections, was built at the top of Wenceslas Square. This monumental edifice, in a neo-Renaissance style reminiscent of the university building in Vienna, was constructed on the site of earlier fortifications and a city gate. The Bohemian museum organisation, which dated from 1818, had been founded by mainly aristocratic patriots and played an important role in the early phase of the Revival. The National Museum was not exclusively Czech in orientation but rather a Bohemian institution. This meant that to a certain degree it was nonpartisan, a status expressed by the Latin – therefore politically neutral – inscription on the façade: MUSEUM REGNI BOHEMIAE (Museum of the Kingdom of Bohemia). Within the museum considerable tribute was paid to famous Bohemian scholars, without any bias towards Czechs.

The Artists' House or Rudolfinum (fig. 6) was also politically neutral. This housed concert auditoriums, a conservatoire and exhibition halls for the new Museum of Applied Art, the annual salons of the Art Society (Kunstverein für Böhmen) and the vast collection of paintings owned by the Association of Patriotic Friends of the Arts (Gesellschaft patriotischer Kunstfreunde).

The constitution of the Rudolfinum encapsulated various stages of the Revival. The Association of Patriotic Friends of the Arts – originally a German-speaking organisation, but later free of any language

bias – was a relic from the earliest phase of the Revival which was still Bohemian-patriot in character. The Association was founded in 1796 by a handful of aristocrats who wished to reverse the decline in the arts. To this end they merged their private art collections into a public collection (1796) and financed the first Prague drawing school (1800) which later developed into the Academy of Fine Art during the course of the nineteenth century. For decades the Association of Patriotic Friends of the Arts had monopolised the art world in Prague and Bohemia. Although rival art organisations had emerged, such as the Art Society and the Art Circle (Umělecká beseda), both of which were free of any language bias, the Association of Patriotic Friends had retained its original character and was still a bulwark of the Austro-Bohemian high nobility. The Association's paintings were finally housed in the Rudolfinum as a result of widespread complaints about Prague's lack of a significant art museum.

Institutions such as the National Museum and the Rudolfinum expressed the aspirations of Prague's liberal elite who formed opinion in the second half of the nineteenth century. The dream that they disseminated, of a culturally superior city where national differences were muted, was eventually rudely interrupted by the process of social differentiation which came increasingly to the fore at the end of the century. The political reality of the late nineteenth century was the growing importance and influence of classes other than the bourgeoisie and aristocracy. New political movements, such as social-democracy and Christian politics, mobilised sections of the population who were concerned with social issues as well as national questions.

The National Theatre

The National Theatre was the best known symbol of the Czech Revival. It was built between 1868 and 1883 in Neo-Renaissance style. There were virtually no references to Slavic or Czech themes on the exterior, with the exception of two statues of the mythological characters Záboj and Lumír by Antonín Wagner.

However, the interior displayed considerably more Slavic themes, despite a profusion of Renaissance-style decorations and motifs. The lunettes in the foyer were painted by Mikoláš Aleš with legendary and mythological subjects freely derived from the Old Czech Manuscripts.

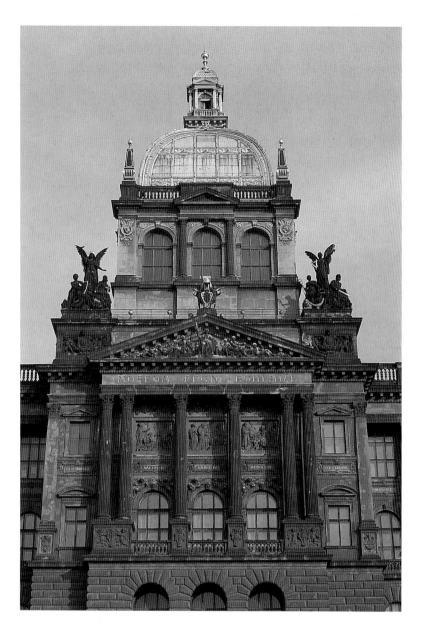

5
The National Museum,
Prague, 1885-90

German or Czech air

With the National Theatre the Czechs proved to themselves that they could rival other nations. However, their frank cultural ambitions and, of necessity, more secretive political demands, brought them into conflict with Bohemian Germans and with the government in Vienna. Political, demographic, cultural and social developments in the second half of the nineteenth century contributed to a build-up of tension between Czechs, Germans and Austria.

German communities in Bohemia traditionally formed about a third of the total population; this purely numerical ratio remained virtually unchanged until the twentieth century. Prague, however, was the exception; here demographic developments were fundamentally at variance with the situation in Bohemia as a whole.

As a result of the Germanisation of Austria's administrative machinery at the end of the eighteenth century, Prague circa 1800 still resembled a Germanic city in which a small Czech minority also lived. A governmental centre with German as the official language, Prague was German in character. However, this did not mean that its residents felt German: they were Austrians first and foremost and had little contact with the German nation. Many attested that they chiefly felt Bohemian. German was only the official language for what was still a relatively small middle class. Anyone who wished to join this class had to speak German, Czechs included. This meant that educated Czechs spoke very little Czech. Josef Mánes, for example, the acclaimed founder of Czech art, wrote abominable Czech and had to use a German translation to help him with his illustrations of Old Czech Manuscripts. This serves to illustrate how language was far from an absolute expression national identity in this period.

It was only at the end of the nineteenth century that language and nationality began to converge. The population ratio in Prague had been turned around: the German community had shrunk from an – albeit ethnically questionable majority – to a minority with scarcely more than thirty thousand souls against a Czech population of several hundreds of thousands. Moreover, Czechs occupied the most important government positions and dominated cultural life. Prague had become Czech.

This position had been obtained partly as a result of the Czechs' successful social and economic development, the major factor being that it had become progressively easier to appear in society as a Czech. Czech politicians had also acquired some modest political influence, which stemmed from the ending of their boycott of the imperial parliament and the period of 'passive resistance'. Among Czech successes was the granting of equal status to the Czech and German languages in 1880, and the division of Prague university into Czech and German departments in 1882. These measures ended German ascendancy. In Prague there was the added element of vigorous Czech immigration which reduced the Germans to a minority. Czech success was particularly reflected by Jewish immigrants to Prague: although this section of the population had traditionally opted for German culture, around 1900 they increasingly chose Czech.

During the final decades of the nineteenth century, Prague society was subject to an inevitable division of nationalities. Although most citizens were brought up speaking two languages and both Czech and German were used in shops, depending on which was most

appropriate, this division was strict and absolute in the sphere of recreation: for every German choir or sports club there was a Czech equivalent. This was a tragic state of affairs since traditionally there were many mixed families. The historian Anton Gindely (Hungarian father, Czech mother, published work in German) feared the moment 'that we have to choose whether we shall henceforth breathe German or Czech air'.[3]

The Czech-German conflict was reflected in culture. Germans in Prague responded to the Czech National Theatre by founding a new German National Theatre which opened in 1888 with a production of Richard Wagner's *Die Meistersinger von Nürnberg*. On a more theoretical level there was the question of the image presented by Czech and German art: could nationality be inferred from a work? The aristocratic patrons who had wished to stimulate the arts in Bohemia circa 1800 had been interested in reviving arts *in* Bohemia, *not* Bohemian art. True art was deemed to be universal, not bound to time or place. Nevertheless the advance of national dif-

ferentiation created a need for more national art. In the eyes of the Czechs, Josef Mánes was the first artist who managed to give substance to the notion of Czech art, although this judgement was partly supported by the idea that Mánes was a Czech artist who represented both

The Rudolfinum or Artists' House

To mark its fiftieth anniversary, the Bohemian Savings Bank presented the city of Prague with a building dedicated to music and the visual arts. The name Rudolfinum referred both to the then Crown Prince Rudolf and the legendary Habsburg monarch Rudolf II (1552-1612), who moved his court from Vienna to Prague where he established a celebrated centre of culture. Josef Zítek, architect of the National Theatre, designed the imposing building in collaboration with Josef Schulz (1840–1917). They drew their inspiration from the ideas of two internationally acclaimed Germans, the architect Gottfried Semper and the composer Richard Wagner.

6
The Rudolfinum or Artists' House, Prague, 1876-84

7
Josef Mánes, **Záboj**, c. 1857, illustration for a contemporary editon of the Old Czech Manuscripts

Záboj

Josef Mánes's best known work is his illumination of the Old Czech Manuscripts. Since their discovery at the beginning of the nineteenth century the manuscripts had played a crucial role in the Revival: these fragments of tenth- and thirteenth-century lyrics showed that, alongside the usual Latin court culture, there had been an authentic Czech culture in medieval Bohemia. A culture with a literature that could be favourably compared with German works of the period, such as the *Nibelungenlied*. Czechs praised Mánes's illustrations for emphasising the Czech (Slavic) character of the texts and for being in keeping with the period in which the manuscripts were written.

universal and national artistic values. The principle of universal art was not abandoned in the generation of the National Theatre, although publications were already writing in terms of nationality.

The battle raged at times in the galleries of the Rudolfinum. The association that organised the annual Prague salons, the Art Society, had also acquired a Czech title, Krasoumná Jednota. Despite the board's pursuit of a strictly nonpartisan and supranational policy, conflicts with the outside world did arise. Czechs protested when

German Bohemian art associations also exhibited in the Rudolfinum's galleries; Czech artists who presented their work in the salons were criticised by their more radical colleagues for the same reasons.

The government in Vienna endeavoured to remain neutral in its policy towards the arts, making great financial sacrifices in an effort to win over the warring parties and reconcile them with each other. Vienna wanted to prevent cultural institutions from splitting into Czech and German departments at any cost. As a result, Bohemian art organisations profited more from royal subsidies than similar organisations in other Austrian lands.

The Prague Academy, which had originally been founded with private capital by the Association of Patriotic Friends of the Arts, received subsidies from Vienna as early as the 1880s. In 1897 the academy became a college and a state institution. A great deal of money poured into Prague from Vienna, much of which was intended to subsidise construction of new buildings for the academy. In return, Vienna insisted that the academy appoint some German teaching staff. The academy complied despite Czech protests.

The Modern Gallery was a bona fide gift from Vienna with political intentions. In 1902, the emperor donated two million crowns for the creation of a collection of nineteenth-century Bohemian art. His objective was clear: he wrote that he hoped 'that both races in our beloved kingdom of Bohemia [would be represented in the collection] in amicable rivalry'.[4] The Modern Gallery's organisation was strictly bilateral; work was bought from both Germans and Czechs. The only opposition came from young avant-garde artists who thought the purchasing policy too conservative and wished their own work to be included in the collection.

Modernism and nationalism

Although there may have been a positive side to cultural competition between Czechs and Germans, this is as hard to establish in retrospect as the negative effect. A more important question is whether modernism, which emerged during the 1890s, brought an end to the cultural clash of nationalities. For the collective ideal of a new culture united Czech and German modernists: irrespective of nationality, they rejected the culture of the previous generation. Czechs and Germans worked together on ventures such as the literary magazine *Moderne Dichtung*, founded in 1897. However, this did not lead to the development of a truly supranational Prague literature.

8
Adolf Liebscher, **The development of painting in Bohemia**, 1890-91, design for a decoration in the Rudolfinum, Czech Savings Bank, Prague

Modernism can be regarded as an offshoot of a broader social and intellectual movement which revised the prevailing mood of nationalism. The initial impulse for this movement dates from the 1880s. In 1886, following the example of a colleague, a Prague professor from the Czech university, Tomáš Garrigue Masaryk, pressed for an investigation into the authenticity of Old Czech manuscripts. Although the genuine nature of these manuscripts was disputed, the subject was taboo in Czech circles. A bitter polemic ensued which unsettled the entire country. Masaryk's opponents claimed that he and his supporters were jeopardising the future of the Czech nation: what would be left of the nation without its glorious history? The manuscript problem was not the only source of dispute. In the same year, 1886, the publicist Hubert Gordon Schauer set the Czech people a hard question, when he asked them what was the state of their nation and what did they consider to be their nation's goal? His own negative assessment of the situation shook the self-confidence that many Czechs had developed during the national Revival. The manuscript dispute and Schauer's article marked the beginning of a change in Czech society. The issues raised were no longer denied, although they could not be resolved. They provoked lively debates which captivated society for decades to come.

Franz Kafka

The writer Franz Kafka (1883–1924) is a famous representative of Prague's literature at the early twentieth century. Of German-Jewish extraction, his parents originally came from the country and married in Prague where Franz's father opened a shop, 'Galanteriewaren en gros Geschäft'. Kafka studied law at the German university in Prague and worked for an insurance company. He wrote his novels and stories in German, although he also spoke Czech.

9
Franz Kafka, c. 1923-24

The liberal culture's reliance on history was now offset by a new realism. This was most apparent in the unhistorical approach to revising national history. Masaryk, who was not a historian himself but a philosopher and sociologist, broke with the custom of using historical arguments to explain the Czech national Revival. He asserted that the Czech nation existed independently of its history, that it was simply a fact.

In his 1894 study *The Czech question*, Masaryk followed Schauer's lead; he examined the Czech nation's task and its place in the world, asking: was there a place for a Czech nation and what was the basis for its existence? Masaryk saw a future role as a defender of universal values, a role which had already been propagated by the reforming movement. His study also covered other areas, considering the problems that faced modern

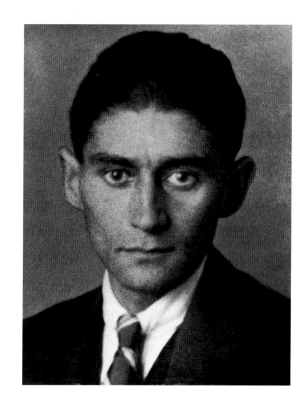

Monument to the historian František Palacký

The historian and politician František Palacký
(1789–1876) was one of the major figures of the
Czech Revival. He expanded Czech consciousness
through his monumental history of the Czech nation
(1836–1876) in which he declared that the history of
the Czech people had been determined by a cen-
turies-long cultural and political conflict with the
Germans. He also interpreted the pre-Reformation
Hussite movement as the high point in Czech history.

Palacký is portrayed seated before a maelstrom
of bronze figures which represent themes and phases
from Czech history. Repression and decay are sur-
mounted by victory and glory. The text on the
pedestal reads: 'The reborn people to their leader
and guiding light'.

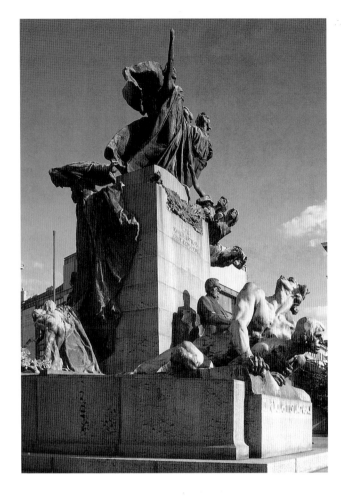

society – especially social issues – from a sociologist's
perspective.

Although these ideas could not be easily translated
into a political programme, they were well received by
many young writers and artists, who were irritated by
what they perceived as the Czech middle class's short-
sighted and complacent isolation. International in out-
look, they noisily rejected the dominant trend of dilettan-
tism and primitive patriotism in the *Modern Manifesto*, an
1895 publication with a strong political flavour. This
marked the true beginning of Czech modernism.

However, even artistic modernism could not escape
the clutches of the nationalism it had originally set out to
rebuff. Although small groups continued to profess a fer-
vid cosmopolitanism and seek contact with the interna-
tional avant-garde, nationalist tendencies began to com-
mandeer modern movements after 1900. This assimilation
was accelerated by political fragmentation and the social
expansion of politics. Genuine political parties and mass
movements developed. Politics took to the streets and
people wanted to see the symbols of their struggle in
public spaces. Modernist artists also received official
sanction when they were commissioned to produce
national monuments.

The majority of leading modern artists were enthusi-
astic about such national commissions: sculptor František
Bílek created several monuments commemorating the
church reformer Jan Hus. Statues of national heroes had
been erected in Bohemia since the early 1870s. However,
such statues were easier to place in Czech provincial
towns and villages than in Prague, where they would pro-
voke the inevitable fierce discussions and government

interference. This explains a period of almost fifty years
in which almost no monuments with overt political signif-
icance were erected in Prague. In buildings such as the
National Theatre, the Rudolfinum and the National
Museum, the policy was to avoid explicit references. It
was not until 1898 that plans for monuments were again
developed in Prague, and a few more years past before
such projects were implemented.

On the centenary anniversary of his death, a monu-
ment to the historian František Palacký was well over-
due. The statue designed by Stanislav Sucharda reveals a
clear tendency to represent history symbolically and
group various periods in complicated syntheses (fig. 10).
A similar approach can also be seen in the Prague monu-
ment to Jan Hus on the Old Town Square. This work by
Ladislav Šaloun compresses three centuries of history,
from the fifteenth to the end of the seventeenth, and
presents them from the perspective of his own genera-
tion (fig. 11). Around the turn of the century there were
also plans for a large statue in honour of the radical
Hussite leader Jan Žižka (c. 1360-1424), but this
remained on the drawing board for many years (the stat-
ue was finally completed in 1950). The fact that even

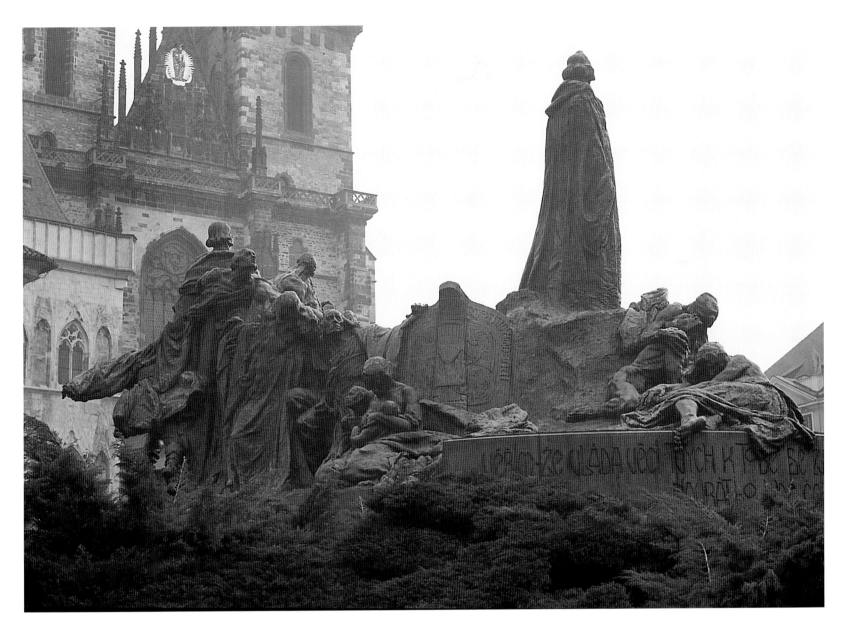

11
Ladislav Šaloun, **Jan Hus**,
Old Town Square, Prague,
unveiled in 1915

Cubist designs were later produced for this statue illus-
trates how nationalism had encompassed modernism,
rather than vice versa. Modernism's original summons to
develop an international art had long been attenuated
and only retained adherents in the exclusive group of the
international avant-garde.

Jan Hus

In 1415 the church reformer Jan Hus (born c. 1370)
was burned at the stake. This statue was unveiled
exactly five hundred years later. Although the monu-
ment commemorated Jan Hus, it also represented
the greatness of the Czech people, their oppression
and their mission. This is expressed by the figure
groups around Hus. It is no accident that the monu-
ment faces the site where, in 1621, defiant Bohemian
nobles were executed in the aftermath of the disas-
trous Battle of the White Mountain. The text on the
pedestal is one of Hus's sayings: 'Love one another,
wish everyone the truth.'

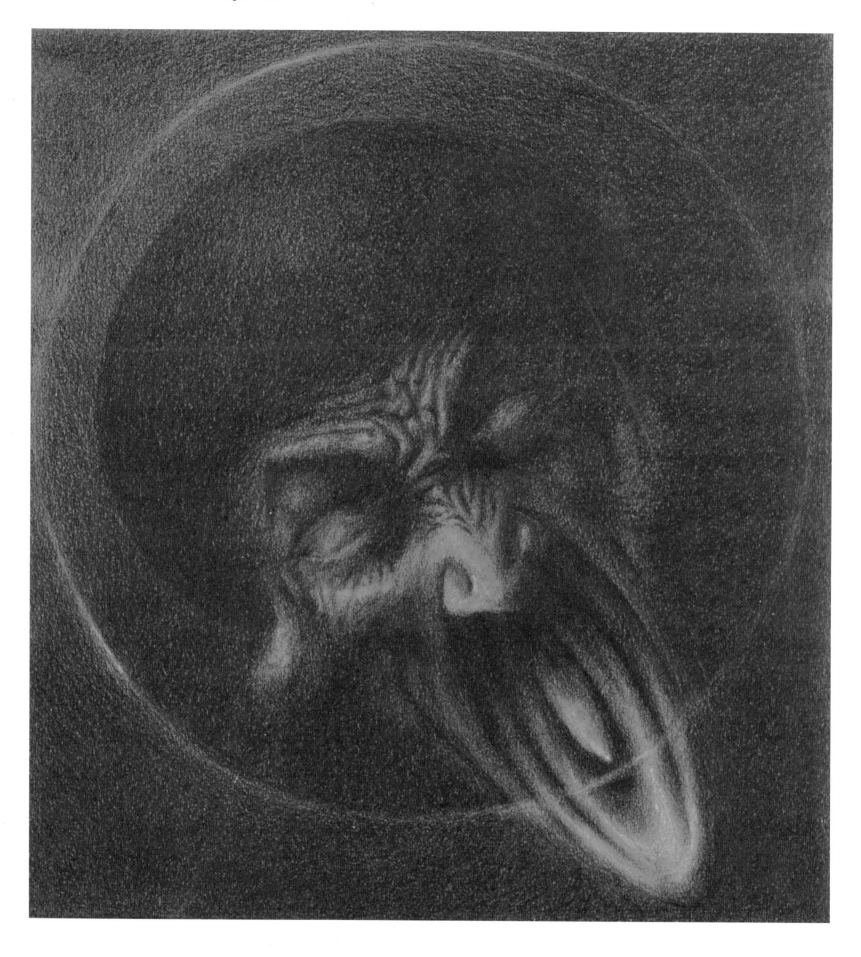

Pictura & Poesis
The interplay of literature and art

Luboš Merhaut

The transition from the nineteenth to the twentieth century brought sweeping changes for Czech art. Here I shall focus briefly on a few of the crucial moments and figures in Czech literature around the turn of the century, with particular reference to the relation between literature and the visual arts.

Developments in art and the growth of a modern Czech culture had always been to a large extent determined by literature. Literary criticism and theoretical articles frequently expressed more general views, which could be applied to the visual arts and music. It is fair to say that the convergence of art forms, which was fully realised in the idea of the *Gesamtkunstwerk*, became one of the characteristic features of the Czech *fin de siècle*. Up to then artistic life had been dominated by the confrontation between a national and a cosmopolitan orientation: in art this meant historicism, tradition, bias and slavophilism on one side and on the other a concern with contemporary, often social, issues such as the pursuit of ideological autonomy and experiment, and a West European, in particular francophile, attitude.

In the course of the attempt to extend the range of art, which in turn was itself striving for autonomy and refusing to serve the prevailing ideology any longer, movements and critical stances followed and combined with each other in rapid succession. Fierce and fundamental debates were waged between the various groups and generations. To quote Karel Teige, one of the leading art theorists of the interwar period: 'At that time the problems of Czech art were consistently, boldly and radically made those of world art, and the problems of world art those of the Czech creative arts.'[1]

It was indeed a revolutionary period in that Czech art, in an attempt gradually to catch up with world

The exile

Arnošt Procházka was the leading figure in the group associated with the journal *Moderní revue* and the author of the decadent-Symbolist programme published in *Almanach secese*, 1896 (Almanac of the Secession movement). In 1894 he published a provocative and typographically audacious volume of poetry, *Prostibolo duše* (Brothel of the soul), which was inspired by the cycle of drawings with the same title by Karel Hlaváček. A poet and artist who died young, he depicted in his work an accumulation of impressions, a fusing of poetic and painterly symbols, of style and evocation, which balanced on the edge of Symbolism and early Expressionism.

12
Karel Hlaváček, **The exile** (study for the cycle in **The brothel of the soul** collection of poems by Arnošt Procházka), 1897, National Literary Museum, Prague

13
Mikoláš Aleš, **Illustration to 'May' by Karel Hynek Mácha**, 1886

Illustration to 'May'

The work of the Romantic poet and writer Karel Hynek Mácha was a constant source of inspiration for Czech art. Mácha was the author of the great cycle *May* (1836) and the founder of modern Czech poetry. From the 1850s he influenced the main artistic movements, from the 'May generation' led by Jan Neruda and the modernism of the turn of the century (including Neo-Romanticism) to the avant-garde of the interwar period. Two of the many painters who were stylistically influenced around the turn of the century by Mácha's poetic images were Aleš, who belonged to the historicism generation of the 1870s, and Kobliha, who was also active as an art critic and essayist in the decadent circle around *Moderní revue*.

trends, was in the course of realising its own version of modernism. The rationalist view of the world had collapsed and, as values became more relative, scholarship, ethics and art began to pursue new ideals, each in its own way. Such concepts as 'truth', 'authenticity' and 'beauty' had to be redefined; they were freed from everyday practice and took a more transcendental turn.[2] Through the number and diversity of movements and

programmes a process of dynamic confrontation and mutual influence developed, especially between Realism (Naturalism), Impressionism and Symbolism. This was most radical in the case of Symbolism, which favoured the move towards fusion in principle and by its nature offered scope for representation in which internal and external worlds, introspection, emotions and reflection of nature merged into a synthesis. Through the aesthetic precepts of modernism, which while varying in style were all aimed at synthesis, a radical solution was sought for the question of what the artist's attitude to art should be, and great stress was laid on having an individual, personal style. Other issues were also raised, such as the relation between art and life, and between the spiritual and the material.

From objective realism to modern subjectivism

In the 1880s Czech cultural life still bore the traces of the growth of national consciousness within the Habsburg monarchy. The emancipation of the Czech language had played a unifying role as a national element in this process. In addition, the aim had already been to form a modern, Czech society and to develop a multi-party political system.

In literature, besides the representatives of the so-called 'national school' (Svatopluk Čech and the magazine *Osvěta* - Education), the tone was set by the poets associated with the 'cosmopolitan' magazine *Lumír* (fig. 104), led by Jaroslav Vrchlický, Josef Václav Sládek and Julius Zeyer. In form and subject matter, in their own work and numerous translations, these poets sought to establish links with literature in other countries. In their sensibility and inclination towards the spiritual and subjective reflection, they were precursors of Neo-Romanticism and Symbolism. Through their versatility, they brought the different art forms closer together and promoted greater autonomy in art.

Thus illustration gradually rose above the level of a simple, descriptive image; the more spiritual spheres which lay hidden in the imagination were discovered. The idea that musical concepts such as harmony and symphony could integrate the various arts and elevate them to a higher plane stimulated the imagination, for instance the Wagnerian idea of 'Art of the future'.

As for the visual arts, in the absence of true art periodicals, literary magazines with a national or cosmopolitan slant published illustrations and reproductions of contemporary work. Modern art criticism also developed

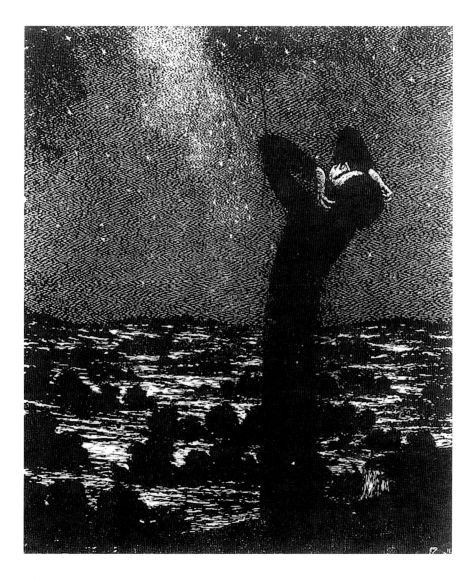

14
František Kobliha, **May night** (from the cycle **May**, 1910-11), Národní galerie v Praze, Prague

in these magazines, so it was written mainly by literary figures and was often intended to popularise art. This tendency was more evident in the 1880s than in subsequent decades. Magazines such as *Ruch* (Activity), including the art supplement *Umělecký ruch* (Art activity), devoted more and more space to art, discarding their narrowly national orientation and providing a platform for criticism that was more Realist in its approach.

The Realist movement, which was linked through the person of the later president Tomáš Garrigue Masaryk with society at large and political life, aimed in the 1880s and 1890s to redefine Czech national values. Realism in art, as expounded by the theorist Otakar Hostinský, rejected historicism and academicism, and called for the approach to everyday reality to be governed by the criterion of 'truth': a rational, scientific approach was the prerequisite for the new art.

This newly developed realism, with its open and analytical vision, also formed the basis for the work of the modernist generation of writers of the 1890s. But

despite their critical attitude to outdated canons, they soon turned against overly descriptive realism and naturalism in the regional and historical novel. Opposing objectivism and materialism, they formulated new, more dynamic principles. In the spirit of Nietzschean individualism and scepticism and under the banner of aesthetic idealism, they emphasised spirituality and introspection, and the autonomy of the poetic image, while advocating the notion of a forceful character – as individual and as artist – who affects how the art work is interpreted.

The links between the various art forms and their common goals can be seen in the most expressive aesthetic and literary/critical texts by the leading critics of the 1890s, first of all in the magazines *Niva* (Meadow), *Vesna* (Spring) and *Literární listy* (Literary pages). But at the same time the differences within this generation became sharper. The exponents of decadent-Symbolism (Arnošt Procházka, Jiří Karásek and the group associated with the magazine *Moderní revue* (Modern review) defended the egocentric and narcissistic approach inherent to aestheticism. They were convinced of the superiority of art and the individual, and saw Art and Beauty as the antithesis of everyday life and petit bourgeois moralism.

As an alternative to this contrived aesthetic, František Xaver Šalda offered a more democratic view of the artist. According to him, the artist consciously influenced his surroundings and connected the life around him to art by means of synthesis, by which he meant an organic unity of artistic expression and a 'way towards life'. For Šalda, this was the point of modernism. This much more dynamic view was apparent in, for example, his article 'Synthetism in the new art' (1892) and in his participation in the group 'Czech moderns' (1895) centred on the magazine *Rozhledy* (Outlooks), and was increasingly influenced by contemporary literary and artistic life. He sought generally formulated principles, such as the inner correspondences between the arts, and new modes of expression for these inner images and reflections, such as the word, line, colour, sound, ascending to the metaphysical.

Literature and art were brought closer together in the period of Impressionism and Symbolism. While literary qualities gradually penetrated art, in literature the influence of art techniques became more evident, for example in stylisation and the description of visual impressions. All this is apparent in the work of the leading poets of the time, Antonín Sova, Jiří Karásek, Otokar Březina, Stanislav Kostka Neumann, Viktor Dyk and Petr Bezruč. This interaction is even more clearly seen in the

15
František Bílek, **Portrait of Julius Zeyer**, 1902, Národní galerie v Praze, Prague

16
František Bílek, **Double portrait of Zdenka Braunerová**, 1900, Uměleckoprůmyslové museum v Praze, Prague

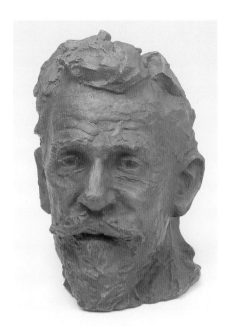

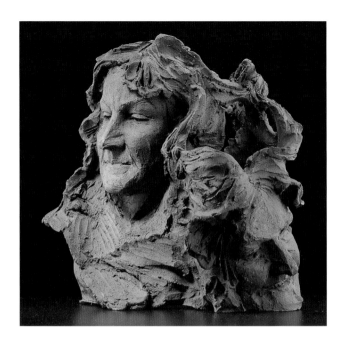

Portraits of Zeyer and Braunerová

Julius Zeyer and Zdenka Braunerová were two of Bílek's few close friends at the turn of the century. Zeyer was an important poet from the Neo-Romantic and Symbolist period and Braunerová was a painter and muse of the cultural elite of Prague at the same time. Both were older Mæcenases of the sculptor and were to a certain extent his link with the 'real' world. At the end of the nineteenth century Bílek developed his own poetry of 'form' which he first applied in the portraits of himself and his close friends.

The portraits of Zeyer and Březina were hollow and somewhat open like a vase, reminiscent of the somewhat older, primitivist ceramics of Paul Gauguin. Although this certainly corresponds with Bílek's earthenware technique, it was also linked to his idea of the human form as being made from clay or 'dust', reflecting the Biblical image of the transience of life on earth.

This double portrait of Zdenka Braunerová forms the apogee of Bílek's portraiture. In this painting he projected his ideas about femininity: a silhouette surrounded by a bright light is reminiscent of the way the Virgin Mary is often portrayed, and yet she is also presented as a devastating *femme fatale*, a figure often depicted by Bílek towards the end of the nineteenth century in the form of a comet driven by a shadow and the earth's gravity.

case of the poet Karel Hlaváček, who was also a practising artist, and conversely in that of the painter František Kaván, who wrote poetry. The reciprocal influence developed through well-designed magazines which consistently paid attention to both disciplines and in which writers and artists published collaborative art reviews; apart from *Moderní revue,* these were the anarchistic *Nový kult* (New cult), the aestheticist *Volné směry* (Free directions) and later, *Umělecký měsíčník* (Art monthly).

The quest for a synthesis of art and life was advocated by Šalda in particular – from 1901 to 1907 when he was the editor of *Volné směry* – and meant in the case of Czech literature at the beginning of the twentieth century that modernism (by now a fully accepted concept) must be interpreted more broadly and given greater scope. Established and new writers experimented further with merging naturalistic, Impressionist, Neo-Romantic and Symbolist elements. In a highly personal way Miloš Marten explored the problem of style and the new spiritual order in the relation between literature, music and painting. The metaphysically inclined work of Otakar Theer and Jakub Deml was also influenced by Symbolism. Some among the younger generation of poets, such as František Gellner, Fráňa Šrámek and Karel Toman, introduced Expressionist elements in their work. Characteristic of these writers is their preference for everyday, mainly urban, reality and social issues. They represent the sceptic individualism and non-conformism of the generation of the 1890s which expressed itself in anarchistic rebellion and a Bohemian attitude: behind a mask of cheerful cynicism lay the awareness of a lost existence.

17
Karel Hlaváček,
Apparition, 1897, National
Literary Museum, Prague

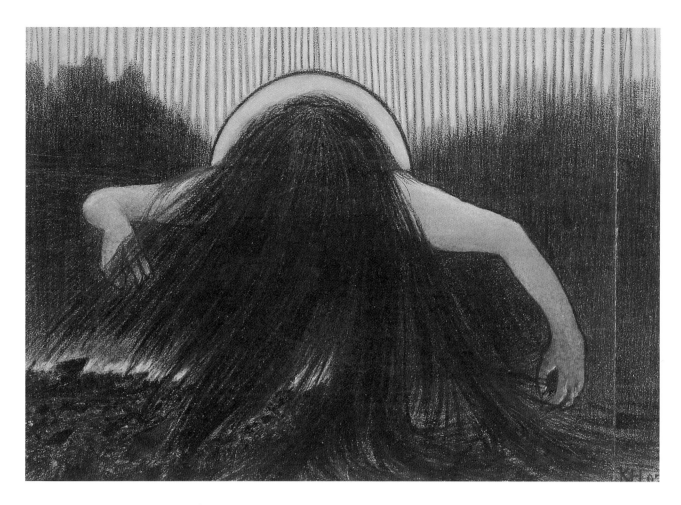

Apparition

Hlaváček produced all his poetic, artistic and critical work in a period of less than three years, and yet his is one of the most significant contributions to the European decadence movement. He focused entirely on the psychological world, as did Félicien Rops, Edvard Munch and Odilon Redon. Hlaváček's visions are filled with social, ethical and aesthetic recalcitrance and his principal means of expression is the symbol which, through a kind of psychic naturalism, often makes a far more drastic impression in his visual art than in his poetry. Obsessive sexual traumas, disillusion and a feeling of pointlessness are the main themes in his work.

In the pastel *The apparition* a flying woman-demon bends over a destroyed world. She is redolent of the woman in Munch, a magical force full of evil powers.

The motif of hair covering the face symbolises an unbridled orgy, as do the pink arms that loom up out of the gloomy background. Through the devilish face, contorted into a violent grimace, the pastel *The exile* also symbolises the woman's demonic character. In a letter to his friend, the Polish decadent Stanislaw Przybyszewski he describes the work's development: 'I understand *The exile* as someone who has been driven from the sexual paradise... the urge had already transformed the mouth into slimy female genitalia open wide in spasm... but afterwards I was seized by such disgust and horror at my own work... that it had to go and I just stylised the whole thing a little'.

27

18
František Gellner,
**Caricature of František
Kupka**, 1905 (published in
the journal **Šibeničky**),
Národní galerie v Praze,
Prague

Caricature of František Kupka

The work of František Gellner shows a predilection
for the Bohemian style, which employed ironic and
grotesque elements and drew inspiration from
cabaret and review. Gellner was a writer (in 1901 he
published a book of poems with the telling title *After
us the deluge!*), a graphic artist and a painter. He also
drew caricatures for humorous magazines in Paris.
Around the turn of the century there was a sharp
increase in the Czech-speaking countries in the num-
ber of satirical magazines in which the special genre
of jokes in the form of drawings and caricatures
accompanied by texts developed. Periodicals such as
Šibeničky (**Gallows**), *Svítilna* (**Lantern**), *Karikatury*
(**Caricatures**) and *Rudé květy* (**Red flowers**) published
work by the artists **Hugo Boettinger, Vratislav Hugo
Brunner and Josef Lada** and by the writers **Jaroslav
Hašek** (author of *The good soldier Schweik*) and others in
Hašek's circle of literary Bohemians.

The Sursum group, founded in 1910, formed a unique
interdisciplinary federation which was allied to the
Catholic-oriented review *Meditace* (Meditation). The
group's members included literati Josef Šimánek and
Rudolf Medek, and artists Josef Váchal, František Kobliha,
Jan Konůpek, Emil Pacovský and Jan Zrzavý. Various ten-
dencies within pre-1914 modern art – Post-Impression-
ism, Expressionism and Neo-Classicism – were expressed
in the work of writers such as the brothers Karel and
Josef Čapek, František Langer, Otokar Fischer, Richard
Weiner and others. Most of these writers worked with
artists involved in the emerging Cubist and Futurist
schools to produce the *Almanac of the year 1914*. At the
instigation of S.K. Neumann this publication promulgated
Bergsonian philosophy.

The synthesis of art forms

Connections between literature and the fine arts were
developed both by literati who wrote about the fine arts
and artists who undertook literary projects. They shared
spiritual ideas and stylistic principles, melding literary ele-
ments with pictorial stylisation. A major role was played
by journals and books, which were increasingly regarded
as artefacts, and illustrations which not only accentuated
the import of the text but also acquired an independent
value and significance. Through this blurring of the
boundaries between art forms, however, a new dilemma
emerged, particularly in the use of metaphors, allegories
and symbols, in the concept of artistic individuality and in
the reception and resonance of aesthetic experience.

In descriptions of the various literary movements the
term 'Secession' is frequently encountered as a general
name for the stylistic correspondence between both art
and literature at this time.[3] For the modernists it meant
a radical rejection of traditional art. In a positive sense
one referred to the 'moderns' or to a renaissance (as a
Nietzschean 'transvaluation of all values'). In the case of
literature, however, the use of the term in such a broad
sense remains too general and only marginally relevant.

However, a narrower interpretation of 'Secession', to
mean the development of a new style, makes it possible
to draw a comparison between art and literature. It is
then noticeable that in literature too the lines dividing
the various genres tended to blur, while the link with art
became ever clearer. This took the form of greater use of
poetic prose, ornament (the decorative use of language),
natural motifs, linearity (the attempt to depict space two
dimensionally and events simultaneously), eroticism, fairy
tales, musicality and the aestheticising of life.

19
Josef Váchal, **Illustration for 'The castle of death' by Jakub Deml**, 1912, Uměleckoprůmyslové museum v Praze, Prague

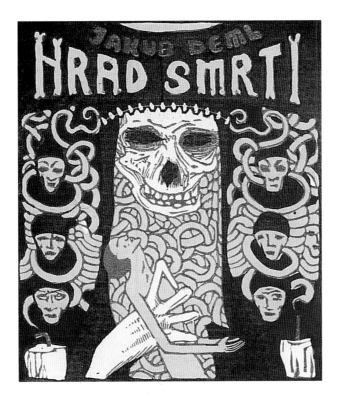

Illustration for 'The castle of death' by Jakub Deml

The creative synthesis of art and literature could also arise from Catholic spirituality and mysticism, as in the writings of Julius Zeyer and Otokar Březina and the sculpture of František Bílek. This spiritual affinity can also be found in Josef Florian, bibliophile, publisher and graphic artist; in Jakub Deml, poet, prose writer and author of literary essays and art criticism; and in Josef Váchal, who embodied a unique combination of writer, graphic artist, typographer, painter and woodcarver. Váchal printed his texts in a typeface he had designed himself, illustrated his books and bound them. In this way he created a highly idiosyncratic style in which he mixed spiritual and parodic elements with a wide range of genres.

The correspondence is most clearly evident in the typology of the image of the artist and in particular his self-projection – in the portrait, the self-portrait or the mask. Stylisation of the self focuses attention on the inner character and creative spirit of the artist. It reflects such phenomena as narcissism, dreaminess and mystification. But at the same time the broad range of characterisations involves a pictorial stylising (or Secession stylising). This is reflected in certain themes from art which occur in poetry – from Vrchlický to Weiner – or in the individual style of the artists themselves, as a metaphor for an innovative but at the same time divided approach to the world through art. Aestheticism drew inspiration from Oscar Wilde's *The Picture of Dorian Grey* (1891) and from such decadent, overwrought works as Joris-Karl Huysmans's *A rebours* (1884), in which the synthesis of art and life has degenerated into a superficial, decorative style. A high point was reached with the deeper and more direct confrontation with the artist in word and image found in Hlaváček, Josef Váchal or Josef Čapek.

The Czech *fin de siècle* continues to fascinate because of its yearning for universality and its pursuit of the transcendental. This spiritual interpretation of the synthesis of art forms was concisely expressed by the Symbolist poet Otokar Březina: 'In art as yet unembodied life forms appear… A painting, sculpture, poem, dream or piece of music – these are all signs capable of conveying spirituality in the enchanted world of phenomena… All art is founded on seeing experiences of another kind.'[4]

Music - 'Another world'

Marta Ottlová

In 1898 the Czech critic František Václav Krejčí referred to music as the polar opposite of science.[1] Music to him was the ideal art form, appealing far more than painting or lyric poetry to the irrational and intuitive aspects of consciousness. This idea is typical of the period around the turn of the century. In a positivist, scientific-technical age music occupied the position of 'another world'. This *fin de siècle* atmosphere, to a degree resulting from the response to Wagner and Nietzsche, was part and parcel of European modernism.

Although the term 'modernism' was used later in Czech music than in other art genres in the 1890s, 'modernity' had already played an important role in the 1870s in the Czech music world – in the discussion surrounding Richard Wagner's work and the polemics on the future of Czech opera. It was a seminal term, a philosophical-aesthetic concept which for the music aesthetician Otokar Hostinský was synonymous with innovation and progress. He was a follower of the Neudeutsche Schule and interpreted the history of music as a progressive evolution. At that time the music drama and the symphonic poem were considered to be the most progressive musical forms.

In his conception Hostinský demanded a national music whose national elements would immediately take it to the fore of the most progressive European music. The most successful composer in this sense was, in his view, Bedřich Smetana (1824–1884).[2] During the 1880s the Czech public began to acclaim Smetana's individual style

The prophetess Libuše

Mašek belonged to the younger generation of painters who, around 1890, were attracted to Paris and the style of Hynais. He developed from a plein-air painter into a painter of decorative, symbolically enchanting scenes of which this painting of the legendary Libuše is a superb example. It was probably painted in the year 1893. This agrees with the date of a number of smaller works from that year in which he applied the optical blend of 'pure' colours, a technique which the Neoimpressionists had introduced shortly before him.

Mašek's image of Libuše characteristically combines the new interpretation of painting as a surface with a kaleidoscope of vibrant light and colour with a fundamental scene from the glorious age of legendary Czech prehistory. He didn't interpret the founder of Prague and the ruling dynasty in the customary triumphal manner. The strange colour of her eyes and hair make Libuše appear more like a ghost than a leader. Nocturnal scenes satisfied the feelings of melancholy and decadence which were becoming increasingly common in Prague at that time.

20
Karel Vítězslav Mašek, **The prophetess Libuše**, c. 1893, Musée d'Orsay, Paris

21
Josef Mařatka, **Study for the bust of Antonín Dvořák**, 1906, Národní galerie v Praze, Prague

as the national style and to recognise Smetana as the founder of modern Czech music. He received even greater recognition in the next decade, thanks partly to the success of his operas and of the Prague National Theatre at the 1892 International Theatre Exhibition held in Vienna. Czechs certainly enjoyed this success with a national pride that was not without a political dimension.

In 1901, under the highly significant title 'Bedřich Smetana and his fight for modern Czech music', Hostinský published the studies he had made of Smetana in the 1870s. The title alone clearly indicates the importance he attached to the composer's work. The music of the *fin de siècle*, however, originated not only in the shadow of the previous generation of founders of Czech music, but also of the succeeding period of around 1910. In the European context this period is identified with the 'revolution' in musical technique. The absence of a clear break in compositional technique in the 1890s gave the music of this generation the character of a style reminiscent of the late-Romantic, of something already past its prime, while at the same time raising expectations of something new.

The artistic situation of Czech music at the turn of the last century, which we now regard as the first wave of modernism, was complex. This was also the time of Antonín Dvořák (1841–1904) and Zdeněk Fibich (1850–1900), who are traditionally ranked among the founders of modern Czech music.[3] Both Dvořák and

Fibich died at the height of their creativity and their work determined the musical profile of the time.

In December 1895, directly after his return from America, Dvořák completed his *String quartets in G major, op. 106* and in *A flat major, op. 105*. These were not only his last contributions to chamber music but also to what is known as absolute music. He then immediately surprised his audiences at home and abroad with four symphonic poems, the settings for ballads by the Czech Romantic poet Karel Jaromír Erben, followed in 1897 by a symphonic poem to his own text, *Heroic song*. The critics were divided, which indicates that the Prague music world had also split into progressives (modernists) and conservatives. Although Dvořák's concert overtures had prepared the way for these programme compositions, he had won an established place among the conservatives with his nine earlier symphonies and his chamber music and had acquired a reputation as a naive and intuitive composer of absolute music. And now he was creating confusion with his symphonic poems. Given Dvořák's significance in Bohemia, however, the critical response was less negative than in Vienna and Germany.[4]

Despite the drawn-out conflicts between the supporters of absolute and programme music, the symphony and symphonic poem in Dvořák's work (in which compositional solutions brought the two genres closer) are examples of modernism's situation. Richard Strauss declared that programme music did not exist and that it was merely a term of abuse used by people who have no ideas of their own. In Strauss's view a programmatic concept may indeed lead to new forms, but music must always develop logically from its own fundaments or else it will become 'Literaturmusik'. The only analysis of Dvořák's setting of Erben's poems in his lifetime was made by another composer, Leoš Janáček (1854–1928), who demonstrated the autonomy of the musical logic of Dvořák's compositions.[5]

After his symphonic poems Dvořák surprised his audience yet again by dedicating himself completely to opera, the genre which he said the nation needed most because it was accessible to a wider audience than concerts. Three works immediately spring to mind, especially the middle one, *Rusalka* (Watersprite, 1901), from the libretto by Jaroslav Kvapil, an author from the younger generation. This work fulfilled not only Dvořák's own expectations but also represented the opera at its peak at the turn of the century, already incorporating as it did many of the features that were to characterise opera in the twentieth century. In his libretto Kvapil had tried to convey the atmosphere of Erben's ballads.[6] Kvapil, a

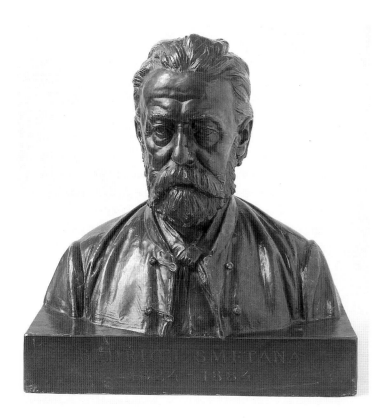

22
Josef Václav Myslbek, **Bust of Bedřich Smetana**, 1892, Národní galerie v Praze, Prague

director with impressionistic traits, gave the composer an enormous range of possibilities for using sound and space to the full in the dramatic imagery; Dvořák composed a refined piece of music theatre encompassing the semantic ambivalence inherent in the post-Wagnerian technique of leitmotiv. This opera continues the romantic theme which juxtaposes the human with the natural world and can also be interpreted as an allegory of human existence (in which the individual consciously takes control of his own destiny and becomes existentially distressed). At the time of the premiere the opera was praised for its lyrical expression, which was mainly created by the fairy-tale atmosphere and which induced a melancholy mood.

A harsh note of criticism was also to be heard, however. This came from the music historian Zdeněk Nejedlý, and was one of the first signals that opposition to Dvořák was beginning to form in Prague university circles. His opponents strove to eliminate him from the history of the development of modern Czech music. Even then, during the years 1910-15, this was being openly discussed in Prague in 'the battle for Dvořák'. Nejedlý appealed to Hostinský's concept of progress but radicalised it to the absolute norm. A place in the history of the nation's music, according to him, was reserved exclusively for progressive composers. Nejedlý constructed his 'correct' line of development in which the criterion of progress represented a somewhat vague body of ideas on

'Smetana-ism'. In Nejedlý's eyes Dvořák fell well short of this measure.[7] We encounter similar 'excommunication' attempts using Smetana's name as a screen well into the interwar years.

One of the first treatises of this sort was Nejedlý's study on Fibich as the founder of the scenic melodrama (1901). However, Fibich's views posed Nejedlý with a difficult problem. Nejedlý's estimation of Fibich as a true successor of Smetana was based on Fibich's *Hippodamia* (1889-91), three scenic melodramas set to texts by the Czech poet Jaroslav Vrchlický. *Hippodamia* is a remarkable example of the Czech reception of Wagner, which was based on Hostinský's interpretation of music drama. Hostinský, who was a good friend of Fibich and also wrote a libretto for him, differed from Wagner in that his starting point was the classical spoken drama and he regarded the scenic melodrama as a further, more progressive developmental phase of music drama.

Fibich again turned away from this path, however, and returned to the opera tradition with all its risks emanating from the genre crisis at that time. He did so, as he himself said, in order not to have to suppress his musical spirit. For him it was all about the musical expression of the innermost feelings, that which cannot be expressed in words and about the ability of music alone to arouse in the listener, in Wagner's words, a *tönendes Schweigen*. In the 1890s Fibich's work became clearly more subjective and eroticism was an important aspect of his imagery. (His love for his pupil Anežka Schulzová was talked about in Prague circles more than his music.) Between 1892 and 1898 he composed a cycle of miniatures for the piano, *Moods, impressions and reminiscences*, which were a musical expression of the ephemeral events in his life.

From the first critical responses onwards *Šárka* (1897) was considered to be different from Fibich's other operas of this period. The theme of the opera is taken from Czech mythology (fig. 23) and a connection was made to Smetana's equally mythological opera *Libuše* (fig. 20). But unlike Smetana's opera, which is about the future and the glorious past of the fatherland, an important shift in emphasis occurs in Fibich's opera. Together with his librettist Schulzová, Fibich sought national material that would enable them to portray the tragedy of a human being who lacks an understanding of ethical norms and who, through passionate commitment to an ideal and blind revenge, is confronted with his own moral conflicts. This theme is entirely consistent with Fibich's other operatic works in the 1890s, when he was the first composer to bring the great tragic and historical themes from world literature to the Czech stage. Reviews of

Šárka show it was felt the opera had a markedly Czech character. This, in turn, indicated that Czech opera was still intended to fulfill a national-representative and political-cultural function. Since the 1860s it had generally been accepted that the national character of a serious opera was guaranteed when material was chosen from the nation's history, whereas in comic operas there was a preference for themes from Czech village life.

Evidence of this is provided by the fate of operas based on the plays of Gabriela Preissová, namely the opera *Eva* (1895-97) by Josef Bohuslav Foerster (1859–1954) and Janáček's *Jenufa* (Her foster daughter) (1894–1903). Socio-critical and tragic material represented a breakthrough in the aesthetics of Czech opera with a village theme because, for the first time, village life was not interpreted idyllically or portrayed in the comic genre. Both composers had their own approach to the dramatic source text. True to tradition Foerster wrote an opera with lyric scenes featuring folklore *couleur locale*. Janáček, however, used the original prose text almost in its entirety, structuring the melody on the basis of his own theory of 'speech melodies'. These he conceived of as an authentic expression of a particular life situation, as 'the expression of a total condition of the organism and all the phases of spiritual activity originating from it.'[8] The premiere of Foerster's *Eva* in the Prague National Theatre in 1899 went almost unnoticed. *Jenufa*, which was in fact Janáček's first significant step towards the poetic realism of his mature operas, was premiered in Brno in 1904. Because it was perceived essentially through the prism of folklore, and was therefore accused of extreme Naturalism, twelve years were to pass before the opera was staged in Prague.

Both Janáček and Foerster had only an indirect influence on musical activity in Prague at the turn of the century. In Prague Janáček, a Silesian living in Brno, was known mainly as a collector of musical folklore, as the author of the successful folk ballet *Rákosz Rákoczy* (1891) and, for instance, as co-author of the musical exposition at the Prague Ethnographic Exhibition of 1895. Foerster followed his wife, the great opera singer Berta Lautererová, to Hamburg. There he worked as a music critic and teacher until 1903, when he moved with his wife to Vienna. However, he remained in contact with Prague where his compositions were also performed. While Janáček composed a large number of his mature works in the years after World War I, Foerster's musical profile was already established in this period.

Foerster's subjective lyricism, present in almost all genres, was supported by a Christian humanism and even attained a kind of symbolist mysticism. 'I do not see love in the narrower sense of erotic arousal; love is for me the symbol of all mysterious and mystical yearning for beauty, nobility, purity, in short for all the virtues embodied in the Christian ideal and in the light of those humans bearing witness to it.' He wrote this in connection with his opera, *The invincible ones* (1908-17) – for which he also wrote the libretto – with the symbolic characters Viktor and Alba. Foerster belonged to the schools who at that time were seeking an essential European tendency of an order of values that was already teetering under the initial shocks of nihilism. With his commitment to re-evaluating old ways of thinking he continued along an avenue Dvořák had already explored in Czech music – consider his *Stabat Mater* (1877), *Requiem* (1890) or *Biblical Songs* (1894).[9] The poetry of Otokar Březina is the literary counterpart in this context as is Bílek in the visual arts.

Foerster's *Third symphony* (1894) typifies the spiritualisation of the monumental composition, an endeavour that he shared at that time with his close friend Gustav Mahler. The philosophical message is the longing for love that is fulfilled at the moment of the Resurrection. This idea recurs in his crowning work, the *Fourth symphony* (1905), subtitled *Good Friday*. The fourth part of this symphony comprises a fugue on three themes ending with a quotation from an Easter hymn about the Resurrection. The melodic approach, the free polyphony (originating from his practical experience as an organist) and his preference for the symbolic reference in the musical quotation are characteristic of Foerster's style. Here and in other works he readily made use of the dance genre. His melodic and polyphonic approach also partly determined Foerster's predilection for vocal work (songs, choral works) as epitomised in this period by *Nine choruses for male voice* (1894-97). While he was composing these pieces, Foerster discovered the lyric poetry of the Czech poet Josef Václav Sládek. Sládek became the key to his choral work, just as the social criticism in the Silesian songs by poet Petr Bezruč played a key role in the choral works of Janáček.

In the 1890s new names appeared on the Czech music scene. At a concert by the prestigious association of artists 'Umělecká beseda' (Art Circle) in 1892, three of Dvořák's pupils at the Prague conservatory, Vítězslav Novák, Josef Suk and Oskar Nedbal were a sensation. The contours of the new generation were emerging. In 1911 the journalist and literary figure Jiří Mahen, writing in *Lidové noviny* (People's paper), described modern music within the new cultural spectrum:

'Our modern art has declined somewhat recently. This is particularly true of literature. [...] Unfortunately there are many indications that Czech painting is no longer in control of its own destiny. The last well-thumbed copy of *Volné směry* [Free directions] is doing the rounds in the coffee houses and presents a sorry sight... Unbelievable confusion reigns in people's heads, in their hearts, shamelessness and snobbery are gaining the upper hand... But it seems to me that Czech composers are certainly on the right path again, they inspire confidence in the future. I have found two names very sympathetic for some time now; just as we have the poet Antonín Sova in literature and Jan Preisler in painting, in music we have Suk and Novák. I hear painstaking work and a feverish élan in their music... Suk's pieces soothe my innermost pain. And Novák? How many years have we now been witness to his songs, to those melancholic pieces of his in which our entire miserable spirit resonates? That has been a special experience for us... And the man has achieved this with his Eastern Moravian songs, his paraphrases of modern Czech poetry and the symphonic cantata *Storm*, his setting of a poem by Svatopluk Čech. The sheer energy of it all... These musicians have taken something from us, the literati, which we could not do. Without manifestos, without clubs, without palace revolutions, without profound essays and political diatribes. [...] Hats off, gentlemen! The regiments of Czech modernists are on the march...'

Despite their subjectivity these words indicate the hegemony of Vítězslav Novák (1870–1949) and Josef Suk (1874–1935) in Czech modern music as early as the turn of the century. Around 1910 Novák was considered the leading personality. Mahen's remark about the absence of manifestos and artists' clubs refers to the fact that these composers did indeed have little interest in forming associations of any kind or proclaiming their ideas in public. Their relationship with the 'fathers' generation was characterised less by protest than respect – for Smetana, who had combined national and social responsibility with the highest artistic standards, was open to the world and had built his own originality on this openness; and for Dvořák, because he had become internationally celebrated.

At the end of the nineteenth century Novák visited Moravia and Slovakia to listen to folk songs there. He also met collectors and devotees of folklore such as Janáček and the Mrštík brothers. Novák's work with folk songs was to prove crucial to the development of his personal style, a style which cannot, however, be attributed to the wave of folkloric enthusiasm triggered by the Ethnographic Exhibition of 1895 in Prague. Novák's

approach to folk music differed from what was customary at the time. He did not try to invoke an idealistic image of life on the land, full of folkloric songs, dances and customs. Instead he analysed the songs and compiled statistics to identify the characteristics of the different regions. Folkloric material always offered Novák far more than the possibility of an exotic musical quotation: through his inclusion of new possibilities for melody, rhythm and harmony, it started a process towards the complication and dissolution of tonal movement.

As the above quotation by Mahen indicates, Novák's almost magical reception by his contemporaries is attributable not least to his 1901-03 lieder cycles: *Melancholy, op. 25*, his setting of poems by Machar, Kvapil and Sova, along with *Valley of the new kingdom, op. 31*, his setting of poetry by Sova. Mahen's intuitive impression of the character of Novák's work was repeated ten years later by Novák himself: 'A deep-rooted melancholy within me, nurtured in my student years by reading the Romantic poets and later the lyric poetry of Hlaváček, Machar and Sova and the plays of Ibsen, as well as by my preference for the solitude of nature, has developed an intense neurasthenia in me. Old pain, which I thought I had overcome long ago, wells up in me again, unspent grief floods over me anew.' [10]

The motifs and sources of inspiration typical of this period can be heard in his symphonic poems *Eternal longing, op. 33* (1903-05), inspired by Andersen, or *In the Tatra Mountains, op. 26*, with the Romantic theme of a landscape before and after a storm. Characteristic of Novák is his rigorous work on the transition from thematic to structural thinking, producing a logical form with a preference for counterpoint and imitation on the one hand and, on the other, an inclination to thematise the harmonic elements into an impressionist polychromy. In many ways this makes his work a forerunner of Debussy's, while Debussy is often mistakenly said to have influenced Novák. Debussy's music was not in fact heard in Prague until Mahler's and Richard Strauss's. One of the many forms of nature in Novák's music, the flight from the city to find comfort in nature's arms, is in his own view conveyed in the programme of the first part ('Largo misterioso') of his *String quartet in D major, op. 35* (1905). This is composed in his favourite form, the fugue, which of course literally means 'flight'.

Josef Suk differed from Novák in terms of musical genre. Suk was for many years the second violinist of the internationally famous Czech Quartet, founded in 1892, a position which took up a great deal of his time and energy. His interest in Eastern European folklore can be heard in his first major composition, the incidental music for Julius Zeyer's fairy tale *Radúz and Mahulena* (1898), which originates from Slovakia. A year later Suk composed a suite from this music, *The fairy tale, opus 16*. Folklore did not, however, become the object of his creative interest. Consistent with the hierarchy of musical genres prevailing at the turn of the century Suk was to feel throughout his life that, with the exception of a few chamber music pieces, the monumental orchestral composition which synthesised the impulses of the symphonic cycle and the symphonic poem was at the top of the hierarchy. Suk's mature style can already be heard in his *Fantasia in G minor for violin and orchestra* (1902-03) and his *Fantastic scherzo* (1903) which, with its stylised dance and scherzo motifs, approaches the grotesque.

The sources of inspiration for Suk's monumental compositions were seldom of a literary nature. In 1904 he chose what was then the popular theme of the historical city of Prague for a symphonic poem of the same name, *Praga*, dedicating it to 'Royal Prague'. The background to the sonata form corresponds to the programme parts, extending from the dream about the creation of Prague bathed in twilight and Libuše's prophecy about the city's future to the reality of heroic Prague threatened by a Hussite army but saved at the last moment by the love for this magnificent city. The joy of this salvation rings through the hymnal ode at the end.

Suk's symphony *Asrael* (1905-06) is the high point of his oeuvre, just after the turn of the century. It is dedicated to his father-in-law Antonín Dvořák and his wife Otilka, who had died in quick succession and whose deaths caused Suk much grief. Mahen's comments on innermost pain, which Suk's compositions endeavour to heal, especially apply to this symphony. The work is about coming to terms with the blows of fate and the last part concludes with resounding catharsis.

Although part of Suk's musical imagery is taken from his own quotations and those of other composers (such as Dvořák's *Requiem* and Suk's own incidental music for *Radúz and Mahulena*) he never use them emblematically but includes them in a thematic process characterised by mutual affinity, the derivation of one motif from another, the Wagnerian 'spell of relationships', and the migration of motifs from one part to another. The rigorous melodisation of all voices with their independence and equivalence, producing a harmonic richness frequently reaching the bounds of tonality, are elements in Suk's 'music prose'.

Emphatic as the words of Mahen in 1911 about the musical innovation of Novák and Suk were, the general situation was very soon to change radically. Strauss's

Salome was performed in the Neues Deutsches Theatre in Prague in 1906. This production was an overwhelming experience for Novák, as it was for so many others. He then further developed and combined aspects of sound and tone in his own style by using every device available to stir up feelings and passions. This occurred in particular in the 'sea fantasy', his setting of the poem *Storm* (1910) mentioned earlier. Here, nature in the form of a storm represents a destructive power and is at the same time a metaphor for human destiny, whereas in his next pantheistic poem for piano, *Pan* (1911), which glorifies all aspects of nature, Novák compares his image of the sea with the images of Böcklin's water nymphs. This he describes in his *Memoirs*.

After 1912 neither Novák's nor Suk's style changed greatly. Both these representatives of modern Czech music gradually came, so to speak, to occupy a space outside both time and history, a history interpreted primarily as that of innovative and revolutionary deeds. And yet their major works and the charisma of their personalities – both were influential teachers – compelled future generations repeatedly to debate their musical legacy, just as they had been compelled to discuss the legacy of the 'founder of modern Czech music'.

Between Salon and Secession

Roman Prahl

At the beginning of the twentieth century Prague witnessed a revival of interest in art that was increasingly focused on modern art worldwide and the avant-garde. This development could only take place once Czech art had complied with certain standard European precepts governing conventional art. Hence, through the 1880s and 1890s a range of art institutions emerged, breathing new life into creativity and debate, which in itself can be regarded as the early history of modern art in Prague.[1]

The salon as criterion and fore-runner of a new age

Broadly speaking, the art of Prague had developed into two mainstreams during the nineteenth century. One movement was closely related to the Czech national Revival and focused mainly on the language aspect of culture. The other was not linked to language at all but to such artistic institutions as the Prague Academy of Fine Art, the painting gallery (Obrazárna) and the art exhibitions funded by patrons of the arts. The art movement could therefore be followed by a wide audience. Until the 1880s the Academy of Fine Art and Obrazárna were financed by benefactors and primarily maintained by aristocrats. Funds for the annual Prague art exhibition were raised by the Art Society (Kunstverein für Böhmen) an association that ran a lottery in aid of art. Compared to similar Central European institutions, this particular art

Emperor Ferdinand I surrounded by his artists

As a painter Brožík was mainly known for his vast historical canvasses, a theatrical form of art which was still extremely popular in the second half of the nineteenth century. For this reason, the Secession generation saw him as the epitome of art from the past. The huge painting depicting Ferdinand I bestowing special privileges on Czech artists was an attempt to compromise with the modernists on the part of both the painter and the Society of Patriotic Friends of the Arts who had commissioned the work. Brožík eventually decided to paint the scene in plein-air, emphasising the informality of the event. He also combined historical and contemporary elements (for example, the furnishings in the foreground).

Shortly before Brožík started the painting, the area around the Royal Gardens (near Prague Castle) in front of the summer residence of Queen Anna, Ferdinand's wife had been the location of historical ceremonies organised by the Czech National Theatre. For both artist and patron, however, this painting was above all a gesture confirming the status quo in spite of the revolt of the Secession painters that had just broken out in Prague.

24
Václav Brožík, **Emperor Ferdinand I surrounded by his artists**, 1900-01, Národní galerie v Praze, Prague

25
Vojtěch Hynais, **Theatre curtain**, 1883, National Theatre, Prague

association was reasonably successful. However, the middle-class shareholders followed the taste of the majority of the audiences, which meant the association preferred established artists from Germany to young native talent.

Around the time of the revolution in Prague (1848), the old quarrels between Czech artists and their official patrons or art institutions reached new heights. At that time Czech artists established their first formal artists' group in an attempt to counterbalance the official art institutions. This initiative on the part of the artists was particularly important because through their action they were seen to be siding with the Czech movement fighting for political and national rights.

In the early 1860s the system of art institutions was given a more definitive shape, which was to remain in force in Prague until the end of the century, only to be toppled then by a group of young artists who engineered a deliberate split (secession) from the older generation, thus giving birth to the Secession movement. The younger artists did not form a new society but joined a group of Czech literati and musicians: the 'Umělecká beseda' (Art Circle, established in 1863). The social divide along lines of nationality – with a German-speaking and an increasingly strong Czech-speaking faction – was not without its repercussions within the society itself. At the start, the fine art sector of the new society had many

good ideas, which were presented with great enthusiasm. There were plans for an art exhibition (preferably permanent), for the creation of their own journal, and even for the building of studios to compensate for the stagnating contribution from the Prague Academy of Fine Art. Their ideas proved to be too utopian and soon died a premature death. Nevertheless, the society was an influential platform for Czech artists and provided a venue for lively discussions and entertainment. In addition to this, art shops, and even specialised galleries containing national art had already existed since the first half of the nineteenth century. One of these galleries opened in Prague in 1873 in the prestigious Ferdinand Street and continued to do business right up to the First World War. This was called the 'Salon' in a somewhat overstated allusion to the Parisian Salons. As the gallery did business all year round and focused on local contemporary art, it formed a specific counterbalance to the annual exhibition of the official Art Society. Another alternative to traditional salon art appeared in the 1890s in the gallery of the Topič publishing house, also in Ferdinand Street. The activities of this gallery resulted in the first exhibition of artists of the Secession movement in the spring of 1898.[2]

Art became the flagship of new Czech culture – at least if we are to believe the newspaper reports and rhetoric of the period. The design and decoration of the

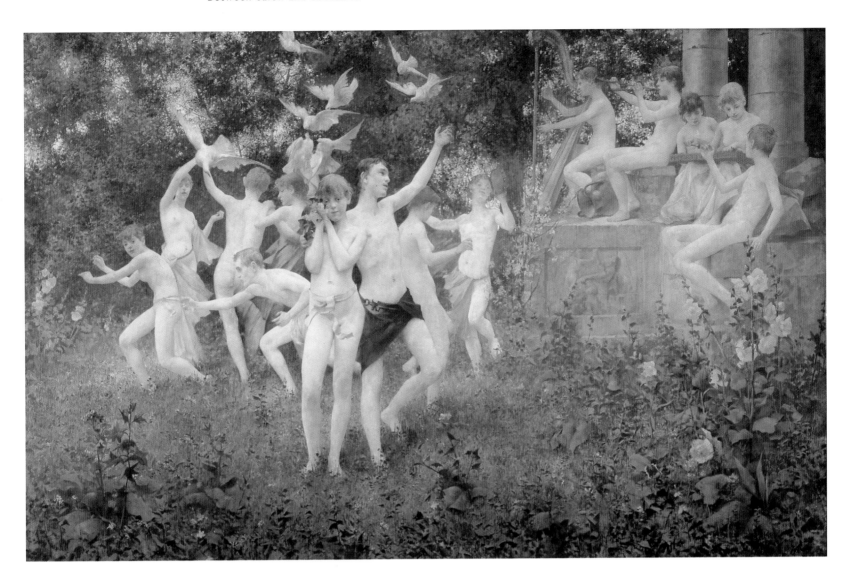

26
Karel Vítězslav Mašek,
Allegory: pastorale,
1889, Národní galerie v
Praze, Prague

National Theatre was viewed as a challenge for Czech artists. It was the first opportunity that had arisen to represent modern Czech mythology in a public space, and the first opportunity to try out ambitious monumental work. While the National Theatre's interior decoration was being completed, the Czech city government of Prague began to purchase works of art with a view to forming a National Gallery. The envisaged collection was to consist of a series of spectacular paintings with themes from Czech history. That plan was realised by the mayor of Prague and a few advisors who soon depleted the funds by purchasing two colossal works by the history painter Václav Brožík in the 1880s and 1890s. This attempt to set up an alternative institution in the form of a permanent, central collection of contemporary art contributed, towards the end of the century, to the establishment of the Modern Gallery of the Bohemian Kingdom, partly financed by the Austrian state.[3]

Meanwhile the necessary modernisation of the art institutions went ahead, particularly as a result of reforms within the Academy of Fine Art, which eventually became a state institution in 1897. The most conspicuous new modern institute in Prague in the 1880s was the Artists' House, or Rudolfinum – the first monumental building for art in Prague. The concept differed from that of the Künstlerhaus in Vienna – where art and music associations occupied two separate buildings – in that the Rudolfinum was set up as a truly multifunctional institution for musical and artistic life. According to the original aims, recorded in the 1870s, a great number of organisations from the worlds of music and art were to make use of this artistic centre. The School of Applied Art, and later the Museum of Applied Art, were given separate buildings in the immediate vicinity of the Rudolfinum, all located around what is nowadays Jan Palach Square.

The Rudolfinum epitomised the resurrection of Prague as the historical seat of the Muses. It was supposed to iron out difficulties between past and present, and between modernisation and tradition. However, the

27
Vojtěch Hynais, **Poster for the Jubilee Exhibition in Prague**, 1891, Uměleckoprůmyslové museum v Praze, Prague

The idea of an art salon that would truly represent the nation materialised at a different location in Prague, namely at the trade fair grounds (Výstaviště). The first large exhibition to take place there was the Jubilee exhibition at the beginning of 1891, which included a retrospective of earlier art and a survey of new works. With the organisation of this Jubilee exhibition, the time-honoured vision of a Czech Prague was presented to the public. The exhibition marked the first 'self-glorification' of Czech artists in a Czech environment and certainly contributed more to the popularisation of the fine arts than the design and interior decoration of the National Theatre. Although Prague saw more of these large exhibitions in the following years (1898, 1902 and 1908), it was not long before the young artists refused to present their work in this form. A number of artists even refused to contribute to the first event, the megalomaniacal Jubilee exhibition of 1891. As well as triggering satisfaction and a sense of achievement, it should have acted as a first early-warning sign.

Attempts by Czech artists to integrate with one another, thus disguising the differences in their artistic and theoretical orientation, were nipped in the bud by the first exhibition of the Secession artists in the spring of 1898. In the following years attempts were made to boycott the official salon art style as well as the Umělecká beseda, and new artists' societies and newspapers were set up. The establishment of institutes and the use of the media, which was indispensable for the development of modernism in art, climaxed in the autumn of 1896. It was then that the avant-garde set up the journal *Volné směry* (Free directions), which was mainly dedicated to art. It aimed to provide a platform for critical discussion and greatly contributed to the creation of shared artistic principles. A new artists' society came into being as well, Mánes, which had once been a students' society. Mánes attempted to bring together the disparate tendencies of the 1890s under one umbrella. The society was named after the trend-setting painter of nineteenth-century Prague, Josef Mánes. Its previous history could be traced as far back as the mid–1880s and to the Czech artists' colony in Munich. In the 1880s it had proved a radical influence on the older generation of Czech painters and sculptors.[5]

The National Theatre Generation

The World's Fair held in Vienna in 1873 heralded what seemed to be the definitive decline of numerous local schools of art in central Europe, including the Prague

centralist idea of a seat for the musical and artistic life of the city with a neutral language ran up against the problem of clashes between various rival factions which led to a polarisation of the two groups. In the Rudolfinum the need was felt for a representative body to deal with the conflicts that had arisen in the everyday running of the institution; they even had to deal with disputes about how the building and its contents should be used. One bone of contention was the annual demands made by the Salons for part of Obrazárna's permanent collection. Even the building itself became an unwilling theatre of war as its symbolic role as conveyor of the dynamism on the modern art scene was called into question. The battle cry proclaimed that if it were truly dynamic it should have relied more on improvisation rather than opting for a definitive structure.[4]

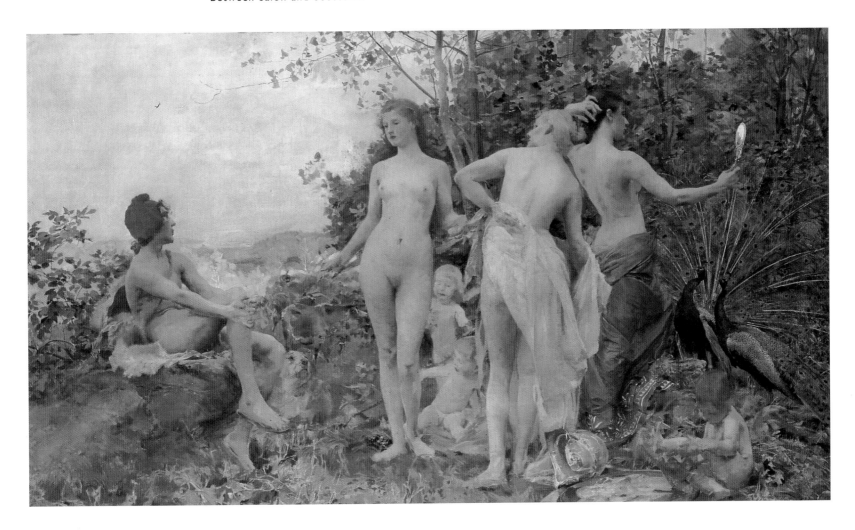

28
Vojtěch Hynais, **Study for the painting 'The judgement of Paris'**, 1892
Národní galerie v Praze, Prague

Study for the painting 'The judgement of Paris'

Hynais' studio in Montmartre was unofficially *the* school for painters who came to Paris from Bohemia at the end of the 1880s and during the 1890s. Hynais was already working at the Prague Academy of Fine Art. The definitive version of *The judgement of Paris*, measuring 2.4 x 4 metres, was painted in this Paris studio and the adjoining garden which the artist had had laid out to study human models in natural light.

Hynais combined naturalistic and decorative elements in his paintings and endeavoured to find a formula for his extremely radical inspiration which was far broader in scope than Japonism or Impressionism. He was sharply criticised in central Europe, however, for his 'French' nudes and veristic portrayals of mythological figures. Although *The judgement of Paris* received recognition from the public, the ministry in Vienna for a long time refused to grant him a subsidy for it. Eventually the painting was bought for the Czech Academy of Science and Art by the Mæcenas Josef Hlávka, the founder of the Academy, even though he had also shown some reluctance towards this work.

29
Mikoláš Aleš, **Josef Mánes seeking a patron in Prague**, illustration in the journal Šotek, 1880

30
Vojtěch Hynais, **Mrs Hrušová with her daughters**, 1896, Národní galerie v Praze, Prague

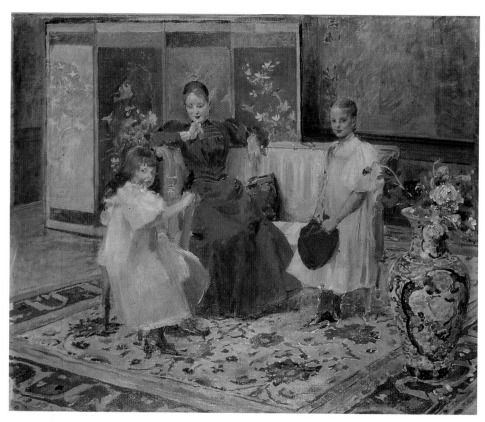

academy. From then on national schools of art could only really show what they were worth in an internationally competitive field. The majority of talented Czech painters at the time had become experienced and found acclaim in Munich, Vienna, Rome or Paris.[6]

The decoration of the Prague National Theatre was tangible proof of the evolution of Czech art, because here national themes and universal ideas converged. This prestigious decorative commission left its mark on a whole generation of painters and sculptors. The theatre's crowning glory – which shocked those who had commissioned it – was the theatre's curtain designed by Vojtěch Hynais and painted in the Parisian-influenced salon style (fig. 25). To everyone's surprise it was the younger generation of artists who won the competitions organised to select the people to decorate the theatre. This choice was meant to contribute to an optimistic ambience in the midst of the many crises and conflicts taking place at that time, and to show that there were signs of a very healthy national art revival among young artists. This conception still dominated the artistic scene when the so-called nineties generation made its entrance fifteen years later.[7]

The painters and sculptors of the National Theatre generation felt already more allegiance to the literati than to architects. This was due to their discussions as members of artists' societies and what they read in journals. Cooperation between artists and architects – including their teamwork in the building of the National Theatre – was undertaken for practical reasons and was bereft of ideological affinity. The traditionally separate courses for architects and artists at the Technical School and the Academy of Fine Art were partly to blame. The situation only began to look up in 1884 with the establishment of the School of Applied Art in Prague, and improved even more when the celebrated architect and pioneer of modernism Jan Kotěra returned to Prague from abroad.

Czech literati and art historians were the first to adopt the role of art critic and to support promising talent in the newspapers and journals. In so doing they were in some ways cultivating a potential buying public, which was still sorely lacking in Prague. The community of artistic Bohemians, consisting of both artists and somewhat older literati, provided important psychological support. Nevertheless, moments of interaction between literature and art were more valuable than journalistic protection, which failed to resolve matters anyway if they involved really stubborn characters and their conflicts with officialdom. The opportune starting

31
Vojtěch Hynais,
**Preliminary study for
the poster for the
Ethnographic
Exhibition**, 1894,
Národní galerie v Praze,
Prague

32
Vojtěch Hynais with his
model Suzanne Valadon in
the studio, 1890

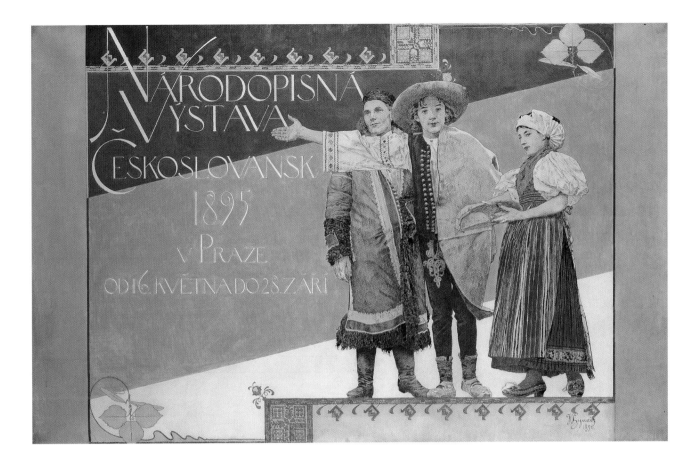

33
Mikoláš Aleš, **Design for
the title page to the
Old Czech Manuscript
'Královédvorský'**, 1883,
Národní galerie v Praze,
Prague

34
Luděk Marold and Alfons
Mucha, **Diploma for
Mikoláš Aleš**, 1886,
National Literary Museum,
Prague

35
František Ženíšek and
Mikoláš Aleš, **The muses
forsaking Bohemia**, study
for the triptych on the ceil-
ing of the foyer in the
National Theatre, Prague,
1880, present whereabouts
unknown

36
Luděk Marold, **Design for
a poster for Nestlé**,
1897, Národní galerie v
Praze, Prague

Design for a poster for Nestlé

Marold became a real hero to the younger Czech
Secession painters in the second half of the nine-
teenth century, not only as the counterpart to the
official taste but also because of his personal con-
duct. He was expelled from the academy and then
spent several successful years in Paris as an *affiche*
designer. Although he really belonged to the genera-
tion of virtuosi from the late *Gründerzeit*, he was given
a warm welcome in Prague, in fact far warmer than
that of his much more famous friend and contempo-
rary, Alfons Mucha. Unlike Mucha, Marold made no
consistent attempt to transform the naturalistic
style he began with into a decorative one.

Marold completed very few oil paintings, yet
these pictures by no means make an uncertain
impression. His solution for capturing the fleeting
moment, in which there was a great deal of interest
at the time, at times verged on ecstatic vitalism. In
this sense, his large-scale design for an *affiche* in oil is
programmatic. It was bought by the Modern Gallery
in Prague for its permanent display in 1905.

37
Beneš Knüpfer, **The last salute**,1894, Národní galerie v Praze, Prague

position of the new talent did not exclude them from experiencing harsh conflicts and deep frustrations. The most telling illustration of this is to be found in the person of Mikoláš Aleš, the most original painter of the seventies generation, who was later to become a respected personality for the next generation. He became the *enfant terrible* of the Prague art scene having been expelled from the art academy for insulting a tutor. He shared this dubious honour with Antonín Chittussi. The young Aleš clashed with the authorities over local taste on a number of occasions. This, and his zealous patriotism, speeded up the decline of his utopian ideas about harmony between national and artistic ideals.

The image of the artist as a misunderstood genius in a middle-class setting was first projected in the Czech context by Aleš. This protest reverberated through his drawings which were used as illustrations for articles in the satirical periodical *Šotek* (Little Devil). His criticism was not only confined to the lack of patrons, but mainly to the lack of understanding shown by society to the artists of the time, a society mainly driven by materialism and positivism (fig. 29). In 1886 a society of young Czech students, the forerunner of the Mánes Artists' Association, supported Aleš's cause after his illustrations for the so-called 'Old Czech Manuscripts' had been ridiculed by the critics for being naive and referred to as a childish, botched job (fig. 33). The society appointed Aleš as their honorary chairman and published the diploma that commemorated his appointment. Luděk Marold, also expelled from the art school (but in his case for being idle),

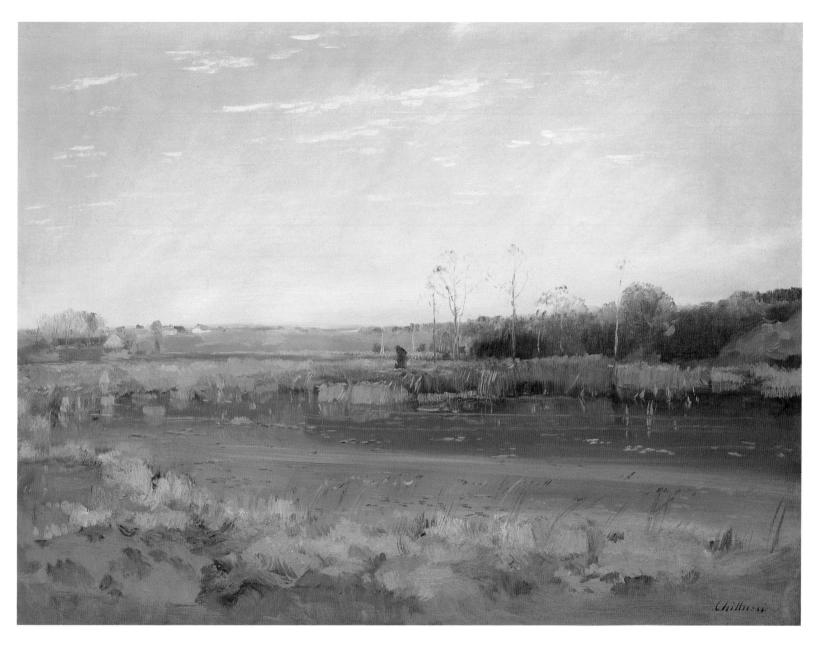

38
Antonín Chittussi, **Fen near Člunek**, c. 1886, private collection

Fen near Člunek

Chittussi was one of the first artists to stand up to the official institutions in Prague. When the paintings he had made in France were seen as examples of cosmopolitanism, he protested. He found it necessary to distance himself from the Impressionists because of his intuitive rather than visual approach to the image. His work reached a climax in the mid 1880s when he used the experience he had acquired painting landscapes in France to portray the fens in Southern and Eastern Bohemia. His approach to this imagery varied from the spontaneous to poetic.

Chittussi's work is generally regarded as a continuation of poetic Neo-Romanticism with elements of the *paysage intime* and the late Barbizon School.

39
Max Pirner in his studio,
1886-87

emphasised in the illustrated part of the diploma the artist's relationship to the public – no longer one of martyrdom but of triumph. He drew a middle-class man being struck by an artist's lady-friend, his jaunty little walking-stick being broken in the process (fig. 34).

The ascendancy of the National Theatre generation was accompanied by greater diversity in the work of sculptors and painters, which in the main corresponds with the prevailing tendencies at the advanced artistic centres. As well as a conservative, academic stream and a mainstream of moderate salon art, Prague also had perpetrators of unconventional art, such as in the work of artists like Aleš or Chittussi. Nonetheless, in the 1880s

salon art attracted most attention with its spectacular paintings for a large audience. Typical of this was work by the aforementioned painter, Brožík, creator of enormous history paintings (fig. 24). For the 1890s generation of Secession artists he was *the* example of someone who made salon art with non-artistic means, captivating a massive audience without killing true individuality.

The theoretical premises underpinning Czech art criticism during the rise of the National Theatre generation were in fact very close to the principles formulated in the seventies by Miroslav Tyrš, one of the founders of the patriotic gymnastics association Sokol (Valk) and the aesthetic ideologist of the Neo-Renaissance in Prague.

40
Max Pirner, **Frustra**, 1886-93, Národní galerie v Praze, Prague

Frustra

The years 1886-87 had a decisive influence on Max Pirner's innermost development. He had by this time finished his painting *Finis* (fig. 41) and was working on several series of paintings and drawings. A little later, the cycle of drawings (in charcoal and white chalk), *Love, life, hate and death*, were proof of this change. This cycle marked the end of his ambitions to produce epic paintings for exhibitions and the start of a simpler way of working on a smaller scale which enabled him to develop his ideas and use of iridescent colours more freely.

Frustra, a painting depicting the struggle of Pegasus with the powers of darkness, was to form the central panel of a triptych, of which the side panels depicting the figures Love, Contemplation and Life on one side and Madness, Hate and Death on the other have been preserved virtually intact. At various stages in his work Pirner returned to some of his fundamental and formal ideas and to his ideas on the subject, such as the motifs of embrace and struggle. This reflected the atmosphere of late Romanticism in music, literature and the visual arts. In his paintings and drawings Pirner protested against the painting as an imitation of an 'outward' reality and even more strongly against contemporary naturalism. He seldom showed his work in public and the last time was at the first exhibitions of the Secession societies in Vienna (1898) and Prague (1899).

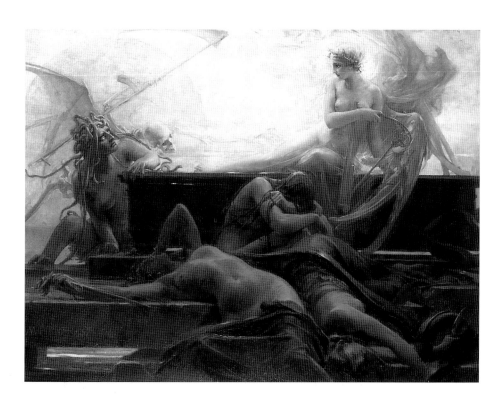

41
Max Pirner, **Finis**, 1887, Národní galerie v Praze, Prague

42
Hanuš Schwaiger, **The water man**, 1885, private collection (on loan to the Národní galerie v Praze, Prague)

The water man

The retrospective exhibition of Hanuš Schwaiger and Max Pirner in Prague in 1887 confirmed the existence and the significance of these individual personalities from the older generation of painters. Neither of them was connected with the official art world, nor were they very popular with the general public. Their work is representative of the Neo-Romantic style and, as illustrators, they often chose motifs from old legends and fairy tales. Antitheses were characteristic of Schwaiger's work; the lone individual against the crowd or life in the medieval as opposed to the contemporary city.

One of Schwaiger's principal domains was the paraphrasing of old-German and other Northern masters. He was inspired by their painting technique, their themes and highly stylised, silhouette-like drawing methods. The unpainted under layer in his painting *The water man* prompts associations with the gold background of medieval paintings. His figures' expressive character, moving between horror and caricature, is typical of this artist.

He defended 'healthy' art against the massive onslaught of French productions – just like the rest of the official art critics in Central Europe. In contrast to the virtuosity of form seen in the French, the originality in the Czech's own production was supposed to be based on an idea, a great epos. Art that did not focus on a collective idea, nor on the conflicts of human existence and an analysis of contemporary life, was dismissed as subjectivist and was regarded as a symptom of artistic crisis and cultural decadence. Nevertheless this refined art of painting, typical of the modern 'sensory' period with its difficult to define moods, also had its pioneers in Central Europe. One exponent of this idea was Gabriel Max (1840–1915),

a German from Prague who influenced most of the painters of the National Theatre generation.[8]

The National Theatre generation inherited the old quarrels between Realists and Romantics and developed somewhere between the Naturalist and Neo-Romantic movements. The work of Hynais mentioned earlier was influenced by the French and inclined towards cultivated naturalism. The Czech landscape painter with the Italian surname, Chittussi, also imported plein-air and use of light from the French, although in his case he transformed it into a characteristically melancholic mood. Czech artists willingly portrayed their frame of mind in tragic pictures of their own history, even during the opti-

43
Felix Jenewein,
Exuberance (from the
Plague cycle), 1900,
Národní galerie v Praze,
Prague

mistic period when the National Theatre was being deco-
rated and restored to its former glory. The entire atmos-
phere of imminent decline and fall, which was projected
onto the nation's past, can be explained by the discor-
dant nature of the artistic scene at that time. The shady
side of the artist's existence was allegorically portrayed
by Maxmilián Pirner in his painting *Finis* from 1887 (fig.
41). Pirner was an eminent sensitivist and a forerunner of
Prague Symbolism. The painting, which shows the muse
being threatened by death, can be interpreted in a Neo-
Romantic or neo-idealistic sense as an allegory, a mani-
festo expressing the scepticism of Pirner's generation
faced with the unfair battle between the ideals of Art and

the harsh realities of Life. However, the work also shows
the modern ambivalence of symbolism. It is more than
just a traditional depiction of the downfall of the noble
heroine. The tragic story of Art is also imposing in that it
is iconographically embedded in the story of the resur-
rection of Christ.

Another teacher of the Secession generation, the
sculptor Josef Václav Myslbek, was equally open to the
themes of Czech decadence. In the early nineties
Myslbek was preoccupied with the idea that music should
be the sounding board for the Czech soul, which he
expressed in a sculpture for the foyer of the National
Theatre (fig. 45). While looking for the right form for his

44
Josef Václav Myslbek, **Swan song**, 1894, Národní galerie v Praze, Prague

Preliminary studies for 'Music'

In 1890 Myslbek received a stipend from the ministry in Vienna to produce an important sculpture. He had already made a statue of Smetana. The new piece, *Music*, was intended for the Czech National Theatre. With this statue Myslbek intended to portray music as the soul of the nation. Looking at the artist's sketches and drawings which have been preserved, the creative process surrounding the statue could almost be described as dramatic and it produced a wide range of results.

The final work, which was not placed in the theatre until 1912, combines monumentality, for example in the heavy drapery, with tenderness, as expressed in the kissing of the musical instrument. Some sketches show a muse embracing a violin, while other designs elaborate on the idea of a tree

as the origin of the musical instrument and on the romantic image of the popular motif of the tree nymph or the mythological figure of Daphne.

Myslbek combined a lyrical mood with tragedy in his reclining design for *Swan song*. The image of Czech decadence, the alarming vision of the Czech past as a period of decline, which had become so commonplace in the 1890s, was an exception for this artist. His colleague Ženíšek explicitly expressed this decline and decadence in one of the panels of a triptych on the ceiling of the theatre's main foyer, close to the place allocated for *Music*. The triptych depicted the three periods of the Czech nation: *The Decline*, *the Golden Age* and *the Revival of art* (**fig. 35**). Max Pirner worked on a similar allegory of art in his programmatic painting *Finis* from 1886 (**fig. 41**).

45
Josef Václav Myslbek,
Preliminary studies for 'Music', Národní galerie v Praze, Prague
Second design, 1892-94
Fourth design, c. 1895

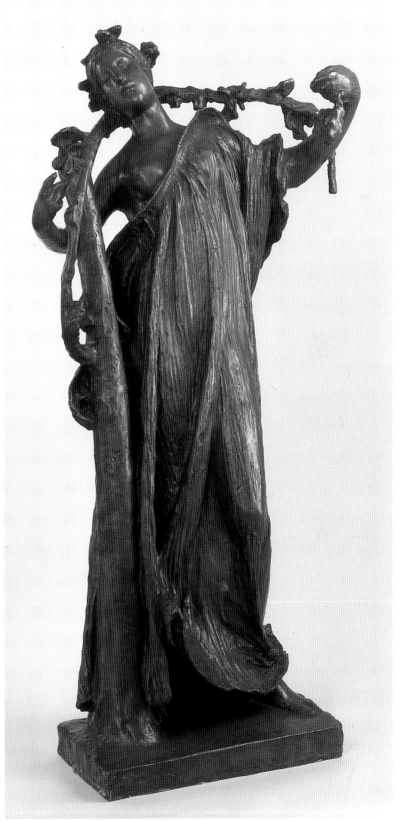

46
Felix Jenewein, **Good
Friday morning**, 1895,
Národní galerie v Praze,
Prague

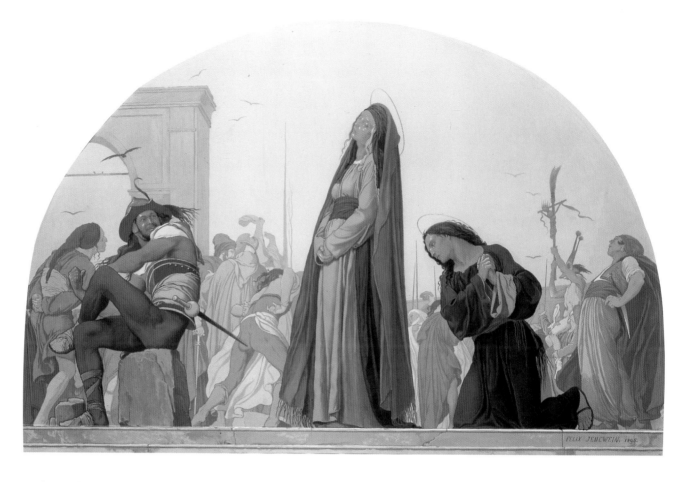

sculpture he made a series of sketches, which vary in
mood from ecstatic enthusiasm to a personification of
death in *Swan song* (fig. 44). The sculptor eventually
returned to the tender lyricism of Josef Mánes, which he
associated with solemn monumentality. In so doing he
confirmed an age-old tendency to idealise art, thus bear-
ing the brunt of the bitter sarcasm vented by the 'angry
young men'.[9]

This sort of controversy between generations of
artists – whether between father and son, or teacher and
pupil – confirms rather than undermines the coherence
and dynamism of modern art in late nineteenth-century
Prague. This contentious situation cannot disguise the
fact that the real premises of modern art had already
been formulated by the generation of artists working in
the 1870s. By the end of the nineteenth century, salon
art could no longer be considered the only standard in
Prague. It was the art of the masters which quickly devel-
oped into an official style, only to lapse into convention-
ality. Even though 'poetry' was generally given priority
over individualistic 'ecstasy' because it was more accessi-
ble, the Prague art scene was still home to a few head-
strong personalities who created unusual and original
works of art.

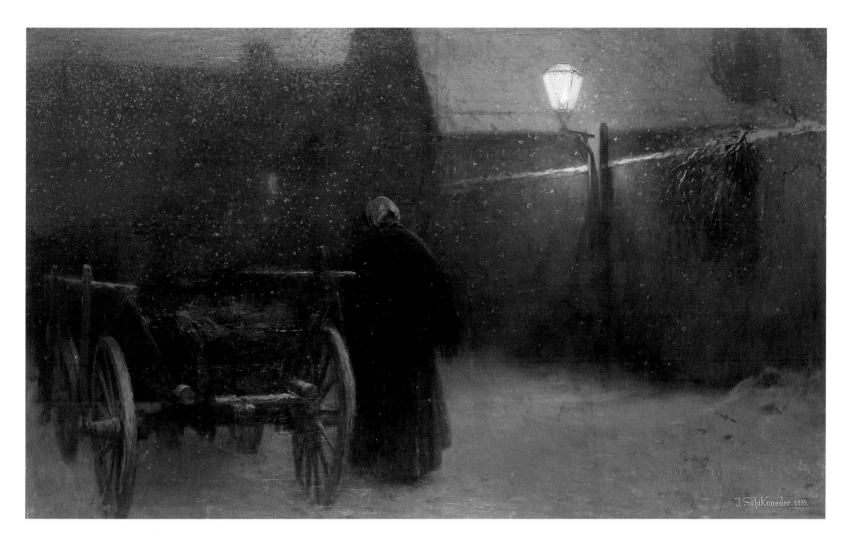

47
Jakub Schikaneder, **Snow**, 1899, Národní galerie v Praze, Prague

Snow

After his naturalistic early period with images of hard labour and of the sad lives of lonely people, Schikaneder developed his idiosyncratic style of mood painting after 1890, making more use of pictorial rather than literary means. He mainly used a lonely and static figure dominated by a general atmosphere of melancholy. In Schikaneder's work the mood is generally in the context of the transience and finiteness of human life to which mankind must resign itself. At the same time he opposed the unambiguousness of subject and emphasised the coherence of colour and light in the painting. At the peak of his career, the relationship between natural and artificial light was a prominent aspect. He used sfumato in these paintings to emphasise the subdued reflection of light on the decorative surface. Schikaneder usually chose an evening or nocturnal setting and, from the end of the century, concentrated almost exclusively on urban scenes with images of old Prague.

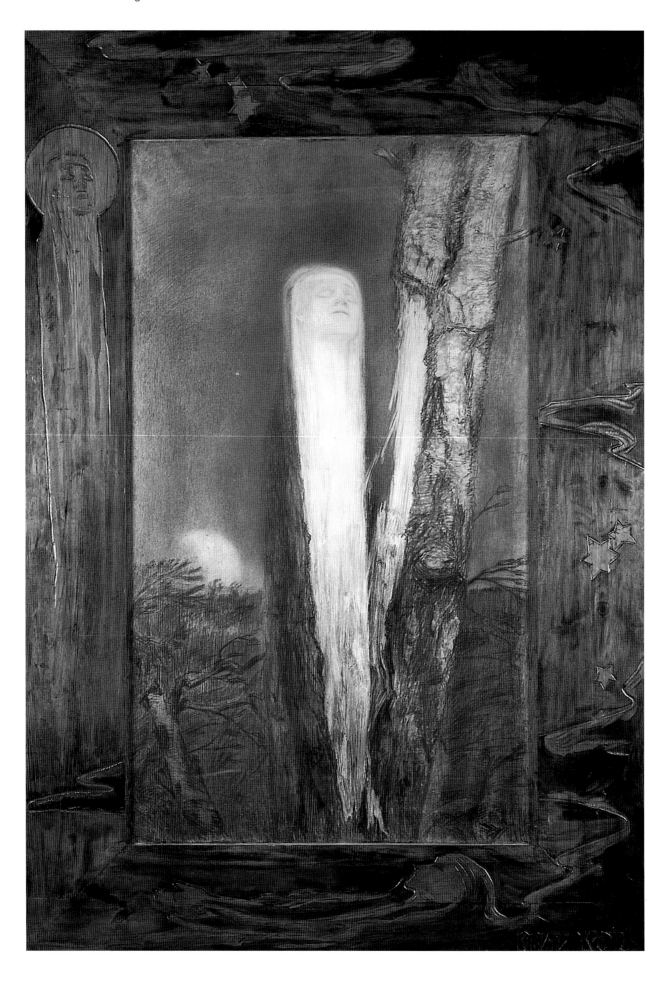

Towards a new synthesis

Petr Wittlich

In 1905 a collection of essays and lectures by the leading art and literary critic František Xaver Šalda (1867–1937) was published in Prague. The book was a passionate personal appeal to Czech artists and Czech society as a whole to raise the art of their nation to a universal, international level. Šalda, who had for some years been the editor-in-chief of the most important art magazine in Prague, *Volné směry* (Free directions), backed up his arguments by drawing on his extensive knowledge of modern cultural life in France and Germany. He had a talent for discovering noteworthy modern artists, associating with them in the dramatic struggle for the creation of a new culture.

The struggle for tomorrow

His appeal was applauded by the generation of artists that had emerged in the 1890s, becoming the focus of attention in no time. They were organised in the Mánes Artists' Association, which had originally been founded as a students' society in 1887. In that year many young painters returned to Prague from Munich, undoubtedly prompted by the reform of the Prague Academy of Fine Art where Maxmilián Pirner and Julius Mařák had been appointed teachers. In 1893 these two Neo-Romantics were joined by Vojtěch Hynais who had returned from Paris and who had contributed a plein-air light (illusionism) to the academic figurative style. Not long afterwards, in 1896, the sculptor Josef Václav Myslbek was appointed professor; until then he had taught at the School of Applied Art and, like Hynais, was open to French influences. This new, inspiring teaching staff made a deep impression on the younger generation of artists.

The artists' association Mánes took some time to find its artistic bearing and was constantly exposed to provocation in the course of this search. Karel Hlaváček, a decadent poet and self-taught draughtsman involved with

Mother!

Bílek produced a whole series of large-format charcoal drawings on his most important Symbolist themes. These displayed both his predilection for fanciful religious subjects and his need to express his neo-Platonic light Symbolism. In the centre of the drawing entitled *Mother!* a manifestly radiant anthropomorphic figure, eyes closed like a sleepwalker, is freeing itself, expressing a spiritual process which occurs in nature under the influence of cosmic light.

The drawing is connected with the Christological cycle which chiefly occupied Bílek in the 1890s. This cycle began with *Ploughing* (1892), reached a high point in the monumental work *The Crucified* (1898, St Vitus Cathedral, Prague), and also included the charcoal drawing *How a sunbeam died in the wood of a cross* (1899, Národní galerie v Praze, Prague), which elaborates the basic theme of *Mother!*

48
František Bílek, **Mother!**, 1899, Národní galerie v Praze, Prague

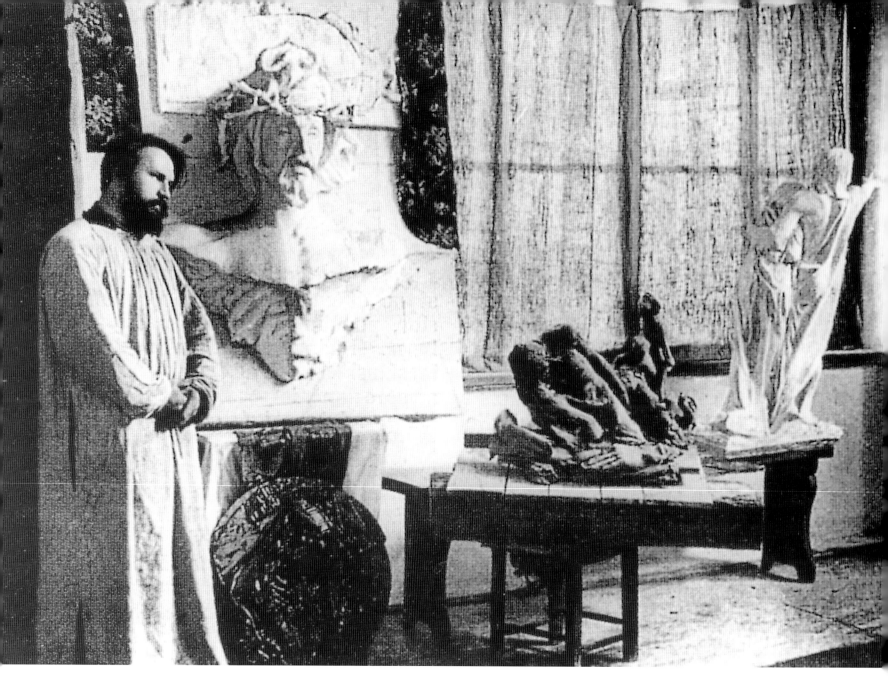

49
František Bílek in his studio
in Chýnov, 1902

the magazine *Moderní revue* (Modern review) in 1897-98
(just before his early death) heaped accusations on the
young members of Mánes; his principal charge was that
they were years behind the times. *Moderní revue* was
inspired by French-Belgian Symbolism and was the first
journal in the Bohemian lands to take note of artists
such as Rops, Redon, Beardsley and especially Munch,
whose work was to play an exceptionally important role
in modern art in Prague.[1]

The artists of Mánes felt a disdain for what they saw
as the over-literary aspirations of decadent-Symbolism. In
their first manifestos, which accompanied the Society's
first exhibitions in 1898, they claimed their right to a
'pure painterly expression', by which they mainly meant a
purely pictorial way of looking at nature. This element of
new sensuality was very much a typical feature of the
new mode of expression that they had in mind; it was in

this spirit too that one should see their rejection of any
far-reaching stylisation or ornament that was so typical
of the Viennese Secession.

A moral reveille

The rejection of Symbolism did not, however, mean that
these young artists didn't advocate any specific ideas,
even if they did so largely on moral grounds. The first
Mánes exhibitions were advertised with posters by
Arnošt Hofbauer; in the first poster the corpulent little
god Mammon is being teased by the muse of art, while in
the second the captain of the good ship 'Mánes' is throw-
ing a life buoy to a man in danger of being submerged by
a tidal wave reminiscent of Hokusai (figs. 124 and 125).
The 'radical' sculptor and draughtsman František Bílek
was well represented in the same exhibition.

60

50
František Bílek,
Astonishment, 1907,
Národní galerie v Praze,
Prague

51
František Bílek, **Jan Hus –
Tree struck by lightning
that has burned for cen-
turies**, 1901, Gallery of the
City of Prague

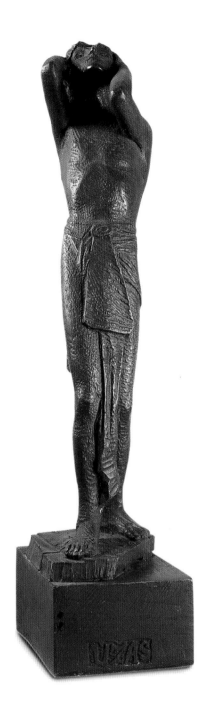

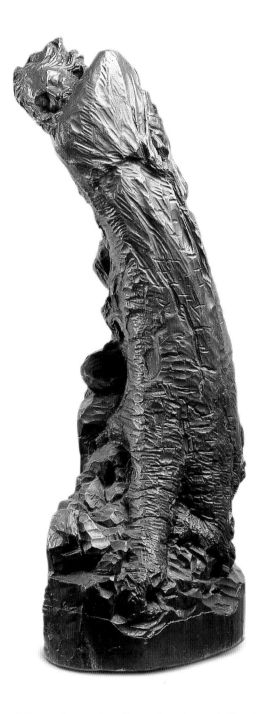

Jan Hus – Tree struck by lightning that has burned for centuries

In 1900 a competition was held to design a statue for Prague of the Czech reformer and national martyr Jan Hus. Although Bílek did not enter the competition, he did produce his own artistic concept of the theme in which he associated the historical figure of Hus with the universal symbolism of cosmic light.

The ecstasy of sacrifice, represented by the tree set ablaze by lightning, recalls in theme and form the sublimated emotionalism of exuberant Czech Baroque. It is also possible that Bílek wished to respond to Munch's *The scream*, which had been printed in *Moderní revue*, the journal of Czech decadentism, in 1897. Comparison of the works is interesting as they exemplify two different approaches to the 'formula of pathos', a popular contemporary theme.

Bílek eventually constructed his statue of Jan Hus, a monument almost 12 metre high, from 1912 to 1914 in the town of Kolín on the river Elbe.

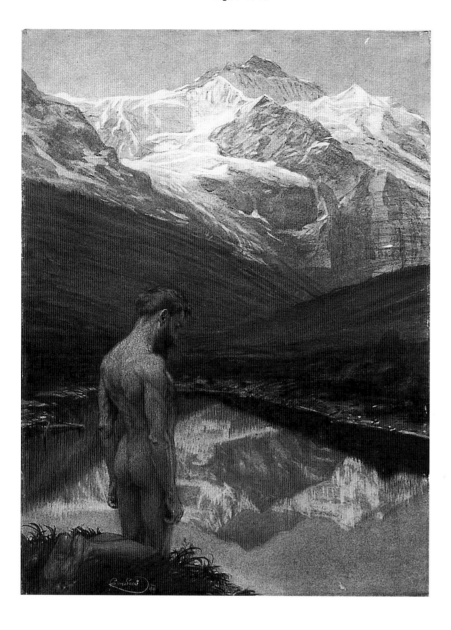

Meditation

Although Kupka made Paris his permanent home from 1895, his ideas were enduringly influenced by the spiritualist rituals he experienced during his earlier years in Vienna. There, for example, he regularly exercised naked in natural surroundings, under the guidance of his 'guru', the extravagant painter Karl Diefenbach.

The drawing entitled *Meditation* is saturated with Nietzschean ideas and proclaims a deep longing to return to the universal dimension of nature. One interesting feature is that the kneeling figure is not primarily worshipping the high mountains but rather their reflection in the lake. This is a reference to cosmic narcissism, a leitmotif in Kupka's later abstract work.

52
František Kupka,
Meditation, 1899, Museum
of Fine Art, Ostrava

Bílek was the first artist to rebel against existing aesthetic norms. In 1892 the Prague art committee refused to extend his scholarship in Paris, after he rubbed them up the wrong way with his sculptures *We must till the earth as punishment for our sins* (1892, Gallery of the City of Prague) and *Golgotha* (1892, Chýnov), sculptures that are characterised by an unusually dramatic and naturalistic approach to a religious theme. For the rest of the nineties Bílek's work was a protest against this verdict. He produced a large number of highly original art works which are among the most important of Czech Symbolism as, for instance, the wooden statue *The Crucified*, completed in 1898 (currently to be seen in the St Vitus Cathedral in the Prague Castle complex). Besides work in wood and clay Bílek also produced large, independent charcoal drawings, which revealed the more fantastic side to his passionate imagination. The Messianic energy in his

work that originated in a higher, moral message was also expressed in his vision of Czech history. He became intrigued by the figure of Jan Hus, the founder of the Czech Reformation, a martyr of the Czech people who coined the slogan, 'The truth shall triumph'. In 1901 František Bílek responded to a design competition for a monument to Jan Hus in Prague; his entry was a wooden statue representing his view of the martyr. The emphasis is on the symbolism of light which the sculptural form, as it were, dematerialises, conveying the artist's fundamental idea that man forms an integral part of a higher cosmic world (fig. 51).

Bílek's sculptures often evoke the exuberant Czech Baroque style, but they equally belong to contemporary attempts to create a new sort of *Gesamtkunstwerk* or work combining different art forms, even though he was fiercely opposed to ornament as a goal in itself. His

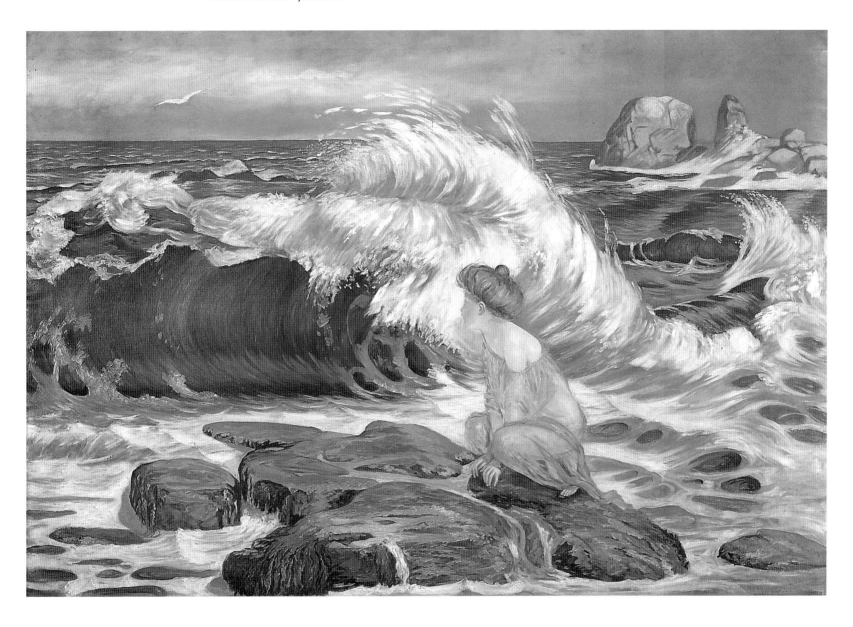

53
František Kupka, **The wave**, 1902, Museum of Fine Art, Ostrava

interesting ceramic work with its greyish-black patina (fig. 16), his woodcuts, architectural plans and furniture designs for his studio home in Prague testify to his efforts to create a complex artistic form that would relate to modern man's fundamental emotions.

Another striking, solitary figure in the Czech art world was František Kupka, who lived in Paris from 1895 on. In his work too we can discern a fiercely critical attitude, but in his case the influence came from Anarchism. For instance, he published several cycles of prints in the French press that were inspired by this movement. He was also more generally affected by an amalgam of ideas that were typical of Symbolism and the idealism of the nineties. A cosmic religious feeling, in which the great elemental processes in nature and the world were dominant, played a significant role in his work. With this as his background, Kupka would pursue an entirely new direction at the begin-

ning of the twentieth century, tending towards abstract art.

Bílek and Kupka both played a John-the-Baptist role in the circle of the younger members of Mánes; they were apostles of a new epoch characterised by artistic sincerity. Their message of the artist's personal responsibility for his or her programme and work also encouraged the younger generation to search for topical artistic themes and to give them concrete form.

Mood landscapes

Landscape as a genre was already a dominant presence in the first Mánes exhibitions. This was partly because it related to the interests and expectations of the public, and partly because the landscape painters had established their own extraordinarily rigorous requirements for this genre. After Julius Mařák took up his post at the Prague

54
František Kupka, **The way of silence**, 1903, private collection (on loan to the Národní galerie v Praze, Prague)

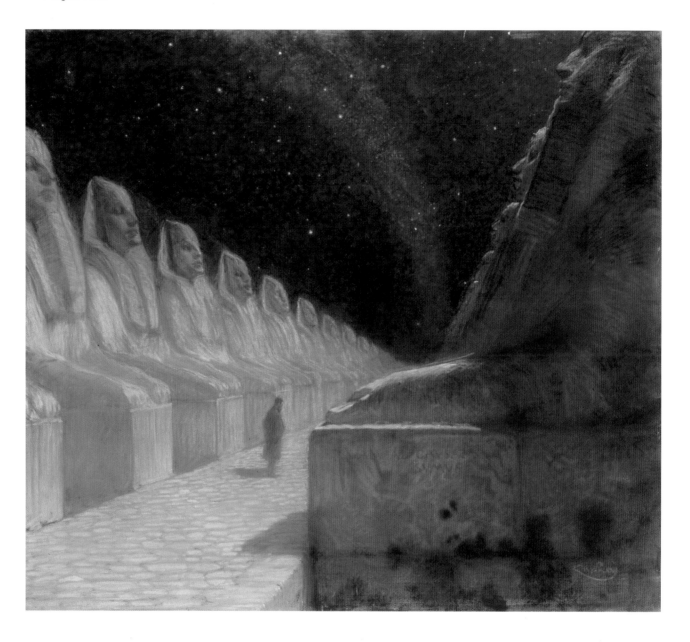

54
František Kupka, **The way of silence**, 1903, private collection (on loan to the Národní galerie v Praze, Prague)

Academy of Fine Art in 1887, a class in landscape art started up. It was the students of this class who formed the most tightly-knit group in the school during the next few years. In the 1890s the Mařák class frequently followed their teacher to the country in the summer, meeting in the village of Okoř not far from Prague. Here the beautiful valley with its brook offered the students a new repertoire. Mařák had previously been in the habit of making studies of the play of light in the forest; for his pupils the sparkling surface of the stream was an even more suitable subject for deeper inquiry into the relation between colour and light.

Some striking personalities soon emerged. František Kaván initially painted spacious realistic panoramas of local landscapes, with areas of sky over the horizon making for an unusual incidence of light. In the second half of the 1890s, however, he suffered a sort of nervous break-

down which led among other things to a friendship with the decadent-Symbolist poet, Hlaváček and to writing poems with a similar atmosphere. His altered temperament could also be seen in some of his night and evening landscapes, in which the infrequent background figures turned into wraiths, taking on grotesque, allegorical forms. In the Autumn of 1895 he and Otakar Lebeda, another of Mařák's talented pupils, painted gloomy scenes of the fish ponds of southern Bohemia. This 'gloomy manner of painting' irritated their teacher. In the next few years Lebeda's volatile, sensitive personality emerged fully in his paintings. The colours ceased to relate to nature and the tones became sharper, with the paint applied in short, sturdy brushstokes. The colour too dissolved into an iridescent rainbow-like mist or disappeared completely in a clouded layer of paint. Lebeda's repertoire displays the contemporary interest in shimmering water and

55
Otakar Lebeda, **Cabbage field (Nigrín's lime tree at Vysoké on the Jizera)**, 1894, Národní galerie v Praze, Prague

Cabbage field (Nigrín's lime tree at Vysoké on the Jizera)

This painting by seventeen-year-old Lebeda shows he was one of the most talented students in Julius Mařák's class at the Prague Academy of Fine Art. Lebeda's inclusion in Mařák's renowned class did not prevent him from painting with other artists, such as František Kaván who was somewhat older.

In this work Lebeda has endeavoured to transcend the usual formulas for landscape painting: the accentuated foreground is photographic in perspective. The dramatic colours and aggressive brush strokes betray the painter's psychological turmoil.

Lebeda's moody landscapes contain hidden symbols such as mountain lakes or winding paths, and seem to reflect the painter's neurotic syndrome. After an attempt to produce a large figure piece (*Young man struck by lightning*, 1900–1901, Národní galerie v Praze, Prague) Lebeda committed suicide at the age of twenty four.

mountain lakes, but it also contains such motifs as a winding path in a landscape with an impressionist flavour.

One leading member of the Mařák class was Antonín Slavíček, who would develop into the most important representative of the new Czech landscape art. Like his colleagues of the 1890s, he painted in Okoř, but was also active elsewhere – in the park of Veltrusy castle, for instance, and the country estate of Hvězda, where he worked on autumnal, predominantly melancholic images. He often used tempera as a medium and, while drawn to the new sensuality, he was also concerned with the decorative aspects of a painting, as one can see from his treatment of composition and the way he applied his paint. He was inspired in this by the poster art of the time.

The situation just described is typical of the whole field of the new Czech landscape art and is closely related to the genre that one could call 'mood' landscapes. The term *Stimmung*, or mood, is typical of the period and refers not only to the particular emotional content of these paintings, but also to a certain philosophical undertone. At the end of the 1890s, on the sudden death of Julius Mařák, František Kaván, a former pupil, wrote a memoir about his studio for the *Volné směry* (Free directions) in which he stated the concept of 'mood' as a programmatic principle. He declared that mood was an important, positive, personal quality and preferable to normal sensory impressions; it was that additional element that inscribes miraculous signs of the world on the soul and is accompanied by feelings of exaltation and passion. The content of a mood is the way in which a personal vision 'powerfully unfolds, so that all themes, elements, events, forms and colours attain a harmonious balance.'[2]

The concept of mood was developed as a theoretical basis for modern art by Alois Riegl. It was actually an old term from the Romantic philosophy of art, updated by F.T. Vischer in the second half of the nineteenth century.[3] For Central European painters the concept heralded a new understanding of the meaning and function of a painting, which they saw not just as a painted surface but also as an integrated entity with a deeper content. Šalda too was occupied with landscape painting in what is perhaps the most important essay in his collection *The struggle for tomorrow*, 'The new beauty: its origin and character'. He viewed the new approach to landscape and the new feeling for space that this genre displayed as factors that lent the art a new vitality. He pointed out that, while people had previously delighted in whatever was 'small, secluded and forgotten', now 'their greatest love is for

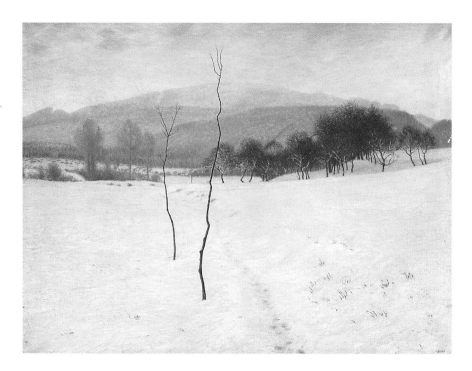

56
František Kaván, **Rain over Tábor**, 1903, Museum and Gallery, Hořice

those places on earth where cosmic gusts of wind are at their fiercest and where the echo and reverberation of the Cyclopean heart of the universe are at their loudest.'[4]

Šalda's ecstatic remarks about the new perception of the open country fitted in perfectly with the poetic sensitivity of the 1890s, which often gave voice to the melancholy of the *fin de siècle*, both in the poets' favourite genre – the nature lyric – and in the new landscape art. The artist who explored this vein of poetic vision of the countryside most thoroughly was probably Antonín Hudeček, who originally worked as a painter of portraits and public figures. However, influenced by the Mařák class, Hudeček underwent a total conversion to landscape. The sense that prevailed in this epoch that landscape represented a state of mind was translated by Hudeček in a way that was loosely related to French Pointillism; the result was a mosaic of short, colourful strokes, producing a richly varied palette of slightly broken half-tones. In this way the objects in a painting blended in a solemn play of colour and light, changing in character according to the intensity of the light at the time of painting. According to the critic Karel B. Mádl, Hudeček's depiction not only of dusk but also of the colourful sparkling light of spring made him an admired master of subtle moods.[5]

In conceptual terms, then, mood was an important premise for the birth of modern Czech painting. The concept also occurs in artists who did not strictly belong to the Mařák school. There was Václav Radimský, for instance, who studied in France where he came into contact with Monet's late Impressionism and later with Alois Kalvoda who, influenced by the decorative style of the time, brought a strong sensibility for line to his moods. Even in Kalvoda's work, however, a vehement emotionality dominated, for which the new genre of landscape art in the 1890s had provided the basis.

The poetic persona

The third Mánes exhibition was held in 1900. Hudeček exhibited a painting, *Evening silence* (fig. 59) which proved he had absorbed the experience acquired by the young landscape artists on the theme of a human figure in a landscape. The painting, *The poor country* by Maxmilián Švabinský (fig. 62) and Jan Preisler's triptych, *Spring* (fig. 68) were comparable programmatic paintings. Their presence at the Mánes exhibitions in Prague and Vienna heralded the rise of a new 'figural' painting.

In the three paintings just mentioned, the relation between the persona and the landscape he or she is situated in has a deeply symbolic character. In Hudeček's painting a woman wearing city attire is reflected in the still lake of an evening landscape, while the surface of the water shines as though it were the eye of the world. In *The poor country* by Švabinský, a poorly dressed young girl makes a hieratic gesture towards the viewer, which is not intended as a general allegory of nature but as an extremely individualised incarnation of the call of the landscape itself.[6] In his version of the Judgement of Paris, *Spring*, Preisler shows an even more striking sense of melancholy in the central figure.

What all these paintings have in common is a shift from the general allegorical level to one of individual emotion, as if the painter is in search of new original values, unswerving in his aim to mingle sensory reality with themes drawn from his imagination. This shift can be clearly seen if one compares these works with those made by Švabinský and Preisler a few years earlier. Švabinský's famous *Union of souls* of 1896 (fig. 64) is a Neo-Romantic attempt to relate the character of a poet, whose eyes are shining with melancholic inspiration, with the appearance in a dream of his muse, set within an idealised Italianate landscape. In the second half of the 1890s Preisler too made a number of paintings expressing Neo-Romantic visions, such as *The kiss* or *Spring evening* (fig. 71), in which only fantasy figures can be seen. His attempt to explore the figure of the knight-errant in a large cycle ended with the painting *Seduction* – a free interpretation of *Knight surrounded by*

57
Antonín Slavíček, **Inner life, birch wood**, 1897, Národní galerie v Praze, Prague

58
Antonín Slavíček, **Autumn dawn**, 1897, Národní galerie v Praze, Prague

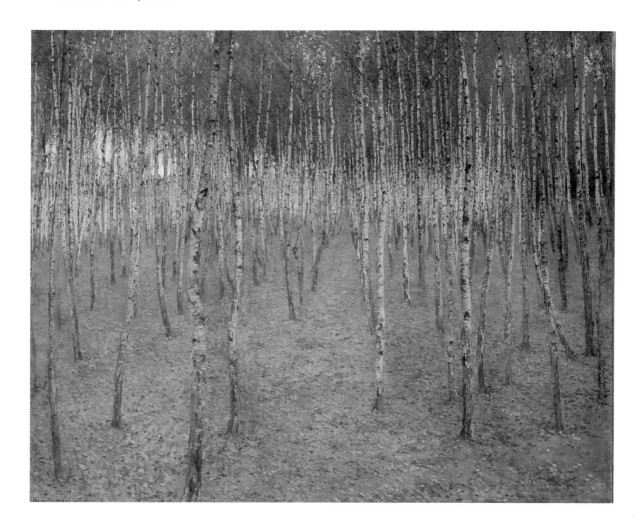

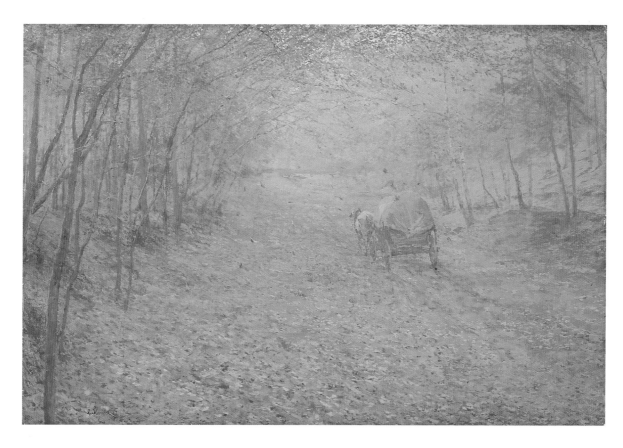

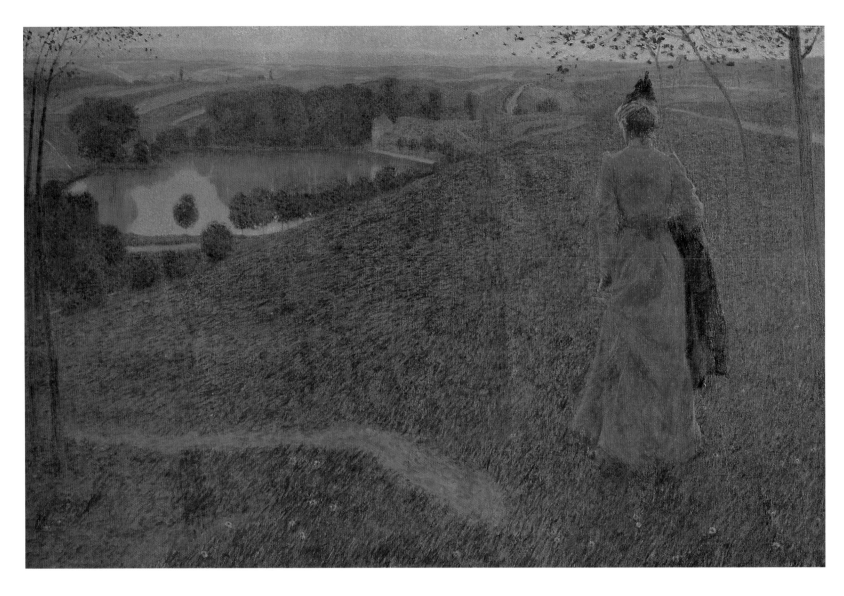

59
Antonín Hudeček, **Evening silence**, 1900, Národní galerie v Praze, Prague

flowers by Georges Antoine Rochegrosse of 1894.

The new modes of depiction that became the fashion in landscape painting and nature poetry, eventually provided the necessary impetus for the figuralists to arrive at a more convincingly modern form of painting. During this development, their use of colour also advanced, with the artists becoming more free and demurring less about experimenting with it. The theme of a woman surrounded by flowers can often be seen in works from this period; you might say that the more effective the suggestion is of the scent of flowers the stronger the power of pure colour becomes. In this way Hudeček, Slavíček and, later, Preisler succeeded in lending their paintings an unprecedented intensity of light and, more importantly, a new pictorial unity. According to the art historian Antonín Matějček, Preisler's triptych *Spring* is the first example of an oil painting freeing itself from the illusionist technique of 'green reflexes' (a technique with which Hynais had

only recently made a great impression on young painters); in this way artists were free to set sail for the new horizons of Post-Impressionism.[7] It was also no coincidence that Preisler's triptych was intended to decorate an interior – one of the first Art Nouveau constructions in Prague, the Peterka house on Wenceslas Square designed by the architect Jan Kotěra. This was Preisler's own response to the aesthetics of the posters with Art Nouveau elements that were already familiar in Prague.

This new direction, however, was anything but self-evident in painters' circles in Prague in 1900 and their responses to developments in modern art from Western Europe were on the whole fairly complicated. The great art exhibitions held during the World Fair in Paris in 1900 hardly helped to clarify matters and the much-debated jubilee expositions also served only, if anything, to sow confusion. In the end it was the Rodin Pavilion at the Place d'Alma that appealed to them as artists.

60
Antonín Hudeček, **Fresh young green**, 1900, Národní galerie v Praze, Prague

61
Alois Kalvoda, **View of the Berounka**, c. 1906, Moravian Gallery, Brno

62
Maxmilián Švabinský, **The poor country**, 1900, Národní galerie v Praze, Prague

Psyche

Hudeček trained as a painter in Munich (where he joined the Ažbe class) and Prague (under Václav Brožík). He subsequently specialised in poetic mood landscapes which he produced in Okoř, like the painters in the Mařák class which Hudeček joined in 1897. During this period he also proved to be a fine sketcher and drew a number of allegorical themes in the new style of the Secession. Hudeček only worked some sketches into finished drawings four years later, apparently for a planned exhibition in Vienna.

However, one work, *Will-o'-the wisps*, met with such ridicule, that he did not return to this symbolic genre.

Psyche is an outstanding example of Hudeček's lyrical mood landscapes. In this work he has mastered a freely interpreted late Impressionist technique which he uses to render the magical moonlight sparkling on the water. The symbol of a reflecting water surface also appears in many other works by the artist, such as *Evening silence* (**fig. 59**).

63
Antonín Hudeček, **Psyche**,
1901, Národní galerie v
Praze, Prague

64
Maxmilián Švabinský,
Union of souls, 1896,
Národní galerie v Praze,
Prague

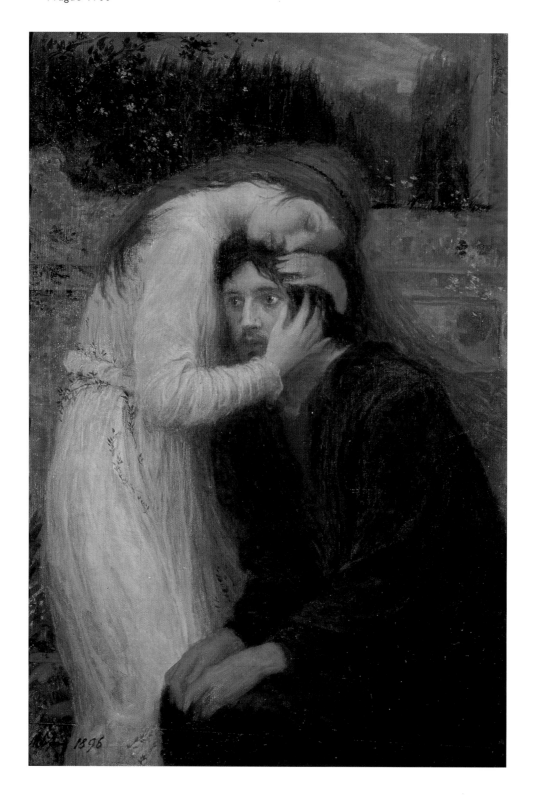

Union of souls

Švabinský was a leading pupil of the Neo-Romantic artist Pirner at the Prague Academy of Fine Art. His intention was to find new means of expression within his teacher's figurative mode. Švabinský's work is characterised by southern influences: Mediterranean classical culture was his model, albeit viewed through the eyes of northern painters such as the English Pre-Raphaelites or Puvis de Chavannes. The canvas entitled *Union of souls* is thence imbued with an idealism that suppresses the painting's inherent erotic tension. Švabinský also proved to be an excellent interpreter of Slavic sensualism, particularly in his graphic oeuvre. His thematic works are often highly narrative.

65
Maxmilián Švabinský,
Camelia, 1903, Národní
galerie v Praze, Prague

66
Maxmilián Švabinský,
Portrait of a lady, 1904,
West Bohemian Gallery,
Pilsen

67
Jan Preisler, **Fairy tale**,
1902, Museum of Fine Art,
Ostrava

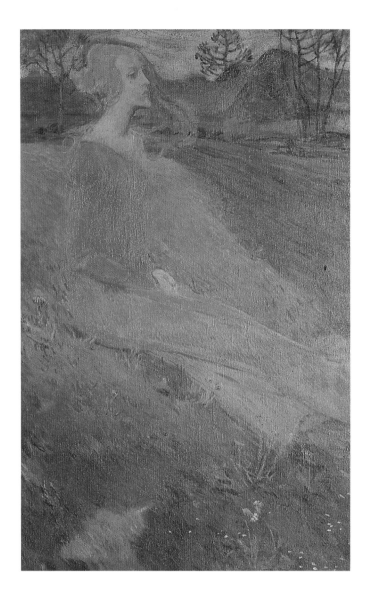

68
Jan Preisler, **Spring** (trip-
tych), 1900, West Bohemian
Gallery, Pilsen

Spring

This triptych was displayed in 1900 at the third
Prague exhibition of the Mánes Artists' Association.
It was enthusiastically received by critics who
described the work as a new 'programmatic painting
for the end of the nineteenth century'. Their atten-
tion was chiefly drawn by the painting's 'wry charm'
with which Preisler gave an entirely modern spin to
Parisian Art Nouveau. The work may also have been
produced in response to Vojtěch Hynais's painting
The Judgement of Paris which was presented to the
Czech public in 1898, at an exhibition in the
Rudolfinum in Prague (fig. 28).

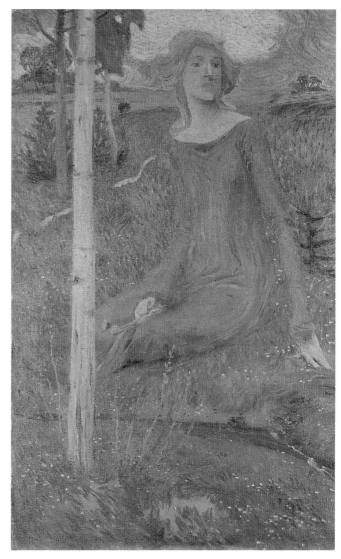

With its Post-Impressionist use of colour planes Preisler's painting is decidedly different in style from Hynais's illusionist approach. The work is also clearly influenced by the aesthetics of modern posters, a genre in which Preisler was also active.

The triptych is based on a series of remarkable drawings which all attest to Preisler's meticulous preparation for the final work and his commitment to the subject. The melancholy adolescent boy, seated in an attitude of despair in a Czech spring landscape, thus represents a high point in the development of the 'poetic persona in nature' theme, which increasingly dominated Czech art during the 1890s.

69
Jan Preisler, **The knight errant**, 1897-98, West Bohemian Gallery, Pilsen

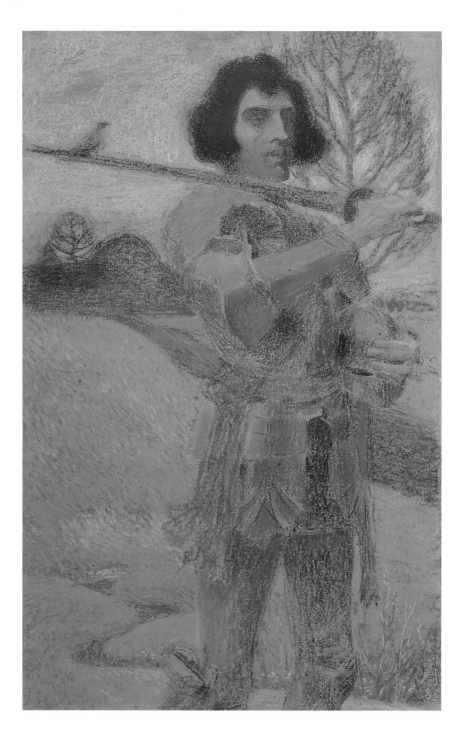

The knight errant

This pastel drawing is a preliminary study for Preisler's planned cycle 'An adventurous knight'. The work represents Preisler's interpretation of popular representations of a hero on his quest for an ideal. This theme is Neo-Romantic in origin (Edward Burne-Jones) and regularly appeared in the German-Austrian cultural context (Hans Thoma, Gustav Klimt, Gustav Mahler).

The drawing is connected with Preisler's painting *Seduction* (also in the West Bohemian Gallery), a melancholy work which represents the impossibility of attaining the ideal.

Although Preisler never produced his planned polytych, this pastel drawing shows how, at the beginning of his career, he could successfully interpret powerful emotions through purely painterly means. The fanciful fairy tale theme which recurs in several Preisler works (for example, *Fairy tale*, fig. 67) helped the artist to break free from the prevailing naturalist trend and develop his own original vision.

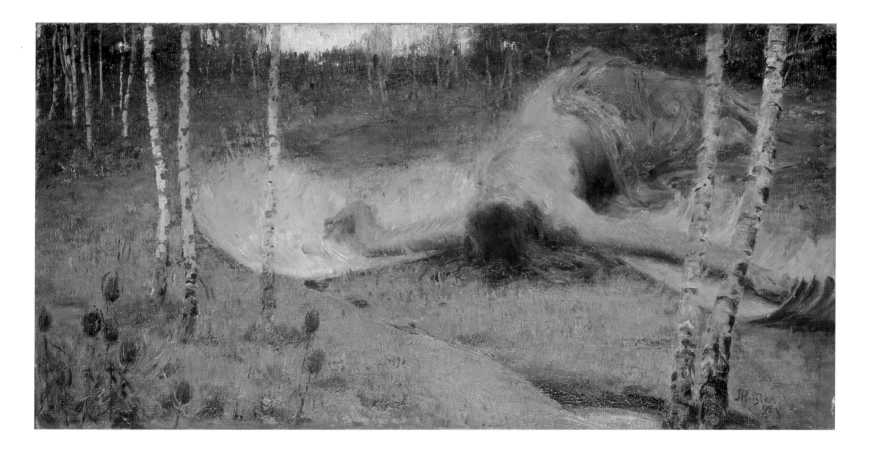

70
Jan Preisler, **The wind and
the breeze**, 1896, Národní
galerie v Praze, Prague

71
Jan Preisler, **Spring
evening**, 1898, Národní
galerie v Praze, Prague

Antonín Hudeček, **Spring fairy tale**, 1898, Národní galerie v Praze, Prague

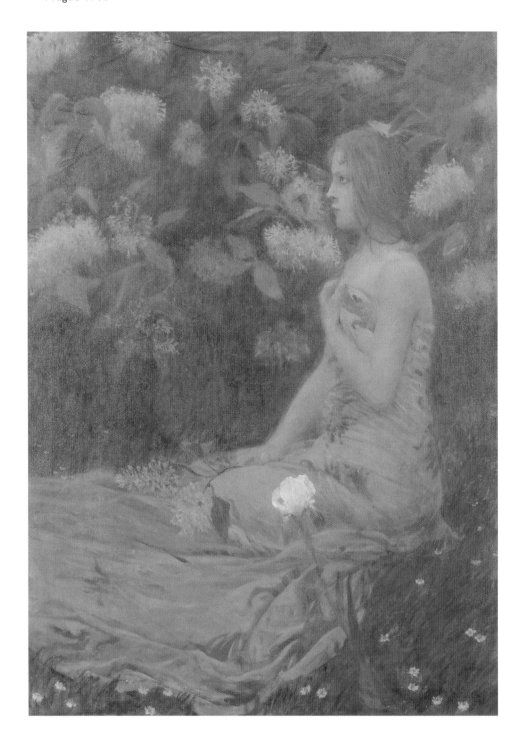

Pathos

Rodin had a great impact on Czech painters as well as sculptors. Arnošt Hofbauer and Miloš Jiránek, two envoys of the Mánes association, edited a special issue of *Volné směry* devoted to him. After the Paris exhibition the sculptor Josef Mařatka had the good fortune to work in Rodin's studio; it was thanks to him that the Czechs were able to obtain the loan of a number of Rodin's sculptures for the great one-man show finally held in Prague in 1902.[8]

These events had a specific political background. The Czechs were driven by nationalist considerations to shake off the influence of Vienna and hence deliberately looked to France for new cultural impulses. Czech politicians – and Prague city councillors in particular – supported this initiative and Rodin was brought in triumph to the city in 1902, mainly, however, as a representative of French republicanism. One positive feature of this nationalist commitment was the fact that the call for political freedom was now raised in the field of culture as well. Hence, in Prague, Rodin contributed to the

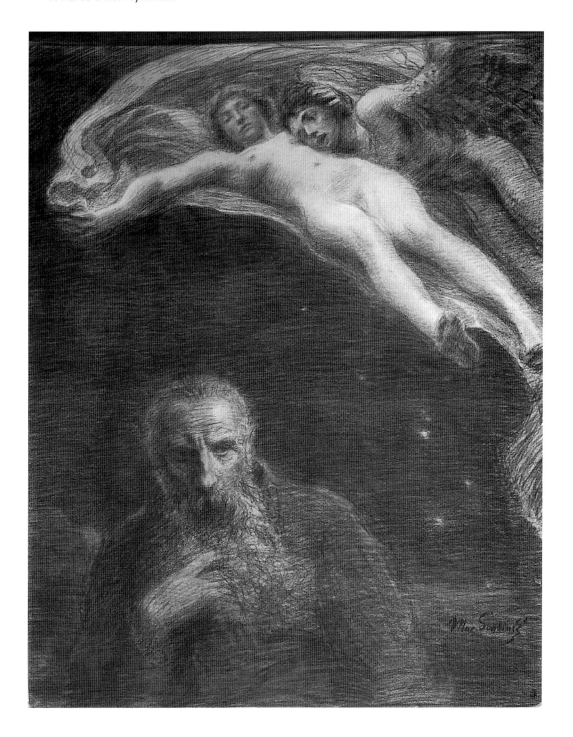

73
Maxmilián Švabinský, **The inspiration of Rodin**, 1901, Národní galerie v Praze, Prague

assault on or even the destruction of a series of accepted cultural and aesthetic norms, certainly in artists' circles but also to a certain extent among the public at large.

One extraordinary section of the Rodin exhibition was his drawings and studies for sculptures which depicted the intimate details of the human body and sexuality with an unprecedented openness. Nothing like this had been seen before in Prague. Artists in particular were fascinated by the freedom that Rodin conveyed in such an inspiring fashion. Czech artists regarded Rodin as a high

priest, a genius who had breathed new life into the art of sculpture – 'a dead, fossilised language from ancient times, once powerful but now extinct' – and who 'had caused the artistic mother tongue of the age, its blazing unconventional and pristine forms of expression, the conduit of the spiritual currents of the times, to resound', as Šalda wrote in his introductory essay for the exhibition.[9] The show was held in Mánes's new exhibition pavilion, designed by Kotěra, and was the most successful of all the activities undertaken by the association before the First World War.

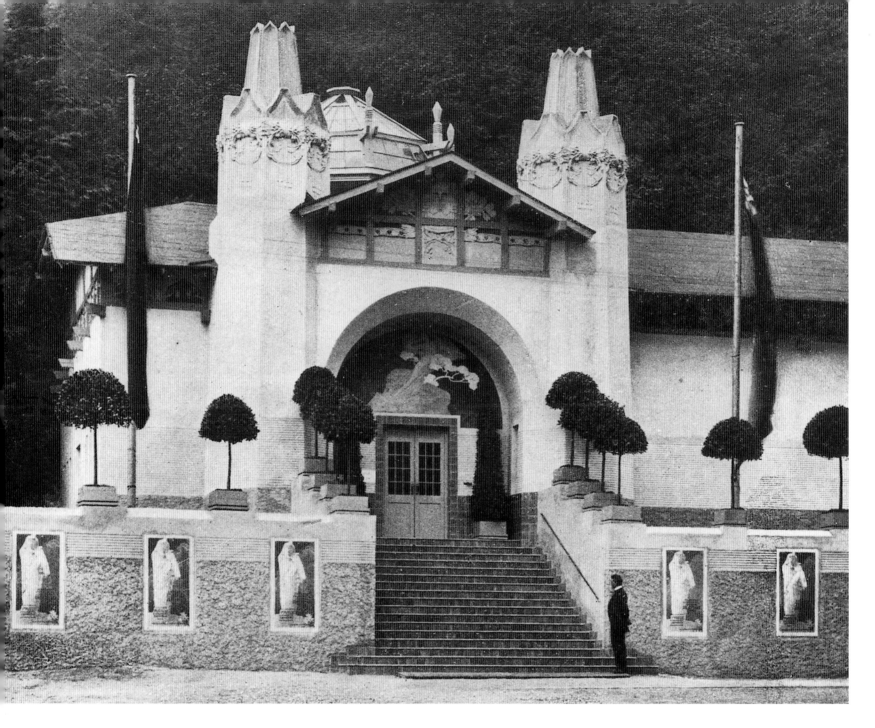

74
Jan Kotěra, **The Mánes Pavilion in Prague**, 1902

Rodin was the first genuinely powerful figure in modern art to have an impact on Czech cultural circles and his work was seen as a prototype of artistic creativity. It was regarded as the fulfilment of the fundamental unity of biological, psychological and philosophical aspects, realised in such artistic means as material, line, volume, light and space. Artists shifted the focus of their attention from the copying of human forms to their psychophysical situations and processes, with their own rhythm and dynamics. This was why Rodin was often compared with a cosmic natural force, as expressed for instance in the decorative work around the figure of Balzac in Vladimír Županský's exhibition poster (see fig. 74).

That the Czechs greeted him with such enthusiasm can in part be accounted for by the exuberant native

Baroque style that continued to influence their cultural tradition. This explains why Czech sculptors were able to spontaneously come up with powerful emotional qualities, often attaining a high degree of pathos. In the 1890s František Bílek had already done much work in this area, but under Rodin's influence a more general liberation occurred. It even had an impact on the world of official monumental art: the great statues in Prague of František Palacký by Stanislav Sucharda (fig. 10) and Jan Hus by Ladislav Šaloun (fig. 11) are unthinkable without Rodin's *Gate of hell* and his *Burghers of Calais*.

Naturally Czech sculptors did not aim simply to copy Rodin's work, but to empathise genuinely with the new dramatic dimension they saw in his art. This is why the small works by young sculptors who had only recently

75
Auguste Rodin with a group of Czech artists during his exhibition in Prague, 1902 (Rodin seated left, with Alfons Mucha standing next to him)

passed through the classical studio of Myslbek also displayed the same ardent quality. Josef Mařatka succumbed directly to Rodin's influence when he made his unique fragments of hands, feet and torsos, all of them characterised by an unabashed sensuality. His bust of Antonín Dvořák (fig. 21) takes the process a stage further than the heads of the *Burghers of Calais* and draws inspiration from a typical theme in French Symbolism, that of the 'inward gaze': with closed eyes and such an intensity of expression that the border between life and death seems to dissolve. Quido Kocián used sculpture in this way to purge himself of his tendency to depression, which he saw as symptomatic of the crisis of the modern individual in his conflict with the world. The skilful modeller Bohumil Kafka, initiated by Sucharda in the secrets of making reliefs and plaques, concentrated entirely on Symbolist themes during his years in Paris, stressing their psychological impact. In his *Woman sleepwalking* (1906, fig. 76) he gave supreme voice to that strange domain of psychic angst hidden at the time behind ornamental stylisation or sensual rapture.

Much of this passion was attributed later to the influence of the work of Schopenhauer and Nietzsche,[10] but something more fundamental also smouldered beneath the surface of the melancholic syndrome of the 1890s and burst into flames on coming into contact with Rodin's ardent genius. Rodin was labelled by Šalda as an artist with the power to create artistic symbols out of the mysterious depths of his own soul and the inner, hidden tragic sense of life. According to him the source of this art was a fundamental chaos in psyche and nature that only found its form in the process of creation. Šalda

raised the issue then of the relation between culture and nature, a question that would later play a significant role with the younger generation of artists as well.

In the Autumn of 1902 yet another important exhibition was held in Prague, again organised by Mánes and devoted to contemporary French painting. This was a retrospective show of the Nabis group (the word is Hebrew for 'prophets') with whose work Czech artists had become acquainted in the 1890s. Besides the Nabis, Impressionist painters were also represented, though with only a few works. A debate started around the whole question of Impressionism. A problem thus arose that was typical of Central European artists in general, namely that they were hardly in a position to come to any agreement on the real premises of modernism. At the opening of the Autumn exhibition of French art Šalda proposed that, 'French art forms a flowing line, by comparison in art elsewhere there is only a series of disparate points with space in between.'[11] The decisive difference according to him was between art that was the product of a deliberate creative experiment and that which depended on pure improvisation.

Lyrical Impressionism

The sensuality of these mood landscapes brought about a shift in Czech art from traditional themes and schemes to an art that was increasingly ready to express spontaneous feelings. In the paintings of Slavíček, the leading figure in Czech landscape art in the first decade of the twentieth century, the space of traditional perspective yielded completely to a spontaneous, almost physical involvement of the artist and/or viewer in the atmosphere that unfolds in the landscape. It was not a matter of passive reflection, but of active participation, of identifying with the theme. Slavíček therefore not only painted in the famous village of Kameničky, but also in his native Prague. His small panels, which he made outdoors, and his larger, panoramic paintings (made on commission in 1908) are among his most important works.

A crucial element in Slavíček's work was continuous painting, a permanent act of responding to the world from one's own viewpoint, making for a close relationship between artist and surroundings. Slavíček operated on the frontiers of Impressionism, especially when he painted more monumental themes, such as the historical buildings of Prague.

These somewhat later paintings by Slavíček, introduced with the label of 'Impressionism', differed from

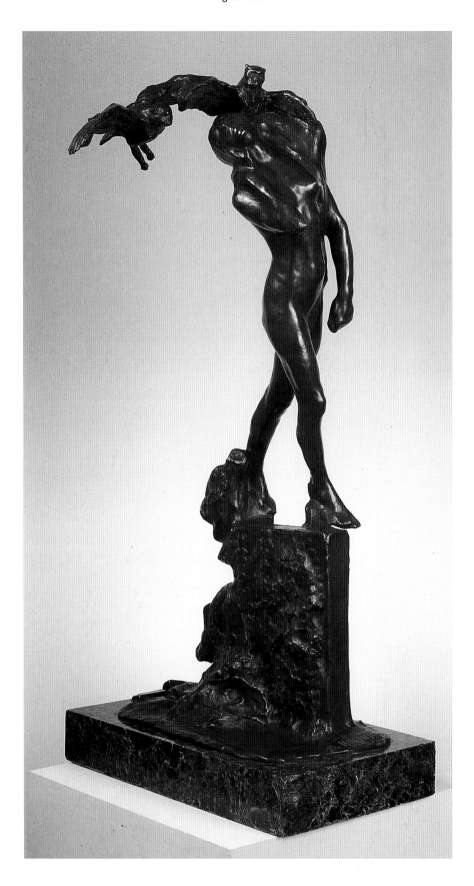

76
Bohumil Kafka, **Woman sleepwalking**, Národní galerie v Praze, Prague

the mood landscapes of the 1890s in the direct and spontaneous manner with which the painted surface is created. In this respect his comments on 'colour spots' and ornament in his letters are worth noting. Despite his basic spontaneity then, he did share certain ground with the trend that emphasised form and gave primacy to the principles of readability and repetition. However, what was important to Slavíček was ornament that was not a human creation, but which could be traced back to universal nature.[12] The need to return to the primitive, original level of a simple uninhibited view of the world worked for him with the power of a purifying myth.

For a moment artists must have felt as though they had no choice but to imitate Slavíček, but there was a younger painter who proved capable of conducting an independent enquiry into the inspiration of nature. This was Jindřich Prucha, an artist who emerged in about 1910 and who was just as open as Slavíček to the extreme sensory exaltation induced by the landscape and to achieving a level of mystical ecstasy about the unity of man and the world. He endeavoured to capture this through the colourful brilliance of the world of nature. Prucha worked in that rarely attained borderland where the image inspired by its model in nature, is converted into an absolute and independent art work in the artist's psyche. Even so, Prucha never really crossed the threshold of abstraction, remaining within the confines of a colourful Expressionism.

In the field of figuration, Czech Impressionism was by no means as successful as it was in landscape painting, even though there were some talented painters. One of them was Ludvík Kuba who had joined the Ažbe school when in Munich. The most interesting figure, however, was the painter and theoretician Miloš Jiránek. Not only did he reject traditional allegories; he also made short shrift of the decorative work fashionable at the time. His committed naturalism took French models as points of reference. Jiránek was one of the leading advocates of 'pure painting'. He took his subjects from everyday life, so that his interiors, portraits or sporting themes have the character of an eye-witness account. Jiránek's Impressionism and his preference for bright colours was all part of his enthusiastic philosophy of life. This led him to a degree of self-sacrifice for modern Czech art. Without his personal commitment the high profile of *Volné směry* and all the other activities of the Mánes Association is hardly imaginable.

The special reception of Impressionism by the young Czech artists at the dawn of the twentieth century was

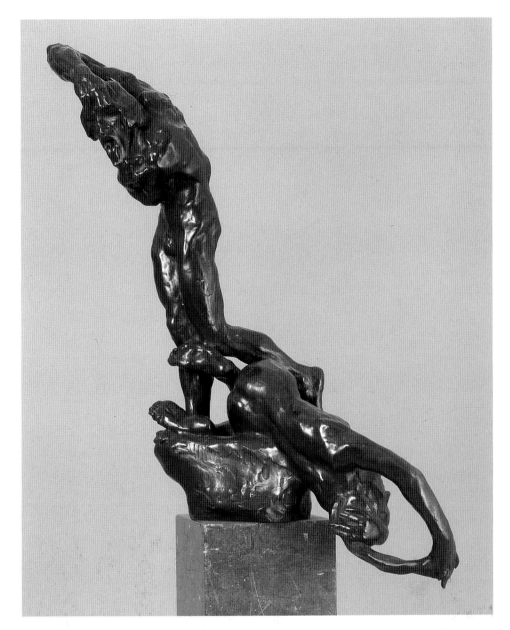

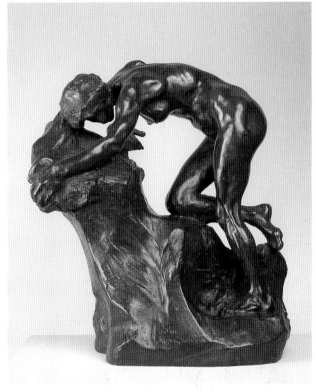

77
Bohumil Kafka, **Insanity**, 1905, Národní galerie v Praze, Prague

78
Josef Mařatka, **Ariadne abandoned**, 1903, Národní galerie v Praze, Prague

Ariadne abandoned

In 1900 the young Czech sculptor Mařatka gained a scholarship to study in Paris. There he became captivated by the work of Rodin, managed to gain access to the French master and worked for four years as an assistant in his studio. Mařatka assimilated Rodin's ideas with remarkable speed; his work is a free reflection of Rodin's dramatic approach. Mařatka gave new meaning to body fragments in his studies of hands and feet, while his group of female nudes, which includes *Ariadne abandoned*, echoes the symbolic character of Rodin's sculptures. With his *Portrait of the composer Antonín Dvořák* (see fig. 21) and other works, Mařatka also tried his hand at a new concept of the portrait, in response to both Rodin's *Burghers of Calais* and Bourdelle's series of 'Beethovens'.

Mařatka also played a leading role in arranging the Rodin exhibition in Prague, which would radically influence Czech sculpture at the beginning of the twentieth century.

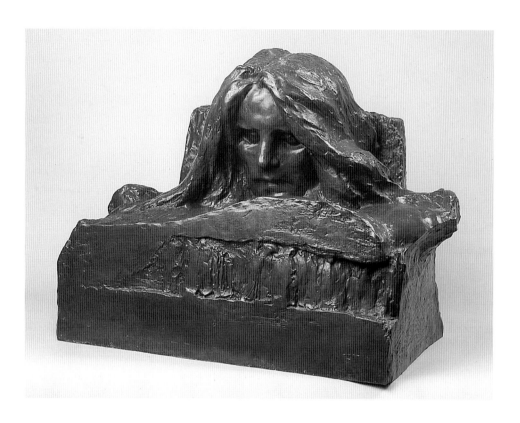

79
Stanislav Sucharda, **Study for a memorial sculpture**, 1909, Národní galerie v Praze, Prague

80
Bohumil Kafka, **Mummies**, 1904, Národní galerie v Praze, Prague

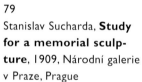

Study for a memorial sculpture

The artist Sucharda was a prominent figure in the Secession movement. For many years he was president of the Mánes Artists' Association and a professor at the Prague School of Applied Art. He was also a member of various cultural organisations; hence his involvement in projects to raise major monuments, such as the huge figure of nineteenth-century national historian and politician František Palacký (1898–1912) which was erected in Prague (fig. 10).

During work on this figure Sucharda, an admirer of Rodin, produced a series of remarkable preliminary studies. These models of details acquired an independent status such as this bronze, which refers to the Battle of the White Mountain near Prague in 1620, a tragic turning point in Czech history. The sculpture eventually decorated Sucharda's own grave. Sucharda also made a considerable number of plaquettes, a genre in which he achieved great mastery, largely due to his particular style of surface relief.

Mummies

Kafka studied monumental sculpture under Josef V. Myslbek and mastered Secession style under Stanislav Sucharda. Like most sculptors, he was wildly enthusiastic about the work of Auguste Rodin. During his years in Paris (1904-08) Kafka's sense of connection with Rodin became particularly evident, influencing both his form and choice of symbolist themes.

Kafka's wide-ranging interests also affected his approach to sculpture. His fascination for the ethnographic collections in the Trocadéro inspired this work entitled *Mummies*; his interest in the psychology of hysteria and the subconscious led him to create series such as *Woman sleepwalking* (fig. 76). During his time in Paris Kafka also included more popular themes in his work. His experiments in form were imbued with a unique expressiveness, derived from his Czech background where allusions to exuberant Baroque tradition were still strong.

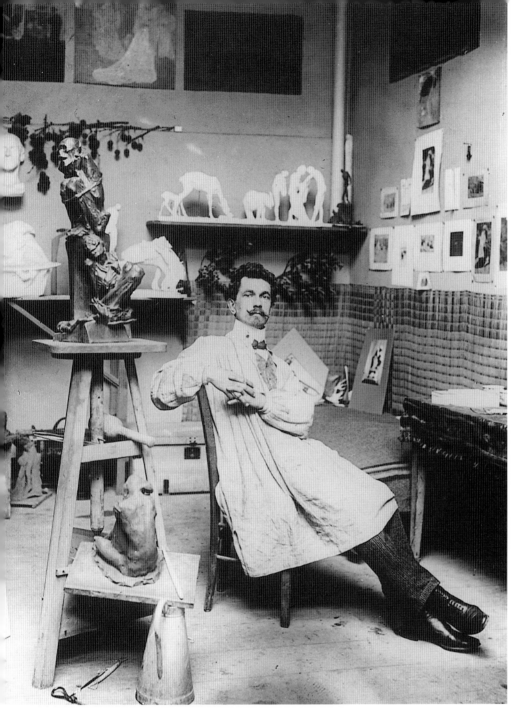

81
Bohumil Kafka in his Paris studio with the sculpture **Mummies** beside him, 1904

instruments in an orchestra. At the same time it also adds a mysterious depth and power to all this beauty, so that it becomes inward and transcendent. Mood swallows up reflection, intuition replaces logic. Instead of material, ponderous, dead knowledge one now obtains a fresh and profound understanding through impressions, feelings and enthusiasm. And so the mind is freed from the shackles of static thought processes and man's inward gaze is granted love and vitality so that he can contemplate all that is mysterious in an unrestrained fashion.'[13]

His admiration for lyrical Impressionism as the foundation of the modern artistic sensibility was a first step for Marten in the direction of a genuinely modern culture. According to him the artist should not simply capture or undergo moods and impressions, he should also allow his life to be dominated by the magic of image and word. The means for this are his own imagination and his capacity to create a personal style.

A new synthesis?

Around the turn of the twentieth century 'synthesis' was the key word that linked the advances of modern art with the spiritual domain. Running counter to the analytical spirit of the nineteenth century, the climax of which was the materialistically-inclined mentality of Positivism, Symbolism rose like a tidal wave. The call for a new synthesis also gave rise to the concept of Art Nouveau. But even in the first years of the twentieth century, the limits of a pan-aesthetic project like this were plain. The modern age rose in principled and total revolt against formulas for stylistic unity of this sort.

This did not mean that the idea of an all-embracing synthesis was yet exhausted. However, the foundations needed reviewing and its original meaning were in need of new vigour. 'Synthesis' went hand in hand with the health of modern man and this had been fatally disturbed by modern civilisation. It was for this reason that such a pronounced utopian and primitivist emphasis was put at the disposal of this idea. Art was regarded as one of the most important means of attaining it.

Šalda had written an essay at the beginning of the 1890s about 'syntheticism' in the new art.[14] According to him this lay mainly in the ability to express the inner relation between perception and essence in the 'concrete symbolism' of the art work. Ten years later Šalda, a man of letters, began to frequent artistic circles and this made him more aware of the problem of the form in which this relation might be expressed. The Czech artists' reliance on the model of French art was further reinforced by the

accompanied by a certain sensory gusto and openness towards the world. This bold sensuality was not only based on observation but above all on the emotional experience of visual reality. The originally analytical side of Impressionism yielded here to an emotional hankering for an elemental unity with the object depicted. That is why this form of art was given the name of 'lyrical Impressionism'. Its essence was well described by the Czech art critic, Miloš Marten – essayist and member of the board of *Moderní revue* – in summing up the results of this trend in 1906: 'a tuning and synthesis of all the elements of emotional life comprises the most authentic and enchanting aspect of lyrical Impressionism. It culminates in a sensory magic of impressions, with all its genres and gradations combining to form a musical unity, like

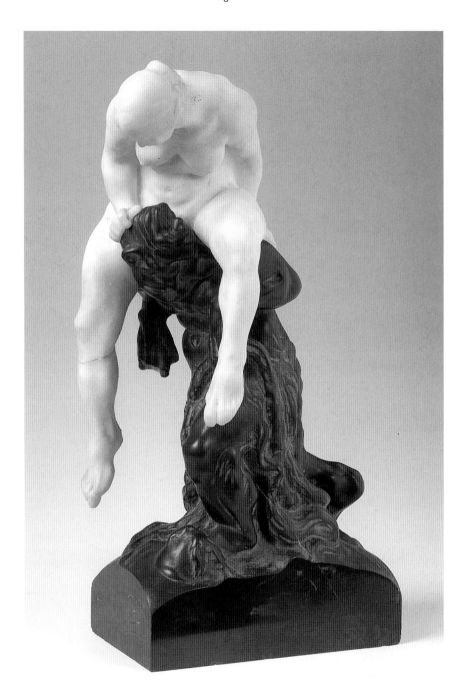

82
Ladislav Šaloun, **The Devil
and Kate**, 1917, Národní
galerie v Praze, Prague

The Devil and Kate

Although this sculpture is based on a theme from the opera of the same name by Antonín Dvořák from 1899, it was only completed during the First World War. Like many other Czech sculptors Šaloun was greatly influenced by Rodin. This is particularly evident in his greatest piece of work, the famous Jan Hus figure group (1900–1915) on Old Town Square in Prague (fig. 11).

In his smaller pieces of sculpture Šaloun heightened the sensual and erotic aspects of what was essentially symbolist work. He based himself on fairly divergent theories, in particular Nietzsche's doctrine of the Dionysian foundation in the artist's attitude to the world, and other, spiritualist ideas characteristic of the *fin de siècle*.

Šaloun was also one of the most prolific decorative sculptors at the beginning of the twentieth century: he produced many monumental works for a range of new public buildings in Prague. These sculptures betray the influence of Czech baroque tradition, as can be seen in the Municipal House (Obecní dům) on Republic Square, the City Hall's New Building and the Central Station.

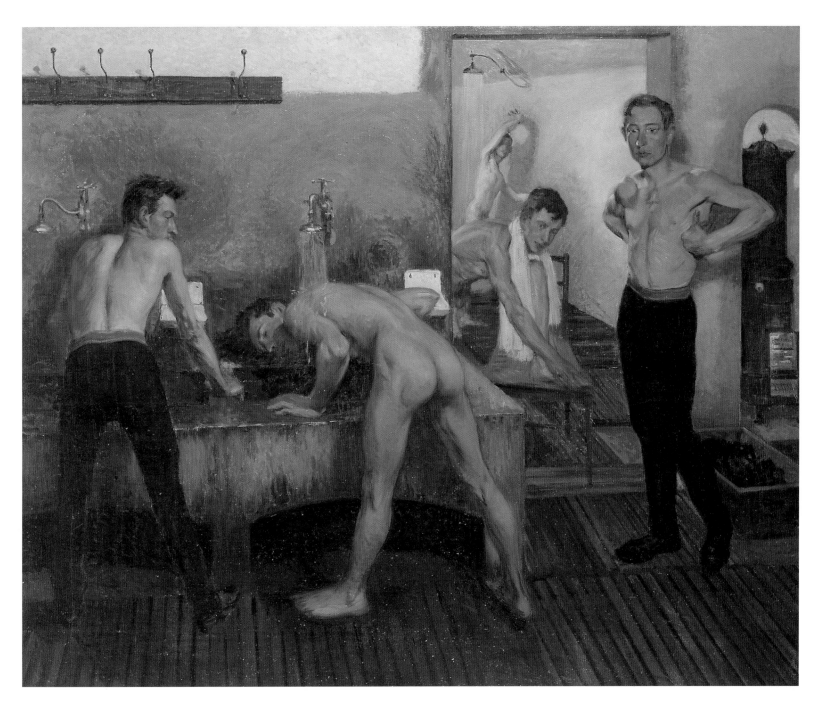

83
Miloš Jiránek, **Showers in the gymnasium of the Prague Sokol Gymnastic Association**, 1901-03, Národní galerie v Praze, Prague

enthusiastic reception of the writings of the German Francophile Julius Meier-Graefe and his 'doctrine of unities'.[15] His concepts about the need for a new synthesis between line and colour provided theoretical grounds for Czech artists to take the step to Post-Impressionism. The leading figure in this field was Paul Gauguin.

This crucial theoretical step towards the foundation of modernism went hand-in-hand with the creative activities of a number of painters, the most prominent being Jan Preisler. In 1902 he and Antonín Hudeček travelled to Italy where he acquired a new theme, which he developed in a series of paintings, *The black lake* (1904, figs. 90, 92). He became fascinated by the dark, silent surface of a

deep body of water surrounded by figures. In remarkable pastel and oil sketches he converted various moods derived from 'unfaithfulness and gloom' into figures both real and idealised.

In the scene in the painting that finally emerged the figure of a naked, youthful poet is related to the image of a white horse and a tree of life. It was in this series that Preisler succeeded in creating a striking unity between the visual aspect and the content. The structure of the relations is indicated by an alternating use of black and white – respectively the positive and the negative, although they are semantically ambivalent here. The almost unfathomable black lake is traditionally associated

84
Miloš Jiránek, **Study in white I**, 1910, Regional Museum, Liberec

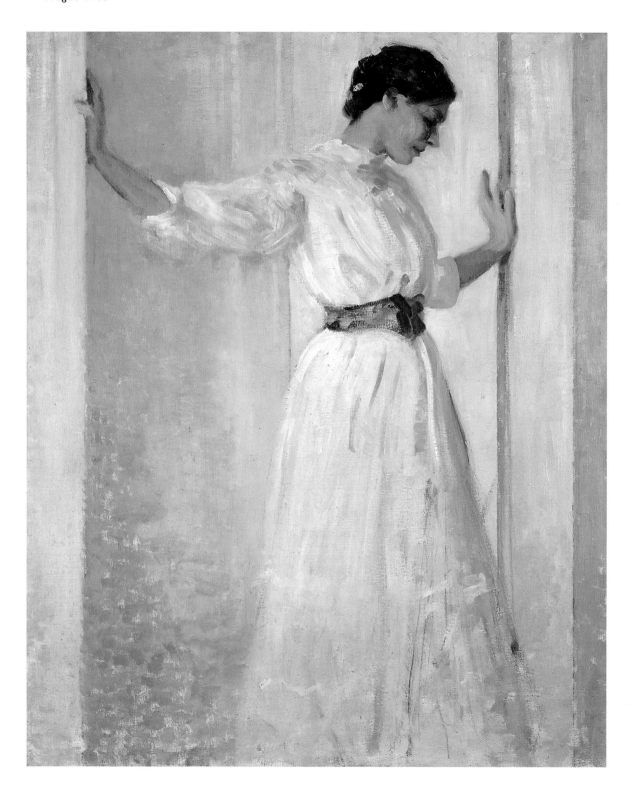

85
Karel Špillar, **In a café**, 1904, Národní galerie v Praze, Prague

Study in white I

Jiránek was a fervent adherent of Impressionism from his student years when he transferred from Pirner to Hynais at the Prague Academy of Fine Art. Inspired by Ruskin he believed that the only form of truth in art lay in an extreme sensualism, an opinion which he propagated with gusto as a major art critic and organizer of the Mánes Artists' Association.

Jiránek's studies in white, a series which he created between 1908 and 1910, are the high point of his oeuvre. He combined a free use of colour with sympathy for the unique value of every facet of reality. In his collection of essays entitled *Impressions and peregrinations* (1908) Jiránek also displayed a great gift for seeing life as a whole in a single small detail.

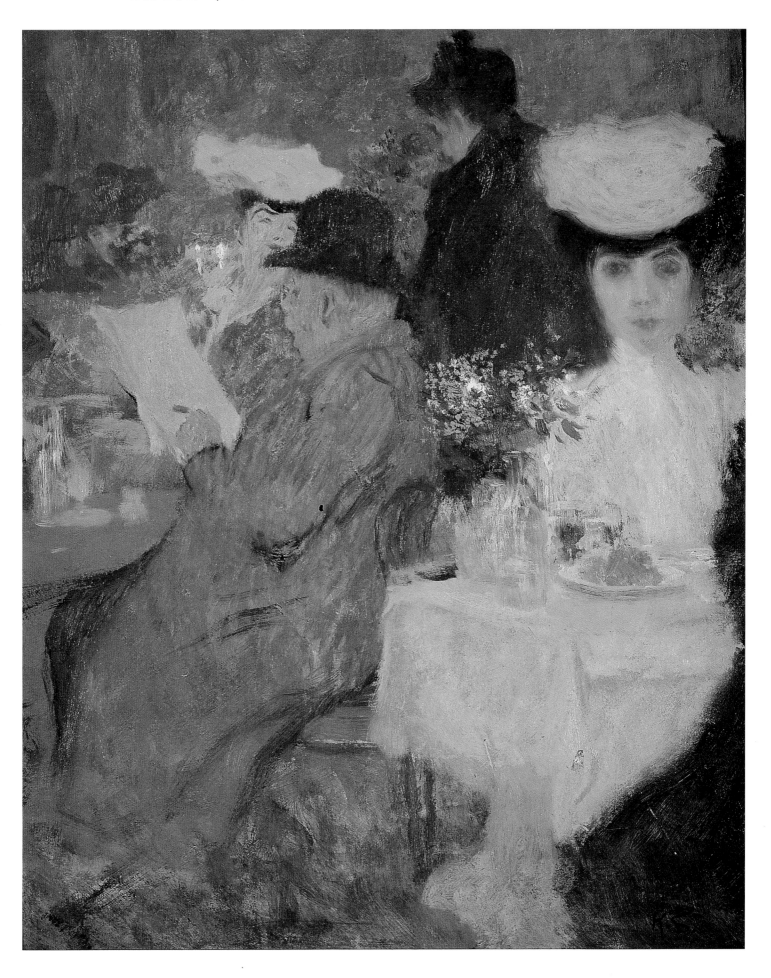

86
Otakar Nejedlý, **Snow on
the ice rink**, 1907,
Národní galerie v Praze,
Prague

87
Antonín Slavíček, **Country road in Kameničky**, 1903, West Bohemian Gallery, Pilsen

Country road in Kameničky

Slavíček is the most famous Czech landscape painter from the period around 1900. He started his career in Mařák's class with melancholy works (*Autumn dawn*, fig. 58). The paintings he produced between 1900 and 1910 are marked by a much greater sympathy for life, whose roots lay in Slavíček's empathic bond with the natural world in his native region.

In the years 1903–1906 Slavíček painted a whole series of works during his summer holidays in Kameničky, on the Czech-Moravian Plateau. There he also attempted to found a painters' colony, partially modelled on Worpswede in Germany. Slavíček may be considered an Impressionist painter. He had a highly emotional relationship with his themes, as can be seen from his correspondence. Much of his most important work is based on subjects from Prague where Slavíček produced both remarkable plein-air sketches and large thematic paintings (*Prague seen from the bank of the Letná*, 1908, Národní galerie v Praze, Prague). After suffering a stroke in 1910 Slavíček committed suicide.

Young man by a lake

'The black lake' is one of the most important themes in Preisler's work; it also occupies a special place in the development of Czech modern painting. Preisler became fascinated by the south on a journey to Italy in 1902, in the company of the painter Hudeček. He assimilated this 'exotic' experience in his own unique manner.

The study entitled *Young man by a lake* confronts a figure, seated under the symbolic tree of life, with a dark and mysterious body of water. Although Preisler employed a standing figure with a white horse (life) in later versions, the black surface of the lake remains highly suggestive. The work also demonstrates a successful balance between expressive technique and Symbolist theme. In such apparently colourless paintings Preisler achieved a perfect synthesis of form and content.

'The black lake' series of works (figs. 90, 92) represents a turning point in Czech painting as artists adopted the modernist objectives set out by progressive art critics (Meier-Graefe). It was no accident that Preisler's *Black lake* was reproduced in vignette form alongside the Czech translation of Whistler's essay 'Ten o'clock' in the journal *Volné směry* (Free directions).

88
Jindřich Prucha, **In a beech wood**, 1911-12, Národní galerie v Praze, Prague

89
Jan Preisler, **Young man by a lake**, 1903-04, West Bohemian Gallery, Pilsen

In a beech wood

Prucha's work concludes a phase of development in Czech landscape art that had evolved from Impressionism. The 1905 Munch exhibition held in Prague was a major influence on the formation of his ideas; this exhibition also covered the issues of Fauvism and Expressionism. Prucha sought to associate himself with Slavíček and consummated Czech lyrical Impressionism with his superb feeling for colour. Theoretically speaking, he worked on the fringes of Expressionism, while retaining a certain empirical approach to subject. Prucha originally studied philology and wrote a small book of essays on the nature of Czech art tradition. He died at the beginning of the First World War, when he was not quite 28 years old.

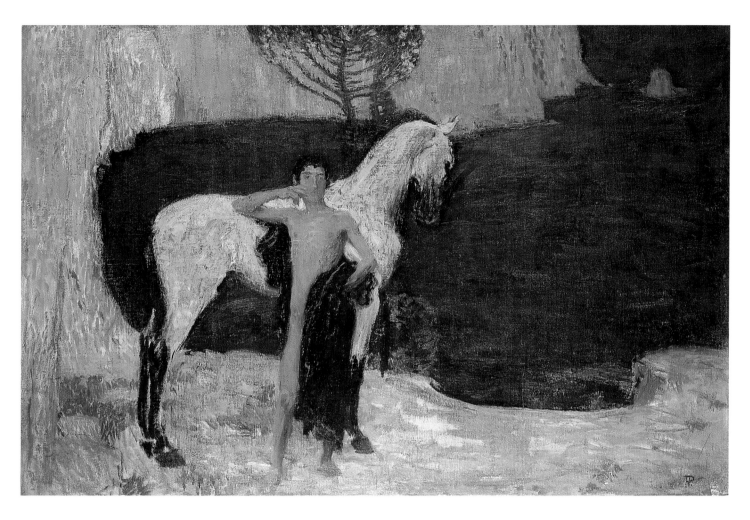

90
Jan Preisler, **The black lake**, President's Chancellery, Prague

with the realm of death, but the surface is as smooth as a mirror, offering a possibility for self-reflection and spiritual uplifting. The horse is a demonic symbol of profound longings and instincts, but its whiteness means it is also sacred and can therefore be associated with divinatory powers and intuitive knowledge. Finally there is the man, a poet in the prime of life, at the genuine centre of the macrocosm of natural forces and of the composition.

The corrective context in which the figure of the young poet is situated in Preisler's paintings is not there by chance. In the ninth series of *Volné směry* (1904/1905) an article was published by Camille Mauclair about classicism and academicism, in which he labelled the classical era as exemplary for modern art.[16] A reveille of cultural optimism was now sounded against the pessimism and melancholy so ubiquitous in the 1890s.

In the field of theory the new strategy emerged as a renewed appeal for style. The art critic Miloš Marten, who had given such an illuminating account of the roots of lyrical Impressionism, was resolute in his dismissal of the superficial observation and passivity of this trend. He called for new work with an artistic vision that would convert theme into form and 'would change the vague

and mixed material of ideas and impressions into a unified and harmonious spiritual image'.[17] Meanwhile, in his review of the major exhibition of French art in Prague held in 1907, Šalda made this appeal: 'This ambitious and brilliant goal – the creation of a new decorative art, an art of great, systematic beauty and purity, looms ever more distinct on the horizon of contemporary painting: all roads lead in that direction!'[18]

Towards the end of the first decade almost the entire generation that had emerged in the 1890s was trying to attain this cultural Utopia. Preisler, who had previously collaborated with architects, was now endeavouring to lay the basis for a new mural painting, working mainly for Kotěra's buildings. His programmatic optimism was expressed amongst other things in a dominant combination of yellow and green (fig. 91). The changing of the guard among the sculptors who had contributed towards the new *Gesamtkunstwerk* was also indicative. Sucharda, the Impressionist and follower of Rodin, was replaced by Jan Štursa, one of the first to respond to Marten's call for a new style. He was also influenced artistically by the message of Bourdelle who had had an exhibition in Prague and had rejected Rodin's tragic style in a lecture.

95

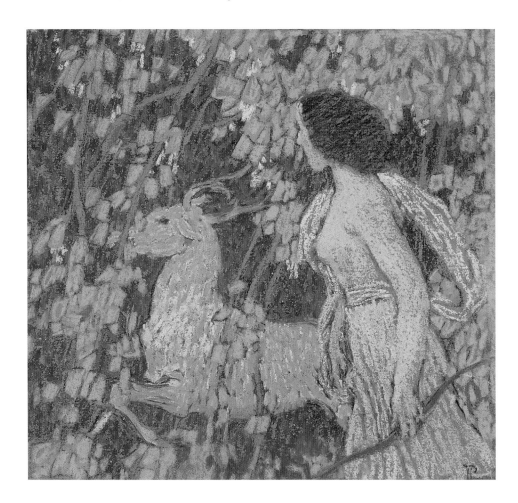

Diana hunting

This pastel comes from a later period in Preisler's career, when yellow-green emerged as the dominant colour in his palette. The artist's previous melancholy work was replaced by a poetic vision in which he endeavoured to recreate the utopia of paradise lost through ancient mythological themes.

Preisler drew on the experience he had acquired working on decorative commissions gained in collaboration with leading architects such as Jan Kotěra and Osvald Polívka. He also did his best to satisfy the criteria laid down by art critics, such as the synthesism demanded by František Xaver Šalda. Preisler chiefly modelled himself on French painters such as Puvis de Chavannes and Paul Gauguin. Inspired by the vision of Paul Cézanne he would later focus on the theme of bathers, (fig. 96).

91
Jan Preisler, **Diana hunting**, 1908, Art Gallery, Litoměřice

92
Jan Preisler, **The black lake**, 1904, Národní galerie v Praze, Prague

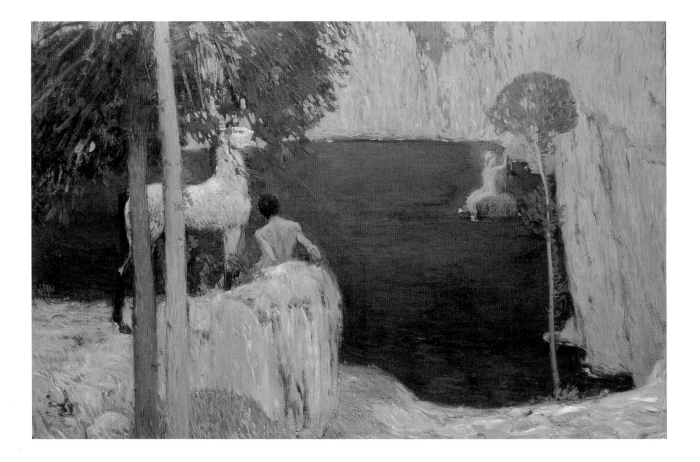

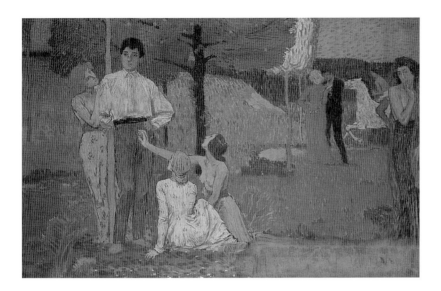 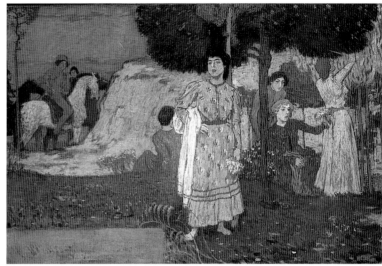

93
Jan Preisler, **Seduction I**,
1907, West Bohemian
Gallery, Pilsen

94
Jan Preisler, **Seduction II**,
1907, Museum of Art,
Olomouc

95
Antonín Hudeček, **Wood**,
1911, Národní galerie v
Praze, Prague

96
Jan Preisler, **Bathers**, 1912,
West Bohemian Gallery,
Pilsen

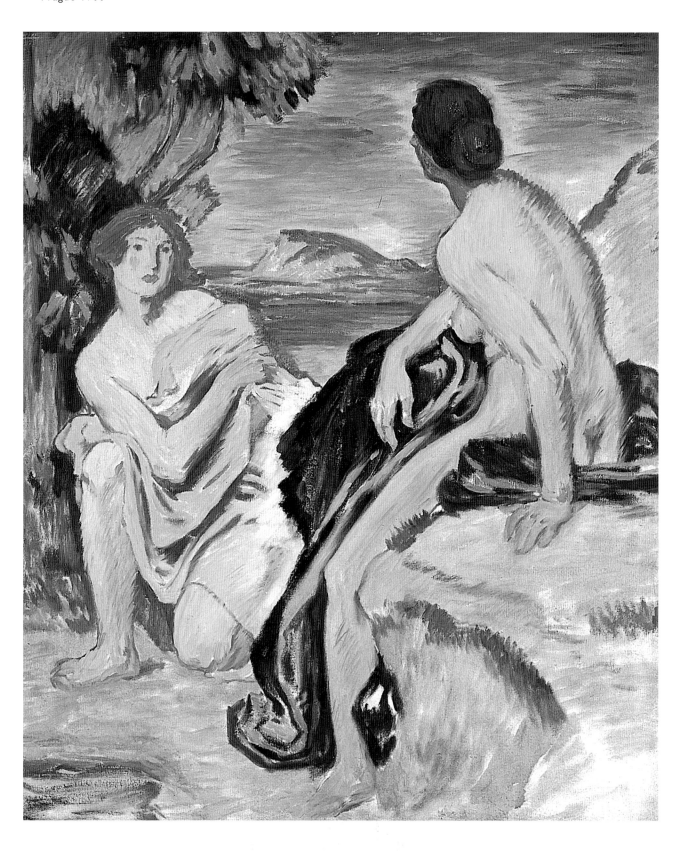

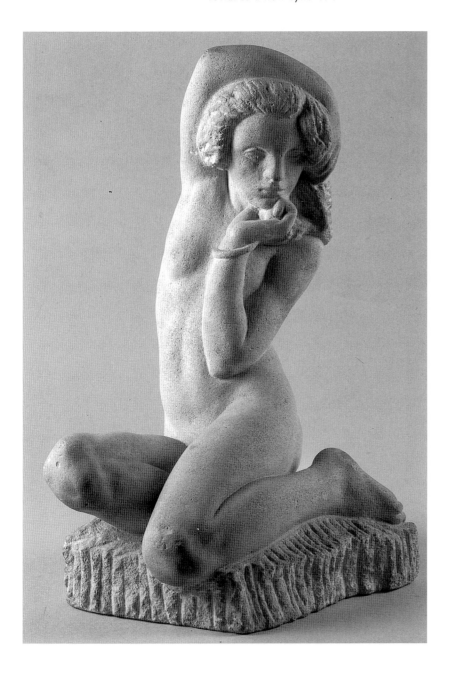

97
Jan Štursa, **Melancholy girl**, 1906, Národní galerie v Praze, Prague

Melancholy girl

Štursa was originally a stonemason. He became a prominent member of the 'Taille directe' movement, although he did not adopt all their ideas unquestioningly. His oeuvre comprises many small sculptures that manage to convey a powerful aura of inner feelings. These include various versions of *Melancholy girl*, which were soon regarded as a symbol for the poetic melancholy of the rising generation at the beginning of the twentieth century.

Moreover, this work represents an important moment in the development of Czech art: artists heeded influential art critics such as Šalda and Miloš Marten and began to turn away from the prevailing trend of lyrical Impressionism, searching for a more substantial style. In his subsequent sculptures Štursa also emphasized this tendency, which was further reinforced by the Prague exhibition of work by the French sculptor Bourdelle in 1909. Štursa sought a new, stricter structure for sculpture which would develop into a distinctive form of 'modern classicism'.

Bourdelle also thought it was right that sculpture should be completely subordinate to architecture.

It was in this connection that the term 'new classicism' began to be used, a concept that in itself might mean a number of different things. The example of the recently rediscovered Paul Cézanne served as a model for a lively balance between nature and style. However, Marten began to publicise the later work of Emile Bernard, who was a particular admirer of that tradition. This brought him into conflict with the younger generation of Czech artists that emerged after the memorable exhibition of Edvard Munch held in 1905 by the Mánes Association.

The art inspired by the idea of a new classical style, which had such a strong influence on Kotěra, Preisler, Štursa and many of their contemporaries represented a

sort of new *juste milieu* in around 1910; its typical feature was a refined decorative style, closely related to the character of Czech society which had gained in maturity and had by now acquired the background to cultivate modernity. However, it is interesting that the new style did not please everyone, as one can read in a letter from Preisler to Sucharda in which he complains that his generation has attained so few of the youthful aspirations 'that once used to set our minds ablaze'.[19]

The real heritage of this generation would seem then to be Preisler's *Spring* (fig. 68) and *Melancholy girl* by Štursa (fig. 97), works in which the youthful aspirations of the artists for self-realization and personal identity had begun to take on a definite stylistic form without any loss of original poetic and philosophical power.

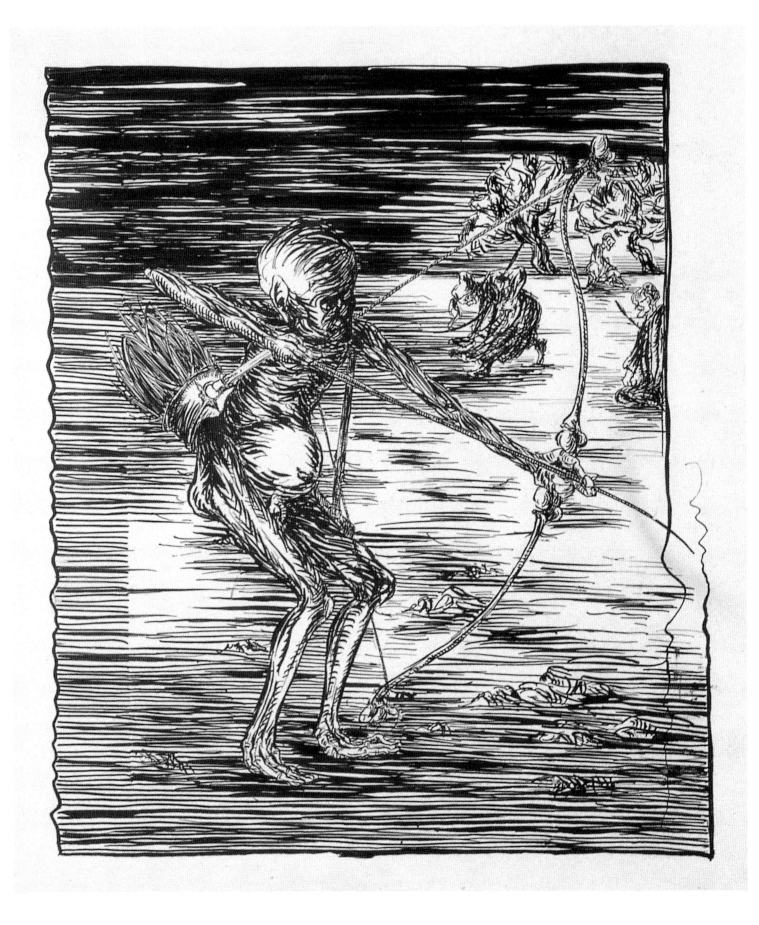

Illustration as harmony

Iva Janáková

'I illustrate a book that is cursed, ridiculed, not understood; a sad book. It's already still, still... Passionate hands have just been playing wild, half-crazy arias on the piano; these passionate hands are now hanging down, slack. It's already still, still. And now they continue to play a sexual impromptu, only in the dark. It sounds smothered, sombre... My drawings are intended to suggest this fundamental sentiment.'

98
Karel Hlaváček, **Title page design for 'The brothel of the soul' collection of poems by Arnošt Prochazka**, 1897, National Literary Museum, Prague

These are Karel Hlaváček's introductory words to the cycle of drawings and graphic art he produced to illustrate the 1897 anthology by his friend Arnošt Procházka, *Prostibolo duše* (Brothel of the soul) (fig. 98). Although Hlaváček often felt himself to be alone in his endeavours, towards the end of the 1890s several more voices were to be heard, such as those of Viktor Oliva and Zdenka Braunerová, who regarded musicality as the most elevated means to illustratively accompany literary works. The concept of musicality surfaces in the work of František Xaver Šalda and Otokar Březina as the element capable of raising the synthesising unity of life and art to a higher, transcendental level.

The understanding of illustration as the focal point of discussions about the new concept of synthesis in literature and art fits within this context. In turn, musicality was linked to other ideas such as suggestion (Šalda, Hlaváček) and resonance (Miloš Marten), which also have a psychological import. The liberation of the intuitive powers that penetrate the mysterious space behind word and image had to be created by the synthesis of artistic impressions that generated reading and seeing. Therefore, the striving towards musicalisation and hence also the spiritualisation of illustration was not an isolated problem of form but, in relation to reality, had to guarantee a more powerful and authentic experience of the feeling of being alive.

The idea of the non-descriptive illustration had its precursor in Mikoláš Aleš and his 1884 renderings of Old Czech Manuscripts (fig. 33). Three years earlier he had produced the triptych *Poetry-Painting-Music* and accompanied this with quotations from Karel Hynek Mácha's romantic poetic work *May* (fig. 13). Now he expressed the musicality in the dramatic, pulsating rhythm of the highly imaginative floral ornament. The critics received Aleš's illustrations badly; the prevalent way of illustrating was based on action and narrative, with illustrators often using the methods of painter-caricaturists such as Luděk Marold, Viktor Oliva and Adolf Liebscher, or the Neo-Romantic allegory. Here, illustrators such as Maxmilián Pirner, Emil Holárek and Felix Jenewein depicted the literary theme in a figurative scene personifying a particular intrinsic conflict. Since this way of working was accessible

99
Mikoláš Aleš, **Cover for Aleš monograph**, 1896, National Literary Museum, Prague

100
Vojtěch Preissig, **Illustrations, typeface, design and binding for Petr Bezruč's collection of poems 'Silesian Lieder**, 1909, Uměleckoprůmyslové museum v Praze, Prague

Cover for Aleš monograph

After Josef Mánes, Aleš became known as the legendary example of modern, original art, even though he was not recognised by the official authorities. His position was due to two conflicts in the mid 1880s when his participation in the decoration of the national Museum formed part of the public discussion. The commission concerned had approved several of Aleš' original designs but never allowed him to carry them out. The second conflict was about the head-on attack by an influential journalist on Aleš' illustrations for the so-called Old Czech Manuscripts as being childish scribble. Attempts to produce an illustrated version of these manuscripts, particularly after Mánes, are an important part of the initial phase in the development of the modern Czech book.

After completing his studies, Aleš made a name for himself as a spontaneous artist and was to become one of the most popular illustrators, for example of Czech folk songs and children's books, and as a decorative artist making painted ornaments for architecture. As some of the drafts for the manuscripts show, he was more than simply knowledgeable about the heraldry and blazonry of the Middle Ages and the Renaissance. Although his compositions were seldom asymmetrical, they already encompassed what were later to become features of the Secession style. This was particularly evident in the spatial arrangement of ornament, in the dynamic relation between figure and background, and in the imaginative blend of elements from folk art.

Illustrations, typeface, design and binding for Petr Bezruč's collection of poems 'Silesian Lieder'

The *Silesian Lieder* collection is one of the finest examples of modern Czech book production. From around 1890 many artists already knew the phenomenon of the book as a *Gesamtkunstwerk* but, as an excellent designer, Preissig was the only one of his generation with the craft background needed actually to create it. Specially for this book he applied an English typeface with an expressive form so that it would harmonise with his woodcut illustrations.

For Preissig the *Silesian Lieder* concluded the period of Secession art. Bezruč's unambiguous and moving poetry, which is a social and human protest on behalf of the Silesians as a repressed ethnic group, directed Preissig's expression towards realism and simplicity. Here, the Symbolist motifs already anticipate expressive tendencies in Preissig's later experiments with abstract forms. In the initials, which reveal his profound interest in Japanese graphics, he develops variants of the leaf-and-thorn motif that are linked with Bezruč's poetry and create a certain rhythm for the book composition as a whole. The book is finished in a rigid, de-luxe grey-leather binding. With this edition Preissig was introducing to Czech book art a new type of book: Anglo-Saxon, perfectly produced and sumptuous without being garish.

to the broader public, publishers gave it priority and artists using new illustration methods had to resort to magazines. These also offered a space for artists with a dual talent – artists with literary aspirations and writers with artistic ambitions. It is precisely here that we see the strongest desire for the rejuvenation of the illustration genre: Hlaváček and Stanislav Kostka Neumann (*Moderní revue* – Modern review), Jan Preisler (*Volné směry* – Free directions), František Bílek (*Nový život* – New life) František Gellner (*Nový kult* – New cult) and, later, Josef Váchal (*Meditace* – Meditation). Neither was this an isolated, purely Czech development: in the 1890s many European poets gave their anthologies unique designs or illustrated them to enhance their authenticity – for instance Max Elskamp, Stéphane Mallarmé and Alfred Jarry.

In Bohemia the literature of the 1880s and '90s played an important part in releasing the imagination that lies in the deeper layers of the psyche, and introduced a new scale of sensory impulses. Decadent poetry was also characterised as music and nuance, including the work of Julius Zeyer and Otokar Březina, who influenced not only their contemporaries but also a number of early twentieth-century artists. Zeyer inspired with his 'sensually experienced spiritual imagery' , with the enigmatic world of Eastern myth and Christian mysticism.[2] Elements in his work include an oversensitive hero in a dreamlike landscape as well as cosmic scenes. Březina's eruptive, symbolic images create a majestic synthesis of the individual and humanity in general, of the sensual with the spiritual, the metaphysical and the religious. The inherent, poetic values themselves invite, as it were, further independent development. 'Tout reste à faire – tout reste à refaire – all awaits the moment when it is again to be felt, cast, written or painted. Nothing has been said definitively, nothing is finished.'[3]

In the late 1890s three artists whose work had a strong literary inspiration produced pioneering work for modern, twentieth-century illustration. First and foremost Karel Hlaváček, who was greatly influenced by Félicien Rops' *Les Diaboliques* with its inner psychic visions, its obsessive and traumatic images and dream scenes. Hlaváček's illustrative oeuvre for his own texts and those by decadent friends from the circle around *Moderní revue* was heavily influenced by the second-generation Symbolists such as Jan Konůpek and František Kobliha with their illustration cycles. There was also Jan Preisler, particularly with his illustrations for the poetry of Březina, Zeyer, Neruda and Opolský in which he transformed the Neo-Romantic allegory into a self-stylisation

Vampire

Kobliha belongs to the second wave of **Symbolism**, first as a member of the **Sursum** artists' group and later as a central artist in the **Moderní revue** group. Like Sursum's other members he refers to **Symbolism** and **Decadence** in Europe around the turn of the century. His work is strongly inspired by literature, at first primarily by the work of **Karel Hlaváček**. Kobliha illustrated two of Hlaváček's collections, *Towards morning* (1896) and *Vindictive cantilena* (1898) with several woodcuts. Hlaváček also inspired Kobliha with his conception of the illustration as a free cycle of fantastical images.

Kobliha removes the original heaviness from the images in Hlaváček's work, giving them a more dreamlike and introspective expression. The woman as vampire should not be interpreted as a *femme fatale*; in Kobliha she is a symbol of the cosmic mystery and human existence. He works this image into his black-and-white woodcut — the medium he felt most comfortable with — in masterly fashion. The fine range of black-and-white tones lend even greater emphasis to the introspective and subtle character of his illustrations.

102
Hanuš Schwaiger, **Design for a cover for Wiesner's book of fairy tales**, 1885,
private collection (on loan to the Národní galerie v Praze, Prague)

103
Alfons Mucha, **Illustrations for 'Le Pater'**, 1899,
Uměleckoprůmyslové museum v Praze, Prague

of the artist as a literary hero. This profiling has a sophisticated psychological and highly sensitive character related only loosely to the literary model. Preisler's lyrical, imaginative illustration was to become of lasting value to Czech twentieth-century painting (Josef Šíma, Toyen and others).

František Bílek, regarded as the third in this group of artists, had the strongest and lengthiest link with literary Symbolism. He interpreted the literary model from his own philosophical position – which was determined by the hermeneutic writings of the time – from his own visionary insight and on the basis of his subjective Biblical exegesis of the world. Bílek's artistic visions transformed the literary models of his good friends Zeyer and Březina into a metaphysical image idiom (fig. 106). His strong emphasis on spirituality gave him the idea of accompanying his work with brief, symbolic texts, which effectively turned it into an 'illustration' of his intellectual-religious conceptions. For him the images he took from literature and reinterpreted (the temple, the sphinx, the blind, high priests, prophets) were always to remain part of a greater philosophical concept that penetrated all areas of his work and therefore his own and other artists' illustrations.

Poetic and ecstatic aesthetics in word and image

In nineteenth-century Bohemia the illustration of belles-lettres occurred on a very small scale, with only a few large publishers such as A. Wiesner bringing out the occasional de luxe album in the second half of the century. Towards 1900, however, both specially and conventionally illustrated literary publications increased in number. These included, for instance, those produced by the publisher Jan Otto and the primarily French-oriented patron of the arts, František Topič. Important exhibitions of Czech and foreign artists, which included Walter Crane and Joseph Sattler, were held in Topič's salon (fig. 130).

Modern illustration became part of the movement throughout Europe that promoted the book as a work of art, the aim of which was to harmonise all components: illustration, ornament, typography, print, paper, binding, et cetera. In Bohemia this movement was initially oriented towards France. *Moderní revue* and the identically-named 'Library' (1894–1924), an edition in which primarily French Symbolist authors were published, was inspired mainly by the magazine *Mercure de France* and the associated series designed by Rémy de Gourmont. A system of numbered, bibliophile editions was achieved in practice

Alfons Mucha, **Design for
the journal 'Lumír'**,
1898, Národní galerie v
Praze, Prague

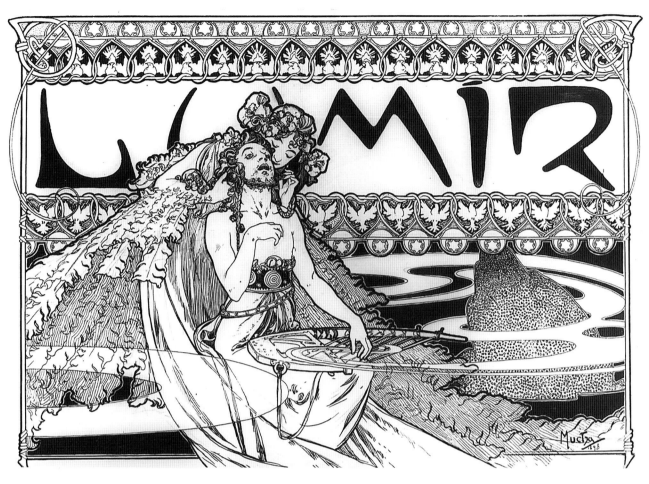

for the first time. But ultimately it was English book culture, with Morris' printwork and Crane's design – both men were strongly influenced by Ruskin – that was to provide the exemplar for the Czechs. This orientation derived largely from well-travelled Czech artists such as Zdenka Braunerová and Vojtěch Preissig, whose early book designs were to form the basis for both the modern Czech book as well as the first theorists and critics in this field: F.X. Šalda, Miloš Marten and the erudite compositor Karel Dyrynk.[4] Much attention was lavished on the phenomenon of illustration by art associations such as Umělecká beseda (Art Circle) and the artists' association Mánes, which offered space in the literary supplements and special editions of the magazine *Volné směry*.

After the turn of the century the individual attempts of various literary and art acquaintances culminated in a broad cultural school. The publication of books of aesthetic and literary quality arose from the spiritual revival with which the cultural elite confronted the political uncertainty at the time – a turbulence that was provoked in part by certain liberal Austrian laws.[5] New publishers brought books on to the market in larger print runs and at more attractive prices, and continued the earlier orientation towards foreign models and contemporary –

primarily French Symbolist – literature. They also started publishing the young Czech writers from the second wave of Symbolism.

The most important publishers were from the circle around the *Moderní revue*, with the principal Prague editions appearing in the series 'Books by good authors' by Kamilla Neumannová, the 'Modern library' edited by K.H. Hilar and 'Symposium' by Hugo Kosterka. The Society of Czech bibliophiles (Svaz českých bibliofilů) began its activities in 1908. In Stará Říše in Moravia the Catholic publisher Josef Florian produced his series 'Studium' and 'The good work,' introducing French Catholic and German Expressionist writers into Czech culture. His progressive vision with regard to his literary fund and the high artistic quality of his books made him a publisher of European stature.[6]

From the second half of the 1890s the anarchists also played an active role in book culture. Grouped around the magazine *Nový kult* (New cult) and the series of the same name edited by Stanislav Kostka Neumann they demanded attention for social topics that, given these anarchists' single-mindedness, also influenced artistic form. The direct perspective they offered of the urban masses (Gellner) and ethnic minorities (the Silesia of

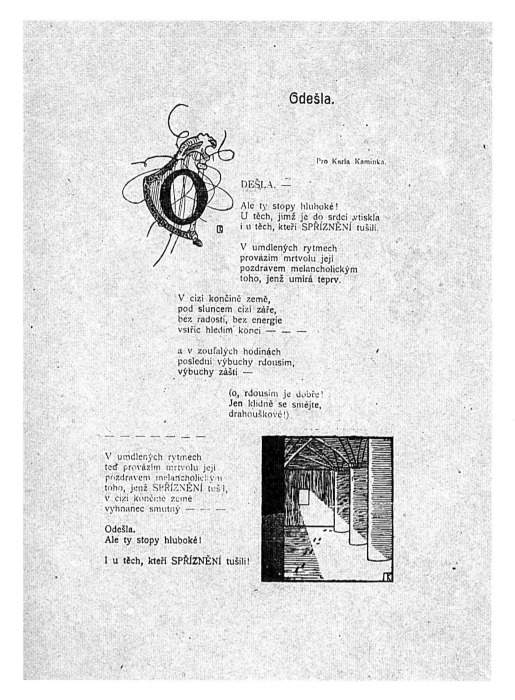

105
Stanislav Kostka Neumann,
**Proud and passionate
apostrophes**, 1896,
Uměleckoprůmyslové
museum v Praze, Prague

Proud and passionate apostrophes

This poetry collection is the first modern Czech artist's book illustrated by the author himself. Neumann had already produced typographic designs for books on several occasions and made ornamental drawings for the magazine *Moderní revue*. His own book was the culmination of experiments the Moderní revue circle had conducted in an attempt to bring about a new perception of the book as a unique personal form of expression.

Neumann's collection became the most lavishly produced book in the Czech decadent movement. Not only the paper and the format but also the initials and illustrations were highly unusual for the Czech art world. For that reason a good deal of fun was poked at the book at the time. Neumann's source of inspiration was the German art magazine *Pan*, especially the illustrations it carried by the Belgian Charles Doudelet. Using this source as his basis, Neumann created his own decadent iconography, with the various symbols expressing a motif from the poem. The book's text and artistic form belong to the radical, anarchistic expressions of the time, with the artist using this to accentuate his antibourgeois attitude. He does this by being provocative with themes that are still clearly inside the realm of taboo, thus laying bare the psychological tension engendered by our confrontation with a society in disintegration.

Petr Bezruč) led to new expressive techniques in literature. Other forms in the ascendant were *Lieder*, dialects and the vernacular (compare the composer Janáček's musicalisation of the melody of language forms at the same time). New images of the commonplace, the drab and the banal were also coming into use.

The voice of reality demands a different kind of 'musicality' as far as illustrative accompaniment is concerned. From the revival in the tradition of caricature by artists such as Hugo Boettinger, Gellner and František Kupka there is a return of the action-based illustration that, while based on pithily realistic drawing, nevertheless expresses an inner tension. These manifestations carry the seeds of Expressionism as evinced by Gellner's Secession-influenced early work. He worked as a caricaturist for the Paris publications *Rire*, *Les temps nouveaux* and *Cri de Paris*, and his two anthologies of poetry influenced an entire generation of artists, including Josef Váchal. Gellner's later drawings for newspapers already have a genuinely Expressionist character. An influential factor in Vojtěch Preissig's shift from Secession style to Expressionism was Petr Bezruč's poetry, which he enlivened with simple and coarse woodcuts (*Slezské písně* – Silesian Lieder, 1909, fig. 100). At the time, it was Preissig's coloured etchings and aquatints that were regarded as among the most 'musical' symbolic expressions.

106
František Bílek,
Illustration in Otokar Březina's collection of poems 'Hands', 1902,
Uměleckoprůmyslové museum v Praze, Prague

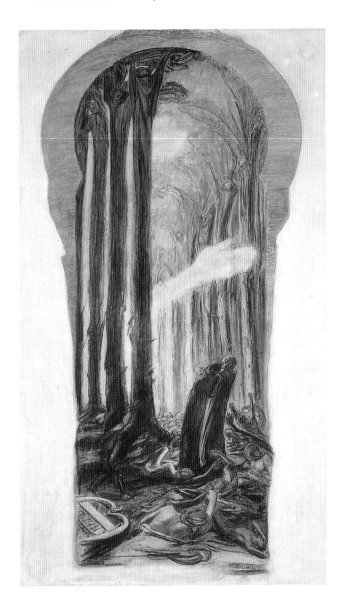

Illustration in Otokar Březina's collection of poems 'Hands'

The sculptor and graphic artist František Bílek's extensive work was highly influential in various areas of the visual and literary arts. Characteristic is his visionary orientation linking Christian and Oriental myths, with the religious and moralistic pathos emphasising the tragedy of human existence. Text and script are an integral component of his two– and three–dimensional work, and the symbolism of the image is strengthened by the symbolism of the word. In this, his use of text structures as a pictorial element of equal value is clearly inspired by the work of William Blake.

As an older friend, the poet Otokar Březina was a great formative influence on Bílek's personality. The poetry collection *Hands* was to become a means of communication between these 'soul brothers' in which Bílek conducted a dialogue with literary work and motifs interpreted from Březina such as 'the blind', 'builders of cathedrals', 'visionaries' and the 'initiated'. The collection comprises Bílek's first major illustration cycle. Using a chain of figurative metaphors he illustrates in highly apposite fashion Březina's epos of man's cosmic history, a theme Bílek would later return to. The figures' Gothic-esque silhouettes, their ecstatic gestures, the distortion of form to enhance the spiritual expression and the dramatic chiaroscuro contrasts in his drawings were also to characterise his later wood sculptures.

Around 1905 a new musical connotation emerges: colour (Šalda, Emanuel Chalupný).[7] The flourishing of graphic techniques is also relevant in this context. While the illustrations of the 1890s were still being reproduced in a painterly fashion, after the turn of the century original graphic techniques came to the fore with all their colour contrasts and intensity. Masters in etching, such as Hlaváček and Zdenka Braunerová, and in the woodcut, such as Bílek, were now followed by a number of others: Tavík František Šimon, Max Švabinský, Viktor Stretti. Preissig again achieved exceptional results with his experimental, multicolour printing.[8]

The musically expressive possibilities of graphic illustration in combination with colour and expressionist tendencies were developed by members of the literary-artistic group Sursum (1910-12) in their magazine and in the

publication *Meditace*. They were reproached for their literary sympathies far more than the artists of the 1890s were. Sursum carried through Symbolist poetics of the illustration to the extreme. On the one hand we see a striving towards a freer, psychological interpretation in the spirit of Hlaváček, on the other the illustration enhancing the magic world of the written word. Both types of illustration form a social sounding board for the irrational world of internal and external forces that govern human life. Musical excitation, leading even to frenzy, appears in colour – including on the black-and-white scale – and in the rhythm of the lines.[9]

The illustrations of Sursum members is highly individualistic and the graphic techniques also correspond to the particular artistic types. The most closely linked with the book illustration genre is the work of Josef Váchal,

107
Karel Hlaváček, **My Christ**,
1897, National Literary
Museum, Prague

who created a sarcastic counterpart to the pathetic
visionariness of František Bílek. For Bílek the book was a
sacral object, for Váchal totemic, magical. This included
the cover, endleaves, typeface and, of course, the illustra-
tion, and he often authored both the text and the illus-
tration. He derived his colour combinations for the
woodcuts, which he excelled in, from magic. He illustrat-
ed spiritualist texts – both his own and Sursum mem-
bers' – and texts by religious heretics and Christian mys-
tics, especially those published by Josef Florian and Jakub
Deml. In 1912 Váchal illustrated Deml's text *Hrad smrti*
(The castle of death, fig. 19), giving rise to one of the first
literary-expressive combinations in which an expression-
ist manifestation entirely transforms the symbolist roots
of the imagination.[10]

In his etchings and drawings Jan Konůpek displays a
nervous sensitivity about his literary sources of inspira-
tion. With his highly imaginative interpretation he empha-
sises not only the irrational elements of Sursum's literary
models but also those of K.H. Mácha's *May*. Celebration
of the poet Mácha's centenary actually generated numer-
ous new illustrations. The most notable of these include
the cycle by František Kobliha (fig. 14), who afterwards
produced several series of illustrations for Hlaváček's
poetry. As in Preisler, we find in Kobliha a personal char-
acterisation of the artist as a literary hero when the cos-
mic night forms the theatre of inner dramas. The painter-
ly nuances and the tonality of the black-and-white wood-

cut are an echo of decadent poetry, but convey even
more intensely the disquiet and disillusion of man in the
twentieth century. Jan Zrzavý's talent as an illustrator
only really became evident later. His early work, connect-
ed with Sursum and based on Zeyer's Neo-Romanticism,
consists of images of dreams and scenes from the sublim-
inal (see fig. 116).

The illustrations from around the turn of the century
were a maximal form of expressing the desired goal to
achieve a synthesis of poetry, the fine arts and music. The
musical quality became a highly dramatic element in illus-
tration. First, as a changing manifestation the illustration
was differentiated from the rational and unambiguous
allegory. Subsequently, the multifaceted nature of the
symbolic representation brought the artists of the 1890s
generation to a far more complicated structure. After the
turn of the century the tendency towards musicality
brought about a thematic simplification and abstraction.
The new generation of artists, who were actively absorb-
ing impulses from Expressionism, attempted to achieve
musicality using other means of expression: colour and
line, with the motif reduced to a few figures – and some-
times even to a single figure. Ultimately the musical,
poetic qualities would make way for a new conception of
time and space, in connection with modernism. But as a
perpetually changing phenomenon the illustration as har-
mony was to pass many milestones as the twentieth cen-
tury continued to develop.

108
Jan Preisler, **Illustration for a poem by Jan Neruda**, 1901, Národní galerie v Praze, Prague

109
Jan Preisler, **Frontispiece to the collection of poems 'Poisons and medicines' by Jan Opolský**, 1901, Národní galerie v Praze, Prague

Frontispiece to the collection of poems 'Poisons and medicines' by Jan Opolský

Thematically, Preisler's illustrations are closely bound up with his fine art. The chief protagonist is frequently the artist himself, who allows the viewer a glimpse into his emotional life and suffers from the desire for an ideal and the impossibility of achieving it. This painful conflict is reflected in his relationship with the woman who, as elusive as a chimera, is always retreating before him. Preisler's heroes are linked with European art from around the turn of the century, for instance with the illustrative work of Fernand Khnopff and Henri De Groux.

Jan Opolský, a second-generation Symbolist poet, articulates the tragic fate of the modern poet, his exclusion and desire for authentic emotions as well as the feeling of not being understood. Preisler expresses this through the fine nuances visible in the pierrot figure's facial expression, which conveys both narcissist disdain as well as something that is deeply harrowing. The hero's distress is not purely subjective since it arises from a feeling of disillusion with the world and society in general. As with other illustrations for work by Czech writers such as Julius Zeyer and Jan Neruda, a melancholic, evocative landscape is accompanied by the suggestion of a cosmic dimension.

110
Václav Hradecký, **Illustration from the cycle 'Bestia Triumphans'**, 1903, National Literary Museum, Prague

111
Jan Konůpek, **Ecstasy**, 1911, Moravian Gallery, Brno

Ecstasy

Konůpek, a member of the Sursum artists' group, conducted a dialogue with the Symbolist literary and pictorial imagery of around 1900. Literature was still a source of inspiration for him. In his early drawings, gouaches and graphic work he is fascinated by conditions of spiritual exaltation and mystical experience. He enriched the *femme fatale* motif with a new type symbolising spiritual states such as meditation, contemplation and ecstasy. Pathos and dramatic gestures lend these figures a greater psychic tension.

Konůpek's Symbolist motifs are permeated by his interest in the next world and spiritualism. Already as a Sursum member he was a superb illustrator, able to convey a literary model in terms of an irrational and imaginative atmosphere. During the same period he dedicated himself to ornamental work — influenced by Viennese decorativeness — and to designing applied art.

112
Josef Váchal, **Visions of
seven days and planets**,
1910, Uměleckoprůmyslové
museum v Praze, Prague

113
František Gellner, **Cover
for 'The conversion of
St Vladimir'**, 1904,
Uměleckoprůmyslové
museum v Praze, Prague

Visions of seven days and planets

Váchal is one of the most original figures in Czech
art from around 1900. Like František Bílek and Karel
Hlaváček he was engaged simultaneously in litera-
ture and art, in which he perpetually went further
than the artistic conventions of the time. He
excelled in graphics and coloured woodcuts. After
the disintegration of the Sursum artists' group,
which he was a member of, his work was sidelined
and from that position he sarcastically commented
on the art world.

For him the book was a genuine, creative means
for securing a grasp on reality. Using this medium he
conducted a dialogue with himself, with artistic tra-
dition and with the world. His work complemented
the efforts of the Secession movement to turn the
book into a *Gesamtkunstwerk*, but at the same time he
was opposed to any form of decorativism and
endeavoured to bring out the expressive qualities of
all the book's components: the illustration, the bind-
ing and the end paper. He created various typefaces
whose possibilities for psychological expression he
regarded as more important than legibility. He was
inspired by the medieval and Baroque book and by
popular prints. The text of *Vision of seven days and planets*
refers – as do so many books by Váchal – to Christian
mystics, heretics, visionaries and spiritualists.

Váchal was the first Czech artist to work system-
atically on the so-called 'artist's book'. He was a fully
trained bookbinder, a highly gifted graphic artist and
a self-taught compositor; he also wrote his own texts
and published them himself.

Cover for 'The conversion of St Vladimir'

The artist and writer František Gellner developed
out of the anarchist circle around Stanislav Kostka
Neumann. As a Bohemian and rebel he unmasked
petit-bourgeois society and later, as a journalist, the
world of politics. He was one of the first Czech
artists of the period to direct his attention to actual
reality. His poetry addresses bourgeois nature and
the simplicity and sensitivity of urban folklore. His
collections, *After us the deluge!* (1901) and *The joys of life*
(1903), did not fail to influence contemporaries such
as Josef Váchal.

Gellner was an outstanding caricaturist with a
suggestive, elliptical style inspired by Thomas
Theodor Heine and Félix Vallotton. In his self-por-
trait, like his paintings, he used rapid, Neo-
Impressionist-like brushstrokes. The characteristic
nakedness and sensitivity of his drawings were to
became stronger in the caricatures he later pro-
duced for newspapers. These caricatures already con-
tained an Expressionist spontaneity and psychologi-
cally suggestive features. Gellner's remarkable pro-
duction was ended by his untimely death at the start
of World War I.

114
František Kobliha, **Title
page for 'Aurélie' by
Gérard de Nerval**, 1911,
Uměleckoprůmyslové
museum v Praze, Prague

115
Josef Váchal, **Illustration
for Josef Šimáneks
'Wanderings of the
little elf'**, 1911,
Uměleckoprůmyslové
museum v Praze, Prague

116
Jan Zrzavý, **Zeyer's garden (Sister Paskalina)**, 1907, Národní galerie v Praze, Prague

Zeyer's garden (Sister Paskalina)

Zeyer's literary work greatly influenced the generation of the late Symbolists, especially those in the Sursum artists' group. His prose, for instance, was a source of inspiration for Jan Zrzavý, who accentuated still further the tension between the sensual and the spiritual so characteristic of Zeyer. The theme of Zeyer's novella *Sister Paskalina* is that of authentic spirituality manifested exclusively through the physical world. The story is from a legend about a nun who leads two lives, a spiritual life in her convent and a sensual life in the world. The convent garden Zrzavý uses to express Sister Paskalina's spiritual side is given an exotic location in Asia.

Through this spontaneous drawing with an erotic-spiritual colour symbolism, Zeyer's literary model is interpreted as his personal desire for harmony of the soul, which is stifled by physical instincts.

117
Jan Konůpek, **Title page and illustration for the poem 'May' by Karel Hynek Mácha**, 1910, Uměleckoprůmyslové museum v Praze, Prague

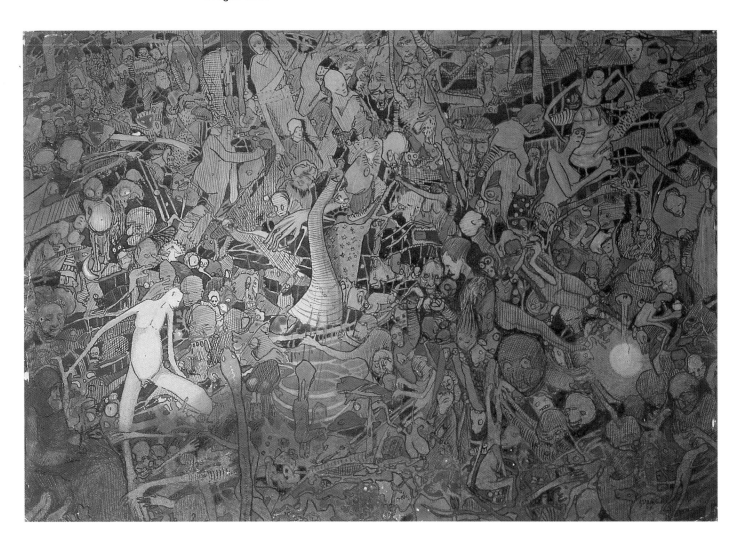

118
Josef Váchal, **Elemental plain**, 1907, National Literary Museum, Prague

Elemental plain

Váchal and other members of the Sursum artists' group often reacted in the form of grotesque sarcasm and blasphemy to the Symbolist motifs from around 1900. In so doing, Váchal drew on the work of František Bílek, Edvard Munch and Félicien Rops. As far as literature is concerned he was inspired by the work of Léon Bloy and Joris-Karl Huysmans as well as by mystical, theosophical and astrological texts. Of all the representatives of late Symbolism it is Váchal's work that corresponds most with the incipient Expressionist manifestations of the time. With

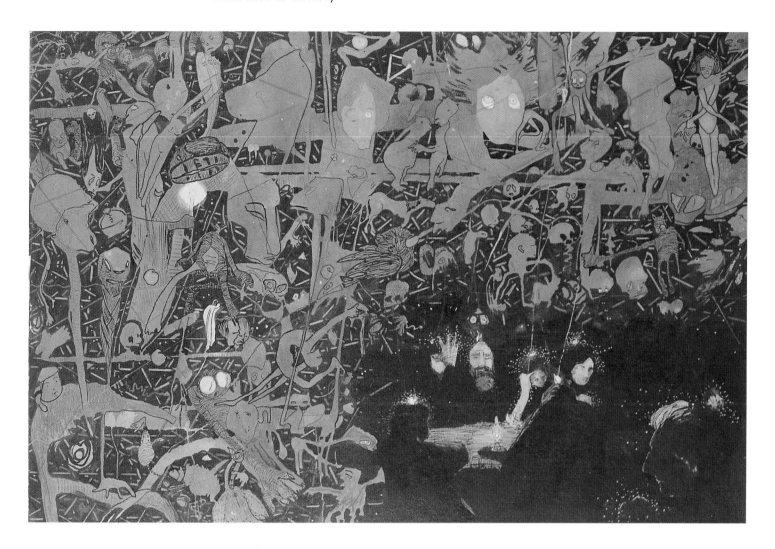

119
Josef Váchal, **Astral plain**,
1907, National Literary
Museum, Prague

his occult tendencies he opens up new opportunities
for art. He provokes with visions that are of demonic
origin and with personifications of physical instincts
and passions.

As for the development of *Elemental plain* he notes
in his *Memoirs* that he had created drawings with 'fan-
tastic faces and figures that loom up in a regular,
medial way'. The figurative and abstract motifs in
this painting still reveal the stylisation from the
Secession period but, at the same time, have a highly
expressive tension caused partly by the colour sym-
bolism.

ČÍSLO 2. PROSINEC 1896. ROČNÍK I.

An artistic synthesis on paper

Iva Janáková

The synthesis of literature and the visual arts between 1890 and 1900 was not simply a matter of mutual inspiration. In fact, it was a very conscious endeavour originating from a desire to change the intellectual and cultural climate and to develop a contemporary style. The most effective medium for bringing about this change were the journals, whose numbers increased substantially in Europe and the United States during these years. Inspired by these foreign examples, which focussed on synthetic content and intelligently conceived design, the programmatic journal *Moderní revue* (Modern review) was founded in Prague in 1894. It attempted to raise Czech literature and the visual arts to a higher level and viewed the production of Czech artists through the prism of developments taking place in the rest of Europe. It also polarised the visual arts into various camps.

The art journals

The intellectual climate of the 1890s was strongly influenced by *Moderní revue* (1894–1925), the platform of the decadent branch of Symbolism.[1] Published by a small group of littérateurs, it guaranteed an irreconcilable and radical stance vis-à-vis Czech visual arts. This was manifested primarily in the critiques launched by the most striking figure in this arena: the poet, artist and critic, Karel Hlaváček (1874–1898), who met with an untimely death. The nature of the journal – with its predilection for elitism and aestheticism – changed after the turn of the century, when it became a bastion of conservative spiritual traditionalism. According to Arnošt Procházka, then editor-in-chief of the journal, the primitivism of the second generation of Symbolists was rejected.

The generation of the 1890s was also influenced by the journal *Nový život* (New life; 1896–1906), the organ of the Catholic Modernists who wanted to transform Catholic art in the spirit of Symbolism. Moreover, they aimed to give all sorts of individual trends a religious significance. A distinctive and artistically universal figure in this circle was the Benedictine priest Sigismund Bouška, whose friend František Bílek became *Nový život*'s most important artist in the second half of the 1890s. When this journal was discontinued, the young generation of Catholic intellectuals, writers and artists, such as Emil Pacovský, Josef Váchal, Jan Konůpek, who had been rejected by *Moderní revue*, established a new journal entitled *Meditace* (Meditation; 1908–1911). In addition, there was the artists' group Sursum (1910–1912), which united various individuals from *Nový život*, who shared an interest in Christian mysticism, occultism and hermetism.[2]

These journals are notable for the attention they devoted to visual elements: the striking covers, illustrative headings, borders and vignettes artistically supported the literary pieces, the critical reviews and the illustrations. However, as the journals usually included highly diverse artistic contributions, their quality as a whole was rather variable. The editorial board of *Volné směry* (Free directions), which was established in 1896, must be credited for attempting to give the entire magazine a single, clear style, much like a *Gesamtkunstwerk,* whereby all of its

120
Adolf Wiesner, **Cover design for 'Volné směry'**, 1896, Uměleckoprůmyslové museum v Praze, Prague

121
Karel Hlaváček, **Cover for
'Moderní revue'**, 1896,
National Literary Museum,
Prague

Cover for 'Moderní revue'

Moderní revue, the full title of which is 'Modern review
for literature, art and life', was the first Czech jour-
nal to expound international ideas of modernism.
Contrary to the strong nationalism that dominated
Czech society in the 1890s, *Moderní revue* was open to
contemporary developments in art elsewhere in the
world. For example, it introduced the European
decadence style and Symbolism with translations of
literary works, reproductions of visual art and its
own aesthetic programme emphasising the psycho-
logical aspects of art. In 1897-98, the poet Karel
Hlaváček became one of the journal's central figures,
if not its most talented representative. The cover
shown here is programmatic in character. Art, for-
merly always represented allegorically by the Muses,
has become an exotic symbol: a woman as a mon-
ster, vampire and serpent all in one. This image cor-
responds with that of the *femme fatale*, who symbolis-
es the magic power of evil. Evidently, Hlaváček culled
inspiration from a drawing by Félicien Rops, pub-
lished in the journal *La Plume* in 1896. He was one of
the important inspirers of the *Moderní revue* associa-
tion and, in 1898, Hlaváček himself published an
enthusiastic article about Rops in that journal.

components, such as type, images and decoration, were of a kind and intended to create an emotional effect.[3]

The first volumes of *Volné směry*, the periodical of the Mánes Artists' Association, reflected a strong literary orientation and became the driving force behind the Czech Secession movement. Competitions were organised among its members; it stressed the importance of being well-informed about artistic developments abroad; and it attached great value to art criticism. As the periodical of an association, it served as a platform for a variety of views and thus reached a much broader public than *Moderní revue*, which was far more specialised.

After the turn of the century, more trend-setting journals profiled themselves in connection with the emerging Constructivist tendencies. For the applied arts sector this was the periodical *Dílo* (Oeuvre) founded in 1903, which sought inspiration in the Viennese decorative style. In 1908, a group of modern architects founded their own professional journal, *Styl* (Style). Its sober design by Jaroslav Benda reflected the programme of the geometrical modern style, for which this journal became the platform. Only in connection with the revolutionary Expressionist and Cubist concepts of the young generation of artists and architects did a substantive synthesis of literature, philosophy, the visual arts, the applied arts, architecture and even music emerge once again. This took place in the pages of *Umělecký měsíčník* (Art monthly), which appeared between 1911 and 1914. Like Expressionist books, its design reflected an emphasis on a dramatic composition of text and image.[4]

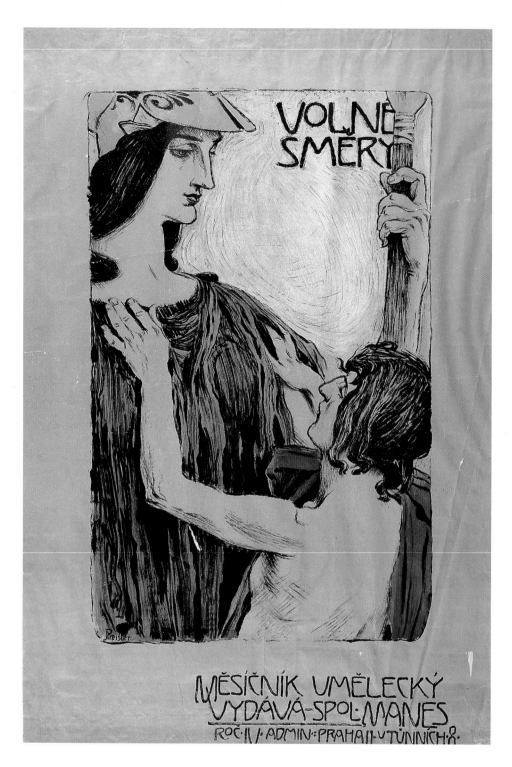

123
Jan Preisler, **Poster for
'Volné směry'**, 1898,
Uměleckoprůmyslové
museum v Praze, Prague

Posters for the first Mánes exhibition and 'Volné směry'

Hofbauer, like Preisler, was one of the most important designers of *affiches* in the Mánes artists' association. The *affiche*, or poster, for the first exhibition of Czech Secession painters and modernists was more concerned with the subversive satire of young artists than with aesthetics. Hofbauer won the competition organised by the Mánes artists' association with a design that was not only reminiscent of his own obvious connection with Prague, but also one of the sketches by Gustav Klimt destined for *Ver Sacrum*. The exposition, publicised by this *affiche*, was accompanied by controversy about the official and stagnating character of the works of art and demands for the emancipation of Czech artists, which were published in the periodical *Volné směry*. The poster shows the muse flirting with the personification of the bourgeoisie in the form of a disinterested Buddha, provoking interest in the new art. The Buddha not only referred to Far Eastern art, but also to the older, famous caricature by Honoré Daumier, *The little Chinese god*. The exhibition attracted few purchasers and although the poster incited the necessary commotion, it was loudly denounced in the press as an attack on the art-loving public of Prague.

Hofbauer and Preisler in particular were responsible for an exemplary graphic production of *Volné směry*. This concerned the cover of the magazine and the logos that were added to the reproductions of works of art. Preisler's poster advertising the magazine was a variation of the composition that was also used on the cover and as a vignette. The relationship between the young lad and Minerva clearly refers both to Oedipus — who is trying to solve the riddle of the Sphinx — and to Pygmalion whose sculpture of a woman came to life.

124
Arnošt Hofbauer, **Poster for the first Mánes exhibition**, 1897, Uměleckoprůmyslové museum v Praze, Prague

125
Arnošt Hofbauer, **Poster
for the second Mánes
exhibition**, 1898,
Uměleckoprůmyslové
museum v Praze, Prague

126
Arnošt Hofbauer, **Poster
for a recital by Hana
Kvapilová**, 1899,
Uměleckoprůmyslové
museum v Praze, Prague

127
Alfons Mucha, **Princess Hyacintha**, 1911,
Uměleckoprůmyslové museum v Praze, Prague

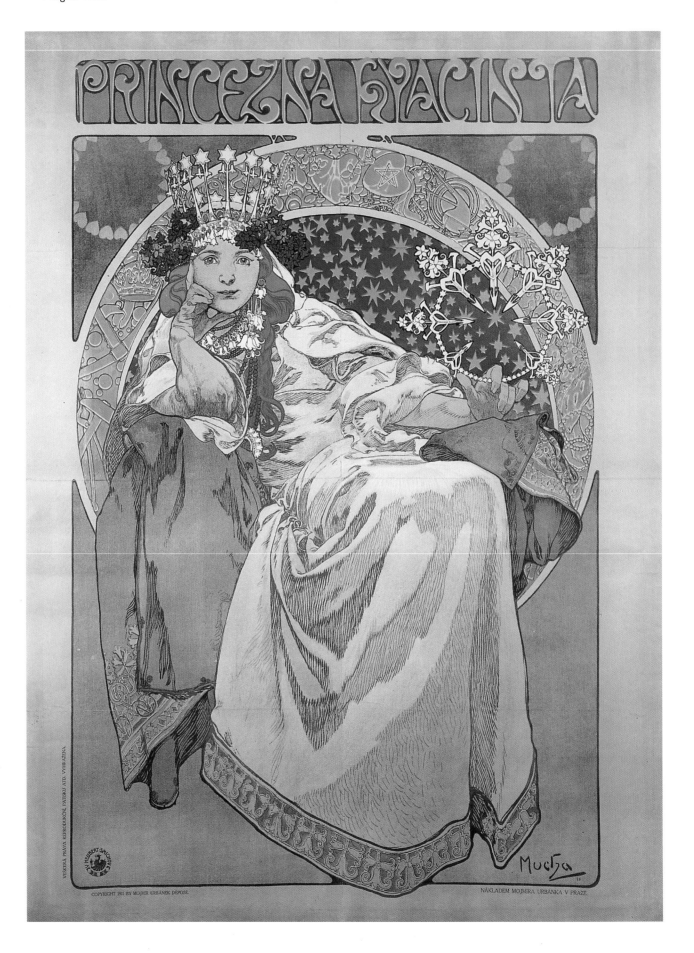

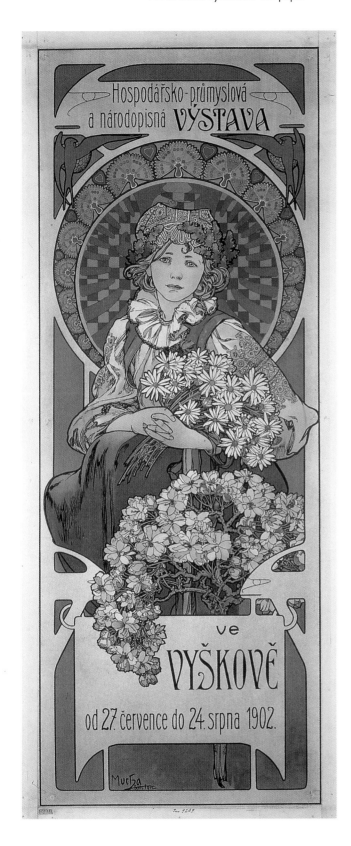

128
Alfons Mucha, **Poster for Economic, Industrial and Ethnographic Exhibition in Vyškov**, 1902, Mucha Trust

Satirical magazines were also crucial for the cultivation of the Czech art scene. The generations of painters of the 1880s and 1890s (Mikoláš Aleš, Viktor Oliva, Luděk Marold, et al) published in journals, including *Humoristické listy* (Humorous pages), *Švanda dudák* (Švanda the doodler) and *Šotek* (Little devil). After the turn of the century, the young generation of caricaturists considered their craft as an independent artistic field, characterised not only by its significant content, but also by clearly recognisable styling (Josef Lada, František Gellner, František Kupka, et al).[5]

The fact that Czech art was often weighed down by the ideas it was meant to propagate was regularly targeted by the caricaturists. Posters also came under fire.

Posters

Posters were welcomed in Bohemia as a new art form that established a link with current affairs. The generation of the 1890s also saw it as a means of bringing the new art – Symbolism – within reach of broader segments of the population.[6]

Czech posters of the 1890s are typified by their close ties with painting. Accordingly, painters (from the generation of the National Theatre and the Mánes Artists' Association) were the first major poster designers in Prague, a city with a tradition of excellent lithographic workshops and firms, like those of Haase and Neubert. In the integration of type and images, Czech posters adopted elements primarily from French posters, leading to the emergence of a unique form in the course of the 1890s. A characteristic feature of this was a complicated visual structure promulgating general national and artistic ideas. Consequently, Bohemian posters were far more reserved than the frivolous French or the more expressive German models. Czech posters of the 1890s also retained illusionist elements found in painting and a typical painterly tonality, which contributed to their general mood.

The competitions, criticisms and other publications that were systematically issued were of cardinal importance to the Mánes Artists' Association. For example, the association had posters designed for both its own exhibitions, and those of other organisations. In this connection, discussions were held concerning the principles of image and form in posters by Arnošt Hofbauer, Jan Preisler and Vladimír Županský. The originality of Hofbauer's posters was derived from a revolutionary handling of the symbols of the time and from the artistic

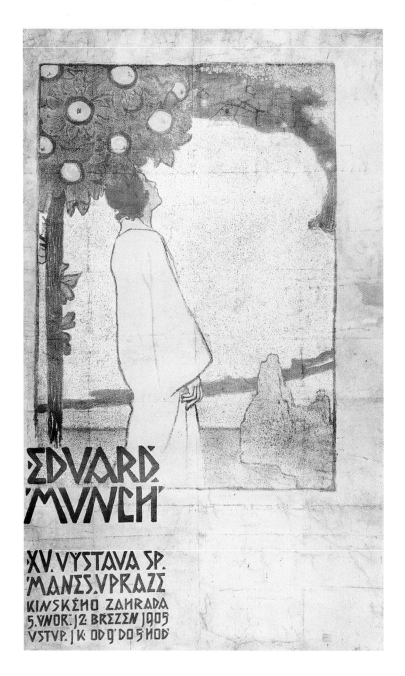

129
Jan Preisler, **Poster for the Munch exhibition**, 1905, Uměleckoprůmyslové museum v Praze, Prague

130
Vojtěch Preissig, **Poster for Preissig's exhibition in Salon Topič**, 1907, Uměleckoprůmyslové museum v Praze, Prague

Poster for Preissig's exhibition in Salon Topič

Preissig's poster for his own exhibition at the Prague salon of the publisher Topič attests to his superb typographic skills and his profound admiration of Japanese art. The unity of text and image and the pithy character of the poster as a whole, make it one of the most aesthetically effective posters ever made. The 1907 exhibition in Prague was a great success. Preissig's graphic work, in which he experimented with colour combinations, can be characterised as a Symbolist fusion of visual art, poetry and music, which was considered revolutionary in European graphic arts.

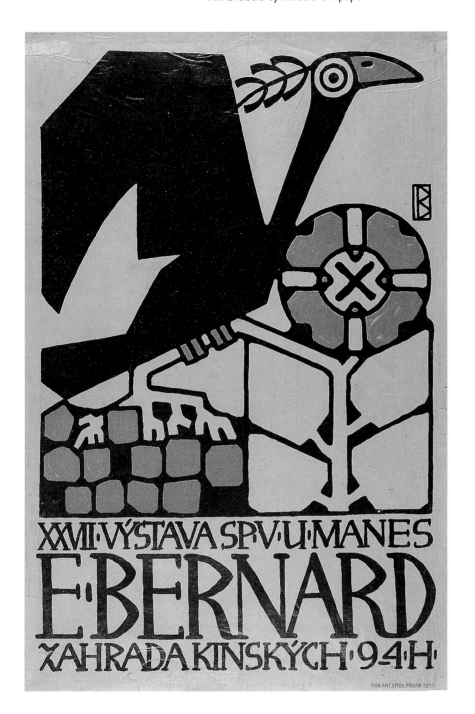

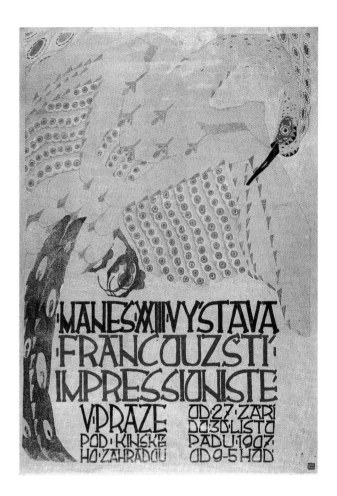

131
Jaroslav Benda, **Poster for
the Bernard exhibition**,
1909, Uměleckoprůmyslové
museum v Praze, Prague

132
František Kysela, **Poster
for the French
Impressionist
exhibition**, 1907,
Uměleckoprůmyslové
museum v Praze, Prague

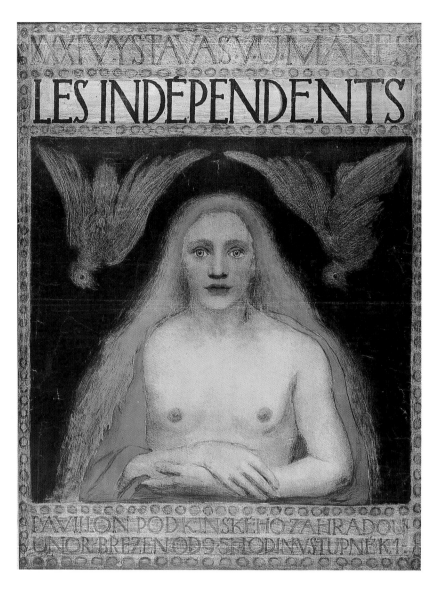

133
Vratislav Nechleba, **Poster
for the Mánes exhibi-
tion of 'Les
Indépendants'**, 1910,
Uměleckoprůmyslové
museum v Praze, Prague

composition of colour planes which were inspired by Japanese woodcuts. For his exhibition catalogues, Preisler used images from his own free and expressive art, and his significant contribution to the genre was the creation of a dynamic balance between the type and the imagery.

Towards the end of the 1890s, posters also appeared underscoring commercial, rather than lofty ideas.[7] Influenced by French posters, the work of Luděk Marold and Viktor Oliva exhibit concisely visualised images, aggressive, direct colours, and a reduction of illusionist elements, all with the purpose of immediately appealing to the viewer. In contrast, the Czech Parisian Alfons Mucha met with a lack of understanding on the part of the Czech public. He exhibited his collection of posters for the theatrical productions with Sarah Bernhardt in Prague in 1898, however, the art critics considered his substantively and formally sovereign work too exotic, culturally eclectic and entirely superficial.

Specific qualities can be ascribed to the cultural posters by the German minority in Bohemia. Their poster designers were recruited from the 'Verein der deutschen bildenden Künstler in Böhmen' as of 1895. The influence of expressive German posters is felt in the work of Emil Orlik, Richard Teschner and Hugo Steiner-Prag.[8]

The representatives of so-called geometric modernism from the first decade of the twentieth century worked with a new principle. They saw posters primarily as a composition on a two-dimensional surface. Influenced by the Viennese Secession, these graphic artists incorporated the decorative effect of the flat surface consisting of geometric motifs and colour combinations in their posters. The type was often perceived as the fundamental constructive principle of the poster, thus displaying the same tendency evident in the book arts. The various motifs were steadily reduced to ever more abstract shapes, as in the posters by Benda, Brunner and Vojtěch Preissig. While the possibilities inherent to the posters by the young generation of the 1890s were depleted in the course of time, they nevertheless paved the way for Cubism, Expressionism and Art Deco.

Art photography

The idea of a synthesis of all sorts of artistic disciplines also caught on in modern art photography. This discipline was perceived as sharing thematic and formal similarities with painting, the graphic arts, music, theatre, dance and literature. As a new art form, photography in Bohemia received little publicity, although the magazine *Volné*

134
František Drtikol,
Cleopatra, photograph,
1913, Uměleckoprůmyslové
museum v Praze, Praag

směry sometimes included photography with strong pictorial (painterly) qualities.[9]

The changing attitude towards photography, namely that it was more than simply a reproductive technique or veracious documentation, was brought about by a circle of amateur photographers. They relied on a technically highly developed generation of photographers specialised in portraits and Prague *vedutas* from the last thirty years of the nineteenth century, including Jindřich Eckert and František Fridrich. The Photographers' Club, founded in 1889, ultimately declared photography to be an art form. Its members responded to the growing artistic tendency toward introspection and the visualisation of suggestive ideas through photographic experiments with technically complicated methods. Improved photographic techniques made it possible to manipulate the negative and to adjust photographed reality to suit the subjective vision of the artist-photographer.

In the 1890s these tendencies found expression primarily in landscape photography. The photographers Otto Šetele and Zdenko Feyfar exhibited an interest in light effects, tonality and mood, and borrowed imagery from landscape painting. In the process, they often found inspiration in paintings by František Kaván and Antonín Slavíček.

Landscapes also became the prime subject of the first photographers trained abroad, František Drtikol and Vladimír Jindřich Bufka, who opened the largest photography studios in Prague. Their photographic landscapes display an emancipation from a certain dependence on painting. This is not only evident in the choice of subject matter, but also pictorially, in the use of a palette inherent to the photographic medium. Dramatic colour contrasts and twilight settings are characteristic of the expressive images of the mining district where František Drtikol was born. In his photographs, the versatile innovator, Bufka, incorporated the theme of 'magical' Prague nocturnes and of the dynamic world of technology, which altered life so radically around the turn of the century. Drtikol, too, employed images of Prague very differently from the familiar nineteenth-century Prague *vedutas*. In his album *Courts and courtyards in old Prague* of 1911, he very astutely conveyed the dark Prague corners as sites of eerie visions, which correspond with the literary

135
František Drtikol, **Girl
with eyes closed**, photo-
graph, 1910,
Uměleckoprůmyslové
museum v Praze, Prague

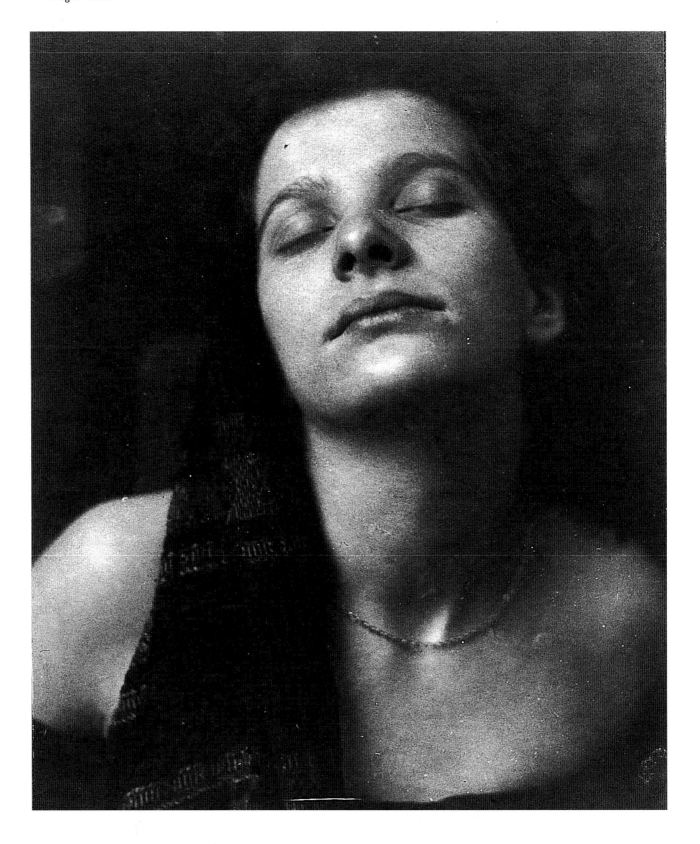

136
František Drtikol,
Polyptych with nude children, photograph, c. 1909, Uměleckoprůmyslové museum v Praze, Prague

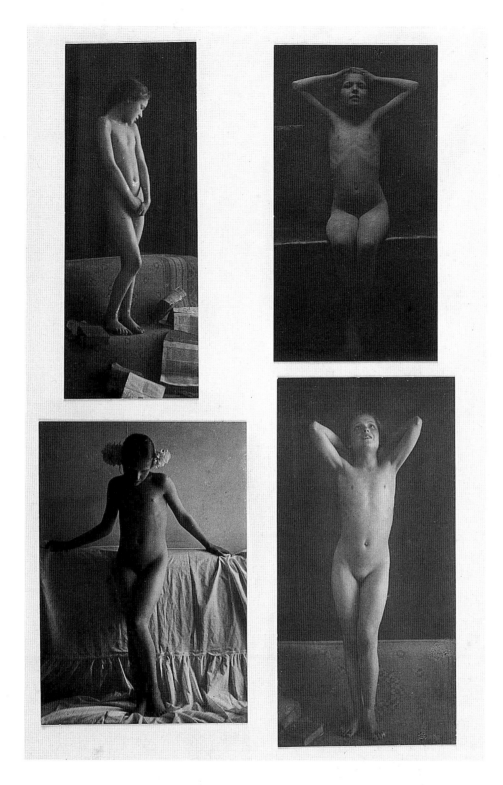

Polyptych with nude children

Drtikol's interest in the nude in photography is connected with his fascination with the human body as an expression of psychic and spiritual powers, something that was also evident in Czech painting of the time.

Women and girls as the personification of particular mental states was a frequently occurring theme in late Symbolism (for example, in the work of members of the artists' group Sursum). Drtikol's nudes also have a literary background and are often modelled on a Symbolist concept combined with the elegant contours of the human form of Secession style. The nude girls simultaneously display a clear corporeality and sensuality, although not at the expense of fragility and intimacy. In this respect they are comparable to Jan Štursa's sculptures (fig. 97).

137
Vladimír Jindřich Bufka,
Evening mood, photo-
graph, c. 1908,
Uměleckoprůmyslové
museum v Praze, Prague

138
František Drtikol, **Eve**,
photograph, c. 1913,
Uměleckoprůmyslové
museum v Praze, Prague

Evening mood

Like František Drtikol, Bufka – who trained in Vienna
– distinguished himself as a professional photograph-
er in a time that witnessed the emancipation of art
photography. His thematically varied work is inform-
ed by Symbolist art and poetry. His literary predilec-
tion is evident in his choice of landscape imagery, in
keeping with certain views on contemporary paint-
ing, wherein the landscape is more a landscape of
the soul. The mysterious light and the melancholic
mood also feature in landscapes in the graphic arts
and were matched in photography by the use of spe-
cial technical processes and the manipulation of
both the negative and the positive.

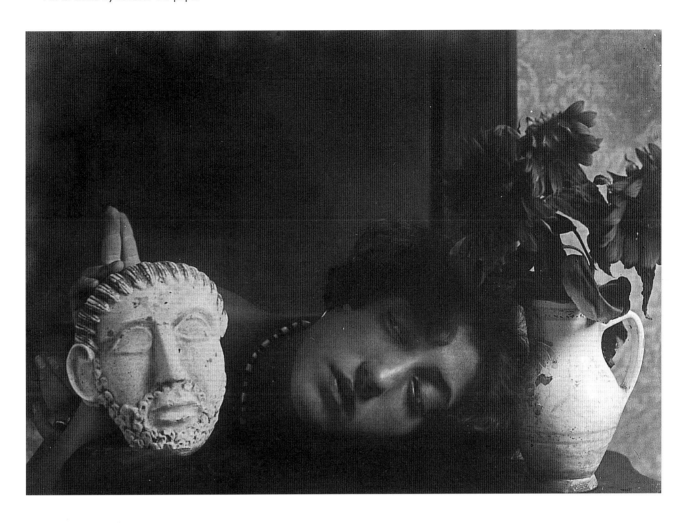

139
Karel Novák, **Woman with antique mask**, photograph, c. 1910, Uměleckoprůmyslové museum v Praze, Prague

images of the city in the Expressionist works of Prague-German writers such as Gustav Meyrink and Franz Kafka.

The pictorialism of Drtikol's work is associated with portraits of women, which were stylised in the spirit of Symbolism familiar from painting, and with nudes, which brought him international fame. In contrast to the psychologising and expressive tendencies of the Sursum group, Dritkol's nudes, including blossoming young girls and children, tend towards a strongly erotically charged sensual symbolism (fig. 136).

Drtikol's photographs would remain characterised by a poetic undertone in the 1920s and 1930s. Even with an austere Art Deco-like stylisation, a dreamy sensual echo still resonates; evidence of the strong influence of Symbolism, which, according to the writer Otokar Březina, poisoned our soul with its dreams and thus made possible the flowering of a new, modern movement in art.[10]

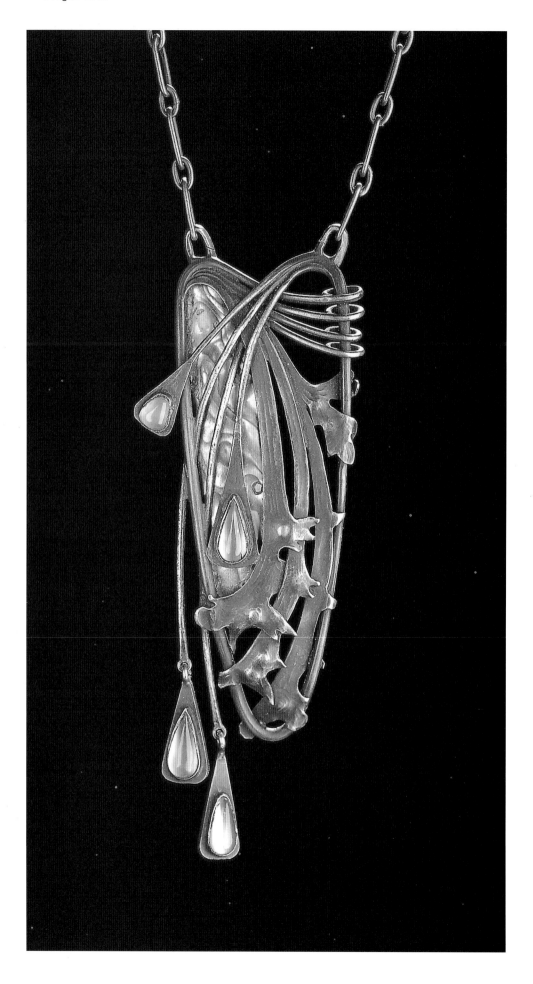

From ecstatic decoration to individual modernism
Applied art 1897–1910

Sylva Petrová

...how can a definitive statement be made in this chaos and torrent of largely unassimilated impressions, when today's revise yesterday's and tomorrow's will probably repudiate what I still regard as sacred today?[1]
Miloš Jiránek

The new renaissance of the art industry

Czech decorative and industrial art around 1900, like other fields of the arts, reflected a national situation riven by social and political conflict and further complicated by Czech and German antagonisms. Moreover, as in the rest of Europe, the transition from the old to the new century engendered a revision of generally accepted values; it also inspired feelings of oppression, confusion and apprehension about an uncertain future. However, architecture, industrial design and objects made by hand or produced in series enjoyed a tremendous recovery, prompted by new industrial manufacturing techniques, new forms of communication, such as the telegraph, telephone and cinema, and new forms of transport, such as the car and the aeroplane.

Although Czech territory had long remained on the periphery of modern industrial civilisation, it finally became an important area for such development during the second half of the nineteenth century. The 1908 Prague exhibition held by the Chamber of Commerce (fig. 174) showed that, at the turn of the century, the major industries of the Austro-Hungarian Empire were situated in Bohemia and Moravia. These included the Empire's largest sugar processing plant, distillery, printing works, machine factory, flour mill and coal mine. Ninety per cent of the Austro-Hungarian glass industry was also located in the north and south of Bohemia.

The pressure of mass production and mass consumption quickly changed the character of such cities as Prague, Pilsen and Hradec Králové, where increasing numbers of coffee houses, department stores, bridges and hotels were built. In the period 1900–1914, entire districts were redeveloped, for instance, Josefov in Prague. Prague fashion studios began to produce aviator and automobile outfits alongside evening wear; they also made sports bloomers for emancipated ladies. Concrete, metal frames, wrought-iron and glass prefabricated components gradually changed the character of buildings,

140
Josef Ladislav Němec,
Pendant, 1903,
Uměleckoprůmyslové
museum v Praze, Prague

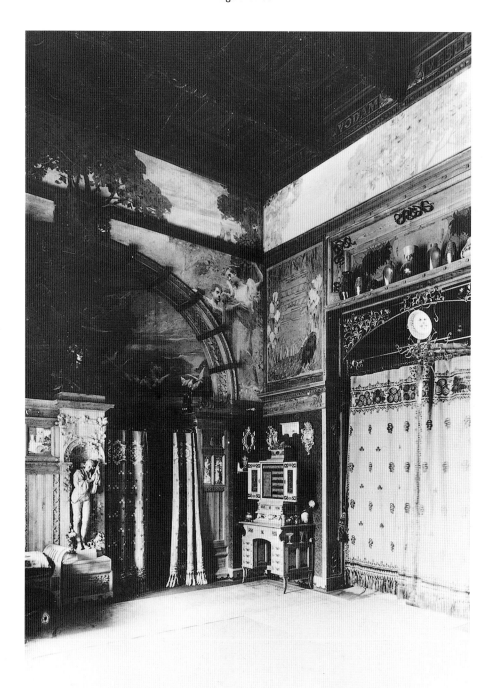

Interior of the Prague Chamber of Commerce
Although the 'Czech' interior at the Paris World Fair, designed by Josef Fanta and Jan Koula, still owed something to Neo-Renaissance-style historicism, it met with great success and won a series of prestigious awards. These included a gold medal for furnishing and decorating public buildings and houses, a gold medal for decoration and soft furnishings, a bronze medal for artistic execution and an honourable mention for stained glass.

The interior owed some of its success to the fact that it was the first truly Czech interior to be displayed at an international exhibition. The design was certainly striking as its creators had endeavoured to produce a modern and exemplary interior for a nationally-conscious Czech intellectual. The interior comprised a dining room (designed by Jan Koula) and a study with library, office area and tiny chapel (designed by Josef Fanta). The entire concept attracted so much attention because both designers had also responded to the contemporary Art Nouveau style and also been inspired by influences from England, France, Belgium and Vienna. The new design trend was evident in the decoratively panelled walls and ceilings, and the ceramic, glass and metal objects which completed the interior.

At the end of the exhibition part of the interior was transferred to the Museum of Applied Art in Prague where it was reassembled in a modified form.

141
Interior of the Prague Chamber of Commerce
at the Paris World Fair, 1900

while the first ideas on industrial design were formulated. These ideas are exemplified by the curved furniture produced by Thonet, a company founded in 1857 and based in the small Moravian towns of Koryčany and Bystřice pod Hostýnem. The moral and aesthetic theories of William Morris and John Ruskin, who focused on the relationship between industrial and hand-crafted designs, guided a new reform movement, particularly after 1901 when their studies were published in Czech, by Jan Laichter. Two prominent Czech institutions owed their existence to such ideas on the preservation and development of the applied arts: the Museum of Applied Art and the School of Applied Art, both founded in 1885.

The Prague School of Applied Art had many famous professors: these included the architect Jan Kotěra, the furniture maker and woodcarver Jan Kastner, the sculptor and ceramicist Celda Klouček, silversmith Emanuel Novák and his pupils, the versatile designer František Anýž, and the painter, ceramicist and textile designer Anna Boudová-Suchardová. As early as 1898, the school had developed a persuasively modernist programme which gained it the honour of an independent stand at the 1900 Paris World Fair. This comprised an interior by Friedrich Ohmann, who had just left the school as a professor, and his successor Jan Kotěra. Other Austro-Hungarian technical colleges, which had become accepted

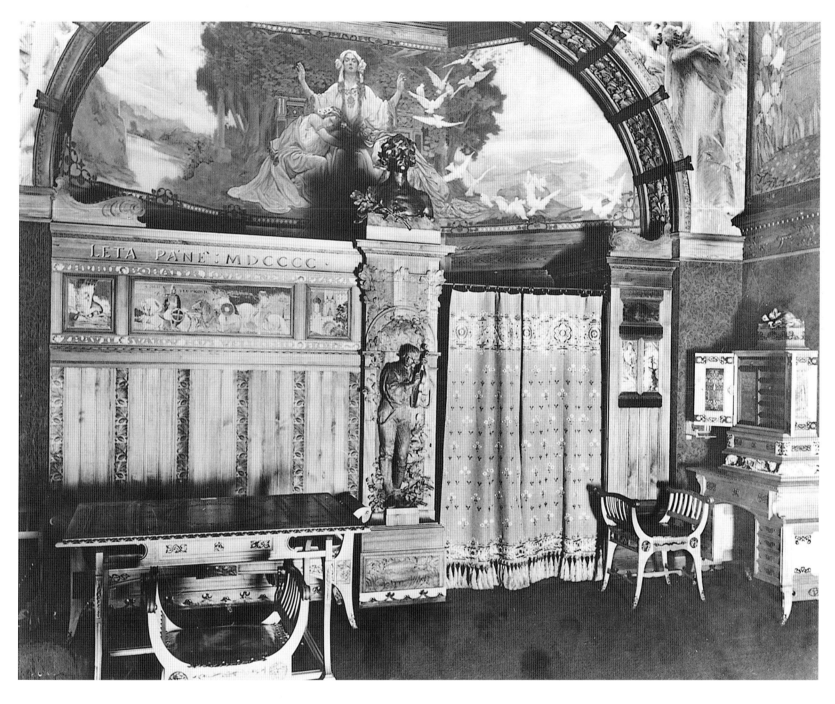

142
Interior of the Prague Chamber of Commerce at the Paris World Fair, 1900

institutions in Czech regions during the second half of the nineteenth century, also helped to create a favourable climate for the acceptance of the Vienna Secession as an arts movement.

Efforts to break free from the heavy burden of vacuous historical decoration, and find a suitable modern form of expression, were comparatively late when compared with the development of applied art elsewhere in Europe. They occurred at roughly the same time as the 1897 Secession in Vienna. Austria, to which the Czech regions belonged in this period, was one of the last European countries to adopt the 'new art' (Art Nouveau) in architecture and applied arts. Writers of the time implied that

this new style was still not widespread in applied art, even after the turn of the century.[2]

Although art journals before 1900 were filled with reproductions of objects in Art Nouveau style – skilfully worked jewellery by Josef Ladislav Němec from the silversmiths' school in Prague, posters from the studio of Viktor Oliva, Arnošt Hofbauer or Luděk Marold, and ceramics by Anna Boudová – historicism continued to leave its mark in conservative Czech circles. This is attested by Czech interiors, even those of the School of Applied Art and the Prague Chamber of Commerce which also had a stand in the Austrian pavilion at the 1900 Paris World Fair. Despite all the successes and apparent triumph of

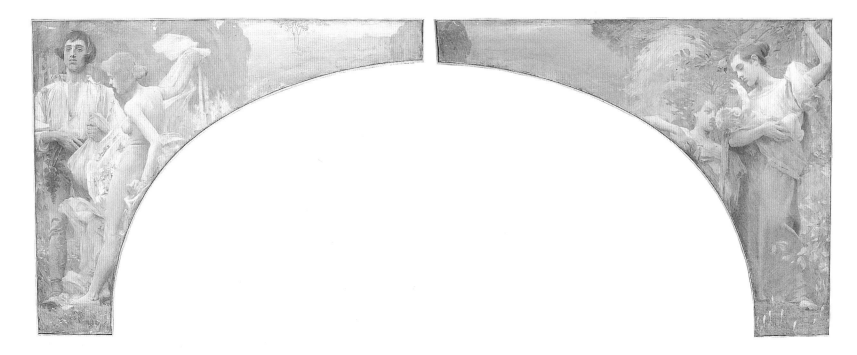

143
Jan Preisler, **Harvest** and **Blessed fruits**, 1899, decorative panels for the Paris World Fair, 1900 Uměleckoprůmyslové museum v Praze, Prague

new ideas, they did not appear to enjoy much stylistic similarity.

Although the new style reached a high point in the applied arts within the first five years of the twentieth century, it was not universally accepted. The older generation rejected the 'new art', while historicism survived in the work of artists inspired by folk tradition. This can be seen in the work of the multifaceted Jan Koula and the furniture and glass produced by the painter Zdenka Braunerová. Folk art influences reverberated in the architecture and furniture of Dušan Jurkovič, Jan Kastner and Josef Fanta. Historicism also maintained its hold on many kinds of industrial product. Jan Kotěra had completed one of his most sucessful projects, the Laichter house, and Czech Cubism was already evolving in the applied arts when the Obecní dům (Municipal House), designed by architects Antonín Balšánek and Osvald Polívka, was finished in 1911 (figs. 192 and 200); the façade is still robust Neo-Baroque and betrays the hand of Polívka. Where architecture displayed signs of arrested development, owing to the influence of conservative investors, glass and ceramic design was a more flexible domain. Unlike the historicist tradition, new modernism in architecture developed from a narrower frame of reference into synthesis.

The Corso coffee house in Na příkopě, designed by Friedrich Ohmann, was built before 1900. Although the façade bears lingering traces of Neo-Renaissance elements, the Corso is regarded as the first Prague building in the new Secessionist style. The Central Hotel, in the Hybernská, also by Ohmann and completed by his pupils,

is stylistically more striking (fig. 153). However, the most expressive work from this early phase of the Secession movement is the 1899–1900 façade of the Peterka house on Wenceslas Square, into which Kotěra threw all his creativity.

As in other artistic fields, professional journals played a considerable part in the development of new ideas. From 1896, the Ruskin-oriented artists' association Mánes acquired a leading role in the propagation of new artistic ideas through its journal *Volné směry* (Free directions); after 1909 the magazine *Styl* (Style) became the mouthpiece of modernism, although to a much lesser degree. *Volné směry* published key articles by Karel Boromejský Mádl, Jan Kotěra and František Xaver Šalda on the applied arts. In 1903 an article by Šalda in the journal proved integral to the professed aims of the leading style exponents. In retrospect, his article broke new ground in its rejection of artistic separatism and elitism and its repudiation of the traditional hierarchy of disciplines (with free expression at the summit and the trivialised 'minor applied arts' at the base).[3] Šalda's call for the spiritual and symbolic unification of life and the artistic disciplines is equally avant-garde: 'Style, as the highest cultural value both of art and of life, is the object of our hope. We want a new style. For us – after a period of schism and divergence – this means we want a new marriage between art and life, a new sanctification of daily life.'[4]

Modernist reform in the field of crafts and applied arts was more than an aesthetic or technical (rather, technological) conflict: it was also a political and intellec-

144
Alfons Mucha, **Poster for the Austrian pavilion at the Paris World Fair**, 1900, Uměleckoprůmyslové museum v Praze, Prague

145
Alfons Mucha, **Menu design for the official banquet during the Paris World Fair**, 1900, Mucha Trust

tual contest. Avant-garde art as an artistic programme was rejected on principle by a section of the public. It also encountered political resistance from the defenders of the Czech nation's past. Prior to 1897 support for national culture had often degenerated into confrontation, or found expression in an accumulation of references from folk art and national symbols.[5] Exponents of the Secession movement cherished an ambition that was highly relevant to the age: the creation of a *Gesamtkunst* that was supremely Czech, yet which also allowed them to join with other European countries in the establish-

ment of global cultural values. Efforts to stimulate national expression merely through historical copies and replicas were considered formalist and dilettanteist.[6] Opponents of modernism accused its adherents of failing to respect their cultural legacy and, of course, of a lack of national feeling.

National pathos doggedly infiltrated the interior decoration of public buildings; these interiors provided iconographic evidence for the long existence of the Czech people and communicated respect for their centuries of history. Czech Symbolism on a smaller scale

146
Josef Fanta and Stanislav
Sucharda, **Cabinet**, 1900,
Uměleckoprůmyslové
museum v Praze, Prague

147
Jan Kastner, **Chair**, 1899,
Uměleckoprůmyslové
museum v Praze, Prague

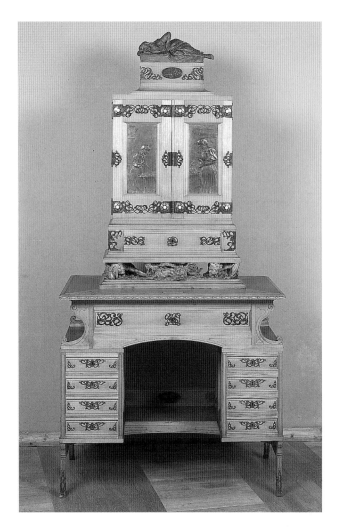

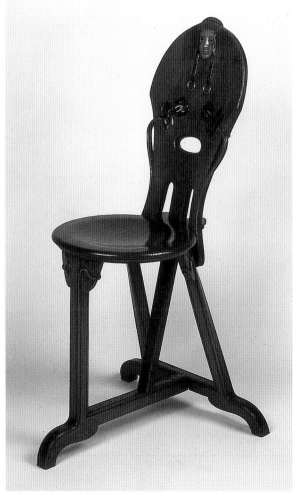

could also be found in decorations which employed characteristic local trees or native flora, in silversmiths' preference for native stones (the Czech garnet) and the use of 'typical' Czech, i.e. plump, facial types and figures for masquerons (fig. 162), caryatids and female bodies. The latter appeared in architecture, ceramics and decorative metal both as a subject and an ornament.

Bohemian production of applied arts and crafts was subject to a number of highly diverse impulses, which came directly from France and Germany or indirectly via Vienna. Unlike so-called free art, the applied arts were less influenced by French-speaking regions and cities such as Paris, Nancy and Brussels. During the initial phase of this new style, however, an important model was (Parisian) floral, dynamic, linear decoration of the Mucha, Van de Velde or Horta type. Vienna also played a major role, particularly the circle around the Wiener Werkstätte (Vienna Workshops). Thanks to these influences, and also the very real collaboration between Viennese designers and Czech craftsmen, stylised, geometric forms permeated Czech art. Regions along the German border formed the easiest point of entry for

Chair

This three-legged chair, with a girl's mask carved from wood on its folding back, was one of the items in the interior that the Prague School of Applied Art displayed at the 1900 Paris World Fair. Teachers and students had worked together on the design and construction of the interior. Architect Jan Kotěra supervised the entire project.

Like the rest of the interior, the chair was designed in the spirit of the then new Secession style. Its combination of internationally fashionable floral decorations with elements from Czech national folk art is striking. The chair is simple in construction yet clever in conception.

Jan Kastner taught woodcarving at the school, a craft in which he was also a master. His artistry at woodcarving was not only showcased in the Paris interior but also regularly displayed in many other interiors submitted to international exhibitions.

148
Josef Fanta and Ludvík
Wurzel, **Desk**, 1900,
Uměleckoprůmyslové
museum v Praze, Prague

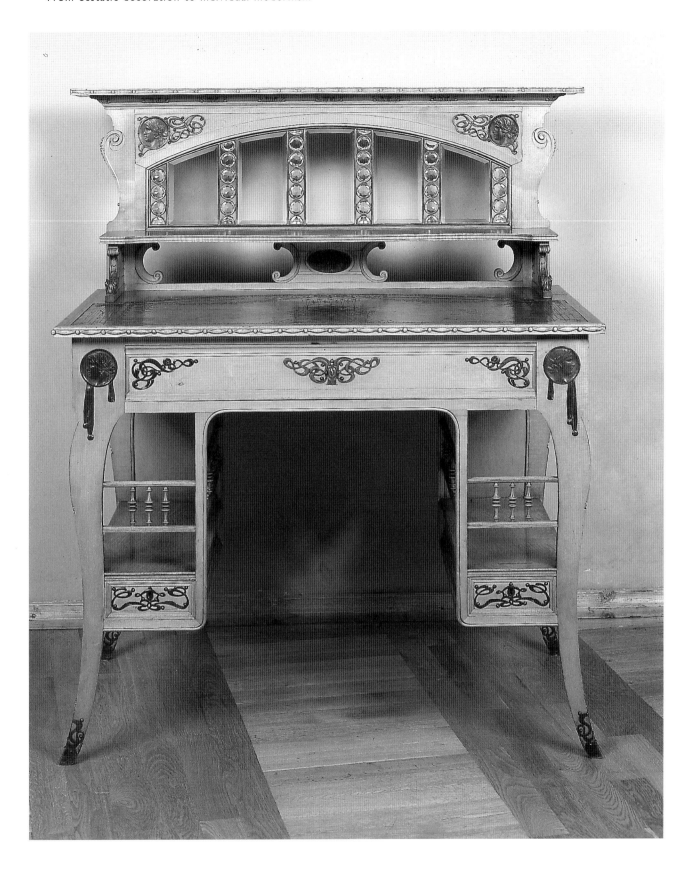

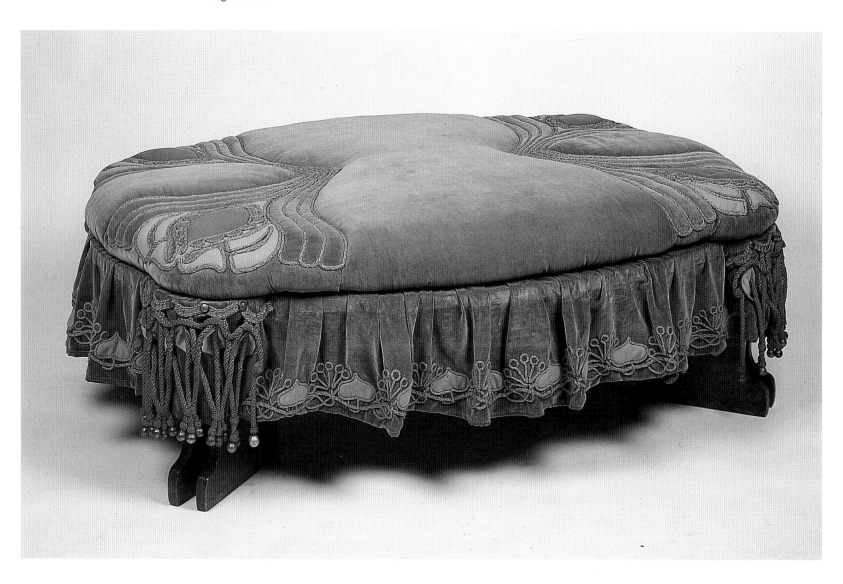

149
Jan Kotěra, **Divan**, 1899,
Uměleckoprůmyslové
museum v Praze, Prague

such influences; for example, geography determined the tendency of German technical schools to use Kamenický Šenov and Nový Bor for glass manufacture. Czech products were also influenced by William Morris's English Arts and Crafts movement, which persisted in Czech regions for many decades. Fabrics and designs for furnishings and sportswear were generally English, occasionally Scandinavian. Czech textiles of the period did not meet the required criteria, with the exception of Rudolf Schlattauer's tapestries, produced at his Zašová atelier, and products made at the Jaroněk brothers' textile workshop in Rožnov. The English influence was also evident in the architecture of middle-class houses and villas. Architects such as Dušan Jurkovič and Jan Kotěra borrowed key elements like the English staircase, and other details that determined the ambience of interiors. English bathroom appliances and lavatories were also much copied. At a later stage, Japanese influences penetrated via France and England and became incorporated in the design and decoration of ceramic services.

Although the influences of global Art Nouveau were welcomed with open arms and were regarded as a catalyst for cultural emancipation, a chance to catch up with western culture, they were also viewed with a certain degree of prejudice and reserve. Critics of the Vienna Secession accused the movement of being overly stylised, boring and monotonous. However, the real problem was that the Secession was the official style of the Austrian authorities and could thus expect fierce opposition from the Czechs, who resisted any form of central government from Vienna. This is the only possible explanation for the scandal that threatened to follow the 1900 publication of an article on the work of Viennese architect and professor Otto Wagner.[7] French and Belgian influences – graceful and dynamic line compositions that determined the form and decoration of furniture, glass and ceramics, book bindings, architectural elements, jewellery, cutlery and the like – met with great sympathy. Such influences were welcomed for their link with French republicanism, their similarity to local traditions and because the floral

150
Josef Fanta and Ludvík
Wurzel, **Chair**, 1900,
Uměleckoprůmyslové
museum v Praze, Prague

151
Josef Fanta, **Lamp**, 1900,
Uměleckoprůmyslové
museum v Praze, Prague

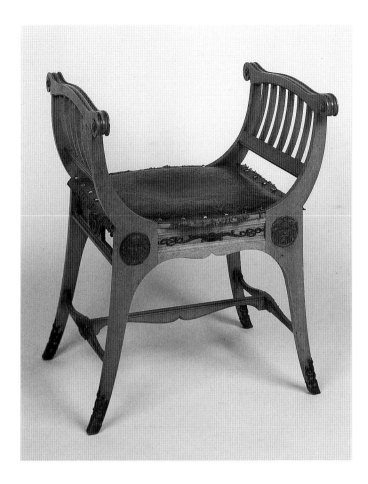

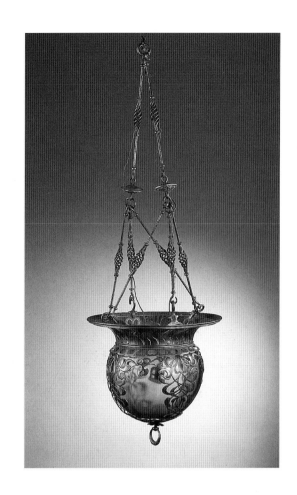

152
Josef Fanta, **Supraporta**,
1900, Uměleckoprůmyslové
museum v Praze, Prague

ornamentation, poetry, lyricism, eroticism, nostalgia and energy so characteristic of French and Belgian Art Nouveau had much in common with Slavic sensualism.

However, designs for posters, jewellery and cutlery by the Czech Alfons Mucha, a key figure in French Art Nouveau, were treated with suspicion in his native country: critics were quick to judge them too fashionable and frivolous. Czech artists were often the first to express doubts when a fellow Czech artist gained international recognition. The growing importance of rationalism, particularly in the work of Jan Kotěra, also sidelined the influence of artists such as Mucha and Hector Guimard in Czech circles. Mucha's designs, which were published

in Paris in the years 1898 to 1905, struck a more sympathetic chord with industrial artists, for example, at the glassworks in Prague.[8] The products of such works, and the studios of Jan Syvalter, Wolf and Štětka, Gustav Habich, Josef Vlasák and others, were typical of the Czech version of Art Nouveau. They included decoratively glazed or etched glass, as well as traditional stained glass, which was generally based on foreign designs for use in the new villas and apartment blocks being built in various Prague districts.

With its emphasis on stylisation, this 'new art' offered the applied arts an opportunity to express its new principles in different ways. Under the banner of the so-called

153
Friedrich Ohmann,
Central Hotel,
1899–1901, Prague

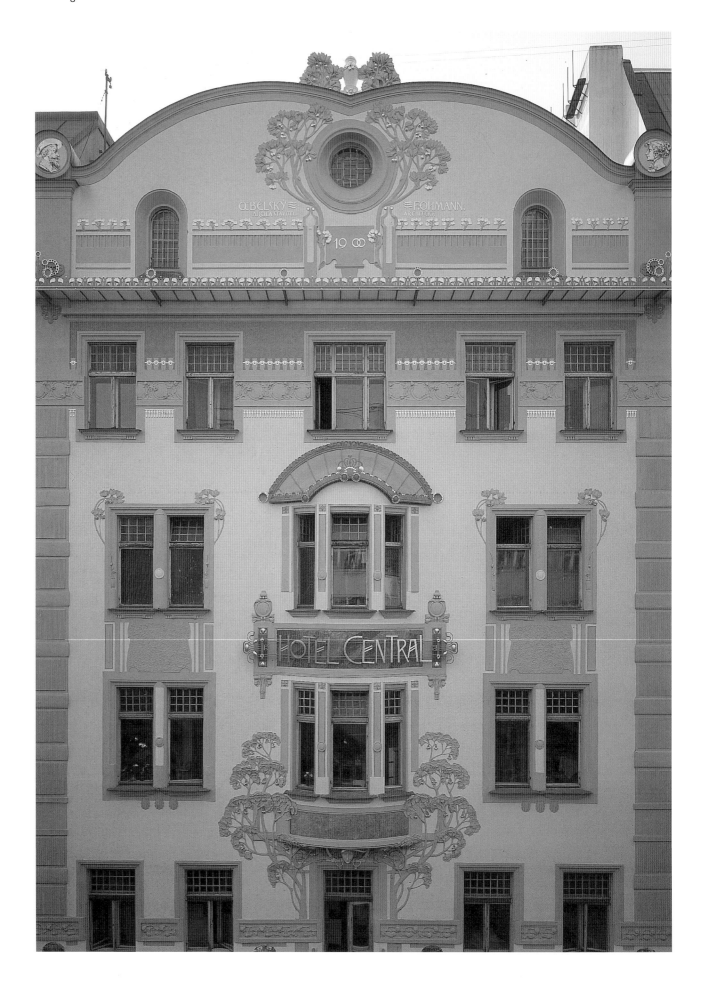

154
Karel Babka, **Vase**, c. 1900,
Uměleckoprůmyslové
museum v Praze, Prague

Gesamtkunstwerk architects, sculptors, painters and other artists began to design applied art. Their collaboration with Czech industry, workshops and schools provided a useful experience of 'one-off design', which would become a speciality of Czech art more than fifty years later. In addition to all the care lavished on unique works of art, artists also became interested in ordinary, everyday objects, or design with an industrial character.

The Secession movement's ideas on style soon acquired highly expressive substance in glass products. The Bohemian glass industry had led the field during the Baroque and Biedermeier periods. It now rose to the challenge of etched and engraved glass by the Frenchman Emile Gallé, and the French firm Daum, with products made by Harrachov, Moser, Rückel and others. Acceptance of Secessionist style was considerably accelerated when unique glass pieces made by the American Louis Comfort Tiffany were exhibited by the Liberec Museum in 1897. One of the leading glassworks was the Loetz company from Klášterský Mlýn in southern Bohemia, which won international renown. From 1897, the company, which was run by its owner, the nobleman Max von Spaun, collaborated with prominent figures from the art world such as Koloman Moser, Josef

155
Comb with Medusa,
Turnov Technical College
for Gold and Silversmithing,
c. 1900,
Uměleckoprůmyslové
museum v Praze, Prague

156
František Anýž, **Brooch**, c.
1900, Uměleckoprůmyslové
museum v Praze, Prague

Hoffmann, Leopold Bauer, Adolf Beckert and the painter
and textile designer Marie Kirschner. However, most
glass manufacturers (Wilhelm Kralik & Sons in Lenora,
Josef Pallme–König & Habel or Josef Rindskopf in
Košt'any near Teplice, Carl Goldberg and Josef Gerner in
Bor) produced large series of pieces that had not been
commissioned by a designer.

Ceramics were less acclaimed than Czech glass,
despite being of good quality, such as the ware industri-
ally produced in the region around Teplice, Duchcov,
Znojmo, Blansko and Trnovany. As with glass, schools
and academies played a key role in production. The
Prague School of Applied Art, the ceramic school in
Bechyně, southern Bohemia, and the technical school in
Znojmo, southern Moravia, all subscribed to the geo-
metric Viennese style. The school in Teplice felt more
sympathy for French influences. In addition to excel-
lent pieces by Celda Klouček and Anna Boudová-
Suchardová, two sculptors made outstanding contribu-
tions to the new modernist theory: the mystic
František Bilek and the Symbolist Ladislav Šaloun (fig.
164).

Metal casting, metal work and jewellery formed a dis-
tinctive facet of the new Secessionist style, although
these disciplines did not always achieve the stylistic
intensity of non-Czech products. Together with the
Prague schools, Turnov Technical College played an
important role in the field of jewellery. Marie
Křivánková-Eretová, a self-taught jewellery designer from
Prague, helped to create a new formal language for
Czech jewellery: she replaced the Secession's fluid,
stylised play of lines with an expressive geometric form
and strictly geometric ornamentation.

Modernism and individual design

As early as 1900 some Czech designs displayed a dislike
of organic forms and ornaments. From around 1905, geo-
metric tendencies began to supplant the dynamic forms
of Secesssion style, converting floral modernism into a
geometric version. This development was not simply a
question of different decorative styles, but a shift in the
entire concept of spatial design and other functions of
applied art. This is demonstrated by works which express
the rationalist ideas of the Belgian Henry van de Velde,
developed under the influence of Otto Wagner (motto:
'there is only beauty in what is functional'), or of his
three architect colleagues from Vienna, Joseph Maria
Olbrich, Adolf Loos and Josef Hoffmann. The Czech

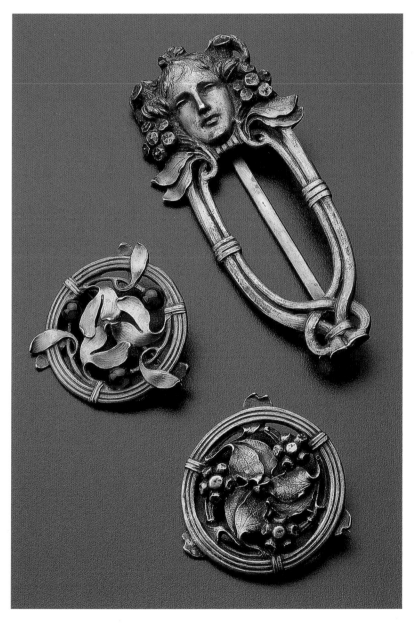

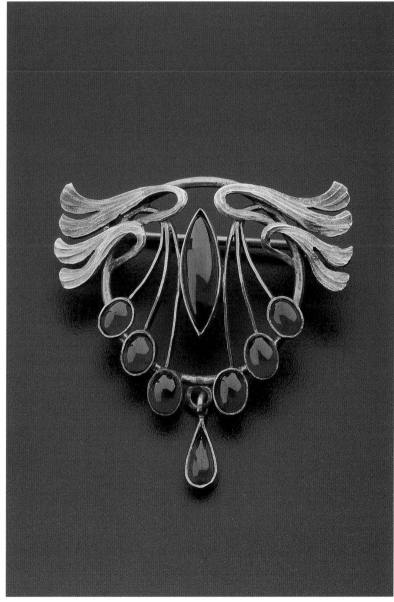

157
Emanuel Novák, **Clasp and
two brooches**, 1900,
Uměleckoprůmyslové
museum v Praze, Prague

158
Brooch, Turnov Technical
College for Gold and
Silversmithing, 1900,
Uměleckoprůmyslové
museum v Praze, Prague

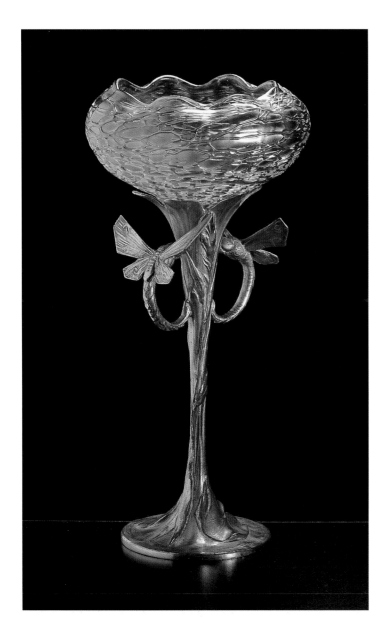

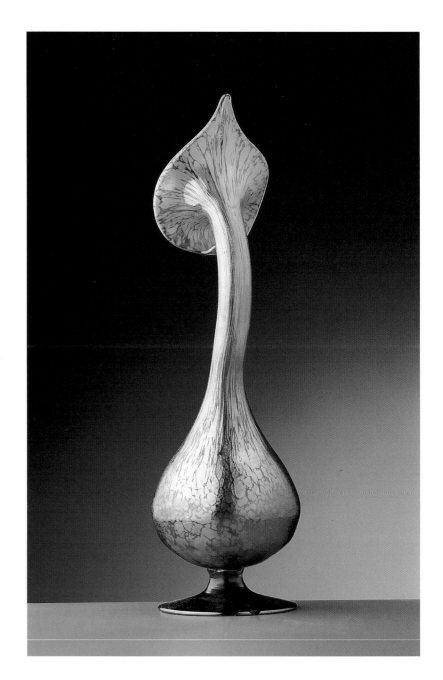

159
Goblet, Johann Loetz
Witwe glassworks,
Klášterský Mlýn, 1896,
Uměleckoprůmyslové
museum v Praze, Prague

160
**Vase with butterfly
motif**, Johann Loetz Witwe
glassworks, Klášterský
Mlýn, 1898,
Uměleckoprůmyslové
museum v Praze, Prague

Vase with butterfly motif

Although founded in 1836, the Loetz family glass-
works in Klášterský Mlýn, a small town in Šumava
(Bohemian Forest), were not the oldest works in
Bohemia. The company was renowned for its use of
coloured glass, fine cubist decorations and, above all,
Tiffany-style iridescence (decoration with parallel,
wavy glass filaments, smudgy iris motifs, 'butterfly'
technique and the like). Loetz successfully participat-
ed in World's Fairs in Europe (Paris 1889 and 1900)
and the United States (St. Louis 1904, Chicago
1893). From 1900, designs were produced by artists
such as Kolo Moser, Marie Kirschner and Josef
Hoffmann.

161
Miroslav Havlík, **Vase
(Wave)**, c. 1900,
Uměleckoprůmyslové
museum v Praze, Prague

162
Anna Boudová-Suchardová,
Vase with masquerons,
1900, Uměleckoprůmyslové
museum v Praze, Prague

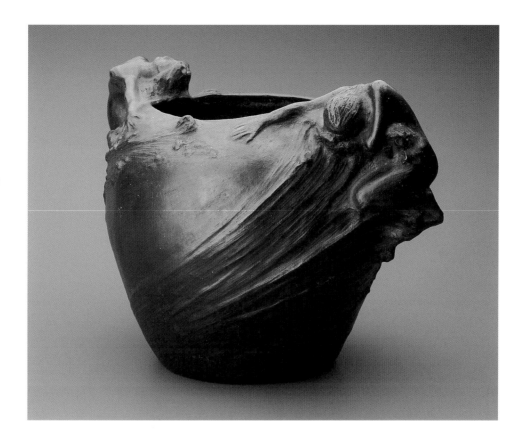

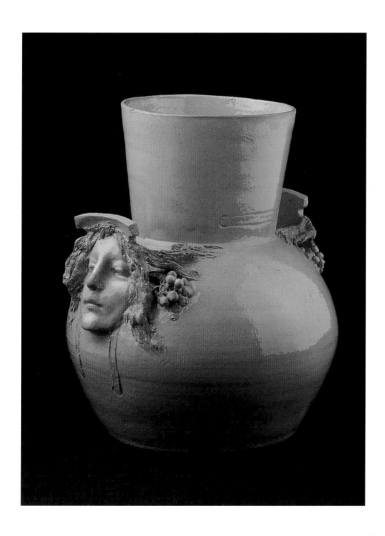

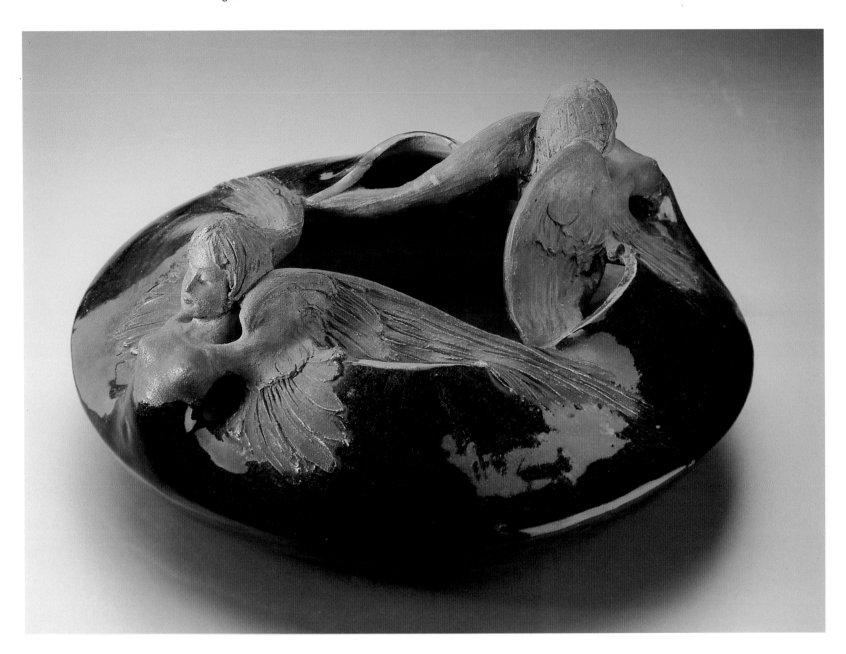

163
Anna Boudová-Suchardová,
Dish with harpies, 1900,
Uměleckoprůmyslové
museum v Praze, Prague

modernist movement was also attracted by the decorative geometry of Scottish architect and designer Charles Rennie Mackintosh. The new poetics were described by Šalda in an article in which he eulogised a plainly designed, abandoned railway bridge as the embodiment of the Constructivist ideal.

However, the work of architect Jan Kotěra, a pupil of Otto Wagner, was of overriding importance in the sphere of geometric and Constructivist design. Kotěra was a member of the Mánes association, a professor at the Prague School of Applied Art and, from 1910, a professor at the Prague School of Fine Art. Although his wide-reaching activities as an architect, designer, pedagogue, theoretician and publicist generated many conflicts, his ideas gradually won acceptance. Kotěra spent the first five years of his career developing his own austere style.

By 1900, however, he had already formulated the theoretical aspect of his avant-garde path: to Kotěra, architecture was primarily the organisation and construction of space, with ornamentation a secondary consideration.[10] Kotěra was unable to put his ideas into practice in Prague until 1906, after which he built his own villa on Hradešínská, a house for the publisher Jan Laichter on Chopin Street in the Vinohrady district (fig. 170), a water tower in the Michle district and other edifices. The museum in Hradec Králové, eastern Bohemia, built in the years 1909–1913, is considered the most important work of Kotěra's architectural career (fig. 175). In the buildings mentioned above, Kotěra achieved perfect harmony between architecture and interior as he designed everything down to the smallest detail, even the decorations and minor functional elements (railings, banisters, door handles, etc.).

164
Ladislav Šaloun, **Vase (The kiss)**, 1899,
Uměleckoprůmyslové museum v Praze, Prague

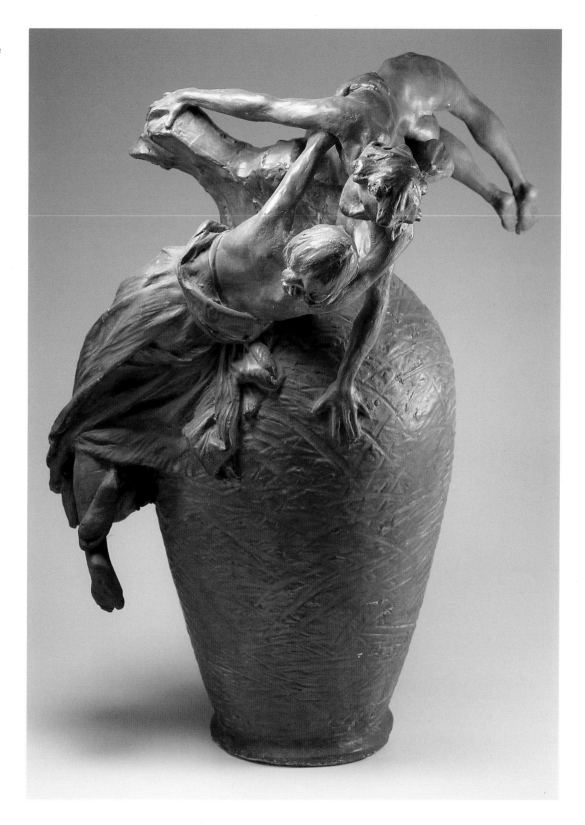

Vase (The kiss)

With this original design, Šaloun won a competition organised in 1899 by the journal *Volné směry* (Free directions). His design was then produced in a small series by a ceramic works in Bechyně, southern Bohemia. Šaloun was an important representative of the Secession movement in Czech sculpture. He cre- ated a variety of important statues and figure groups, and also taught at the Prague School of Applied Art. Throughout his career, Šaloun remained true to a lyrical Secessionist style. As well as monumental sculptures, he also produced many small, high-quality designs.

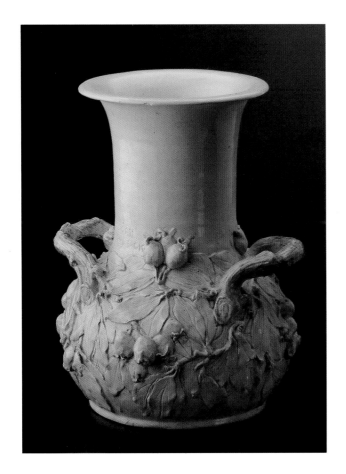

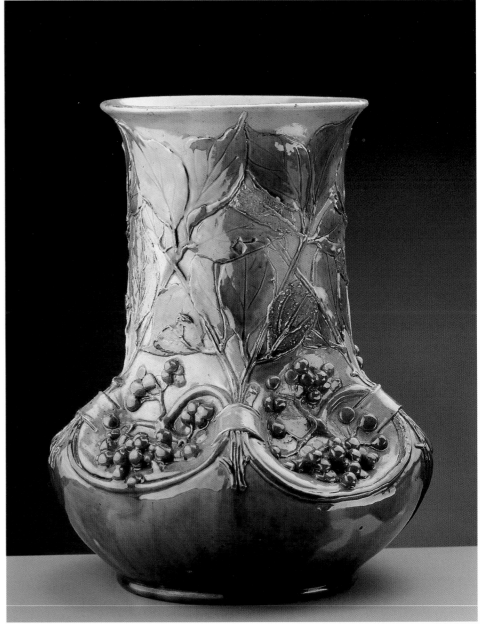

165
Václav Mařan, studio of
Celda Klouček, **Vase**, 1899,
Uměleckoprůmyslové
museum v Praze, Prague

166
Václav Mařan, studio of
Celda Klouček, **Vase**, 1899,
Uměleckoprůmyslové
museum v Praze, Prague

He taught in the same spirit at his special class in decorative architecture at the Prague School of Applied Art. He also chose to design furniture, producing pieces which clearly show his evolution from graceful Art Nouveau plant motifs to a more severe style.

Glass was another sector of the applied arts that Kotěra considerably influenced through his pupils. He only produced one piece himself, a cut-glass bowl set with an engraved tendril decoration, which he designed in 1904; the Harrachov glassworks later made this for Artěl in a plain version without the engraving (fig. 184). The set is unique for this period because it combines an obviously architectural and monumental structure with a practical use. The multi-talented Kotěra is also regarded as the founder of modern industrial design, due to his

famous 1898 design for the Prague tram, which was manufactured by the Ringhoffer firm of Prague.

In the Czech art world a special name, 'individual modernism', was given to designs and projects from what is known as the 'austere period' of Kotěra and his pupils Otakar Novotný, Josef Gočár and several other champions of Viennese architecture, such as Josef Rosipal, who graduated from Prague Technical College. Undoubtedly this was because their particular style was extremely emancipated. Given the Secessionist tendency to cling to decoration and colour, and the movement's general aestheticising of the object, geometric or individual modernism could only be a secondary movement. Nevertheless it proved a fundamental force in the wider development of Prague architecture and applied art. The

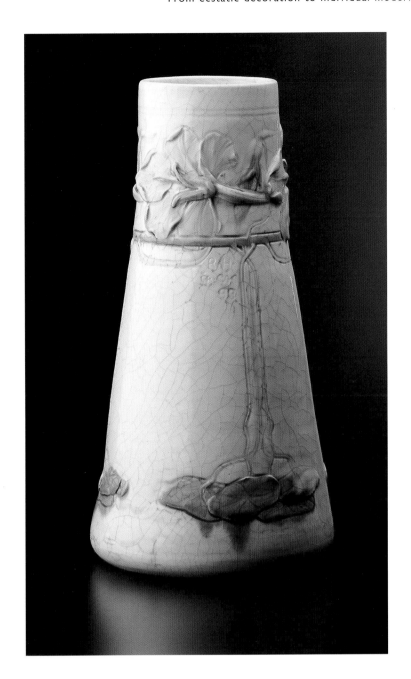

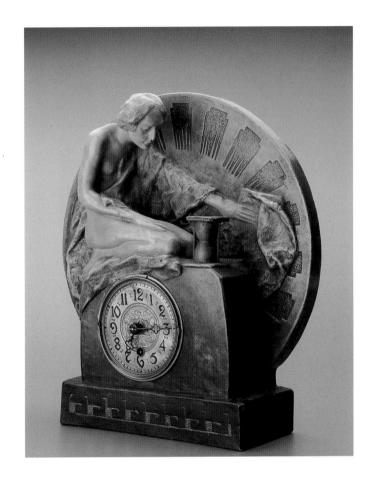

167
Rudolf Hamršmíd, **Vase**,
1899, Uměleckoprůmyslové
museum v Praze, Prague

168
Karel Gabriel, **Clock**, made
by the Bechyně ceramics
workshop, after 1900,
Uměleckoprůmyslové
museum v Praze, Prague

glassworks responded effortlessly to this new movement,
chiefly following the initiative of Rindskopf at Košt'any,
Riedel at Polubný and the Harrachov works. Although the
latter briefly specialised in the production of Tiffany glass,
from 1905 the works devoted some of their output to
individual modernism. This was certainly due to the influ-
ence of Kotěra and his pupils whose designs were made
exclusively by the Harrachov works after 1908. Many of
the ideas and creative principles propounded by individ-
ual modernism proved prophetic visions which would
later be fully developed by the Constructivist and Cubist
movements in the Czech applied arts.

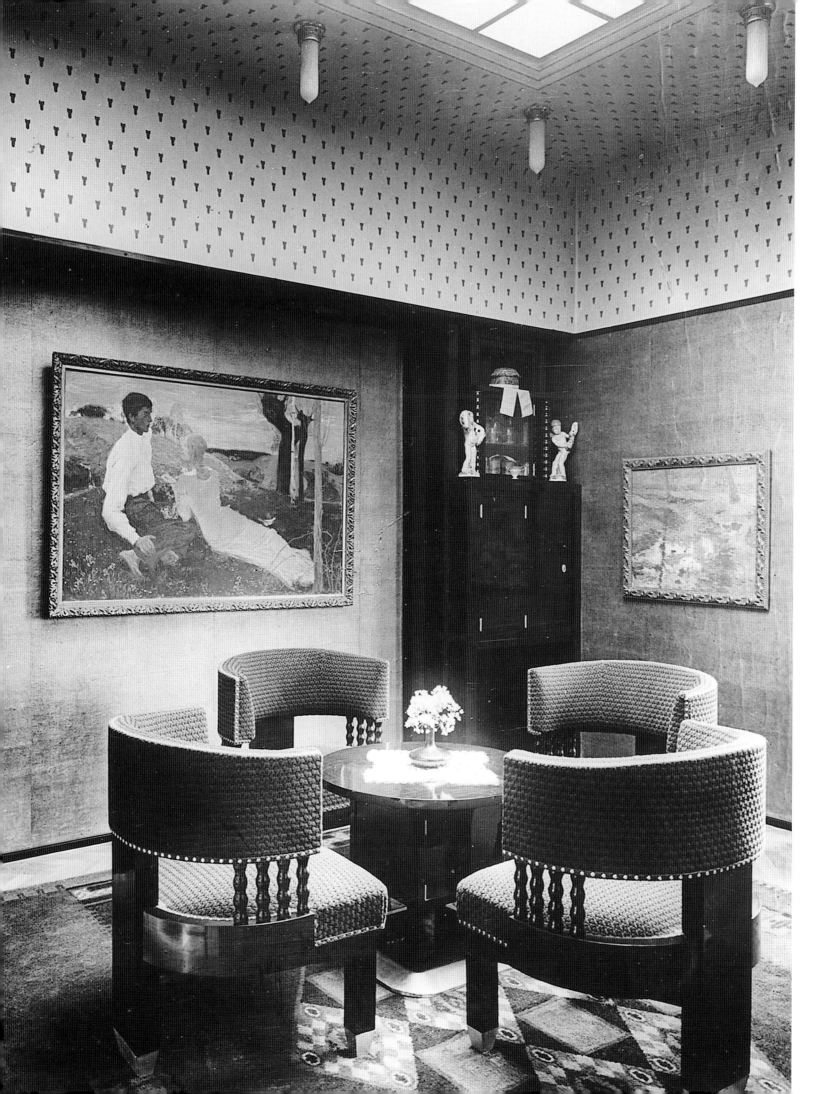

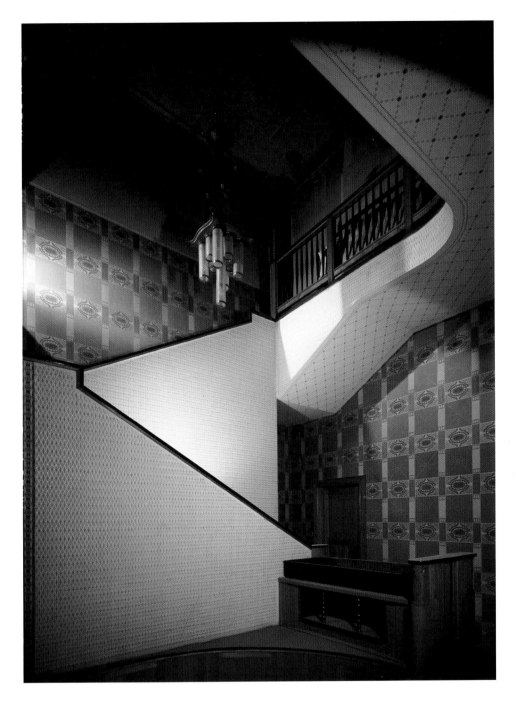

170
Jan Kotěra, **Hall in Jan
Laichter's house**,
1908-09, Prague

169
Interior of Jan Kotěra's
home, Prague

Hall in Jan Laichter's house

Kotěra's 1908 design for Laichter's Prague home made an important contribution to new ideas on modern living. The architect/designer based his design on the concept of a home to meet the needs of a natural, physical lifestyle. Kotěra broke new ground in his subtle and careful division of the functions in the different living areas and in the relevant furniture. He connected the kitchen, office, living room and other areas in surprising ways and equipped them with various pieces of furniture and accessories. Kotěra designed some of the furnishings himself, and chose the rest with great care.

The Laichter family dining room, equipped with a sideboard, a dresser and a table with six chairs, is based on style of the Vienna Secession. In order to meet functional requirements, however, this style was modified by Kotěra's rationalist outlook, which is evident both in the construction, the use of space, the furnishings and all the accessories. The whole interior displays Kotěra's own unique style, which incorporates his personal interpretation of English and Viennese models. The seating in particular betrays the influence of Ludwig Baumann. However, Kotěra radically changed the geometric 'awkwardness' of Baumann's armchair – which was much written about in the period – creating a sophisticated design through the addition of curves in the seat section and runner and the addition of a third leg.

The furniture from Laichter's dining room was acquired from his heirs in 1965 by the Museum of Decorative Arts in Prague.

171
Jan Kotěra, **Silverware cabinet for Laichter's house**, 1908, Uměleckoprůmyslové museum v Praze, Prague

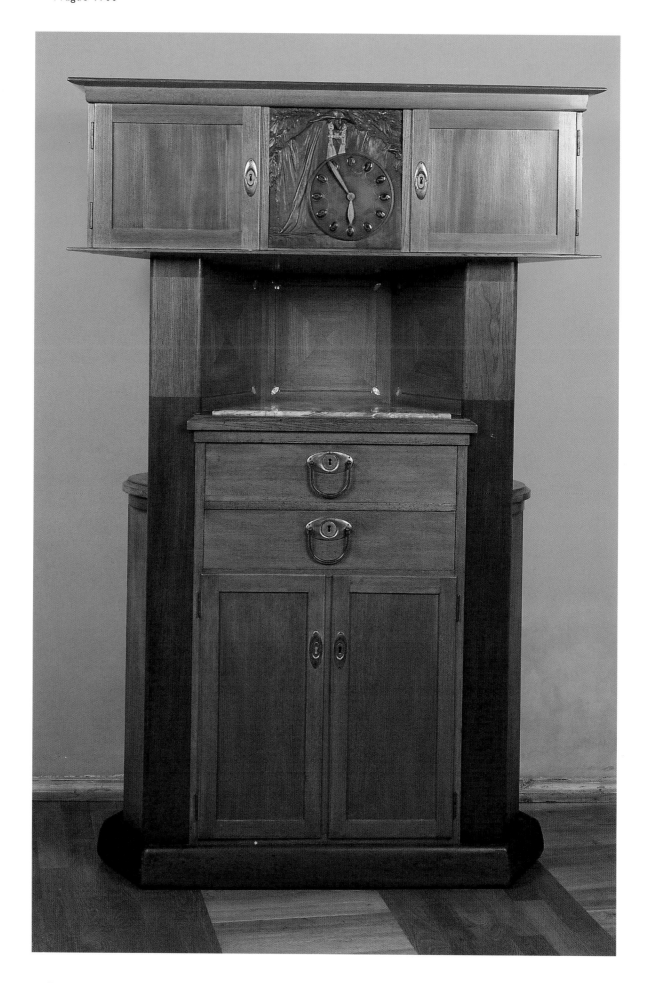

172
Jan Kotěra, **Table for Laichter's house**, 1908, Uměleckoprůmyslové museum v Praze, Prague

173
Jan Kotěra, **Armchair for Laichter's house**, 1908, Uměleckoprůmyslové museum v Praze, Prague

Armchair for Laichter's house

This armchair comes from the dining room in the house of the Prague publisher Jan Laichter. Jan Kotěra's furniture, a high point in his oeuvre, is characterised by measured expression, a feeling for the beauty of natural materials and progressive views on the layout and furnishing of a home. The architecture of Laichter's house is based on strict geometric form which is also typical of British architects such as Charles Rennie Mackintosh.

174
The Chamber of Commerce pavilion during the 1907-08 Jubilee Exhibition, Prague

175
Jan Kotěra, **Museum in Hradec Králové**, 1909-13

176
Ludvík Bradáč, **Cover for
'The ways of beauty' by
Arnošt Procházka**, 1908,
Uměleckoprůmyslové
museum v Praze, Prague

177
Marie Křivánková,
Pendant, after 1910,
Uměleckoprůmyslové
museum v Praze, Prague

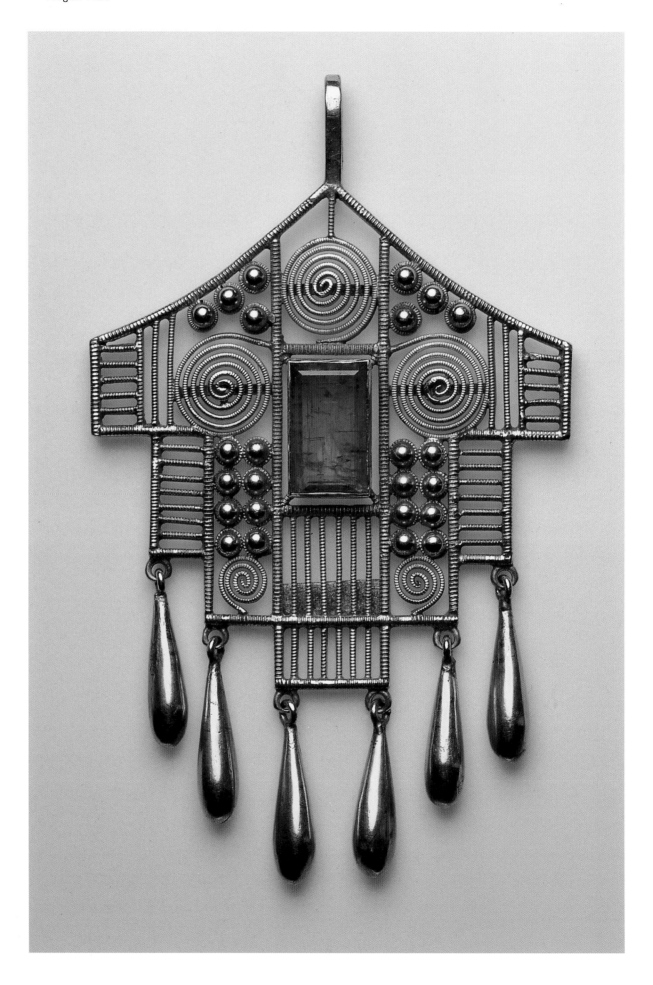

178
Josef Ladislav Němec,
Pendant, 1907,
Uměleckoprůmyslové
museum v Praze, Prague

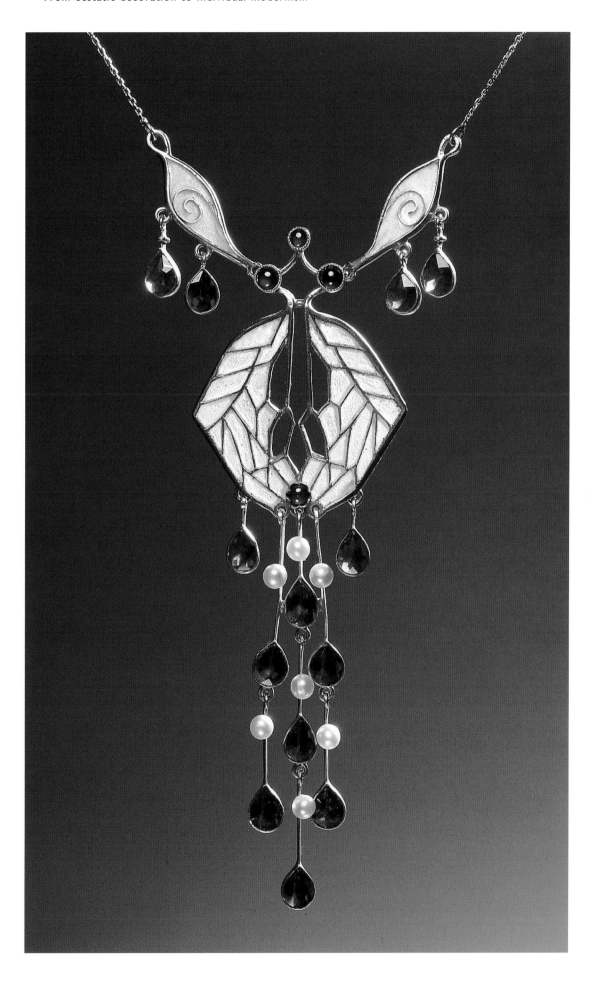

179
Eugen Pflaumer, Jablonec
nad Nisou Technical School,
Pendant, c. 1908, North
Bohemian Museum, Liberec

180
Eugen Pflaumer, Jablonec
nad Nisou Technical School,
Pendant, c. 1908, North
Bohemian Museum, Liberec

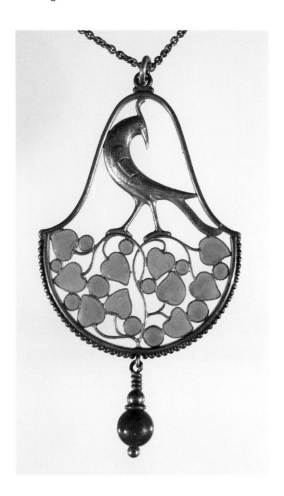

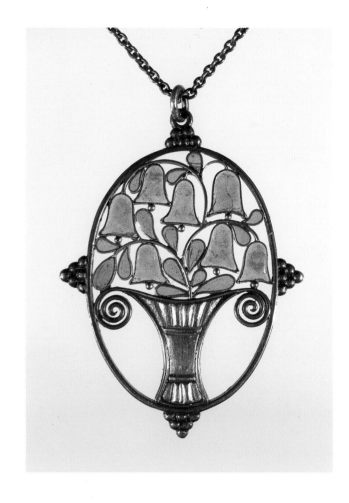

181
Jaroslav Maštalíř,
Bonbonnière, 1909,
Uměleckoprůmyslové
museum v Praze, Prague

182
Karel Ebner, **Bonbonnière**,
1909, Uměleckoprůmyslové
museum v Praze, Prague

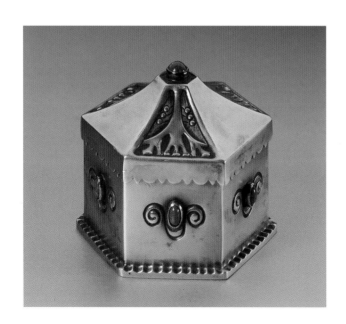

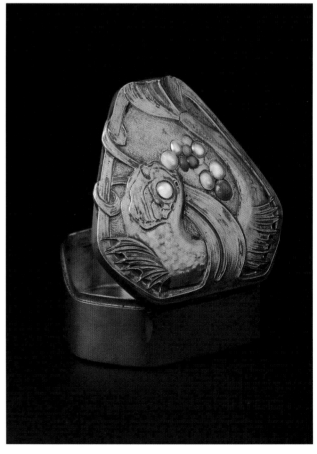

183
Vojtěch Preissig,
Wallpaper design, 1899,
Uměleckoprůmyslové
museum v Praze, Prague

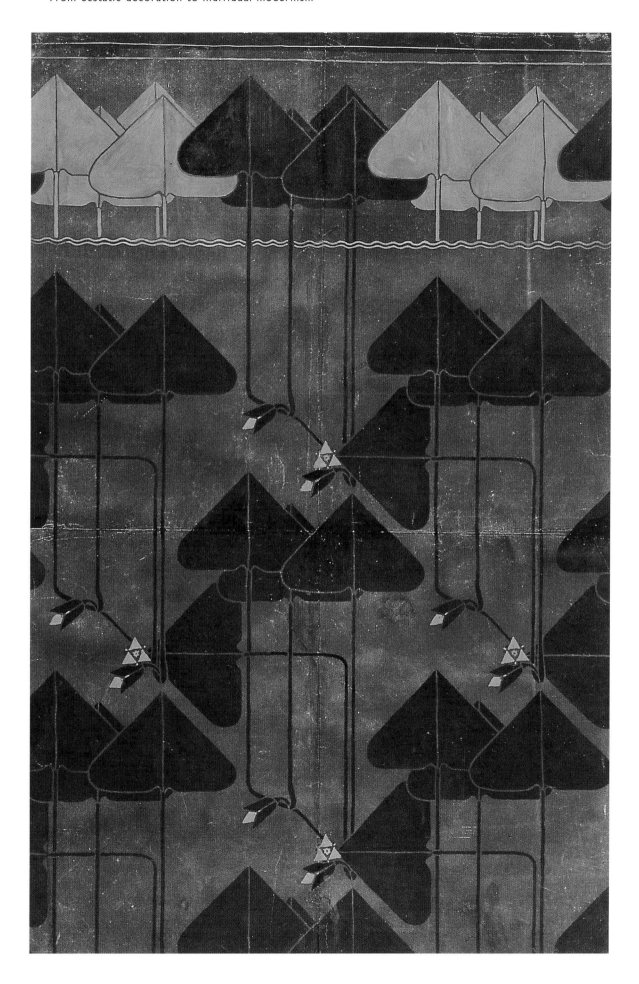

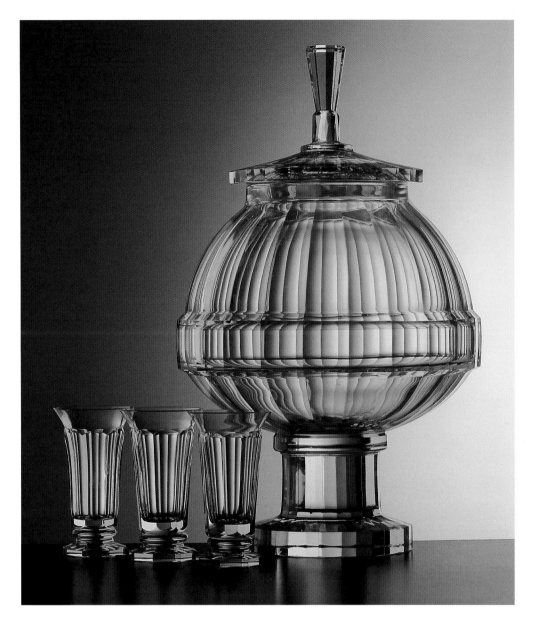

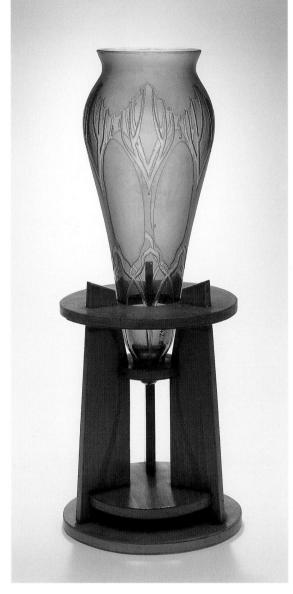

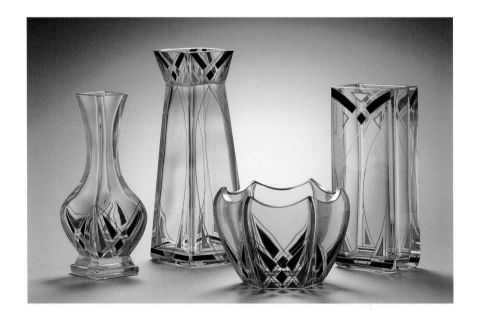

184
Jan Kotěra, **Bowl set**,
Harrachov glassworks,
Nový Svět, 1904–10,
Uměleckoprůmyslové
museum v Praze, Prague

185
Otakar Novotný, studio of
Jan Kotěra, **Vase**,
1899–1900,
Uměleckoprůmyslové
museum v Praze, Prague

186
Vases, Josef Riedel
glassworks, Polubný, before
1904, Uměleckoprůmyslové
museum v Praze, Prague

187
Marie Kirschner, **Vase**,
Johann Loetz Witwe
glassworks, Klášterský
Mlýn, 1903,
Uměleckoprůmyslové
museum v Praze, Prague

188
Carl Schappel, **Vase**, Johann
Oertel glassworks, Bor
(Haida), 1912,
Uměleckoprůmyslové

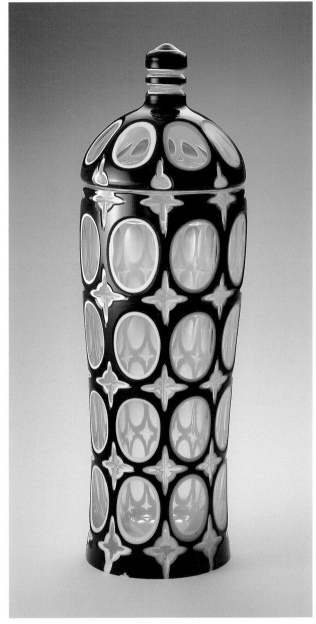

Vase

In the years 1902-14, the multi-talented Kirschner
specialised in glass designs. These were mainly vases
with compact geometric patterns, muted colours
and measured decoration and were produced by the
glassworks in Klášterský Mlýn. For these decorative,
yet functional objects, Kirschner adapted the form to
the qualities of the material, creating original and
elegant designs.

Vase

This goblet (vase) with concave lid is made of
layered glass, coated with black and white and
decorated with engraving. From 1905, the geometric
ornamentation of Viennese and German products
permeated the northern Bohemian glassblowing
region, further enriching the engraved glass
decoration. The Nový Bor glassworks gained renown
both at home and abroad. Its products were
characterised by the varying forms and depths of
engraved decoration, plus the cutting away of
coloured glass layers.

189
Vase, Rydl and Thon
Company, Svijany, before
1908, Uměleckoprůmyslové
museum v Praze, Prague

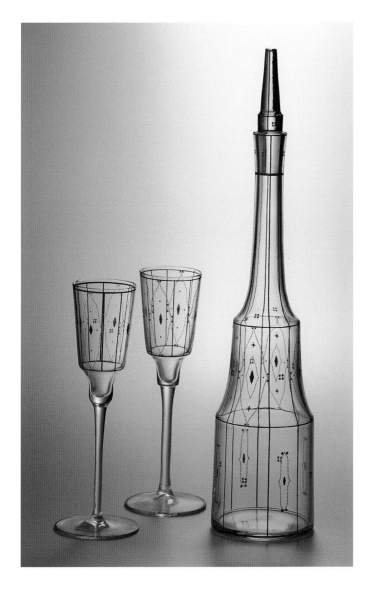

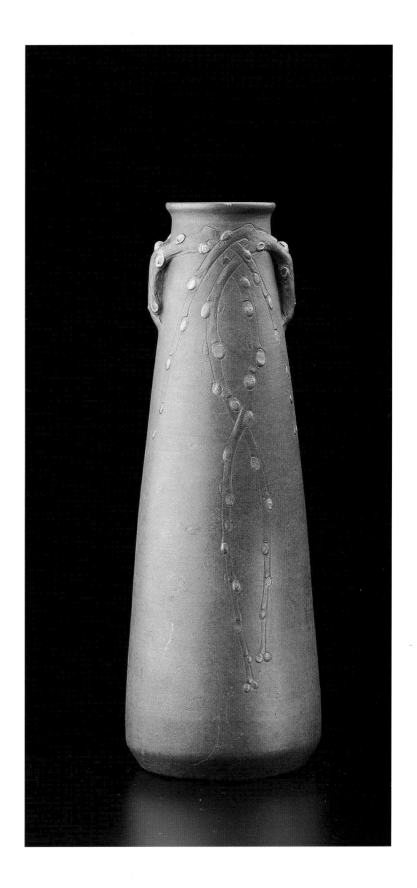

190
**Wine set (carafe with
two glasses)**, glassworks
in Bor (Haida), 1912,
Uměleckoprůmyslové
museum v Praze, Prague

191
Václav Švec, studio of Celda
Klouček, **Vase**, 1908,
Uměleckoprůmyslové
museum v Praze, Prague

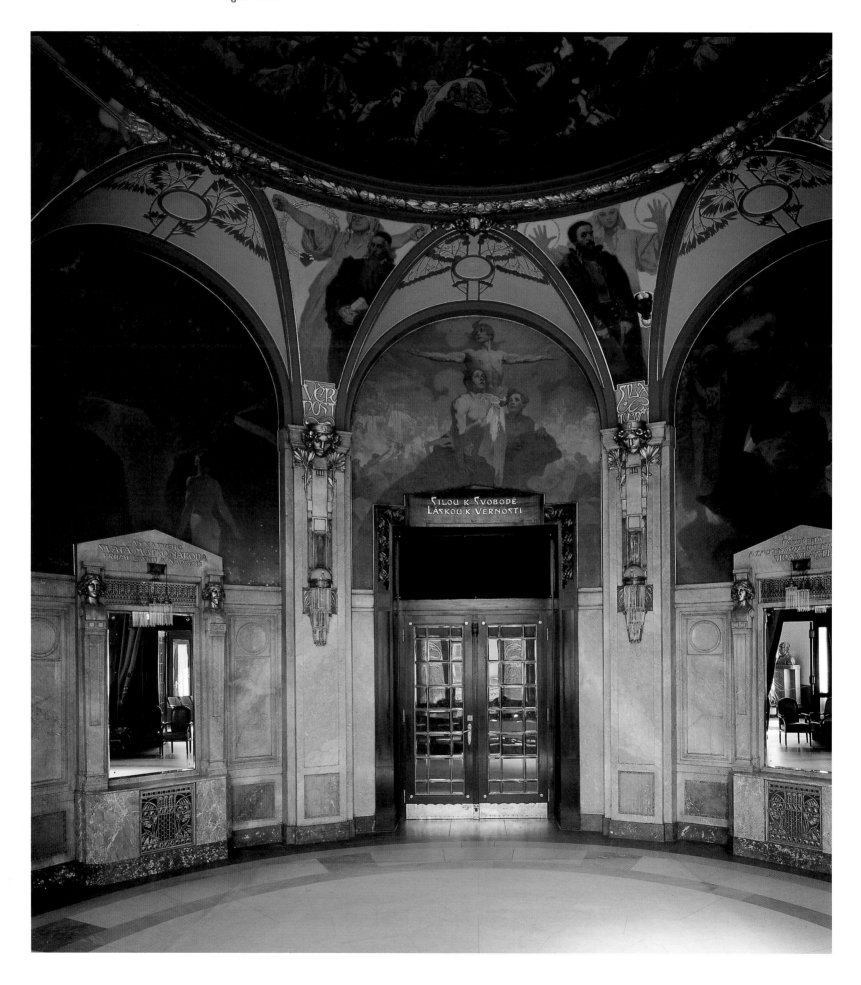

The discovery of a new beauty
The installation of exhibitions and interiors

Roman Prahl

'**In spite of all of its temporary aspects an exhibition, more than any other enterprise, has certain obligations to a period or a moment. Should an exhibition have to propagate a particular style, then it should be a purely modern one, even if others reject it as being excentric.**'[1] **This was the criticism launched by the modernist Zdeněk Wirth at the Jubilee Exhibition of 1908, one of the last in a series of large, general expositions that were held in Prague around the turn of the century.**

In this period, which was defined by strongly changing views on life and living conditions, new links were discovered between art, architecture and industrial production. The installation of an exhibition, particularly in Prague, was also increasingly seen as a means of encouraging self-reflection in modern man. The above quote provides evidence of the large arsenal of creativity and inspiration that was ascribed to an exhibition at the time of the Secession movement and modernism: an exhibition represented the confluence of the activities of architects, designers and artists. Furthermore, in the quote, the term 'style' appears to have been given a different meaning. It became one of the key words in the resistance to artistic conformity and in the pursuit to overthrow the passivity of the visual culture. In the eyes of the artists, the historic *styles* in architecture and ornament had been reduced to hollow and derivative forms.

From Salon to Gesamtkunstwerk

Both the presentation of interiors (at expositions and in journals) and art exhibitions was subject to the very latest trends. These two innovative areas, seemingly far removed from each other, had been steadily growing closer together in the course of the nineteenth century. More than in any other domain, it was here that architects, designers and artists found the necessary freedom to develop an individual approach. Simultaneously, they tried to convince the public at large of their alternative to contemporary industrial mass production. Accordingly, they explored new possibilities for familiarising the public with concepts such as 'beauty' and 'truth'.

The point of reference for this renewal was the standard international form of exhibition installation that prevailed in the second half of the ninteenth century. In these exhibitions the walls were densely hung with paintings, hanging literally 'frame to frame', while the space itself was filled with furniture surrounded by rich tapestries and enhanced with bouquets and other accessories. In fact, their function was that of a salon in an upper-middle-class home. By creating a cross between an exhibition and a salon, a bridge was built to the milieu of the wealthy and art-loving amateur. Objections to the osten-

192
Municipal House, Prague, Interior of the Mayorial Hall with decorations by Alfons Mucha, 1910-11

193
Adolf Liebscher, **Design for a poster for the Jubilee Exhibition in Prague**, 1891, Uměleckoprůmyslové museum v Praze, Prague

194
Interior of the Jubilee Exhibition in Prague, 1891

tatious display and the bourgeois aura emanating from such an interior, crammed with luxurious but otherwise mostly unrelated objects, were first uttered by artists in Paris; the criticisms grew explosively as a result of the upheaval engendered by Secession artists in Central Europe.[2]

Ultimately, it was the avant-garde artists – the propagators of the Secession style – who wanted to effect a radical revision in the art of installing exhibitions and interiors. Their criticism and revolt represented one side of the coin, and evolution the other. As is known, the English tradition in the reformation of industrial art was a source of inspiration for Secession art with respect to

a new style for the applied and fine arts. Another, continental, source for their ideas for a new dynamic unity of various art forms was the older, extremely influential concept of the *Gesamtkunstwerk*, as first formulated by the composer Richard Wagner for large theatrical and operatic productions.[3]

The changes in Prague

Artistic Prague at the turn of the century affords interesting examples of this evolution and of the innovations in the installation of exhibitions and interiors. To be sure, while this development did not follow a straight path, the

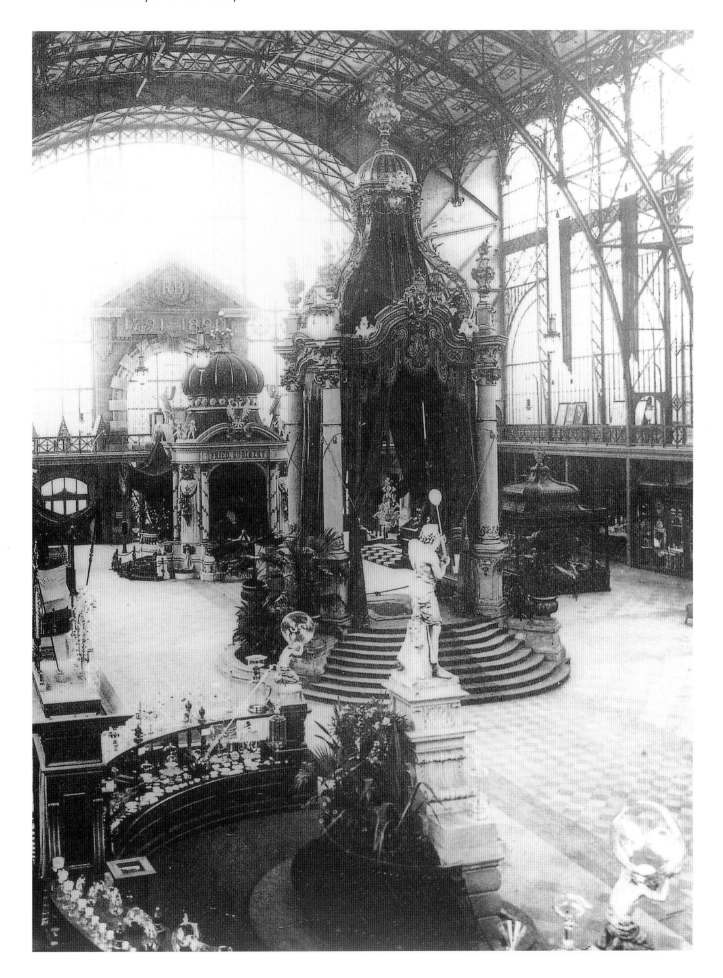

195
Jan Kotěra, **Interior of
the Prague School of
Applied Art at the Paris
World Fair**, 1900

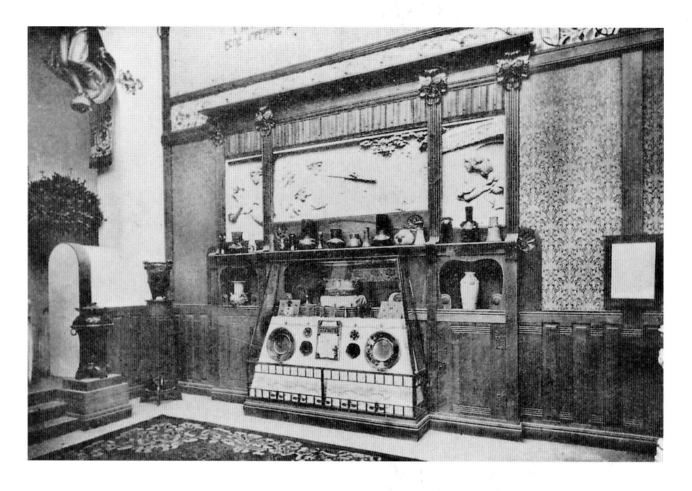

influence of its results was to be great. The more tradi-
tional tendency was represented by the Rudolfinum
(Artists' House), which as of 1885 annually hosted an art
salon. Despite the increasingly dire lack of space in the
Rudolfinum, at the end of the nineteenth century the
annual art salon also comprised commercially attractive
products of contemporary applied art, displayed in spe-
cially designed spaces. As in Vienna, dissatisfaction with
the diversity and hybrid character of this type of salon
grew rapidly among artists in Prague as of the beginning
of the 1890s. Still, due to their popular success, they con-
tinued to be organised right up to the First World War.

Criticism of the Prague art salons, initially primarily
voiced by artists who were committed to national social
concerns, did not subside after their demand to exhibit
their work collectively in one of the rooms had been
met. The abstract identification of national emancipation
with modernity in art only began to disintegrate after the
1891 Jubilee exhibition, which in turn was organised
under the direct influence of the Parisian World Fair of
1889. The Jubilee exhibition mounted on the occasion of
the centenary of the first industrial exposition in
Bohemia, signalled a 'national' alternative for the 'cos-
mopolitan' Rudolfinum. The exhibition itself, however,

prompted the first serious conflicts between Czech
artists, anticipating the Secession movement. The first
'modern' counterparts of large-scale expositions like
those held in the Rudolfinum or the 1891 Jubilee exhibi-
tion, were the smaller shows organised for a select audi-
ence interested in modern art trends: for example, the
exhibition gallery of the publisher František Topič, where
the first two shows of work by Czech Secessionists and
modernists were mounted by the Mánes Artists'
Association in 1898.[4]

Criticism of the annual salon, which had already
appeared in the first year of its existence (1896-97) in the
journal *Volné směry* (Free directions), primarily concerned
the traditional presentation of works of art: the salon did
absolutely no justice to the individuality of the various
artists and their work. Although from our vantage point,
no clear distinction can be made between the installation
of the annual salon and that of Mánes' first exhibitions, as
photographs of the time reveal, the criticisms of the
Prague liberal art salon struck a vital chord. Not only did
the works on view have to be carefully selected on the
basis of their quality, they also had to be exhibited in such
a way that they did not interfere with each other,
stronger still, they had to reinforce each other.

196
Jan Kotěra, **Interior of
the third Mánes exhibi-
tion with works by
František Bílek**, 1900

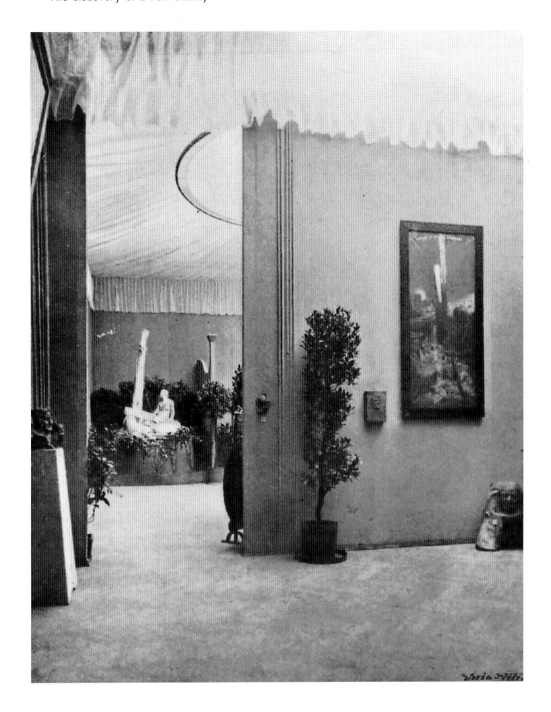

Parallel to the developments within the art salon at
the Rudolfinum, a growing interest emerged in the artis-
tic designing of exhibition areas and their installation of
applied art as of the mid–1880s. In Prague, this was sup-
ported by the School of Applied Art and the Museum of
Applied Art, which had been established by the Chamber
of Commerce. At a spacious Prague venue (Výstaviště:
trade fair grounds), specially installed for the Jubilee exhi-
bition of 1891, the Prague architects, designers and
craftsmen/artists had already gained experience in creat-
ing and installing interiors in the modern fashion. This
experience would serve them well at the large national
exhibitions that were to follow: the ethnographic exhibi-

tion of 1895 and the 1898 exhibition devoted to archi-
tecture and civil engineering.

The Chamber of Commerce and the School of
Applied Art each ultimately installed their interiors at the
Prague presentation at the 1900 Paris World Fair. The
most important exponent of the School of Applied Art
was Friedrich Ohmann, the architect of the first Prague
buildings in the Secession style. The recognition awarded
both interiors at this exhibition was chiefly related to
the quality of the designs and the execution of a few
individual objects, rather than their overall effect. It was
difficult to achieve such an all-encompassing effect under
the frequently altering circumstances, particularly since it

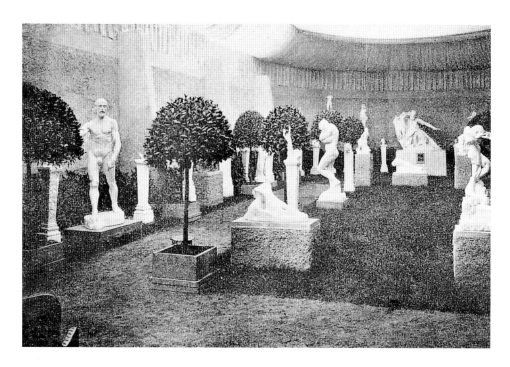

197
Jan Kotěra, **Interior of the Rodin exhibition in the Mánes pavilion in Prague**, 1902

was important for the diversity of the products by different artists to stand out.

In comparison with Vienna and in particular with the radical *Raumkunst* of the Vienna Secession exhibitions, the *Gesamkunstwerk* of the exhibition in Prague was fairly subdued. Prior to the founding of the national School of Applied Art, Czech painters and sculptors trained separately from the architects or designers and, until the turn of the century, membership of the artists' association Mánes remained almost exclusively limited to artists. The first exhibitions mounted by Mánes, towards the end of the nineteenth century, were even less interested in establishing links between fine and applied art or exhibition design than the annual Prague salon, for which they were criticised by certain representatives of modernism.[5]

Jan Kotěra and the Mánes Artists' Association

For Prague, the collaboration of the architect Jan Kotěra with painters and sculptors from the Mánes Artists' Association at the end of the nineteenth century was of historical importance. In his interior designs, Kotěra evinced the highest respect for painting, sculpture and prints. He fostered qualities of simplicity and purity, features Mánes' first exhibitions had also striven for in an attempt to distinguish themselves from both the overcrowded atmosphere of the annual salon in Prague and the overdone aestheticism of the Viennese Secession (fig. 196). The specific characters of the exhibitions of the Prague modernists also issued from a different relation-

ship between paintings and sculptures than that encountered at the Viennese exhibitions. Not only were the Prague sculptors in the majority, but their work often aspired to more than simply serving as a decorative element in a building or room. A pendant to Kotěra's design were the elegant and subdued Hagenbund exhibitions in Vienna designed by Josef Urban. With respect to one of Kotěra's installations, the criticism at the time was crystal clear: 'Although the installation recalls Urban's arrangement of the most recent Hagenbund exhibition in Vienna, it is nevertheless far friendlier and more attractive.'[6]

Vital to Kotěra as an architect of art exhibitions was the pavilion built by him for Mánes in 1902 for an exhibition of work by Auguste Rodin (figs. 74, 197). This, the first exhibition organised by the association in its own pavilion, also served as an outstanding example of modern exhibition design. The monographic Rodin show was presented as a journey to a different, wondrous world of modern art.

In the pavilion, located in a scenic park at the edge of a factory district not far from Prague's historic centre, the architect used the symbolism of Paradise. The *mise-en-scène* of the exhibition symbolically emphasised spiritual and eternal nature, while all too conspicuous conventional or technical aspects were eschewed. The exhibition panels and other elements designed by Kotěra could, with a few minor adjustments, give each new exhibition a totally different impression of the pavilion's interiors, an impression attuned to the collections on view.

The successful ventures of the Czech modernists at the beginning of the twentieth century were also quite evident at large exhibitions outside Prague: in Vienna and at foreign presentations of the Habsburg monarchy, including the World's Fairs (for example, in St. Louis in 1904).[7] Kotěra, his pupils and other architects who belonged to the avant-garde, focussed primarily on the art of exhibiting and installing interiors. They did this in a period during which conservative architects and patrons deprived them of major commissions. An example of a happy symbiosis of exhibition design with a quasi home interior is the installation of the entrance area of the Mánes exhibition pavilion in 1905. The festive and stately character of that interior relied on the harmony between the entrance's clearly delineated function and the balanced symbolic decoration (fig. 198).

Jan Kotěra was also the architect of the permanent installation of the Modern Gallery of the Bohemian Kingdom that opened in Prague in 1908, for which the pre-existing art pavilion of the Jubilee exhibition was adapted. A year later, Kotěra received a commission to

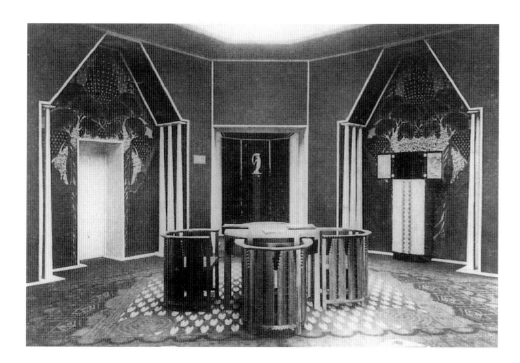

198
Josef Gočár, **Entrance hall to the Mánes pavilion**, 1905

build a museum (1909–1913), however – like most of his larger commissions – this was outside Prague, in Hradec Králové, in the middle of East Bohemia. Kotěra and his associates were also responsible for the large new pavilion that was built for the Chamber of Commerce's presentation at the Prague exhibition, held to mark the Emperor's Jubilee in 1908.

Secession and modernism

The first decade following the Mánes exhibition in Prague represents a period in which the installation of exhibition areas, as well as several private interiors, constituted a challenge for collaboration between modern architects and artists. Subsequently, individual objectives and problems surfaced once again in architecture and art in a process that eventually drove them apart. This became apparent around 1910 at exhibitions of the youngest generation, united in the group 'Osma' (The Eight). It also manifested itself in the 'emancipation' of architects from the Mánes Artists' Association. Just as artists in the 1890s had sought new possibilities for artistic expression and ideas in writers, so, too, did architects at the beginning of the twentieth century in artists.

Nevertheless, the results from this period of collaboration under the common denominator of Secession style functioned as a catalyst to the further, rapid development of the arts after 1910. This was especially the case in the genesis of the various avant-garde movements, such as Cubism and the specific Czech variants in architecture and the applied arts.

This also pertained to the joint presentations of modernist artists and architects at exhibitions in Prague at the time. When the exhibition areas in the largest new Secessionist-style construction – Obecní dům, or the Municipal House – were completed in 1912 (the building was originally intended as the Czech pendant to the Rudolfinum) it garnered attention from painters, sculptors and radical modernist architects. Their orientation was 'non-national' and they lashed out at the conventional Secessionist architecture of the building itself. Yet, their exhibition area, the interior of which was adapted to the group of Cubist-oriented artists and architects, in its entirety radiated great dynamism and expressiveness. Accordingly, those elements were really a reformulation of one of the fundamental ideas current in the time of the Secession and Symbolism (fig. 199).[8]

All of this serves to remind us that it was precisely because of this broadly-based joint effort (involving writers and architects) that artists in Prague were able to discover the Baudelarian 'new beauty' around the turn of the century. And the art of installing exhibitions and interiors too hovered 'between poetry and ecstasy'.

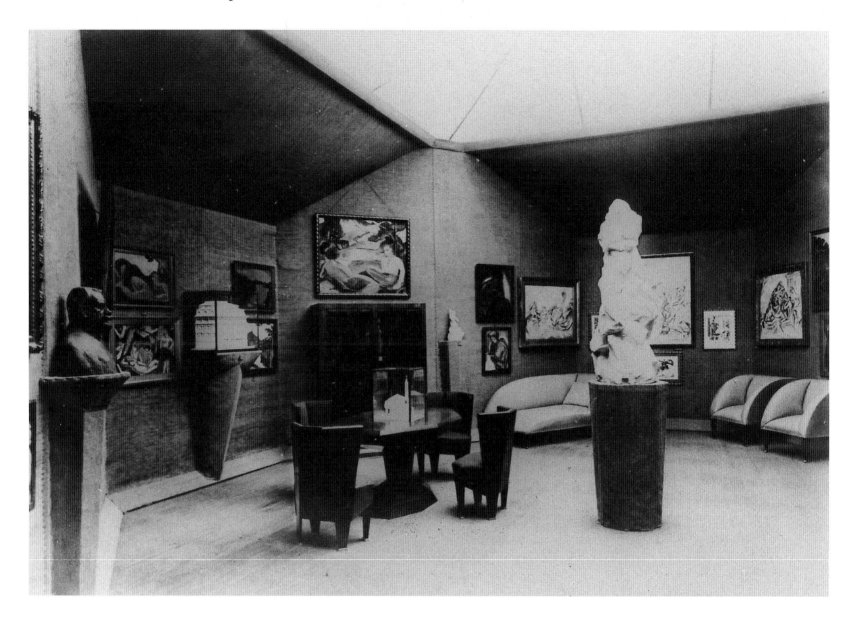

199
Josef Gočár, **Interior** of
the second exhibition by
the Cubist Group in the
Municipal House, 1912

200
Municipal House, Prague,
1904-12

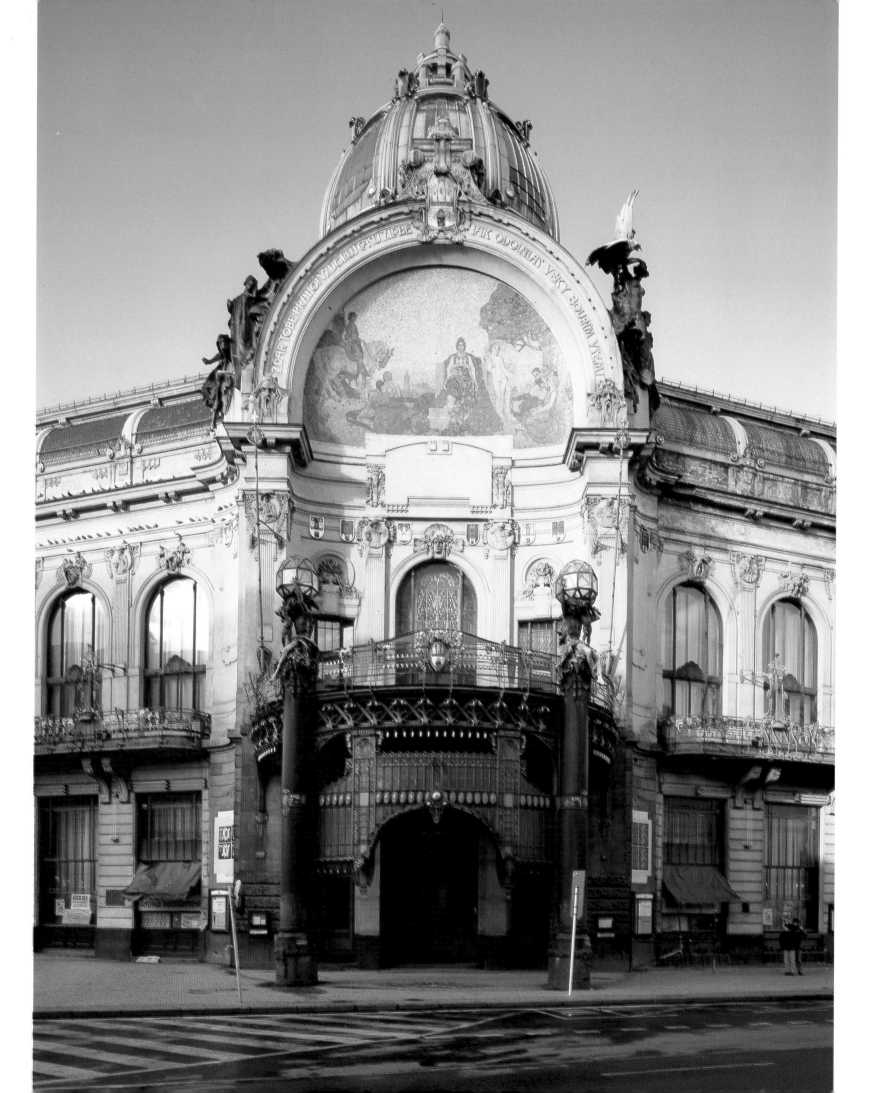

The violation of a dream
Post-Art Nouveau and Post-Symbolism

Alena Pomajzlová

Recent exhibitions of Czech *fin-de-siècle* art and the scholarly publications devoted to them all have in common that they range into the twentieth century and close with a passage dealing with the subsequent period, Expressionism and Cubism.[1] Through this extension Symbolism and Art Nouveau in Czech art continue, as it were, into the initial decades of the twentieth century, but usually without incorporating the contemporary insights in art and the accompanying, profound change in means of expression.

Even so, 1907 is generally regarded as a watershed, marking a caesura from the older Czech art still accommodated within the ninteenth-century framework. That year saw the Osma (The Eight) group, the youngest generation of artists, launching a programme for the first time. With its newly formulated psychological expression and attempt at a new formal composition Emil Filla's *Reader of Dostoevsky* (fig. 201), also dating from this watershed

Reader of Dostoevsky

Filla's painting *Reader of Dostoevsky* dates from the year of the first public appearance by the Osma group (The Eight), to which the advent of modern Czech art is traditionally linked.

Filla was represented at the exhibition with seven paintings, but precisely which these were we can piece together only from recollections and comments noted down at the time. It is said, however, that Filla contributed 'impressionistically painted landscape images.' Clearly, the influence of Max Liebermann was still the most palpable — Filla had got to know his work when he travelled to Germany in 1906. He continued his study tours in Amsterdam, where he admired the work of Vincent van Gogh. Filla's travels also took him to France — in Paris he saw the work of Matisse, Cézanne, Bonnard and Picasso — and Italy. His travel impressions were underscored by his experiences at the Prague exhibitions of Edvard Munch (1905) and the French Impressionists (1907), at which another 'godfather' of modern Czech art, Honoré Daumier, was strongly represented.

Filla painted his remarkably mature *Reader of Dostoevsky* almost immediately after his initial Impressionist period. Although its theme is essentially Symbolist, the content is entirely new, for which Munch was very largely responsible. The painting is a response to the increased interest in exalted and extreme psychological conditions corresponding to the *fin de siècle* atmosphere of decadence. These modern feelings are often the result of the individual's lack of freedom and his conflict with the world around him.

201
Emil Filla, **Reader of Dostoevsky**, 1907,
Národní galerie v Praze,
Prague

179

202
Miloš Jiránek, Edvard
Munch and Jan Preisler,
1905

203
Václav Špála, **Peasant girl**,
1907, Moravian Gallery,
Brno

year, is regarded as the first genuinely modern Czech painting.[2] The differences of opinion between the two generations were also expressed institutionally when, in 1911, the young artists left the Mánes Artists' Association and set up Skupina výtvarných umělců (Group of Fine Artists) with its own magazine, Umělecký měsíčník (Art monthly). Given their fierce opposition at the time, therefore, the link often made between the two generations is all the more surprising. Was the quest purely for external connections and parallels or is there a genuine and more profound relationship between the generations and their ideas on art?

Under the spell of Munch

Every new generation of artists draws lines between itself and its immediate predecessor. For Czech art the Mánes group meant an important step to the higher European level, whose principal tendencies the group also tried to realise within the Czech context. And yet the youngest generation thought Mánes remained overly provincial in atmosphere and was too self-satisfied with its achievements.

The young artists' first critical opinions on the form and function of art developed as early as the first five years of the twentieth century, while they were still studying at the Prague School of Fine Art. But the decisive impetus emanated from the Edvard Munch exhibition held in the Mánes pavilion in 1905. No other single exhibition provoked such controversy and divided the artistic community into two such implacably hostile camps, with an artist's future development crucially determined by the camp he or she belonged to. Of the old generation of art critics only František Xaver Šalda sided with the Munch admirers. This he did in his essay The violator of a dream. In an expressive declaration of love, Šalda sketched Munch as a contradictory, ambiguous person, a 'crude barbarian and sophisticated decadent, a chaotic and characteristic being, half-god, half-animal, more a natural force or a fountain spurting up out of the dark mass than a controlled world and a star.'[3] Here, Šalda was characterising in Munch's work the controversy that was to typify the whole of modern culture and was manifest in the duality of human existence and the conflict of the individual with the world, with the striving towards unity and synthesis replaced by open, genuine polarity.

Of the Mánes group only Jan Preisler responded to Munch – in his cycle of paintings with the theme of a woman by a lake – but he was slated by the critics and went no further in this direction. This increased the

204
Bohumil Kubišta,
**Promenade along the
Arno**, 1907, West
Bohemian Gallery, Pilsen

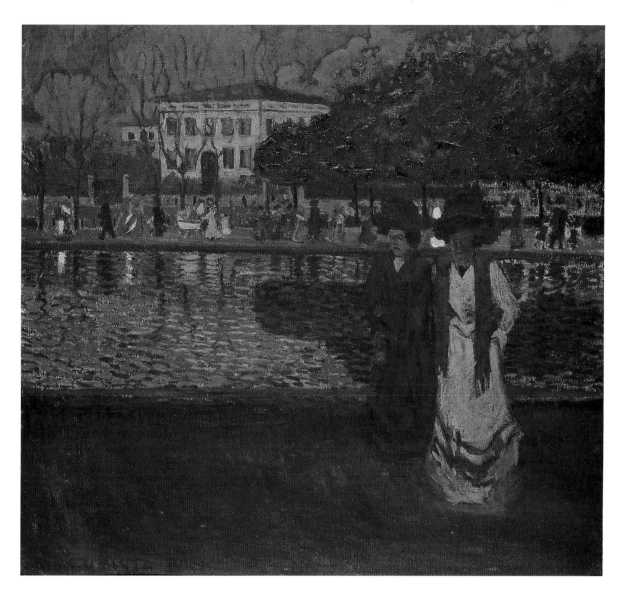

Promenade along the Arno

When Czech painters travelled at the start of the
twentieth century, they usually headed for the cradle
of modern art, Paris. However Kubišta, disappointed
with the teaching at the Prague School of Fine Art,
chose Italy as his first destination. This was primarily
for the many art treasures he wished to see there. In
1906 he enrolled at the Reale Istituto delle Belle
Arti in Florence, although his study of the old Italian
masters was of far more use to him. Florence was
also the inspiration for his oil painting *Promenade along
the Arno*.

The image of two female figures by the river also
appears in the etching *Quay in Florence*, but from the
artistic point of view the painting's adventurous
colours are far more advanced. The composition
consists, remarkably, of three surfaces: the dark fore-
ground alternates with an essentially Impressionist
surface full of reflections on the surface of the river,
whose vivid colours reappear, intensified, in the air
and the motifs in the background. This colour con-
cept, which weakens the realistic working of the pic-
ture in favour of autonomous artistic values, is
entirely new. Despite what is still a traditionally con-
ceived composition, the painting is nevertheless
regarded as one of the most important products of
modern Czech painting.

Kubišta was to develop this colour concept still
further, and he did so by referring to studies of
colour by Goethe, Helmholtz and Chevreul. In the
years to come he was even to make colour his prin-
cipal means of expression. For Kubišta, colours were
important not only for their presumed psychological
effects but also as an additional means of indicating
mystical and symbolic meanings that were so typical
of what was then modern.

205
Bohumil Kubišta, **Bathers**,
1911, Alšova Jihočeská
galerie, Hluboká on the
Vltava

younger artists' regard for Munch all the more. Although his work did not initially constitute an artistic example they could follow unreservedly, they were still motivated by the sincerity of an expressive power that depicted the agonising and extremely personal moments in a human life, even though these were transformed into a general symbol. Munch therefore stimulated the young artists who no longer wished to avoid this type of problem by choosing the easier paths of decorative art, entirely optical means or purely coincidental, painterly motifs that involved a bare minimum of personal inspiration. Together with Van Gogh, Gauguin and Cézanne and their penetrating influences, Munch too strove to assert exclusively pictorial aspects. While still, of course, remaining within the framework of figurative art, the young Czech painters wanted greater freedom of form, colour and line as autonomous elements of artistic expression. However, artists like Filla and Špála, who received Munch so enthusiastically, did not record this until their later memoirs. Any immediate influence is far harder to demonstrate. Despite the approbation for Munch, the Osma group's first exhibition, in 1907, was still a rather eclectic affair. In the subsequent years, too, the search for an appropriate method of artistic expression involved a mixture of a whole range of influences, from the Baroque, via El Greco and Daumier to contemporary French painting.

Existential fears

Among the group of young artists two figures were soon to stand out: Bohumil Kubišta and Emil Filla. Their respective approaches to art differed. While Kubišta was the more intellectual and symbolic, Filla was more sensual and direct. Kubišta's path to his own, idiosyncratic form of artistic expression was longer and more laborious; Filla accepted external stimuli far more readily but, like Kubišta, he analysed them first. In 1907 and 1908 Filla produced two of his most significant paintings, *Night of love* (1908, fig. 207), a work falling within Czech Expressionism and for which he devised new subject matter for the landscape motif, and *Child on the edge of the forest* (1907), a composition in which he is still referring to lyrical Impressionism, although an entirely different relationship between man and nature already prevails. As referred to above, however, the work that in a certain sense was to become programmatic for the young generation was *Reader of Dostoevsky* (1907, fig. 201). This is, perhaps, the painting that illustrates most clearly where the insights and opinions of the two generations meet. The figure with the closed eyes is known

206
František Kupka, **Autumn sun**, 1906, Národní galerie v Praze, Prague

Autumn sun

Kupka is known primarily as a painter who stood at the threshold of abstract art, but his path there was long and complex. After studying in Prague and Vienna he gave up painting almost entirely, devoting most of his time to reading philosophy and theosophy. He then decided to go to Paris, where the literary aspects of his work retreated into the background and he focused his attention on the actual problems of painting. He was inspired mainly by the Fauvist movement and was intensively occupied with the problems of colour, which was to constitute the bridge between his figurative and abstract work.

In the early years of his stay in Paris he created mainly female figures — besides fairly subtly painted *gigolettes* with sophisticated clothes these also included robust female nudes. These make their first appearance in naturalist form in the painting *Ballad - the joys of life* (1901), and later on in *Autumn sun*.

For this latter painting, which Kupka first exhibited at the 1906 *Salon d'automne* in Paris, he took as his basis fairly general themes such as 'The three graces' and 'The judgment of Paris.' The three nude female figures in nature represent three female types on whose bodies the setting sun conjures a scale of fiery, contrasting colours. In the painting the energy of nature is linked with the vitality that emanates from the human body and is rendered visible precisely with the use of colour. Kupka also stated later that 'the emanation of energy in nature and the emanation of the same, vital energy that is in ourselves is always recognisable through the various vibration waves of the colours.'

Autumn sun is so remarkable because it combines two methods of painting, as does Kupka's *Self-portrait* from 1905-06. The female figures are reproduced more or less realistically despite caricatural distortions and exaggerated colour accents. In the background where there should be tree-trunks alternately exposed to light and obscured in shade the painting changes into abstract vertical surfaces, an early fortaste of Kupka's later work. For this reason, *Autumn sun* forms the outer limit of his conventional painting.

207
Emil Filla, **Night of love**,
1908, Národní galerie v
Praze, Prague

only too well from Symbolism, and indicates the 'other' look that extends beyond the world of external phenomena and wishes to express something that lies beyond the reality perceptible with the normal senses.[4] This theme occurs in, for instance, turn-of-the-century Czech sculpture – which was also inspired by Rodin – for example in the work of Ladislav Šaloun and Josef Mařatka, and in painting, where we come across a variant of a romantic personage dreaming with eyes open in, say, Max Švabinský's *Union of souls* (1896, fig. 64), which depicts one of the most significant Symbolist themes: melancholy.

Filla's painting, which refers to the then cult writer Dostoevsky, is concerned with something different. Turning away from Symbolist poetic melancholy it follows the direction of Expressionist or existential fear. The painting reproduces the ecstasy and extreme feelings that entirely absorb mankind, the type of moments for which the painter tries to employ effective techniques of artistic expression. Other than the figure's unnatural posture,

with the head turned away, Filla has also used other artistic methods, such as distortion, dramatic chiaroscuro and an exaggerated use of colour.[5]

Related to the topic of Filla's painting are several representations of extreme psychological conditions by sculptors of the preceding generation on the threshold of the new century, such as Šaloun's *Concentration* (after 1905), Bohumil Kafka's *The visionary*, *Woman sleepwalking* (1906, fig. 76), *Bachanalia* and *Insanity* (fig. 77) and Quido Kocián's *The idiot* (1907). These works are already reflecting far more strongly the problematic relationship between the individual and the world around him, a relationship that was to become the theme of the new art. This is also the reason why the corpus of ideas both in Dostoevsky's novels as well as in Munch's paintings corresponded so well to the young artists' search for a deeper content and a way of expressing the discordant nature of human existence. 'In its reproduction and pictorial embodiment a concept must be an all-determining

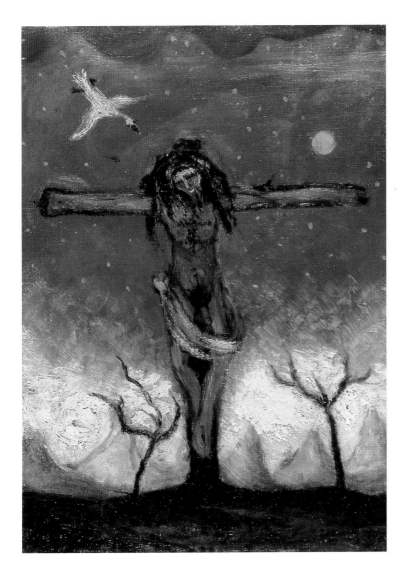

208
Jan Zrzavý, **The Antichrist**, 1908, Národní galerie v Praze, Prague

work.[7] Kupka had not only liberated himself from an underlying literary text but, in highly concrete terms, he dealt more freely with colour: Kupka's painting concentrated 'only' on a scale of shades of yellow, accentuated by a complementary lilac. The colour here is no longer linked to a world immediately perceptible through the senses, but is used on the basis of its own, autonomous expressive value. Although Kupka is still working with a traditional figurative subject, we know from the further development of his work that with this painting he is ushering in abstract art.

Although Filla's *Reader* lacks this clear tendency towards abstraction and so does not yet exceed the bounds of Symbolism, it still remains a key painting for the oeuvre of the time. This is because it straddles the watershed where all Czech art was by now located; it is differentiated both from Impressionist-tinted, older painting as well as contemporary tendencies such as Fauvism and Expressionism.[8] By linking up with a classical Symbolist theme it is geared to the past, but with its extreme exaltation it is reacting to Munch's paintings and corresponding to German Expressionism from which, through its soft characterisation, it at the same time differs.

Filla gradually broke away from these residues, arriving at a more adventurous expression that is livelier and more open. His simplification of form and dissonance of colour in *Night of love* (1908) go the furthest of all. This work – which may originally have been a sketch painted over an older self-portrait – is an undisguised response to Munch both in its cryptic sexual theme as well as artistic expression: the symbolic 'bleeding colour', the artistic allusion and the use of contour lines. In its own way, though, it is still linking up with themes that occur in *fin-de-siècle* painting. Here, the relationship between man and the world around him is often symbolised by a female figure in a landscape, invoking feelings of unity and harmony. In Filla the female figure and landscape flow as it were into a single artistic whole with the earlier unity replaced by disharmony in the colours, in itself symbolising another disharmony in the nature of modern man and the duality between man and world.

The expression behind the mask

The conflict between the individual and the world about him probably forms the most important difference between Epressionist and Cubist art on the one hand and *fin-de-siècle* art on the other. Although some themes remain the same there is a change in meaning. One of

impetus, always red-hot as a fireball, as relentless in its means of expression as a blow from an axe and as wild as a flood,' states Filla.[6] Two articles by Kubišta point in the same direction. These are entitled 'On the spiritual basis of the modern age,' (1912) and 'On the spiritual basis of modern artistic work,' (1914). In these pieces he develops a theory of the art work, which he requires to be based partly on an 'intrinsic content' – on a current idea. However, the relationship he establishes between the 'spiritual basis' and the artistic expression slots directly into the symbolist concept of art as still perceptible, under the surface, in Filla. However, some artists were able to achieve liberation from this.

The art critic Karel Srp compared Filla's *Reader* with František Kupka's *Yellow spectrum* (fig. 210). Although dating from the same year, this work originated in the context of artistically progressive Paris, the cradle of avantgarde art movements. Srp saw a far more definitive departure from the older art in Kupka's than in Filla's

209
Bohumil Kubišta, **Self-por-
trait in havelock**, 1908,
National Museum, Zlín

the thematic domains where this type of change becomes
clearly evident is the portrait, especially the self-portrait.
Filla's *Reader of Dostoevsky* and Kupka's *Yellow spectrum*
already show how, with the use of complementary
colours – a technique that arose as a variation of the
effect of light and shadow – the human face can be trans-
posed from the level of purely sensory perception to a
symbolic level. Kubišta may be the painter who delved
deepest into this area.

After his fairly lengthy period of searching for his
own, personal means of artistic expression, it was pre-
cisely in his self-portraits that he tried to apply the
expressive force, the primary laws of composition and
the various aspects of the meanings of colours.
Remarkable is his *Blue self-portrait* (1909) in which, thanks
to the autonomous power of colour, he created a repre-
sentation that extends beyond an image of the world as
perceived by the senses. As far as the colours are con-
cerned, the work is really an inverted version of Kupka's
Yellow spectrum, but with the subject's gaze directed with
unwavering provocativeness at the viewer. The image of
the artist's own face divided into two occurs in his Paris
sketchbook and several paintings, for instance, *Self-portrait*

in havelock (1908, fig. 209). Of the shade on the face,
Kupka made a dark green mask that covers the face and
separates it into a visible and a hidden part, which has
both a literal and figurative significance. The background
is constituted by colour streams that emanate from the
head and represent materialised inner energy or psychic
powers. The motifs of the mask and human duality reach
their apogee in *The smoker. Self-portrait* (1910), a painting
that is formally already influenced by Cubism and where
the face consists of mutually contrasting blue and brown
geometric surfaces, which creates an impression of two
figures of one and the same person.

Kubišta's entire oeuvre is based on his endeavour to
discover primary laws and principles for constructing a
work of art. He made detailed analyses of compositions,
copied classical paintings (Poussin's, for example) and
prepared sketches of art from classical antiquity and
other ancient civilisations. In so doing he applied mathe-
matics and geometry, the theory of colours and their
perception, psychology and philosophy. His research into
the formal qualities of the work of art was not, however,
an end in itself: Kubišta attributed symbolic meanings to
all the fundamental forms, colours, colour combinations
and mathematical relationships of composition he discov-
ered, so that, through the work of art, he could express a
deeper meaning. Themes from other works by Kubišta
also correspond frequently to these means of expression.
It is clear from these themes that psychic processes and
situations, as well as questions such as life and death
intrigued him, as evinced by *Epileptic woman* (1911), *The
Doppelgänger* (1911), *The hypnotist* (1912), *The kiss of
death* (1912), *The nervous lady* (1912) and *The hanged*
(1915). These motifs, which would suit a decadent-
Symbolist orientation equally well, would appear to con-
trast with the formal structure of paintings (with the
specific form changes of Cubism) that Kubišta created.
However, the combination in which just as much empha-
sis is laid on the expressive aspects as on the subject
matter is not characteristic of Kubišta alone. It can be
seen entirely within the context of the Czech art of the
time (cf. Gutfreund, Filla and Procházka, who also worked
with symbolic themes) and formed a particular link
between the older art and the formal exuberance of the
new art, between German Symbolism and mysticism on
the one hand and French formal bravura on the other. In
Czech art, Symbolism also continues into Cubism; Czech
Cubism therefore differs appreciably from the French
prototype. It is as if the range of Symbolist ideas offers a
counterweight to the experiments with form.

210
František Kupka, **Yellow spectrum**, 1907, Centre Georges Pompidou, Paris

A new spirituality

Highly inspiring for Kubišta's thematic orientation was his friendship with Jan Zrzavý, a representative of the 'second Symbolist generation' that briefly (1910-12) linked up with the Sursum group. While painters such as Kubišta, Filla and Procházka saw Symbolism only as one particular component of their work and for which they then sought a modern form of expression, the Sursum artists opted entirely openly for Symbolism and this searching for the latest modern directions was fairly alien to them. However, the continuity they proclaimed did not mean total rejection of new opportunities for expression since they too were not immune to contemporary developments in art. This is particularly true of two principal representatives of second-wave Symbolism: Jan Zrzavý and Josef Váchal.

Since both were more or less self-taught they may have looked for their examples in rather different places than the Prague academy-trained artists did. Zrzavý discovered antique Italian art and the work of Leonardo da Vinci for himself; Váchal, who was engaged in an uncommonly broad scale of artistic activities – from writing to free and applied graphic art, and bookbinding to painting and woodcuts – was oriented to the peripheral and popular domains of culture: illustrations for folk songs, primitive woodcuts, pot-boiler novels, all 'lowbrow' sub-genres that took him far from the aestheticism that was pretty dominant at the time. Even so, he used the formal methods of modern schools, although frequently parodying them, like Zrzavý, in whose work the mysterious and

dreamlike atmosphere of stylised landscapes *à la* Leonardo da Vinci blended strongly with Munch-like Expressionism, as in *The Antichrist* (1908, fig. 208) and Gauguin-like Primitivism, as in *The island of delight* (1907) and a series of self-portraits.

Although Zrzavý deliberately used Symbolist themes and imagery, the deeper significance of his work lies elsewhere entirely. The difference is at its most evident in the crucifixion motif, which in the preceding period occurs in the work of, say, František Bílek. It is as if Zrzavý is returning here to a kind of primitive naturalism, to a definite human figure that is in sharp contrast to the godlike and timeless manifestation in Bílek.

Shifts of meaning in the crucifixion motif occur regularly in art produced around the turn of the century, but in general these are moralising paraphrases. The decadent image of death, with the artist again provocatively emphasising the genitalia and painting the entire work in the 'wild' manner of Emil Nolde, is a personal confession located entirely in the twentieth century. It is just as much a symbolic expression of the psychological condition of Zrzavý the writer as it is in his self-portraits, in which the spiritual expression blends with eroticism and transcendence with sensuality.

Josef Váchal was perhaps the most self-willed artist as far as his vision of classical themes, religious motifs and contemporary artistic movements is concerned. The primary impulse informing his work is his attempt to free himself from the angst-ridden dreams and visions that persecuted him and also fuelled his interest in spiritualism and magic. He created an entirely personal manner of expression from the most varied of elements, styles and expressive techniques. His work is therefore open to various interpretations – some contradictory – and this is reinforced by a whole range of parodic paraphrases, grotesque exaggerations, ironic slanging-matches and mystifications. Using irony and self-irony Váchal was able to maximise his freedom regarding his use of expressive means. In his experiments, for instance, he achieved quite remarkable results. The painting *Exorcists* (1909, fig. 215) is a mocking reversal of the Christian theme, just as Zrzavý's *The Antichrist* had been. At the same time this is a work that in passing is, as it were, one of the most effective manifestations of modern art. It is detached from usual sensory experience and derives inspiration from the imagination, which may not be corrected by the intellect. Here, expressive primitivism sweeps aside decorative stylisation. The depiction in the painting is also continued onto the wooden frame, whose carving is reminiscent of related experiments by Paul Gauguin and the

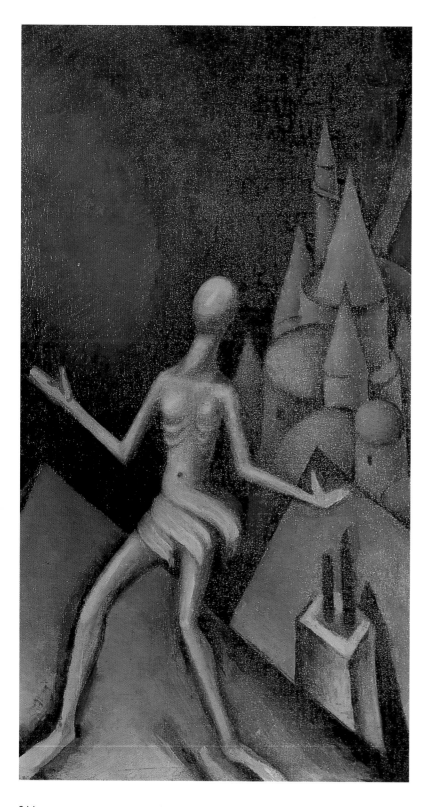

211
Jan Zrzavý, **Sleepwalker**,
1913, West Bohemian
Gallery, Pilsen

German Expressionists. There is an apparent fear of emptiness such that the surface has to be entirely filled. A certain psychological feeling on the artist's part is running in remarkable parallel to the atmosphere of the time, which was utterly lacking in any optimism in phenomena from the external world.

The sketched character of Czech art indicates that it detached itself with difficulty from content-related significance and accepted new formal opportunities for expression only very cautiously, and even then usually only when a significance the artist wished to communicate could be found in them. Modern Czech art, therefore, is rooted more firmly in tradition than its exponents were often willing to admit. Clearly, there was a certain conflict between the modernity proclaimed by young artists and the results of their work, especially in the beginning. On the other hand, the opening up to a new set of problems – notably a new way of looking at human existence, the creation of a new attitude towards reality and the search for a form of spirituality different from what religion had offered – marked a turning-point that would continue to be of influence in the future.

212
Jan Zrzavý, **Melancholy**,
1912, Národní galerie v
Praze, Prague

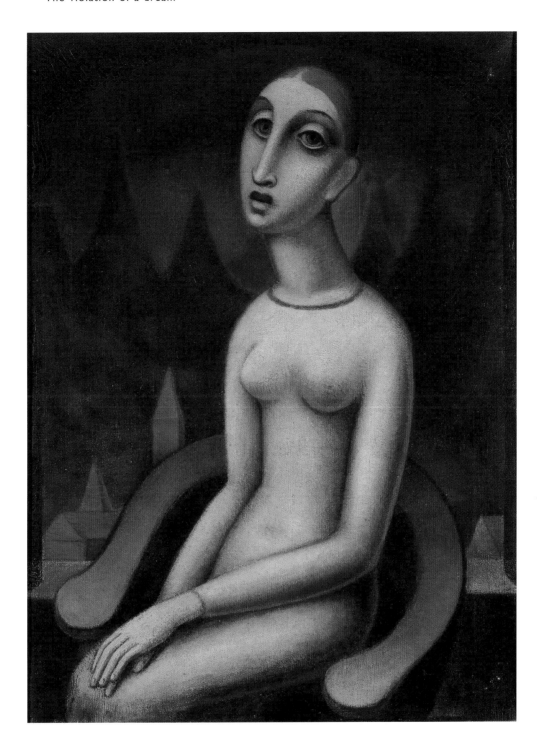

Melancholy

Unlike most of the other avant-garde painters of the
time, Zrzavý did not throw himself into dissecting
the world into Cubist forms. What concerned him
most was not a painting's formal composition but
the inner vision he wished to depict. His source of
inspiration was the mysterious atmosphere of faces
and landscapes in Leonardo da Vinci. Also of influ-
ence was his friendship with Kubišta, who gave him a
clearer insight into the laws of composition and aus-
terity of form. The style that typifies Zrzavý, he

developed after his Symbolist, decorative period and
his exuberantly expressive work from the period
1914–18. He characterised this style as follows: 'In
my art the definitive design is aimed at communicat-
ing the soul's condition, which is anchored in the
darkness of the human subconscious – the place
where all processes originate and from where they
rise to the outside.' Since this type of conception is
already close to a Surrealist perspective of the world
it is clear why the Surrealists should see in Zrzavý
one of their precursors.

213
Josef Váchal, **'Caryatids'
for the library of Miloš
Marten**, 1911, private collection

Caryatids

For a long time Váchal stood some way apart from modern Czech art, not least because he styled himself in the position of the outsider. His membership of the Sursum group (1910-12) was merely episodic. Only recent exhibitions in Prague have shown that, for all his individual techniques, Váchal applied virtually the same principles as the other artists of his time: emphasis on spiritual and inner aspects and a tendency towards primitivism in the search for authentic forms of representation and expression.

In contrast to a well-conceived composition for the painting, something for which French Cubism was valued fairly generally in Czech art, Váchal deliberately chose chaos and preferred exaggeration above moderation and reduction. And in distinction to the frequent, rational correction of inner sources of inspiration, which rapidly make art stylised and sophisticated, his work is dominated by the more immediate struggle with his own state of mind. The 'unartistic nature' of his primitivism places Váchal close to German Expressionism (cf. Woodcuts by Erich Heckel, Max Pechstein, Ernst Ludwig Kirchner and others). He perfected the technique of colour woodcuts, carved wood reliefs and reworked furniture and frames (for instance for his painting *Exorcists*, fig. 215). He also created small sculptures and dolls of dwarves, devils and fantastical beings, and fashioned walking sticks and pipes. Váchal seemed unconcerned whether he expressed himself in terms of 'high' or – measured according to 'artistic' criteria – 'low' art; either way, he strove to invest his artefacts with a 'magic' quality.

Through their primitivist and totemic form, these *Caryatids* for the bookcase of the writer and art critic Miloš Marten are a highly unusual answer to the modern search for the primeval sources of the work of art. Thanks to his perpetual balancing between the serious and the grotesque, Váchal is now also regarded thematically as one of the most original painters in twentieth-century Czech art. This rediscovered artist can take credit for having succeeded in undermining values that had previously appeared to be beyond question.

214
Jan Zrzavý, **Self-portrait with straw hat**, 1910, Moravian Gallery, Brno

215
Josef Váchal, **Exorcists**, 1910-12, Gallery of Modern Art, Hradec Králové

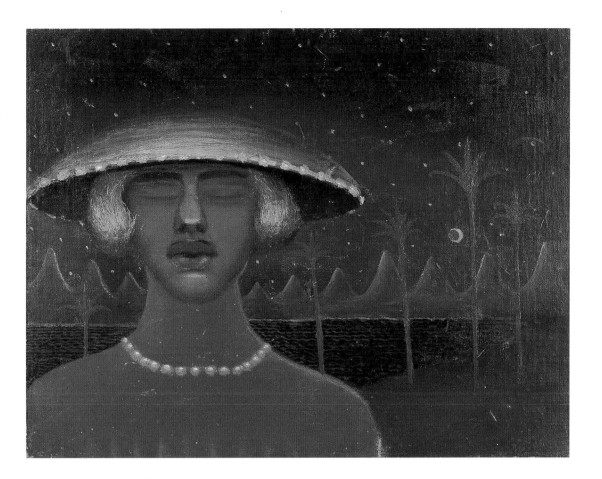

Biographies

Mikoláš Aleš (1852–1913)
Painter, illustrator and designer of architectural decorations. Studied at the art academy in Prague. In his time became the most popular illustrator of folk sagas, fairy tales and folk songs in Bohemia. Honorary president of the Mánes Artists' Association and the Union of Fine Artists.

Design for the title page of the Old Czech Manuscript 'Královédvorský', 1883
pen and ink on paper, 33.7 x 26.5 cm
Národní galerie v Praze, Prague
inv. K 39986
figure 33

Cover for Aleš monograph, 1896
28.5 x 20.5 cm
National Literary Museum, Prague
inv. 10939 MA 176
figure 99

František Anýž (1876–1934)
Metal founder, engraver and goldsmith. Studied at the Prague School of Applied Art. Also an excellent designer. Later established an important metal foundry.

Brooch, c. 1900
gold, emerald, h.: 3.2 cm
Uměleckoprůmyslové museum v Praze, Prague
inv. 73.720
figure 156

Necklace, c. 1900
silver gilt, Bohemian garnets, l.: 32 cm
Uměleckoprůmyslové museum v Praze, Prague
inv. 89.694
without figure

Tablet with two drinking glasses, 1905-08
brass, 19.7 x 2 cm / 5.1 x 3.8 cm / 6.9 x 2.7 cm
Uměleckoprůmyslové museum v Praze, Prague
inv. 95.855 a and b / 1,2
without figure

Karel Babka (1880–1953)
Ceramicist and modeller. Studied at the Prague School of Applied Art. Modelled small decorative figures which were produced in ceramic and bronze. Moved to Moscow in 1912.

Vase, c. 1900
bronze with patina, h.: 12 cm
Uměleckoprůmyslové museum v Praze, Prague
inv. 74.796
figure 153

Jaroslav Benda (1882–1970)
Graphic designer. Studied in Prague at the School of Applied Art and Academy of Fine Art. First came to prominence through his work for leading Prague publishers such as Jan Laichter and Jan Štenc.

Poster for the Bernard exhibition, 1909
lithograph on paper, 94 x 62 cm
Uměleckoprůmyslové museum v Praze, Prague
inv. GP 5.165
figure 131

Cover for Ludvík Bradáč's 'Art of bookbinding', 1912
gilded leather, 19 x 15.5 cm
Uměleckoprůmyslové museum v Praze, Prague
inv. GK 7192-E
without figure

František Bílek (1872–1941)
Sculptor, graphic artist and designer.
Studied at the art academy in Prague and
the Académie Collarossi in Paris. From the
1890s the artist closest to the Catholic
Modernists, although also recognised as a
great artist by other Prague modern art
circles. One-man shows in Bohemia and
Germany; exhibited with the Mánes Artists'
Association in Vienna. One of the most
important representatives of Czech culture
in the fin-de-siècle period.

We must till the earth as punishment for our sins,
1892
bronze, 100 x 42.5 x 32 cm
Gallery of the City of Prague
inv. P 432
without figure

Vase, 1896
glazed ceramic, h.: 43 cm
Uměleckoprůmyslové museum v Praze, Prague
inv. 27.720
without figure

Prologue: illustration for the poem *Pietà* by
Sigismund Bouška, 1897
charcoal and chalk on paper, 85 x 59 cm
National Literary Museum, Prague
inv. 11/824
without figure

Cover design for Volné směry, 1898
29.5 x 23 cm
Uměleckoprůmyslové museum v Praze, Prague
inv. GS 14.444
without figure

Mother!, 1899
charcoal on paper, 139 x 83 cm
Národní galerie v Praze, Prague
inv. K 13206
figure 48

Vase with geometric motifs, c. 1900
ceramic, h.: 20 cm, Ø 14 / 7 cm
Uměleckoprůmyslové museum v Praze, Prague
inv. 89.812
without figure

A place of harmony and conciliation, 1900
charcoal on cardboard, on canvas, 191 x 102.5 cm
Gallery of the City of Prague
inv. K 96
figure 106

Double portrait of Zdenka Braunerová, 1900
ceramic, with graphite patina, 33 x 40 cm
Uměleckoprůmyslové museum v Praze, Prague
inv. 8.761
figure 16

*Jan Hus - Tree struck by lightning that has burned for
centuries*, 1901
bronze, h.: 86 cm
Gallery of the City of Prague
inv. P 457
figure 51

Illustration in Otokar Březina's collection of
poems *Hands*, 1902
40 x 29.5 cm
Uměleckoprůmyslové museum v Praze, Prague
inv. B 34.078
figure 106

Portrait of Julius Zeyer, 1902
bronze, h.: 74 cm
Národní galerie v Praze, Prague
inv. P 2491
figure 15

The blind, 1902 (1926)
wood, h.: 216 cm
Národní galerie v Praze, Prague
inv. P 1019
without figure

Entrance to the gate of the damned, 1906
woodcut, 66 x 50 cm
Národní galerie v Praze, Prague
inv. R 24470 a
without figure

Astonishment, 1907
wood, h.: 58.2 cm
Národní galerie v Praze, Prague
inv. P 2248
figure 50

Building the future temple in us, 1908
woodcuts, 24.6 x 19.5 cm
Uměleckoprůmyslové museum v Praze, Prague
inv. C 26.039
without figure

Poster for the Bílek exhibition, 1908
lithograph on paper, 166 x 90 cm
Uměleckoprůmyslové museum v Praze, Prague
inv. GP 15.952
without figure

Anna Boudová-Suchardová (1870–1940)
Painter, designer of ceramics, textiles and
fashion. Studied at the Prague School of
Applied Art. Around 1900 became known
through her designs for ceramic vases with
distinctive figurative and floral decoration.
Disseminated the Secessionist style
through ornamental pattern books.

Vase with masquerons, 1900
ceramic, engobe, h.: 27 cm
Uměleckoprůmyslové museum v Praze, Prague
inv. 26.620
figure 162

Dish with harpies, 1900
ceramic (with patina), h.: 14 cm, Ø 34 cm
Uměleckoprůmyslové museum v Praze, Prague
inv. 20.734
figure 163

Vase with narcissi, 1900
ceramic, h.: 20 cm
Uměleckoprůmyslové museum v Praze, Prague
inv. 20.172
without figure

Vase with dandelions, c. 1900
majolica, h.: 32.5 cm
Uměleckoprůmyslové museum v Praze, Prague
inv. 20.737
without figure

Vase with branch, c. 1900
ceramic, h.: 14 cm
Uměleckoprůmyslové museum v Praze, Prague
inv. 54.975
without figure

Ludvík Bradáč (1885–1947)
Designer of artistic bookbindings. Studied
in Düsseldorf and worked in Paris. From
1908 ran his own company in Prague

Cover for 'The ways of beauty' by Arnošt Procházka,
1908
intarsia leather, 16.5 x 12.5 cm
Uměleckoprůmyslové museum v Praze, Prague
inv. 10.958-E
figure 176

Zdenka Braunerová (1858–1934)
Studied under the landscape painter
Antonín Chittussi and made several trips
to places such as London, Germany, Italy
and Tunis. An innovator in the field of book
illustration. Highlighted the importance of
traditional Czech printing with motifs from
folk art.

*Illustrations for Miloš Marten's 'Cycle of passion and
death'*, 1907
18 x 23.5 cm
Uměleckoprůmyslové museum v Praze, Prague
inv. G 649-D
without figure

Václav Brožík (1851–1901)
Painter, specialising in historical themes.
Studied at art academies in Prague,
Dresden, Munich and Paris. One of the offi-
cial painters of the Austro-Hungarian
Empire. Probably the best-known Czech
painter in the final quarter of the nine-
teenth century. Lived in Paris and Prague,
where he worked as a teacher at the
Academy of Fine Art.

Emperor Ferdinand I surrounded by his artists,
1900-01
oil on canvas, 245 x 403 cm
Národní galerie v Praze, Prague
inv. O 822
figure 24

Vladimír Jindřich Bufka (1897–1916)
Photographer. Studied at technical colleges
in Prague and Vienna, had his own photo-
graphic studio in Prague. Represented 'pic-
turalism' in the Czech photographic world.
Also experimented with scientific photog-
raphy.

Evening mood, photograph, c. 1908
gum print, 11.2 x 17 cm
Uměleckoprůmyslové museum v Praze, Prague
inv. GF 26.603
figure 137

František Drtikol (1883–1961)
Photographer and painter. Studied in
Munich. In 1910 opened a photographic
studio in Prague. Became known for his
photographs of nudes, portraits and land-
scapes. Represented the Secessionist style
and Symbolism. Later also worked in Art
Deco style.

Polyptych with nude children, photograph, c. 1909
gelatine-silver print, 14 x 5.5 / 12.6 x 6.8 / 12.1 x
8.5 / 14.8 x 7.5 cm
Uměleckoprůmyslové museum v Praze, Prague
inv. GF 38.707 - 38.710
figure 136

Polyptych with nude children, photograph, c. 1909
gelatine-silver print, 12.3 x 8.8 / 11.9 x 8.8 / 13.4
x 9.7 / 11.4 x 9.8 cm
Uměleckoprůmyslové museum v Praze, Prague
inv. GF 38.698 - 38.701
without figure

Two nudes in an interior, photograph, c. 1909
gelatine-silver print, 19 x 24.8 cm
Uměleckoprůmyslové museum v Praze, Prague
inv. GF 38.672
without figure

Girl with eyes closed, photograph, 1910
gelatine-silver print, 19.8 x 16.5 cm
Uměleckoprůmyslové museum v Praze, Prague
inv. GF 38.762
figure 135

Landscape with pond, photograph, 1911
oil pigment print , 20.1 x 25.5 cm
Uměleckoprůmyslové museum v Praze, Prague
inv. 33.775
without figure

Cleopatra, photograph, 1913
oil pigment print, 34.8 x 46.6 cm
Uměleckoprůmyslové museum v Praze, Prague
inv. 38.910
figure 134

Eve, photograph, c. 1913
oil pigment print, 26 x 21.8 cm
Uměleckoprůmyslové museum v Praze, Prague
inv. GF 5.571
figure 138

Karel Ebner (born 1883)
From 1901 to 1907 studied at the Prague
School of Applied Art. Later founded his
own silversmith's workshop.

Bonbonnière, 1909
silver, pearls, coral, moonstone, turquoise,
h.: 6.5 cm
Uměleckoprůmyslové museum v Praze, Prague
inv. 11.683
figure 182

Jindřich Eckert (1833–1905)
Photographer. Started a portraitstudio in
Prague in the 1860s, later photographed
mainly landscapes and townscapes. He also
recorded the reconstruction of Prague's
Jewish quarter. He received many Czech
and foreign awards.

It's evening! Night's on the way (self-portrait),
photograph, 1903
albumen print, 15.1 x 8.3 cm
Uměleckoprůmyslové museum v Praze, Prague
inv. GF 14.188
without figure

Josef Fanta (1856–1954)
Architect and designer. Studied at the
Prague Technical College where he later
worked as an assistant and teacher.
Designed and constructed a series of
prominent buildings, mainly in Prague.
Designs displayed at the Prague

Ethnographic Exhibition and the 1900 Paris
World Fair where these won major prizes.

Josef Fanta, Stanislav Sucharda and Ludvík Wurzel
Cabinet, 1900
maple wood, leather, brass and terracotta,
200 x 91 x 59 cm
Uměleckoprůmyslové museum v Praze, Prague
inv. 20.181
figure 146

Josef Fanta and Ludvík Wurzel
Desk, 1900
maple wood, brass, leather and glass,
121 x 103 x 66 cm
Uměleckoprůmyslové museum v Praze, Prague
inv. 20.168
figure 148

Josef Fanta and Ludvík Wurzel, *Chair*, 1900
maple wood, brass, bronze and leather,
68 x 57 x 51 cm
Uměleckoprůmyslové museum v Praze, Prague
inv. 20.170
figure 150

Lamp, 1900
bronze gilt and glass, h.: 32 cm, Ø 33 cm
Uměleckoprůmyslové museum v Praze, Prague
inv. 20.189
figure 151

Supraporta, 1900
copper gilt, enamel and marble, 34 x 154 cm
Uměleckoprůmyslové museum v Praze, Prague
inv. 97.072
figure 152

Emil Filla (1882–1953)
Painter. Studied at the art academy in
Prague. In 1906 went on a major trip
through Europe; lived in Amsterdam during
the First World War. A leading member of
the avant-garde groups 'Osma' (The Eight)
and 'Skupina výtvarných umělců' (Group of
Fine Artists). Important representative of
Expressionism and Cubism in Czech art.

Reader of Dostoevsky, 1907
oil on canvas, 98.5 x 80 cm
Národní galerie v Praze, Prague
inv. O 3190
figure 201

Night of love, 1908
oil on canvas, 73 x 110 cm
Národní galerie v Praze, Prague
inv. O 3849
figure 207

V. Fleissig (dates unknown)
Bookbinder. An important figure in the
Bohemian Society of Bookbinders between
1890 and 1910.

Cover for 'Princess Pampeliška' by Jaroslav Kvapil,
c. 1900
intarsia leather, 18.5 x 12.5 cm
private collection
without figure

Karel Gabriel (born 1884)
Studied at the Prague School of Applied
Art and in Munich. Worked for the Union
of Ceramic Producers at Bechyně, South
Bohemia.

Clock, made by the ceramic works in Bechyně, after 1900
ceramic and copper/brass, h.: 35 cm
Uměleckoprůmyslové museum v Praze, Prague
inv. 73.795
figure 168

František Gellner (1881–1914)
Poet, writer, draughtsman and graphic artist. Studied art in Munich, Paris and Dresden. Leading figure of his generation, particularly connected with anarchism.

Cover for 'The conversion of St Vladimir', 1904
22 x 14.5 cm
Uměleckoprůmyslové museum v Praze, Prague
inv. GK 10.217-D
figure 113

Self-portrait, c. 1910
pastel on paper, 45.2 x 30 cm
Uměleckoprůmyslové museum v Praze, Prague
inv. GS 18.896
without figure

Figure studies and caricatures, c. 1912
pen and ink on paper, 34 x 45 cm
Uměleckoprůmyslové museum v Praze, Prague
inv. GS 18.919
without figure

Hubert Gessner (1871–1943)
Designer. Studied 1885–1889 at the state school for industry in Brno and later with Otto Wagner at the art academy in Vienna. Worked mainly for Johann Loetz Witwe, Klášterský Mlýn.

Vase, Johann Loetz Witwe glassworks, Klášterský Mlýn, 1900-02
iridised glass, h.: 36 cm
Uměleckoprůmyslové museum v Praze, Prague
inv. 95.601
without figure

Miroslav Havlík (dates unknown)

Vase (Wave), c. 1900
ceramic, h.: 22.5 cm
Uměleckoprůmyslové museum v Praze, Prague
inv. 97.344
figure 161

Antonín Hellméssen (1854–1930)
Architect and designer. Taught at the Prague School of Applied Art. Initially designed in historicist style but adopted Art Nouveau after 1900.

Cover for 'The physiology of modern love' by F. Bourget, 1900
gilded intarsia leather, 18.5 x 12.8 cm
Uměleckoprůmyslové museum v Praze, Prague
inv. 20.336-E
without figure

Karel Hlaváček (1874–1898)
Poet, draughtsman and art critic. Studied in Prague at the Technical High School and the Faculty of Letters at Charles University. During this time also took drawing classes at the Prague School of Applied Art. Published three collections of poems. Leading figure in the *Moderní revue* circle and the 1890s generation of artists.

Cover for 'Moderní revue', 1896
26.5 x 15.5 cm
National Literary Museum, Prague
inv. LANM 66/63/0679
figure 121

Morning light, cover design for Hlaváčeks *Towards morning*, 1896
12.5 x 10 cm
National Literary Museum, Prague
inv. P21G26
without figure

Cover design for the journal 'Zycie', 1897
pen and ink on paper, 49.6 x 22.8 cm
National Literary Museum, Prague
inv. LANM XIA85
without figure

Arnošt Procházka (from the cycle in *The brothel of the soul* collection of poems by Arnošt Procházka), 1897
copper engraving, 13.1 x 10.9 cm
National Literary Museum, Prague
inv. 840/60-4197
without figure

The exile (study for the cycle in *The brothel of the soul* collection of poems by Arnošt Procházka), 1897
pastel on paper, 26.3 x 24.3 cm
National Literary Museum, Prague
inv. IK 3315
figure 12

Apparition, 1897
pastel on paper, 32.5 x 48 cm
National Literary Museum, Prague
inv. IK 3092
figure 17

Title page design for 'The brothel of the soul' collection of poems by Arnošt Procházka, 1897
pen and ink on paper, 65 x 46.5 cm
National Literary Museum, Prague
inv. IK 3312
figure 98

My Christ, 1897
charcoal on paper, 24.2 x 21.2 cm
National Literary Museum, Prague
inv. 94/68 - 1
figure 107

Illustrations for Otokar Březina's 'Polar winds', 1897
23.2 x 19 cm
Uměleckoprůmyslové museum v Praze, Prague
inv. GK 770-D
without figure

Arnošt Hofbauer (1869–1944)
Painter and graphic artist. Studied in
Prague at the School of Applied Art where
he later taught, and the Academy of Fine
Art. His posters, particularly those for the
Mánes Artists' Association, and his graphic
pieces for the journal Volné směry (Free
directions) were his most interesting work.

Poster for the first Mánes exhibition, 1897
lithograph on paper, 110 x 83 cm
Uměleckoprůmyslové museum v Praze, Prague
inv. GP 9490
figure 124

Poster for the second Mánes exhibition, 1898
lithograph on paper, 110 x 84 cm
Uměleckoprůmyslové museum v Praze, Prague
inv. GP 18.908
figure 125

Cover design for 'Volné směry', 1898
29.5 x 23 cm
Uměleckoprůmyslové museum v Praze, Prague
inv. GK 11.010/11-C
figure 122

Poster for a recital by Hana Kvapilová, 1899
109 x 76 cm
Uměleckoprůmyslové museum v Praze, Prague
inv. GP 17.285
figure 126

Vlastislav Hofman (1884–1946)
Architect and designer, also stage designer,
painter and graphic artist, architectural
theoretician. Studied at Prague Technical
College. An important representative of
Cubism in the design world. Designs pro-
duced by the Artěl art association coopera-
tive.

Liqueur set (carafe with three glasses), Antonín Pryl
glassworks, Dobronín, for the Artěl company,
1911
cut glass, h. (carafe): 24 cm; h. (glasses): 8.4 cm
Uměleckoprůmyslové museum v Praze, Prague
inv. 74.831 a and b, 74.832-4
without figure

Franz Hofstötter (1871–1958)

Vase, Johann Loetz Witwe glassworks, Klášterský
Mlýn, 1900
glass, iridised and opalised, h.: 22.5 cm, Ø 6 cm
Bohemian Forest Museum, Kašperské Hory
inv. S 1524
without figure

Emil Holárek (1867–1919)
Painter and graphic artist. Studied at art
academies in Prague and Munich. Best-
known works are his graphic cycles of
social criticism.

Reflections from the Catechism, 1901
album of 50 lithographs, 43 x 33 cm
Uměleckoprůmyslové museum v Praze, Prague
inv. B 30.327
without figure

Oldřich Homoláč (1872–1957)
Studied at the Academy of Fine Art under
Max Pirner and Vojtěch Hynais. One of the
founders of the Mánes Artists' Association;
member of the *Volné směry* (Free direc-
tions) editorial board.

Cover design for 'Volné směry', 1896
29.5 x 23 cm
Uměleckoprůmyslové museum v Praze, Prague
inv. GS 14.441
without figure

Václav Hradecký (1867–1940)
Painter and graphic artist. Studied at the
School of Applied Art and art academy in
Prague. Worked 1901–1908 in France.

Illustration from the cycle Bestia Triumphans, 1903
pastel on cardboard, 81 x 79 cm
National Literary Museum, Prague
figure 110

Antonín Hudeček (1872–1941)
Painter. Studied at art academies in Prague
and Munich, where he also took private
lessons. Member of the Mánes Artists'
Association. One-man shows or exhibited
with the Mánes Artists' Association in
Prague, Vienna and Germany. His Post-
Impressionist and Symbolist landscapes
were particularly celebrated.

Spring fairy tale, 1898
oil on canvas, 105.5 x 75.5 cm
Národní galerie v Praze, Prague
inv. O 14470
figure 72

Autumn, 1898
oil on canvas, 76 x 106 cm
Národní galerie v Praze, Prague
inv. O 3008
without figure

Fresh young green, 1900
oil on canvas, 101 x 101 cm
Národní galerie v Praze, Prague
inv. O 5443
figure 60

Evening silence, 1900
oil on canvas, 121.5 x 181.5 cm
Národní galerie v Praze, Prague
inv. O 8411
figure 59

Psyche, 1901
oil on canvas, 158.5 x 143.5 cm
Národní galerie v Praze, Prague
inv. O 15649
figure 63

Evening in Machov, 1910
oil on canvas, 118 x 132 cm
Museum of Fine Art, Ostrava
inv. O 45
without figure

Wood, 1911
oil on canvas, 93.5 x 115 cm
Národní galerie v Praze, Prague
inv. O 3086
figure 95

Vojtěch Hynais (1854–1925)
Painter. Studied at the Vienna and Paris art academies, lived in Italy and France. Taught at the Prague Academy of Fine Art. Came to prominence through part in decorating the National Theatre. Chiefly influenced pupils through advocacy of plein-air painting.

Poster for the Jubilee Exhibition in Prague, 1891
chromolithograph on paper, 112 x 73 cm
Uměleckoprůmyslové museum v Praze, Prague
inv. GP 21.597
figure 27

Study for the painting 'The judgement of Paris', 1892
oil on canvas, 58.5 x 100 cm
Národní galerie v Praze, Prague
inv. O 5092
figure 28

Preliminary study for the poster for the Ethnographic Exhibition, 1894
oil on canvas, 104.5 x 163 cm
Národní galerie v Praze, Prague
inv. O 5052
figure 31

Mrs Hrušová with her daughters, 1896
oil on canvas, 50 x 61 cm
Národní galerie v Praze, Prague
inv. O 4986
figure 30

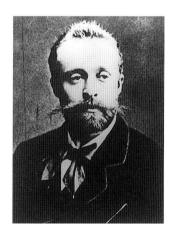

Antonín Chittussi (1847–1891)
Painter, mainly of landscapes. Studied at art academies in Prague, Munich and Vienna. Lived alternately in Bohemia and France. Work produced in strongly rooted plein-air spirit. Both his views on painting in the open air and his position of independence from institutions proved of great influence on painters in the 1890's.

Fen near Člunek, c. 1886
oil on canvas, 57.5 x 75 cm
private collection
figure 38

Pond, 1887
oil on canvas, 66 x 100 cm
Národní galerie v Praze, Prague
inv. O 14659
without figure

Felix Jenewein (1857–1905)
Painter and draughtsman. Studied at art academies in Prague and Vienna, taught at the School of Applied Art in Prague. Popular in the Catholic Modernists' circle at the end of the nineteenth century. One of the prominent Secessionist and Symbolist artists to participate in the decoration of the National Theatre.

Good Friday morning, 1895
pen and ink, watercolour and gouache on paper, 86 x 130 cm
Národní galerie v Praze, Prague
inv. K 12643
figure 46

Cover for Jaro Schiller's 'Si iniquitates observaveris', 1898
30 x 40.5 cm
Uměleckoprůmyslové museum v Praze, Prague
inv. 27.324B
without figure

Exuberance, (from the *Plague* cycle), 1900
chalk and watercolour on paper, 46 x 61 cm
Národní galerie v Praze, Prague
inv. K 12636
figure 43

Miloš Jiránek (1875–1911)
Painter, graphic artist, art critic and writer. Studied at the art academy in Prague and undertook several study trips, chiefly to Vienna and Paris. A leading figure in the Mánes Artists' Association and the 1890s generation.

Raft in Obříství, 1898
oil on canvas, 69.5 x 54 cm
Národní galerie v Praze, Prague
inv. O 8929
without figure

*Showers in the gymnasium of the Prague Sokol
Gymnastic Association*, 190103
oil on canvas, 140 x 169 cm
Národní galerie v Praze, Prague
inv. O 5711
figure 83

Study in white I, 1910
oil on canvas, 75 x 63 cm
Regional Museum, Liberec
inv. O 1817
figure 84

Bohumil Kafka (1878–1942)
Sculptor. Studied at the School of Applied
Art and Academy of Fine Art in Prague;
later taught at both schools. Travelled
through Germany and lived repeatedly in
Paris, his longest stay being from 1904 to

1908. One of the most important
Impressionist, Symbolist and Secession
sculptors.

Decay of life, 1902
bronze, h.: 74 cm
Národní galerie v Praze, Prague
inv. P 1830
without figure

Mummies, 1904
bronze, h.: 67 cm
Národní galerie v Praze, Prague
inv. P 1847
figure 80

Insanity, 1905
bronze, h.: 77 cm
Národní galerie v Praze, Prague
inv. P 1831
figure 77

Woman sleepwalking, 1906
bronze, 38 x 22 x 78 cm
Národní galerie v Praze, Prague
inv. P 6443
figure 76

Alois Kalvoda (1875–1934)
Painter, graphic artist and publicist.
Studied at the art academy in Prague, lived
in Paris and Munich. Exhibited with the
Mánes Artists' Association in Prague and
Vienna; also one of the most active
Moravian members of the Hagenbund. Took
part in Czech exhibitions abroad. One of
the leading figures among young Moravian
painters in the fin-de-siècle period.

View of the Berounka, c. 1906
oil on canvas, 149.5 x 149.5 cm
Moravian Gallery, Brno
inv. A 309
figure 61

Jan Kastner (1860–1912)
Wood carver, sculptor and painter. Studied
at the School of Applied Art in Vienna and
taught at the Prague School of Applied Art.
Produced many sculptures, pieces of furni-
ture and decorative altars in historicist and
Secession styles.

Chair, 1899
various kinds of wood, polychromed, inlaid with
mother-of-pearl and brass, h.: 92 cm

Uměleckoprůmyslové museum v Praze, Prague
inv. 20.110 a
figure 147

František Kaván (1866–1941)
Painter and poet. Studied at the Prague
Academy of Fine Art. Landscape painter,
advanced plein-air practitioner with an
affinity for Symbolism in his fin-de-siècle
paintings and poems.

Meadow in spring, 1895
oil on canvas, 75 x 102.5 cm
Národní galerie v Praze, Prague
inv. DO 6503
without figure

Rain over Tábor, 1903
oil on canvas, 76 x 100 cm
Museum and Gallery, Hořice
inv. U 173
figure 56

Marie Kirschner (1852–1931)
Painter, designer of artistic glass and
ceramics. Privately trained as an artist in
Prague, Munich and Paris. Her glass
designs, produced by the Loetz glassworks
in Šumava (Bohemian Forest), were her
most important works.

Vase, Johann Loetz Witwe glassworks, Klášterský Mlýn, 1902
lightly iridised glass, h.: 15 cm
Uměleckoprůmyslové museum v Praze, Prague
inv. 21.455
without figure

Vase, Johann Loetz Witwe glassworks, Klášterský Mlýn, 1903
lightly iridised glass, h.: 11.8 cm
Uměleckoprůmyslové museum v Praze, Prague
inv. 73.689
figure 187

Celda Klouček (1855–1935)
Sculptor and designer. Studied at the Prague School of Applied Art, where he later taught, and a similar academy in Vienna. His decorations for a number of Prague buildings are a prominent part of his oeuvre. In these he used motifs from the early Secession period. Klouček had such a great influence on his pupils that it is often difficult to distinguish his work from theirs.

Rudolf Hamršmíd, studio of Celda Klouček, *Vase*, 1899
ceramic, enamel glaze, h.: 27.3 cm
Uměleckoprůmyslové museum v Praze, Prague
inv. 20.144
figure 167

Josef Klimeš, studio of Celda Klouček, *Vase with river landscape*, 1898
glazed ceramic, h.: 19 cm
Uměleckoprůmyslové museum v Praze, Prague
inv. 20.792
without figure

L. Vocelka, studio of Celda Klouček, *Vase*, 1904
ceramic, h.: 12 cm
Uměleckoprůmyslové museum v Praze, Prague
inv. 10.855
without figure

P.J., studio of Celda Klouček, *Vase*, 1907
ceramic, engobe, h.: 27.5 cm
Uměleckoprůmyslové museum v Praze, Prague
inv. 20.797
without figure

V. Šidlík, studio of Celda Klouček, *Vase*, 1907
ceramic, h.: 33 cm
Uměleckoprůmyslové museum v Praze, Prague
inv. 10.856
without figure

Václav Švec, studio of Celda Klouček, *Vase*, 1908
ceramic, engobe, h.: 36.5 cm
Uměleckoprůmyslové museum v Praze, Prague
inv. 10.862
figure 191

Antonín Liška, studio of Celda Klouček, *Vase*, 1908
ceramic, h.: 34.5 cm
Uměleckoprůmyslové museum v Praze, Prague
inv. 10.863
without figure

Beneš Knüpfer (1844–1910)
Studied at the art academy in Munich, lived near Rome. From 1890 regularly exhibited in Prague where he tried to get a job as a teacher at the art academy. Many of his paintings exude the aura of Swiss artist Arnold Böcklin.

The last salute, 1894
oil on canvas, 108 × 150 cm
Národní galerie v Praze, Prague
inv. O 4595
figure 37

František Kobliha (1877–1962)
Graphic artist and painter. Studied at the Prague School of Applied Art and the Academy of Fine Art. One of the leading figures of Czech Symbolism. A member of the *Moderní revue* circle and the Sursum group.

Vampire (from the cycle in the *Towards morning* collection of poems by Karel Hlaváček), 1909
woodcut on paper, 20 × 15 cm
National Literary Museum, Prague
inv. IG 12 88189, 942954
figure 101

Reverie (from the cycle in the *Towards morning* collection of poems by Karel Hlaváček), 1909
charcoal on paper, 32.2 × 24.1 cm
Národní galerie v Praze, Prague
inv. K 43 515
without figure

Cover design and title page for 'Aurélie' by Gérard de Nerval, 1911
21.8 × 14 cm
Uměleckoprůmyslové museum v Praze, Prague
inv. GK 4160-D / GS 14.793
figure 114

Cover design and title page for 'The island of exiles' by Jiří Karásek, 1912
23.7 × 16.8 cm
Uměleckoprůmyslové museum v Praze, Prague
inv. D 25.343
without figure

Quido Kocián (1874–1928)
Sculptor. Studied at the Prague School of Applied Art and the Academy of Fine Art. One of the representatives of Symbolism in Czech sculpture at the beginning of the twentieth century.

Šárka, 1897
marble and alabaster h.: 60 × 60 × 135 cm
Museum and Gallery, Hořice
inv. U 421
figure 23

A sick spirit, 1903
plaster with patina, 25 x 52 x 73 cm
Národní galerie v Praze, Prague
inv. P 7883
without figure

Jan Konůpek (1883–1950)
Graphic artist and painter. Studied at the
Prague Academy of Fine Art. Co-founder of
the Sursum group, chiefly represented the
Secessionist syle and Symbolism in graphic
work for books. As founder (1908) of the
society for the reform of applied art, he
designed toys and assorted boxes.

*Title page and illustrations for the poem 'May' by
Karel Hynek Mácha*, 1910
20 x 17.5 cm
Uměleckoprůmyslové museum v Praze, Prague
inv. GK 7294-E
figure 117

Ecstasy, 1910-11
charcoal on paper, 88 x 60 cm
Museum of Modern Art, Hradec Králové
inv. K 1227
without figure

Ecstasy, 1911
etching and drypoint on paper, 9.8 x 7 cm
Moravian Gallery, Brno

inv. C 14 O22
figure 111

Homage to Jiří Karásek, 1911
etching and drypoint on paper, 12.8 x 8.3 cm
Moravian Gallery, Brno
inv. C 14 O15
without figure

Jan Kotěra (1871–1923)
Architect and designer. Studied architec-
ture at the art academy in Vienna, taught
at the School of Applied Art and Academy
of Fine Art in Prague. One of the leading
figures in the Mánes Artists' Association;
exhibited with Mánes in Prague and
Vienna. Often attended Czech presenta-
tions abroad as an important representa-
tive of his country's culture.

Divan, 1899
wood and velvet, 48 x 152 x 115 cm
Uměleckoprůmyslové museum v Praze, Prague
inv. 20.116
figure 149

Bowl set, Harrachov glassworks, Nový Svět,
1904-10
cut glass, h.: 14.5 and 11.9 cm
Uměleckoprůmyslové museum v Praze, Prague
inv. 98.280 a and b 98.283
figure 184

Jan Kotěra and Otto Prutscher, *Drink set*,
E. Bakalowitz & Söhne glassworks, Vienna,
after 1905
cut and gilded glass, h.: 12 / 14 / 15 / 15.5 / 17 cm
Uměleckoprůmyslové museum v Praze, Prague
inv. 63.995 / 64.000 / 64.007 / 64.012 / 64.018
without figure

Jan Kotěra and Marie Teinitzerová, *Wall covering
for the interior of Jan Laichter's house*, 1907-08
188 x 157 cm
Uměleckoprůmyslové museum v Praze, Prague
inv. 65.909
without figure

Jan Kotěra and Marie Teinitzerová, *Curtain for the
interior of Jan Laichter's house*, 1907-08
305 x 141 cm
Uměleckoprůmyslové museum v Praze, Prague
inv. 65.910 a and b
without figure

*Silverware cabinet for the interior of Jan Laichter's
house*, 1908
various woods, intarsia, mother-of-pearl, marble,
brass, 172 x 120 x 44 cm
Uměleckoprůmyslové museum v Praze, Prague
inv. 51.619
figure 171

Chair for the interior of Jan Laichter's house, 1908
various woods, metal, 77 x 56 x 52 cm
Uměleckoprůmyslové museum v Praze, Prague
inv. 65.912
figure 173

Chair for the interior of Jan Laichter's house, 1908
various woods, metal, 76.5 x 47 x 68 cm
Uměleckoprůmyslové museum v Praze, Prague
inv. 65.913
figure 173

Table for the interior of Jan Laichter's house, 1908
oak, metal, 140 x 100 x 81 cm
Uměleckoprůmyslové museum v Praze, Prague
inv. 65.911
figure 172

Josef Kratina (1872-c. 1950)
After studying in Prague, completed his
training in Paris at the Ecole des Beaux-
Arts and the Académie Julian. From Paris
sent various figurative and decorative
bronze objects to exhibitions in Prague and
other Czech cities.

Letter opener, 1902
wood, l.: 31.5 cm
East Bohemian Museum, Hradec Králové
inv. UD 466
without figure

Marie Křivánková (1883–1936)
Self-taught jewellery designer. Represented the late Secession style, influenced by the Wiener Werkstätte. In 1916 opened her own shop in Prague.

Pendant, after 1910
gold, emerald, mother-of-pearl, 6.2 x 4 cm
Uměleckoprůmyslové museum v Praze, Prague
inv. 72.473
without figure

Pendant, after 1910
gold, emerald, 6.2 x 4 cm
Uměleckoprůmyslové museum v Praze, Prague
inv. 75.445
figure 177

Pendant, c.1910
gold, Bohemian garnets, pearls, l.: 30 cm
Uměleckoprůmyslové museum v Praze, Prague
inv. 51.174
without figure

Ring, c. 1910
gold and emerald, Ø 2 cm
Uměleckoprůmyslové museum v Praze, Prague
inv. 80.756
without figure

Brooch, after 1910
gold, emerald, h.: 4.5 cm
Uměleckoprůmyslové museum v Praze, Prague
inv. 97.329
without figure

Bohumil Kubišta (1884–1918)
Painter, graphic artist, critic and theoretician. Studied at the School of Applied Art and the Academy of Fine Art in Prague, lived in Paris from 1909-10. Member of the Osma group (The Eight); one of the most prominent representatives of the moderns in Prague during the period up to the First World War.

Promenade along the Arno, 1907
oil on cardboard, 84 x 90 cm
West Bohemian Gallery, Pilsen
inv. O 37
figure 204

František Kupka (1871–1957)
Painter and graphic artist. Studied at art academies in Prague and Vienna, and at the Académie Julian in Paris. Settled in Paris; from 1910 became a leading representative of abstract painting. Remained in close contact with art circles in Prague. From 1900 exhibited in Prague and Vienna with representatives of the Mánes Artists' Association. Also held one-man shows in Bohemia.

The wave, 1902
oil on canvas, 100 x 145 cm
Museum of Fine Art, Ostrava
inv. O 819
figure 53

The way of silence, 1903
oil on cardboard, 58.5 x 69 cm
private collection (on loan to the Národní galerie v Praze, Prague)
inv. O 12643
figure 54

Autumn sun, 1906
oil on canvas, 103 x 117 cm
Národní galerie v Praze, Prague
inv. O 3835
figure 206

František Kysela (1881–1941)
Painter, graphic artist and designer. Studied at the School of Applied Art in Prague. Best known for his posters and typeface design. Represented late, geometric Secession which evolved into Art Deco around 1913.

Poster for the French Impressionist exhibition, 1907
lithograph on paper, 107.5 x 77.5 cm
Uměleckoprůmyslové museum v Praze, Prague
inv. GP 15.939
figure 132

Otakar Lebeda (1877–1901)
Landscape painter. Studied at the Prague Academy of Fine Art and the Académie Collarossi in Paris. His work is an example of Czech art which occupies the middle ground between Impressionism and Expressionism.

Cabbage field (Nigrín's lime tree near Vysoké on the Jizera), 1894
oil on canvas, 53 x 40 cm
Národní galerie v Praze, Prague
inv. O 3723
figure 55

Autumn, 1898
mixed media on canvas, 71.5 x 106 cm
Museum of Fine Art, Ostrava
inv. O 1293
without figure

Adolf Liebscher (1857–1919)
Painter and designer. Studied at the School of Applied Art in Vienna. Became known for his architectural decorations in Prague and other places in Bohemia. Gained popularity through his illustrations in various journals.

The development of painting in Bohemia, 1890-91, design for a decoration in the Rudolfinum
oil on canvas, 60 x 120 cm
Czech Savings Bank, Prague
inv. 000103
figure 8

Luděk Marold (1865–1898)
Draughtsman, illustrator and painter. Studied at art academies in Prague and Munich, and at the Prague School of Applied Art. Worked in Paris, where he was highly esteemed as an illustrator. Remained in contact with Prague art circles.

Luděk Marold and Alfons Mucha
Diploma for Mikoláš Aleš, 1886
pen and ink, gouache on paper, 54 x 43 cm
National Literary Museum, Prague
inv. LA-US
figure 34

Design for a poster for Nestlé, 1897
oil on canvas, 295 x 212 cm
Národní galerie v Praze, Prague
inv. O 5137
figure 36

Poster for the theatrical show 'Our house during the sanitisation works', 1898
lithograph on paper, 124 x 92 cm
Uměleckoprůmyslové museum v Praze, Prague
inv. GP 17.122
without figure

Václav Mařan (1879–1962)
Ceramicist and sculptor. Studied at the Prague School of Applied Art and the Académie Collarossi. One of the leading figures in Czech ceramic art during the Secession movement; organized ceramic training.

Václav Mařan, studio of Celda Klouček, *Vase*, 1899
ceramic, h.: 31 cm
Uměleckoprůmyslové museum v Praze, Prague
inv. 20.152
figure 165

Václav Mařan, studio of Celda Klouček, *Vase*, 1899
ceramic, h.: 27.3 cm
Uměleckoprůmyslové museum v Praze, Prague
inv. 20.165
figure 166

Václav Mařan, studio of Celda Klouček, *Vase*, 1900
ceramic, h.: 16 cm
Uměleckoprůmyslové museum v Praze, Prague
inv. 20.151
without figure

Josef Mařatka (1874–1937)
Sculptor. Studied in Prague at the School of Applied Art, in Paris at the art academy, and from 1901 to 1904 under Auguste Rodin. One of the group of leading modern sculptors in Prague. Can also be credited with organising exhibitions in Prague, devoted to the work of Rodin and Bourdelle respectively.

Ariadne abandoned, 1903
bronze, h.: 28.5 cm
Národní galerie v Praze, Prague
inv. P 729
figure 78

The wave, 1903
bronze, h.: 22 cm
Národní galerie v Praze, Prague
inv. P 7414
without figure

Study for the bust of Antonín Dvořák, 1906
bronze, h.: 52 cm
Národní galerie v Praze, Prague
inv. P 2716
figure 21

Karel Vítězslav Mašek (1865–1927)
Painter, designer and architect. Studied at art academies in Prague and Munich, and at the Académie Julian in Paris. Taught at the Prague School of Applied Art. His paintings from the period between the late 1880s and early 1890s are important to Prague. Later changed from decorating architecture to producing his own architectural designs.

Allegory: pastorale, 1889
oil on canvas, 180 x 285 cm
Národní galerie v Praze, Prague
inv. O 16479
figure 26

The prophetess Libuše, c. 1893
oil on canvas, 193 x 193 cm
Musée d'Orsay, Paris
inv. RF 19749
figure 20

Jaroslav Maštalíř (born 1887)
Designer. Studied 1900–1904 at the School for Arts and Crafts in Turnov and 1904–1907 at the School of Applied Art in Prague. Represented the late Secessionist style in the field of metalworking.

Bonbonnière, 1909
silver (gilt), lapis lazuli, h.: 6 cm, Ø 7 cm
Uměleckoprůmyslové museum v Praze, Prague
inv. 11.660
figure 181

Alfons Mucha (1860–1939)

Painter, graphic artist, designer and photographer. Studied at the art academy in Munich and the Académie Julian in Paris. During the mid 1890s one of the most important Art Nouveau poster artists. Worked in Paris and later the United States. Had exhibitions in Bohemia and returned to Prague in 1910. A well-known personality in European fin-de-siècle culture.

Design for the journal 'Lumír', 1898
pencil, pen and ink on paper, 30 × 42 cm
Národní galerie v Praze, Prague
inv. K 19447
figure 104

Illustrations for 'Le Pater', 1899
lithograph on paper, 30.5 × 40.5 cm
Uměleckoprůmyslové museum v Praze, Prague
inv. G154-B
figure 103

Judith and Holofernes (Mrs L. De Ferkel during a spiritualist séance), photograph, c. 1899
gelatine silver print, 13.8 × 18.3 cm
Uměleckoprůmyslové museum v Praze, Prague
inv. GF 1.174
without figure

Poster for the Austrian pavilion at the Paris World Fair, 1900
lithograph on paper, 97.5 × 65.5 cm
Uměleckoprůmyslové museum v Praze, Prague
inv. GP 5285
figure 144

Menu design for the official banquet during the Paris World Fair, 1900
64 × 49 cm
Mucha Trust
figure 145

Poster for the Economic, Industrial and Ethnographic Exhibition in Vyškov, 1902
lithograph on paper, 115 × 50 cm
Mucha Trust
figure 128

Study for the painting 'Madonna', photograph, 1904
gelatine silver print, 14.2 × 17.4 cm
Uměleckoprůmyslové museum v Praze, Prague
inv. GF 1.171
without figure

Princess Hyacintha, 1911
lithograph on paper, 127 × 90 cm
Uměleckoprůmyslové museum v Praze, Prague
inv. GP 20.011
figure 127

Josef Václav Myslbek (1848–1922)

Sculptor. Studied under Tomáš Seidan and Václav Levý, before attending the Prague Academy of Fine Art. Later taught in Prague at the School of Applied Art and the Academy of Fine Art. Exercised great influence on an entire generation of sculptors who worked from the end of the nineteenth century, although his ideas clashed with theirs. A key figure in the older school of Czech sculpture. Endeavoured to find a synthesis of traditional national art and international fin-de-siècle criteria.

Záboj and Slavoj, 1882
bronze, 102 × 62 × 65 cm
Národní galerie v Praze, Prague
inv. P 6226
figure 3

Bust of Bedřich Smetana, 1892
bronze, 61 × 57 × 32 cm
Národní galerie v Praze, Prague
inv. P 2436
figure 22

Preliminary study for 'Music'
first design, alternative A, 1892
bronze, 113 × 35 × 35 cm
Národní galerie v Praze, Prague
inv. P 2229
without figure

Preliminary study for 'Music'
second variation of the first design,
alternative A, 1892
bronze, 105 × 37 × 32 cm
Národní galerie v Praze, Prague
inv. P 5470
without figure

Preliminary study for 'Music'
second design, 1892-94
bronze, 109 × 52 × 40 cm
Národní galerie v Praze, Prague
inv. P 2526
figure 45

Preliminary study for 'Music'
fourth design, c. 1895
bronze, 66 × 23 × 19 cm
Národní galerie v Praze, Prague
inv. P 8825
figure 45

Swan song, 1894
bronze, 37 × 94 × 30 cm
Národní galerie v Praze, Prague
inv. P 1554
figure 44

Vratislav Nechleba (1885–1965)

Painter, mainly of portraits. Studied at the art academy in Prague, where he later taught. Exhibited with the Mánes Artists' Association.

Poster for the Mánes exhibition of 'Les Indépendants', 1910
lithograph on paper, 126 × 95 cm
Uměleckoprůmyslové museum v Praze, Prague
inv. GP 15.732
figure 133

Otakar Nejedlý (1883–1957)
Landscape painter. Took private painting lessons in Prague, travelled through Europe, visited India and Ceylon.

Snow on the ice rink, 1907
oil on canvas, 133 x 161 cm
Národní galerie v Praze, Prague
inv. O 3062
figure 86

Stanislav Kostka Neumann (1875–1947)
Poet, journalist and art critic. Initially worked for the journal *Moderní revue*, later established his own podia for literature and the fine arts. Represented literary anarchism and vitalism. One of the key figures in the Prague Decadent and Symbolist movement.

Proud and passionate apostrophes, 1896
32.5 x 22.6 cm
Uměleckoprůmyslové museum v Praze, Prague
inv. GK 8756C
figure 105

Josef Ladislav Němec (1871–1943)
Goldsmith. Studied at the Prague School of Applied Art and the Ecole des Beaux-Arts in Paris. Taught at the Goldsmiths' School and the Prague School of Applied Art. Important Czech goldsmith during the fin-de-siècle period.

Pendant, 1903
silver, gold, mother-of-pearl, chrysolite,
l.: 9.7 cm (with chain 27.5 cm)
Uměleckoprůmyslové museum v Praze, Prague
inv. 72.581
figure 140

Pendant, 1907
gold, Bohemian garnets, pearls,

l.: 30 cm (with chain)
Uměleckoprůmyslové museum v Praze, Prague
inv. 56.039
figure 178

Emanuel Novák (1866–1918)
Goldsmith. Studied at the Goldsmiths' School in Prague; later taught at the Prague School of Applied Art. Represented both historicism and the Secessionist style in the fields of jewellery-making and gold and silver work.

Clasp and two brooches, 1900
silver gilt, garnets, Ø 3.2 / 3.5 cm
Uměleckoprůmyslové museum v Praze, Prague
inv. 20.138/3, 20.138/7
figure 157

Address book, 1900
leather and silver, 14 x 8.8 cm
Uměleckoprůmyslové museum v Praze, Prague
inv. 20.135E
without figure

Karel Novák (1875–1950)
After studying in Vienna and Hamburg opened his own photographic studio in Bremen in 1905. From 1910 taught in Vienna. After the First World War returned to Prague where he founded the photographic department at the Graphic School.

Woman with antique mask, photograph, c. 1910
gelatine silver print, 11.7 x 16.2 cm
Uměleckoprůmyslové museum v Praze, Prague
inv. GF 3.923
figure 139

Woman with small vase, photograph, c. 1910
platinum print, 16.3 x 6.2 cm
Uměleckoprůmyslové museum v Praze, Prague
inv. GF 3.891
without figure

Untitled, photograph, c. 1914
platinum print, 15.3 x 11.8 cm
Uměleckoprůmyslové museum v Praze, Prague
inv. GF 3.895
without figure

Otakar Novotný (1880–1959)
Architect and designer. Studied at the Prague School of Applied Art and undertook study trips to the Netherlands, Belgium and Germany. Represented modern architecture which he promoted enthusiastically.

Otakar Novotný, studio of Jan Kotěra, *Vase*, 1899–1900
cut glass, wood, h.: 34 cm
Uměleckoprůmyslové museum v Praze, Prague
inv. 42.898 a and b
figure 185

Viktor Oliva (1861–1928)
Draughtsman-illustrator, painter and designer. Studied at the Prague Academy of Fine Art; became known for his posters,

journal and book illustrations for leading Prague publisher František Topič.

Illustrations by Max Pirner and *Cover* by Viktor Oliva *for 'Diabolical love' by Jaroslav Vrchlický*, 1887
album with 13 photogravures, 40.5 x 30.5 cm
Uměleckoprůmyslové museum v Praze, Prague
inv. B 28.629
without figure

Emil Orlik (1870–1932)
Painter and graphic artist. Studied at the art academy and took private lessons in Munich. Lived in Prague from 1885 to 1905 with interludes elsewhere; after this chiefly worked in Berlin. In 1900 visited Japan for the first time. Leading figure of the 1890s generation in Prague German-speaking circles.

Verein der deutschen bildenden Künstler, Böhmen, 1897
lithograph on paper, 70 x 100 cm
Uměleckoprůmyslové museum v Praze, Prague
inv. GP 21.190
without figure

Eugen Pflaumer (died 1918)
Goldsmith, teacher. Worked as a goldsmith in the Wiener Werkstätte and taught at the well-known Technical School for Metalwork in Jablonec nad Nisou, north Bohemia.

Eugen Pflaumer, Technical School for Metalwork in Jablonec nad Nisou, *Pendant*, c. 1908
silver (gilt), enamel, lapis lazuli, h: 6.5 cm (with chain 27.5 cm)
North Bohemian Museum, Liberec
inv. S 515
figure 179

Eugen Pflaumer, Technical School for Metalwork in Jablonec nad Nisou, *Pendant*, c. 1908
silver (gilt), enamel, h.: 4 cm
(with chain 25 cm)
North Bohemian Museum, Liberec
inv. S 517
figure 180

Max Pirner (1854–1924)
Painter. Studied at art academies in Prague and Vienna. Influential as teacher at the Prague Academy of Fine Art. Had few exhibitions, although he was one of the forerunners of Symbolism and Secession in Prague.

Forsaken from the cycle 'Diabolical love', 1884
pastel on paper, 59 x 45 cm
Waldes collection, Prague
without figure

Frustra, 1886-93
oil on canvas, 130 x 150 cm
Národní galerie v Praze, Prague
inv. O 4820
figure 40

Illustrations by Max Pirner and *Cover* by Viktor Oliva *for 'Diabolical love' by Jaroslav Vrchlický*, 1887
album with 13 photogravures, 40.5 x 30.5 cm
Uměleckoprůmyslové museum v Praze, Prague
inv. B 28.629
without figure

Pan and Psyche, 1899
pen and ink, watercolour on paper, 53 x 123 cm
Národní galerie v Praze, Prague
inv. K 43142
without figure

Jan Preisler (1872–1918)
Painter and graphic artist. Studied at the Prague School of Applied Art; later taught there and at the Prague Academy of Fine Art. As well as paintings and drawings, his illustrations and architectural decorations were of great importance. Exhibited with the Mánes Artists' Association in Prague and Vienna, and attended Czech presentations abroad. Leading figure in Prague fin-de-siècle modern art.

The wind and the breeze, 1896
charcoal on paper, 40 x 50 / 40 x 85.5 / 40 x 54 cm
Národní galerie v Praze, Prague
inv. K 13959
figure 70

The knight errant, 1897-98
pastel on cardboard, 47 x 29 cm
West Bohemian Gallery, Pilsen
inv. K 883
figure 69

Poster for 'Volné směry', 1898
lithograph on paper, 103.5 x 75.5 cm
Uměleckoprůmyslové museum v Praze, Prague
inv. GP 18.586
figure 123

Spring evening, 1898
oil on canvas, 35 x 71 cm
Národní galerie v Praze, Prague
inv. O 3735
figure 71

Harvest and *Blessed fruits*, 1899, decorative panels for the 1900 Paris World Fair
oil on canvas, both 198 x 257 cm
Uměleckoprůmyslové museum v Praze, Prague
inv. GS 19.035 a and b
figure 143

Spring (triptych), 1900
oil on canvas, 112 x 70 / 112 x 186 / 112 x 70 cm
West Bohemian Gallery, Pilsen
inv. O 897
figure 68

Study for 'Spring', 1900
charcoal and chalk on paper, 41 x 24 cm
West Bohemian Gallery, Pilsen
inv. K 935
without figure

*Frontispiece for the 'Poisons and medicines' collection
of poems by Jan Opolský*, 1901
pencil and black chalk on paper, 44.5 x 35 cm
Národní galerie v Praze, Prague
inv. K 42899
figure 109

*Frontispiece for the 'Poisons and medicines' collection
of poems by Jan Opolský*, 1901
22.4 x 15.5 cm
Uměleckoprůmyslové museum v Praze, Prague
inv. 27.998-D
without figure

Illustration for a poem by Jan Neruda, 1901
charcoal on paper, 57.8 x 45.5 cm
Národní galerie v Praze, Prague
inv. K 36314
figure 108

Illustration for a poem by Jan Neruda, published in
Volné směry, 1901
lithograph, 30.4 x 23.4 cm
private collection
without figure

Fairy tale, 1902
oil on canvas, 101.5 x 79 cm
Museum of Fine Art, Ostrava
inv. O 701
figure 67

Young man by a lake, 1903-04
oil on canvas, 44 x 53 cm
West Bohemian Gallery, Pilsen
inv. O 869
figure 89

The black lake, 1904
oil on canvas, 73 x 113 cm
President's Chancellery, Prague
inv. OPH 588
figure 90

The black lake, 1904
oil on canvas, 100 x 150 cm
Národní galerie v Praze, Prague
inv. O 3497
figure 92

Poster for the Munch exhibition, 1905
lithograph on paper, 152 x 90 cm
Uměleckoprůmyslové museum v Praze, Prague
inv. GP 20.000
figure 129

Seduction I, 1907
oil on canvas, 75 x 116 cm
West Bohemian Gallery, Pilsen
inv. O 635
figure 93

Seduction II, 1907
oil on canvas, 75 x 115 cm
Museum of Art, Olomouc
inv. O 532
figure 94

Adam and Eve, 1908
oil on canvas, 80 x 76 cm
Museum of Fine Art, Ostrava
inv. O 673
without figure

Diana hunting, 1908
pastel on paper, 21 x 23 cm
Art Gallery, Litoměřice
figure 91

Bathers, 1912
oil on canvas, 90 x 76.5 cm
West Bohemian Gallery, Pilsen
inv. O 579
figure 96

Vojtěch Preissig (1873–1944)

Painter, graphic artist and designer. Studied
at the School of Applied Art in Prague and
a similar institution in Paris. Worked in
Prague between 1903 and 1910, then lived
in the United States until 1930. Prominent
figure in the field of modern typographic
design and artistic graphics.

Wallpaper design, 1899
gouache on cardboard, 65 x 51 cm
Uměleckoprůmyslové museum v Praze, Prague
inv. G 2216/9
figure 183

Wallpaper design, c. 1900
gouache on paper, 48.3 x 30.9 cm
Národní galerie v Praze, Prague
inv. 64712
without figure

Wallpaper design, c. 1900
gouache on paper, 48.8 x 31.3 cm
Národní galerie v Praze, Prague
inv. 64818
without figure

Wallpaper design, c. 1900
gouache on paper, 48.7 x 30.6 cm
Národní galerie v Praze, Prague
inv. 64819
without figure

Poster for Preissig's exhibition in Salon Topič, 1907
lithograph on paper, 127 x 93 cm
Uměleckoprůmyslové museum v Praze, Prague
inv. GP 711
figure 130

*Illustrations, typeface, design and bookbinding for
Petr Bezruč's 'Silesian Lieder' collection of poems*,
1909
21 x 13.5 cm
Uměleckoprůmyslové museum v Praze, Prague
inv. GK 11.316-D
figure 100

Antonín Procházka (1882–1945)

Painter and graphic artist. Studied in
Prague at the School of Applied Art and
the Academy of Fine Art. In 1906 went on a
major journey through Europe. Member of
the avant-garde groups 'Osma' (The Eight)
and 'Skupina výtvarných umělců' (Group of
Fine Artists). Represented Expressionism
(Fauvism) and Cubism in Czech art.

Circus, 1907
oil on cardboard, 49 x 66 cm
Národní galerie v Praze, Prague
inv. O 9109
without figure

Jindřich Prucha (1886–1914)
Landscape painter. Took private lessons in
Prague and studied at the art academy in
Munich. Died at the front during the First
World War. Represented Expressionism
(Fauvism) in Czech art.

In a beech wood, 1911-12
oil on canvas, 84 x 96 cm
Národní galerie v Praze, Prague
inv. O 7712
figure 88

Male nude in a landscape, 1912
oil on canvas, 111 x 121 cm
Národní galerie v Praze, Prague
inv. O 7713
without figure

Jakub Schikaneder (1855–1924)
Painter. Studied at art academies in Prague
and Munich. During the 1890s he travelled
through Europe. Taught at the Prague
School of Applied Art. Prominent painter,
famous for his light and mood effects.
Reached his peak around the turn of the
century.

Snow, 1899
oil on canvas, 116 x 181 cm
Národní galerie v Praze, Prague
inv. O 4598
figure 47

A street by night, 1906
oil on canvas, 110 x 95 cm
Národní galerie v Praze, Prague
inv. O 4606
without figure

Rudolf Schlattauer (1860–1915)
Painter, designer and tapestry maker.
Studied at the art academy in Vienna and
travelled through Europe. Had own school
and studios in Moravia (Valašské Meziříčí)
which set new trends in their time (from
1909). On occasion collaborated with simi-
lar organizations in Prague.

Narcissi tapestry, c. 1900
48 x 104 cm
Uměleckoprůmyslové museum v Praze, Prague
inv. 72.824
without figure

Hanuš Schwaiger (1854–1912)
Painter, illustrator and designer. Studied at
the Vienna art academy, lived chiefly in
Moravia, taught at the Prague Academy of
Fine Art from 1902. By then already
enjoyed recognition from modernists in
Prague and Vienna thanks to the indepen-
dence of his work in official art circles.

Design for a cover for Wiesner's book of fairy tales,
1885
24.5 x 17.3 cm
Uměleckoprůmyslové museum v Praze, Prague
figure 102

The water man, 1885
tempera on panel, 57 x 28 cm
private collection
(on loan to the Národní galerie v Praze, Prague)
inv. O 2035
figure 42

The water man, c. 1890
oil on panel, 63 x 54 cm
Národní galerie v Praze, Prague
inv. O 14779
without figur

Antonín Slavíček (1870–1910)
Landscape painter. Studied at the Prague
Academy of Fine Art. Exhibited in Prague
and Vienna with the Mánes Artists'
Association; attended Czech presentations
abroad. One of the most important figures
in fin-de-siècle Czech culture.

In Veltrusy Park, 1896
mixed media on cardboard, 66 x 49.5 cm
Národní galerie v Praze, Prague
inv. O 8304
without figure

Autumn dawn, 1897
mixed media on cardboard, 68 x 101.5 cm
Národní galerie v Praze, Prague
inv. O 784
figure 58

Country road in Kameničky, 1903
oil on canvas, 116 x 136 cm
West Bohemian Gallery, Pilsen
inv. O 682
figure 87

Park in the Letná plain, 1907
oil on canvas, 112 x 137 cm
Národní galerie v Praze, Prague
inv. O 3193
without figure

and decorations for buildings in Prague and elsewhere in Bohemia. One of the leading figures in the field of Czech Symbolist and Secession sculpture.

Vase (The kiss), 1899
plaster with patina, h.: 52 cm
Uměleckoprůmyslové museum v Praze, Prague
inv. 59.454
figure 164

Wild poppies, 1900
bronze, 56 x 18 x 15 cm
Národní galerie v Praze, Prague
inv. P 1519
without figure

The Devil and Kate, 1917
black and white marble, h.: 51.5 cm
Národní galerie v Praze, Prague
inv. P 385
figure 82

Expressionism (Fauvism), Cubism and other avantgarde trends in the Czech art world.

Peasant girl, 1907
oil on cardboard, 70.8 x 54 cm
Moravian Gallery, Brno
inv. A 896
figure 203

Karel Špillar (1871–1939)
Painter, graphic artist and designer. Studied at the Prague School of Applied Art, lived in France between 1902 and 1908. His best known work includes decorations for the Municipal House (Obecní dům) in Prague and several posters.

In a café, 1904
oil on cardboard, 58 x 47.5 cm
Národní galerie v Praze, Prague
inv. O 5283
figure 85

Stanislav Sucharda (1866–1916)
Sculptor. Studied at the Viennese art academy and the Prague School of Applied Art where he later taught. Key figure in the 1890s' generation. Exhibited in Prague and Vienna with the Mánes Artists' Association, and attended Czech presentations abroad.

Study for a memorial sculpture, 1909
bronze, 39 x 46 x 31 cm
Národní galerie v Praze, Prague
inv. P 3827
figure 79

Repression, study for the Palacký monument, 1909
bronze, 23 x 25 x 42 cm
Národní galerie v Praze, Prague
inv. P 3826
without figure

Bust of Vlasta Zindlová, 1911
bronze, 31 x 21 x 50 cm
Národní galerie v Praze, Prague
inv. 5370
without figure

Ladislav Šaloun (1870–1946)
Sculptor. Took private lessons in Prague, later taught at the Prague School of Applied Art. Produced a series of statues

Václav Špála (1885–1946)
Painter and graphic artist. Studied at the Prague art academy, member of the avantgarde group 'Skupina výtvarných umělců' (Group of Fine Artists). Represented

Jan Štursa (1880–1925)
Sculptor. Studied at the Prague art academy, where he later taught. Exhibited with the Mánes Artists' Association in Prague and Vienna, where he was also an active

member of the Hagenbund. A leading figure amongst Czech sculptors and the younger wing of the 1890s' generation.

Puberty, 1905
bronze, 84.5 x 30 x 25 cm
Národní galerie v Praze, Prague
inv. P 2246
without figure

Melancholy girl, 1906
limestone, 24 x 24 x 44 cm
Národní galerie v Praze, Prague
inv. P 1520
figure 97

Portrait of Karel Hlaváček, 1906
limestone, 41 x 28 x 24.5 cm
National Literary Museum, Prague
inv. IP 53
without figure

Eve, 1909
bronze, h.: 190 cm
Národní galerie v Praze, Prague
inv. P 2226
without figure

Maxmilián Švabinský (1873–1962)
Painter and graphic artist. Studied at the Prague art academy, where he soon became a teacher. Exhibited with the Mánes Artists' Association in Prague and Vienna; attended Czech presentations abroad. A brilliant draughtsman and adroit painter, he was the most successful artist of the 1890s' generation.

Union of souls, 1896
oil on canvas, on cardboard, 65.5 x 45.5 cm
Národní galerie v Praze, Prague
inv. O 3318
figure 64

The inspiration of Rodin, 1901
charcoal, wash, heightened with gold, 132 x 96 cm
Národní galerie v Praze, Prague
inv. K 43946
figure 73

Camelia, 1903
pen and ink, watercolour on paper,
123 x 113 cm
Národní galerie v Praze, Prague
inv. K 18184
figure 65

Portrait of a lady, 1904
watercolour and pastel on cardboard,
69 x 58 cm
West Bohemian Gallery, Pilsen
inv. DK 3
figure 66

Richard Teschner (18791948)
Painter and graphic artist. Studied at the Prague art academy and school of applied art in Vienna. Lived in Prague and Vienna. One of the outstanding German-speaking artists in Bohemia.

Poster for a lecture by Paul Leppin, after 1900
lithograph on paper, 130 x 79 cm
Uměleckoprůmyslové museum v Praze, Prague
inv. GP 11.747
without figure

Josef Váchal (1884–1969)
Painter, graphic artist, illustrator, typographer, sculptor and writer. Studied as a bookbinder in Prague and took private lessons in landscape painting. His most notable works include his 'one-man books', which he made entirely himself. Exceptional, multi-talented figure who worked in the interface of Symbolism and Expressionism. Important figure in twentieth-century Czech culture.

Drawings and annotations in František Gellner's 'After us the deluge!', 1902
watercolour on paper, 19.5 x 25.3 cm
National Literary Museum, Prague
inv. 53/7140
without figure

Elemental plain, 1907
pen and ink, watercolour and pastel on paper,
35.9 x 52.5 cm
National Literary Museum, Prague
inv. 97/61-1239
figure 118

Astral plain, 1907
pen and ink, watercolour and pastel on paper,
35.7 x 52 cm
National Literary Museum, Prague
inv. 97/61-1238
figure 119

Poster for the 'Sursum' exhibition, 1910
lithograph on paper, 57x 47 cm
Uměleckoprůmyslové museum v Praze, Prague
inv. GP 12.300
without figure

Visions of seven days and planets, 1910
book cover, woodcuts, typeface, watercolour,
27 x 21.5 cm
Uměleckoprůmyslové museum v Praze, Prague
GK 11.159C
figure 112

Exorcists, 1910-12
oil on canvas, 95 x 94 cm
Galerie of Modern Art, Hradec Králové
inv. O 806
figure 215

'Caryatides' for the library of Miloš Marten, 1911
wood, h.: 91, 91 and 75 cm
private collection
figure 213

*Cover and illustrations for Josef Šimánek's
'Wanderings of the little elf'*, 1911
woodcuts, 31.6 x 24.2 cm
Uměleckoprůmyslové museum v Praze, Prague
GK 7.704C
figure 115

*Illustration for the book 'The castle of death' by
Jakub Deml*, 1912
woodcut, 25.5 x 19 cm
Uměleckoprůmyslové museum v Praze, Prague
inv. GK 7.703C
figure 19

Josef Vélik (dates unknown)
Designer. Worked 1900–1914 for the glass-
makers at Košt'any and Kamenický Šenov.

Vase, Pallme-König & Habel glassworks,
Kamenický Šenov and Košt'any near Teplice,
1900-05
iridised glass, h.: 23 cm
Uměleckoprůmyslové museum v Praze, Prague
inv. 72.093
without figure

Gustav Weisskirchner (born 1876)
Textile designer. Studied 1894-1900 at the
Prague School of Applied Art.

Wall hanging, 1902
175 x 44 cm
Uměleckoprůmyslové museum v Praze, Prague
inv. 55.542
without figure

Adolf Wiesner (1871–1942)
Painter. Studied at the art academies in
Prague, Dresden and Munich.

Cover design for Volné směry, 1896
29.5 x 23 cm
Uměleckoprůmyslové museum v Praze, Prague
inv. GS 14.439
figure 120

Jan Zrzavý (1890–1977)
Painter and graphic artist. Studied art
through private lessons and at the School
of Applied Art in Prague. Major figure of
late Symbolism with avant-garde tenden-
cies. One of the most representative fig-
ures in twentieth-century Czech culture.

Zeyer's garden (Sister Paskalina), 1907
pastel on paper, 22.6 x 26 cm
Národní galerie v Praze, Prague
inv. K 53504
figure 116

Self-portrait with straw hat, 1910
oil on canvas, 32.2 x 21.8 cm
Moravian Gallery, Brno
A 1657
figure 214

Melancholy, 1912
oil on canvas, 62 x 45.3 cm
Národní galerie v Praze, Prague
inv. O 13902
figure 212

Sleepwalker, 1913
oil on canvas, 81 x 45 cm
West Bohemian Gallery, Pilsen
inv. O1002
figure 211

The lovers, 1914
oil on canvas, 44 x 32 cm
Museum of Fine Art, Ostrava
inv. O 680
without figure

Vladimír Županský (1869–1928)
Painter and graphic artist. Studied at the
Viennese and Prague art academies.
Designed a series of posters and catalogues
for exhibitions by the Mánes Artists'
Association. Edited the journal *Volné směry*
(Free directions).

Poster for the Rodin exhibition, 1902
lithograph on paper, 158 x 84 cm
Uměleckoprůmyslové museum v Praze, Prague
inv. GP 5180
without figure

Anonymous

Vase, after 1900
ceramic, h.: 23.5 cm
Uměleckoprůmyslové museum v Praze, Prague
inv. 54.967
without figure

**Jablonec nad Nisou Technical School for
Metalwork**

Necklace, 1906
silver and gold, l.: 32.3 cm
Museum of Glass and Jewellery, Jablonec nad
Nisou
inv. B 1792
without figure

**Johann Loetz Witwe glassworks, Klášterský
Mlýn**

Goblet, 1896
iridised glass, gilded mount, h.: 23.5 cm
Uměleckoprůmyslové museum v Praze, Prague
inv. 92.893, 92.894
figure 159

Vase, c. 1900
transparent glass, iridised, h.: 15.5 cm
Uměleckoprůmyslové museum v Praze, Prague
inv. 94.927
without figure

Vase, c. 1900
transparent glass, iridised, h.: 26 cm
Uměleckoprůmyslové museum v Praze, Prague
inv. 73.153
without figure

Vase with butterfly motif, 1898
iridised glass, h.: 38.5 cm, Ø 11.2 cm
Uměleckoprůmyslové museum v Praze, Prague
inv. 54.163
figure 160

Johann Oertel glassworks, Bor (Haida)

Carl Schappel, *Vase*, Bor (Haida), 1912
cut glass, h.: 29 cm
Uměleckoprůmyslové museum v Praze, Prague
inv. 97.047
figure 188

Wine set (carafe with two glasses), 1912
glass, enamel
h. (carafe): 39.5 cm; h. (glasses): 20 cm
Uměleckoprůmyslové museum v Praze, Prague
inv. 12.796/1 (a and b) 2 and 3
figure 190

Josef Riedel glassworks, Polubný

Vase, 1900
glass, h.: 16.5 cm
Museum of Glass and Jewellery, Jablonec nad
Nisou
inv. SR 228
without figure

Vases, before 1904
opal glass, cut, with enamel and gold, h.: 15.5 /
15 / 7.6 / 18.5 cm
Uměleckoprůmyslové museum v Praze, Prague
inv. 8.776 8.779
figure 186

Rindskopf glassworks, Košt'any near Teplice

Vase, 1901
marbled glass, h.: 15 cm
North Bohemian Museum, Liberec
inv. S 411
without figure

Rydl and Thon Company, Svijany

Vase, before 1908
ceramic, h.: 26 cm
Uměleckoprůmyslové museum v Praze, Prague
inv. 10.815
without figure

Vase, before 1908
ceramic, h.: 12.5 cm
Uměleckoprůmyslové museum v Praze, Prague
inv. 10.816
figure 189

Vase, before 1908
ceramic, h.: 11.5 cm
Uměleckoprůmyslové museum v Praze, Prague
inv. 10.817
without figure

Teplice School of Ceramics

Vase with ray motif, c. 1900
ceramic, enamel glaze, h.: 33 cm
Uměleckoprůmyslové museum v Praze, Prague
inv. 97.800
without figure

Turnov Technical College for Gold and Silversmithing

Comb with Medusa, c. 1900
silver, Bohemian garnets, chalcedony, tortoiseshell,
12.4 x 8.2 cm
Uměleckoprůmyslové museum v Praze, Prague
inv. 90.401
figure 155

Brooch, 1900
gold, garnets, almandine, 3.7 x 6.1 cm
College of Decorative Art, Turnov
inv. 43
without figure

Brooch, 1900
gold, garnets, almandine, 3.8 x 3.8 cm
Uměleckoprůmyslové museum v Praze, Prague
inv. 89.639
figure 158

Letter opener, 1906
bloodstone, almandine, l.: 19 cm
College of Decorative Art, Turnov
inv. 88
without figure

Notes

Prague 1900
From provincial capital to metropolis

Michael Huig
translated by Michèle Hendricks

I Stefan Zweig, *Die Welt von Gestern, Erinnerungen eines Europäers*, Frankfurt am Main 1982 (originally 1944), p. 27.

2 Jan Neruda, quoted by František Žákavec in *Chrám znovuzrození* (Cathedral of the Revival), Prague 1936, p. 11.

3 Anton Gindely, quoted by Richard Georg Plaschka in the introduction to Otto Urban, *Die tschechische Gesellschaft 1848 bis 1918*, Vienna, Cologne & Weimar 1994, p. 22.

4 Emperor Franz Josef I in the act of donation and foundation for the Modern Gallery, dated 6 August 1902, quoted in the exhib. cat. *Moderní Galerie tenkrát, 1902–1942* (The Modern Collection in Past Times, 1902–1942), Prague (Národní galerie v Praze) 1992, p. 7.

Pictura & Poesis
The interplay of literature and art

Luboš Merhaut
translated by John Rudge

I Karel Teige, *Osvobozování života a poezie* (The liberation of life and poetry), Prague, 1994, p. 300.

2 Jürgen Habermas, 'Die Moderne. Ein unvollendetes Projekt', *Kleine politische Schriften*, Frankfurt am Main 1981, pp. 444-64.

3 See Petr Wittlich, *Česká secese* (The Czech Secession movement), Prague 1982; Petr Wittlich, *Prague. Fin de siècle*, Paris 1992; Jan Mukařovský, 'Mezi poezií a výtvarnictvím' (Between poetry and art), *Kapitoly z české poetiky* (Chapters in Czech poetry) I (1948); Karel Krejčí, *Český fin de siècle. Česká literatura a kulturní proudy evropské* (The Czech *fin de siècle*. Czech literature and European cultural movements), Prague 1975; Jiří Opelík and Jaroslav Slavík, *Josef Čapek*, Prague 1996; Jiří Kudrnáč, *Úvod do české secesní literatury. Z času Moderní revue - Literární archiv*

(Introduction to Czech Secession literature. From the age of Moderní revue – Literární archive), Prague (National Literary Museum) 1997.

4 Otokar Březina, *Hudba pramenů a jiné eseje* (Music from sources and other essays), Prague 1989, pp. 11, 47 and 72.

Music - 'another world'

Marta Ottlová
translated by Jean Vaughan

I František Václav Krejčí, 'K estetice symbolismu' (On the aesthetics of Symbolism), *Rozhledy* (Outlooks) 7 (1898).

2 For Hostinský's views on music drama see Marta Ottlová and Milan Pospíšil, 'Zu den Motiven des tschechischen Wagnerianismus und Antiwagnerianismus', in Horst Seeger (ed.), *Oper heute 9, Almanach der Musikbühne*, Berlin 1986, pp. 165-82.

3 See for example the influential treatise by Vladimír Helfert, *Česká moderní hudba* (Czech modern music), Olomouc 1936, with the chapter headings 'Founders of modern music' (Smetana, Dvořák, Fibich, Janáček), 'On the point of breaking with Romanticism' (Foerster, Novák, Suk, Ostrčil) and 'Towards a new style'.

4 See Karin M. Stöckl-Steinebrunner, 'Der unbequeme Dvořák. Reaktionen der Musikkritik auf die ersten Aufführungen der sinfonischen Dichtungen im deutschsprachigen Raum', in Klaus Döge and Peter Jost (ed.), *Dvořák-Studien*, Mainz 1994, pp. 190-96.

5 Published in the 'České proudy hudební' (Movements in Czech music) section in the Brno periodical *Hlídka* (The watch) 2/3 (1897/98); German translation in *Mitteilungen der Schweizer Janáček-Gesellschaft* 53-56 (1988/89).

6 For examples from the libretto see Ivan Vojtěch, 'Rusalka', in Carl Dahlhaus and Sieghart Döring (ed.), *Pipers Enzyklopädie des Musiktheaters*, München 1987, pp. 101-06, which also includes the newest interpretation of the opera. See also Jürgen Schläder, 'Märchenoper oder symbolistisches Musikdrama? Zum Interpretationsrahmen der Titelrolle in Dvořáks Rusalka', *Musikforschung* 34 (1981), pp. 25-39, and

studies on this theme in Marta Ottlová and Milan Pospíšil (ed.), *Antonín Dvořák 1841–1991. Report of the International Musicological Congress Dobříš 17th–20th September 1991*, Prague 1994.

7 See further Marta Ottlová and Milan Pospíšil, 'Motive der tschechischen Dvořák-Kritik am Anfang des 20. Jahrhunderts', in Klaus Döge and Peter Jost (ed.), op. cit. (note 4), pp. 211-16.

8 Janáček clearly explains his theory on speech melody in 'Loni a letos. Hudební studie' (This year and last year. Music studies), *Hlídka* (The watch) 22 (1905), pp. 201-11.

9 See Ivan Vojtěch, 'Vertonte Sprache in der geistigen Tradition der tschechischen Musik. A. Dvořák, Biblische Lieder op. 99, Nr. 4', in H. Danuser and H. de la Motte-Haber (ed.), *Das musikalische Kunstwerk. Festschrift Carl Dahlhaus zum 60. Geburtstag*, Laaber 1988, pp. 579-88.

10 Vítězslav Novák, *O sobě a jiných* (About myself and others), Prague 1946, p. 140.

Between Salon and Secession

Roman Prahl
translated by Kate Williams

1 For a broad survey of people and developments in Prague, including the older generation of artists, see Jiří Kotalík (ed.), exhib. cat. *Tschechische Kunst 1878–1914. Auf dem Weg in die Moderne*, 2 vols., Darmstadt (Mathildenhöhe) 1984.

2 For contemporary art in Prague see Roman Prahl, 'Mikuláš Lehmann. Chapter on the history of the art trade in Prague' in *Staletá Praha* (Age-old Prague) 23 (1997), pp. 23-38, and Gabriela Dupačová and Aleš Zach, in exhib. cat. *Topičův dům - nakladatelské příběhy 1883–1949* (Maison Topič - publishers' stories), Prague (Czech Savings Bank) 1993 (with a résumé in French and English).

3 Roman Prahl, 'Anfänge der Modernen Galerie in Prag', *Belvedere* 2 (1995), pp. 84-97. This also looks into the Czech-German relation in the art of Prague around 1900.

4 For a survey of exhibitions in the Prague Artists' House, the Rudolfinum, see Zdeněk

Hojda, 'Die Prager Kunstausstellungen 1886–1914. Ihr Publikum und ihre Verkaufserfolg', in *Bildungsgeschichte, Bevölkerungsgeschichte, Gesellschaftsgeschichte in den Böhmischen Ländern und in Europa*, Schriftenreihe des Österreichischen Ost- und Südeuropa-Instituts 14 (1988), pp. 251-73, and for reviews on them Vít Vlnas (ed.), exhib. cat. *Obrazárna v Čechách 1796–1918* (The painting gallery in Bohemia 1796–1918), Prague (Národní galerie v Praze) 1996, with a detailed summary in English.

5 For Czech Secession journals, see Iva Janáková's chapter in this catalogue; for the previous history of the journals, see Roman Prahl and Lenka Bydžovská, *Volné směry. Časopis secese a moderny / Freie Richtungen: Die Zeitschrift der Prager Secession und Moderne*, Prague 1993. Both in German and Czech editions.

6 For the 'exchange' of art and exhibitions between Czech Prague and Europe see Anna Masaryková, 'Cizí umělci na výstavách Krasoumné jednoty v Praze' (Foreign artists at exhibitions of the Art Society in Prague), in *Sborník k sedmdesátinám Jana Květa* (an anthology in honour of Jan Květ on his 70th birthday), Prague 1965, pp. 199-205 and Pascal Varejka, 'Les artistes tchèques et les Salons officiels parisiens avant 1914', *Umění* (Art) 32 (1984), pp. 155-69. For the foreign contacts of the Czech avant-garde see Roman Prahl, op. cit. (note 5) and Roman Prahl, 'Hagenbund a Mánes: mezi Vídní a Prahou' (Hagenbund and Mánes: between Vienna and Prague), *Umění* (Art) 45 (1997), pp. 445-60. For the image of modern Vienna in the artistic circles of Prague see Roman Prahl, 'Vídeň v zrcadle české secese a moderny' (Vienna in the mirror of the Czech Secession and the moderns) in Zdeněk Hojda and Roman Prahl (ed.), *Český lev a rakouský orel v 19. století* (The Bohemian lion and the Austrian eagle in the nineteenth century), Prague 1996.

7 For the decoration of the National Theatre in Prague within the context of Central Europe see Roman Prahl and Tamara Bissel, 'The Nation for itself in the curtain of the National Theatre', *Umění* (Art) 44 (1996), pp. 520-39.

8 For more on Tyrš and his role see C. Nolte, 'Art in the service of the nation. Miroslav Tyrš as art historian and critic', *Bohemia* 34 (1993), pp. 47-62. For the early discussion of modern art in Prague and the significance of Gabriel Max see Roman Prahl, '"Dobrou noc, krásné umění v Čechách"? Ke krizi v českém malířství 70. let 19.

Století' ('Goodnight, the fine arts in Bohemia.' On the crisis in Czech painting in the 1870s), *Umění* (Art) 32 (1984), pp. 507-27 (with an English summary).

9 For Kocián's sculpture *The artist's lot* as a satire of that by Myslbek see Petr Wittlich, *Česká secese* (The Czech Secession), Prague 1982, p. 130.

Towards a new synthesis

Petr Wittlich
translated by Donald Gardner

1 For the role of *Moderní revue* (Modern review) in Czech culture, see Otto M. Urban and Luboš Merhaut (eds.), *Moderní revue 1894–1925*, Prague 1995.

2 František Kaván, 'Julius Mařák ve vzpomínce žákově' (Julius Mařák as recalled by a pupil), *Volné směry* (Free directions) 3 (1899), pp. 414-24.

3 The tradition of the concept of 'mood' even emerged in modern art in Giorgio de Chirico's notion of 'pittura metafysica'. See exhib. cat. *Eine Reise ins Ungewisse: Böcklin-De Chirico-Ernst*, Zürich (Kunsthaus), Munich (Haus der Kunst) & Berlin (Nationalgalerie) 1998.

4 František Xaver Šalda, 'Nová krása: její genese a charakter' (The new beauty: its origin and character), *Volné směry* (Free directions) 7 (1903), pp. 169 and 181.

5 Karel B. Mádl, *Umění včera a dnes II, Pětadvacet výstav 'Mánesa'. Kronika deseti let 1898–1908* (Art past and present II. Twenty-five exhibitions by 'Mánes'. A chronicle of a decade, 1898–1908), Prague 1908, p. 48.

6 Ela Vejrychová, Švabinský's fiancée was the model for this painting; she was the perfect type of emotionally emancipated woman.

7 Antonín Matějček, *Jan Preisler*, Prague 1950, pp. 47-48.

8 There is an account of the Rodin exhibition in exhib. cat. *Pocta Rodinovi* (Homage to Rodin), Prague (Gallery of the City of Prague) 1992. See also Alain Beausire, *Quand Rodin exposait*, Paris (Musée Rodin) 1988, pp. 224-36.

9 František Xaver Šalda, 'Géniova mateřština' (The mother tongue of genius), in exhib. cat. *Výstava děl sochaře Rodina v Praze,* IV. Výstava SVU Mánes, Záhrada Kinského od 10.5 do 15.7.1902 (Exhibition of works by the sculptor Rodin in Prague, IVth exhibition of the Mánes Artists' Association, Kinský Park, 10 May to 15 July, 1902).

10 The sculptor Ladislav Šaloun stated this explicitly, much later, in 1920, in his articles in the magazine *Dílo* (Oeuvre).

11 František Xaver Šalda, introduction to the catalogue for the exhibition held by SVU Mánes (Mánes Artists' Association), *Moderní francouzské umění*, Záhrada Kinského od 30.8 do 2.11.1902 (Modern French art, Kinský Park, 30 August to 2 November, 1902).

12 Antonín Slavíček in a letter to Jan Goll, *Vybrané listy A. Slavíčka* (Selected letters of A. Slavíček), Prague 1930, p. 95.

13 Miloš Marten, 'O lyrickém impresionismu' (On lyrical Impressionism), *Moderní revue* (Modern review) 13 (1906-07), no. 19, pp. 9-24.

14 František Xaver Šalda, 'Synthetism v novém umění' (Syntheticism in the new art), *Literární listy* XIII (Literary pages XIII), no. 1-8, reprinted in František Xaver Šalda, *Kritické projevy I (1892–1893)* (Collected criticism, vol. I, 1892–1893), Prague 1949, pp. 11-54.

15 For Julius Meier-Graefe see Robert Jensen, *Marketing Modernism in Fin-de-Siècle Europe*, Princeton (New York) 1994, pp. 235-63.

16 Camille Mauclair, 'Klasicism a akademism' (Classicism and academicism), in *Volné směry* (Free directions) 9 (1904-05), p. 47.

17 Marten, op. cit. (see note 13).

18 František Xaver Šalda, 'Impresionism: jeho rozvoj, rezultáty a dědicové' (Impressionism: development, achievements and heirs), *Pokroková revue* (Progressive review) 4 (1907), pp. 70 and 159.

19 The letter is published in *J. Preisler, Výbor z jeho díla* (J. Preisler, A selection from his oeuvre) Prague 1919.

Illustration as harmony

Iva Janáková
translated by Robert Ordish

1 This collection by Procházka appeared in 1894 as the first volume of *Knihovna Moderní revue* (Modern review library). Hlaváček's cycle, created three years later, was published by *Moderní revue* as the first album.

2 Tomáš Vlček, 'Výtvarné umění v životě a díle básníka snů a vizí' (Art in the life and work of the poet of dreams and visions), in Tomáš Vlček (ed.), *Julius Zeyer. Texty, sny, obrazy* (Julius Zeyer. Texts, dreams, paintings), Prague 1997, p. 179.

3 František Xaver Šalda, 'Hrdinný zrak' (Heroic look), in *Boje o zítřek* (Struggle for tomorrow), Prague 1915, 2nd edition, p. 59.

4 This concerns primarily a decoration by Zdenka Braunerová for Vilém Mrštík's book *Pohádka máje* (May fairy tale), published by Jan Otto in 1897, and a decoration by Vojtěch Preissig for Jan Karafiát's children's book *Broučci* (Little beetles), published by Dědictví Komenského (Heritage of Comenius) in 1903; an issue of the magazine *Assiette au beurre* was devoted to these illustrations in 1902.
In 1911, in his highly remarkable book *Typograf o knihách* (A typography of books) Karel Dyrynk published a critical commentary on the first decade in the development of the modern Czech book, documenting this with numerous illustrations.

5 The Austrian legislation granting freedom of the press guaranteed every citizen the right to produce and sell non-periodical publications, even without a specialist diploma.

6 See the *Josef Florian* catalogues, Prague (Institut français) 1998; *Josef Florian - Dobré dílo* (Josef Florian - A good oeuvre), Roudnice 1992.

7 See Šalda's essay on Munch: 'Násilník snu' (The violator of a dream), in *Boje o zítřek* (Struggle for tomorrow), Prague 1915, 2nd edition, p. 227-39; see also Václav Chaloupecký, *Über Musik der Farben* (On the music of colours), Prague 1906.

8 Vojtěch Preissig describes his typographic skills and pioneering experiences with colour etchings *Barevný lept a barevná rytina* (Colour etching and colour prints), 1909.

9 Worthy of note in this respect are the ornamental book creations by Jan Konůpek and other contemporaries such as Vratislav H. Brunner, Jaroslav Benda and František Kysela.

10 See Xavier Galmiche, 'L'expressionisme continué. Poésie et l'art du livre en Bohème dans les années 10 et 20', in *Prague, une capitale au coeur de l'Europe*, Acte du colloque de la Société des Amis des Musées de Dijon, Dijon 1997, p. 26.

An artistic synthesis on paper

Iva Janáková
translated by Jennifer Kilian and Katy Kist

1 Otto M. Urban and Luboš Merhaut (ed.), *Moderní revue 1894–1925* (Modern review 1894–1925), Prague 1995.

2 Hana Larvová (ed.), exhib. cat. *Umělecké sdružení Sursum 1910–1912* (Artists' group Sursum 1910–1912), Prague (Gallery of the City of Prague and the National Literary Museum) 1996.

3. On Czech magazines of the 1890s, see: Roman Prahl and Lenka Bydžovská, *Volné směry. Časopis secese a moderny / Freie Richtungen: Die Zeitschrift der Prager Secession und Moderne*, Prague 1993, pp. 6-11 (Czech and German edition).

4 On Czech magazines of the first half of the twentieth century, see: Lenka Bydžovská , 'Volné směry a avantgarda' (Free directions and the avant-garde), in Roman Prahl and Lenka Bydžovská, op. cit. (note 3), pp. 74-82. See further, Jarmila Doubravová, ' "Umělecký měsíčník" a hudba' ('Art monthly' and music), in Alena Pomajzlová (ed.), exhib. cat. *Expresionismus a české umění 1905–1927* (Expressionism and Czech art 1905–1927), Prague (Národní galerie v Praze) 1994/95.

5 Miroslav Lamač, *Osma a Skupina výtvarných umělců 1907–1917* (The Eight and the Group of Fine Artists), Prague 1922.

6 On Czech artistic and cultural posters from the turn of the century, see: Josef Kroutvor, *Poselství ulice* (Street reports), Prague 1991; ibid., 'Das goldene Zeitalter des Plakates', in exhib. cat. *Prager Jugendstil*, Dortmund (Museum der Stadt Dortmund) 1992, pp. 71-74; Jan Rous,

'Buchgestaltung und Plakatkunst', in Jiří Kotalík (ed.) exhib. cat. *Tschechische Kunst 1878–1914. Auf dem Weg in die Moderne*, 2 vols, vol. 2, Darmstadt (Mathildenhöhe) 1984, pp. 180-85; exhib. cat. *Prague Art Nouveau. Métamorphoses d'un style*, Brussels (Palais des Beaux-Arts) 1998/99.

7 To date the literature devoted to the Czech poster of the turn of the century treats it chiefly as an artistic poster, which is actually a small part of the poster arts as a whole. Commercial posters by commercial designers or minor painters were only published here and there, and have never been systematically studied (see Petr Štembera, 'The Czech Poster. 19th Century', *Grapheion*, 1997, no. 2, pp. 70-73.

8 Hana Rousová (ed.), exhib. cat. *Mezery v historii 1890–1938. Polemický duch střední Evropy. Němci, Židé, Češi*, Prague (Gallery of the City of Prague) 1994. Also in German: exhib. cat. *Lücken in der Geschichte*, Eisenstadt (Museum Österreichischer Kultur) & Regensburg (Ostdeutsche Galerie) 1994/95.

9 Jan Mlčoch, 'Le picturalisme et l'Art nouveau dans la photographie', in exhib. cat. *Prague Art Nouveau*, op. cit. (note 6), pp. 189-91; and Antonín Dufek, 'Fotografie 1890–1918', in Tomáš Vlček (ed.), *Dějiny českého výtvarného umění 1890–1938* (The history of Czech visual art 1890–1938), vol. IV/4, Prague 1998.

10 Josef Kroutvor and Monika Faber (ed.), exhib. cat. *Photographie der Moderne in Prag 1900–1925*, Linz (Neue Galerie der Stadt Linz), Vienna (Museum Moderner Kunst Stiftung Ludwig) & Frankfurt (Frankfurter Kunstverein) 1991/92.

From ecstatic decoration to individual modernism
Applied art 1897–1910

Sylva Petrová
translated by Michèle Hendricks

1 Miloš Jiránek, 'Listy z Paříže' (Letters from Paris), *Volné směry* (Free directions) 5 (1901), p. 13.

2 Arnošt Hofbauer, 'Něco z moderního dekorativního umění (Something on modern decorative art), *Volné směry* (Free directions) 5 (1901), p. 43.

3 John Ruskin and William Morris had already repudiated a hierarchy of art, with painting at the summit and applied art at the base. In Czech art circles, the aesthetician and musicologist Otakar Hostinský and art historian Karel Chytil, director of the Museum of Applied Art, had also defended the artistic role of 'noble' crafts.

4 František Xaver Šalda, 'Smysl tzv. renesance uměleckého průmyslu' (The sense of the so-called renaissance of the art industry), *Volné směry* (Free directions) 7 (1903), p. 138.

5 Cf. the friction between nationalities amongst members of the organisational committee for the Jubilee exhibition in Prague, analysed in an article by Zdeněk Hojda and Roman Prahl, 'Ze zákulisí výstavy na Výstavě roku 1891' (From the corridors of the Jubilee exhibition of 1891), *Dějiny a současnost* (History and own time) 13 (1991), no. 4, pp. 27-32.

6 Jan Kotěra, 'O novém uměni' (On new art), *Volné směry* (Free directions) 4 (1900), p. 28.

7 'Rubrika Zprávy' ('News items'), *Volné směry* (Free directions) 4 (1900), p. 28.

8 One example is the stained glass windows in a house in Prague-Vršovice (Moskevská 4); the house, designed by Osvald Polívka, was built 1910-11. The windows were made in the Bronec glassworks in Prague-Nusle, from a design by Alfons Mucha, published in 1896 by Champenois of Paris. See also: Jana Horneková, 'Art Nouveau windows in a style of Alfons Mucha', *Glass review* 29 (1974), no. 9, pp. 22-25.

9 František Xaver Šalda, 'Nová krása, její geneze a charakter' (New beauty, its genesis and character), *Volné směry* (Free directions) 7 (1903), p. 181.

10 Jan Kotěra, op. cit. (note 6), p. 189.

The discovery of a new beauty
The installation of exhibitions and interiors

Roman Prahl
translated by Jennifer Kilian and Katy Kist

1 Zdeněk Wirth, 'Jubilejní výstava v Praze 1908' (Jubilee exhibition of 1908 in Prague), *Volné směry* (Free directions) 12 (1908), p. 240.

2 On Secession exhibitions and installations, see especially Sabine Forsthuber, *Moderne Raumkunst. Wiener Ausstellungsbauten von 1898 bis 1914*, Vienna 1991.

3 The core of Wagner's *Gesamtkunstwerk* resided in the utopian vision of the interplay between the various artistic components of large theatrical productions, namely opera. After its expansion to the architecture of theatres, this cardinal concept later assumed a different meaning: a stylistic unity of a work, elaborated in the greatest possible detail by the same author, as was sometimes the case in Secessionist-style architectural projects and its installation. See Harald Szeemann (ed.), exhib. cat. *Der Hang zum Gesamtkunstwerk*, Zurich (Haus der Kunst), Düsseldorf (Städtische Kunsthalle) & Vienna (Museum Moderner Kunst) 1983.

4 The idea for the Jubilee exhibition originated ten years earlier at the Prague Chamber of Commerce as a way to celebrate the 50th anniversary of the foundation of the 'Union for the advancement of industry in the Czech countries'. The Jubilee Exhibition was attended by countless visitors and thus a significant number also saw the art exhibition at the entrance to the exhibition site.

5 The criticism of the lack of interest in applied art products at the first Mánes exhibitions (incidentally, somewhat exaggerated), was put forward by Stanislav K. Neumann. He was not only a writer, but also one of the prominent Secessionists in Prague taking an interest in industrial art as a possibility for introducing new art to a larger audience.

6 For the quote about the affinities of Kotěra's exhibition concept, see: Karel B. Mádl, 'Výstava Mánesa'(Mánes exhibition), *Česká revue* (Czech review), Prague 1903, pp. 647 ff.

7 Kotěra was clearly represented at the World's Fair of 1904 in St. Louis, where the design for the official collection was linked to that of 1900. Two interiors were designed by the Vienna and Prague Schools of Applied Art, while a third interior was reserved for the remaining Austrian schools. Accordingly, in the art exhibition a proper balance between Vienna, Prague and Cracow was also sought. The Czech collection only received

its own pavilion in foreign exhibitions for the first time in 1906 in London.

8 At one of their last shows before the First World War, the exhibition of the Deutsche Werkbund in Cologne in 1914, modern artists from Prague also exhibited in a comparable space which, like in the exhibition at the Municipal House, was activated by diagonals.

The violation of a dream
Post-Art Nouveau and Post-Symbolism

Alena Pomajzlová
translated by Robert Ordish

1 Petr Wittlich, *Česká secese* (The Czech Secession movement), Prague 1982; Tomáš Vlček, *Praha 1900*, Prague 1986; Cathrin Pichler and Tomáš Vlček (ed.), exhib. cat. *Vergangene Zukunft. Tschechische Moderne 1890 bis 1918*, Vienna (Künstlerhaus) 1993 & Kassel (Fridericianum) 1994; Petr Wittlich (ed.) exhib. cat. *Důvěrný prostor/nová dálka. Umění pražské secese* (Intimate space/new distance. Art from the Prague Secession movement), Prague (Obecní dům – Municipal House) 1997; exhib. cat. *Prague Art Nouveau. Métamorphoses d'un style*, Brussels (Palais des Beaux-Arts) 1998/99.

2 Karel Srp, in exhib. cat. *Expresionismus a české umění 1905–1927* (Expressionism and Czech art 1905-27), Prague (Národní galerie v Praze) 1994/95.

3 František Xaver Šalda, 'Násilník snu (The violator of a dream), in *Boje o zítřek* (Struggle for tomorrow), Prague 1973, p. 175.

4 Exhib. cat. *Lost Paradise. Symbolist Europe*, Montreal (The Montreal Museum of Fine Arts), 1995.

5 The artist's right to distort and to an unrestrained use of colour, irrespective of sensory experience, was also a principal thesis of modern art. Later, theoretical articles in the magazine *Volné směry* (Free directions) even equated distortion with composition, creating a path from exaggerated colour and symbolism to the autonomy of colour.

6 Emil Filla, 'Edvard Munch a naše generace' (Edvard Munch and our generation), in *O výtvarném umění* (On fine art), Prague 1948, p. 70.

7 See note 2.

8 The figure with closed eyes occurs frequently in German Expressionism and is also derived from a general corpus of Symbolist ideas. Erich Heckel's painting *Pechstein sleeping* (1910) does not refer to literary Symbolism to the same extent as Filla, but neither does it have the spiritual expression of a Kupka. The motif of the person with closed eyes is a direct assault on the senses in that its structure consists of two complementary colours, red and green. Although the subject is easily legible it becomes a mere pretext for sharp colour disharmonies, with the almost animal expression contrasting both with the calm meditation of Kupka's painting and Filla's traditionally toned *Reader of Dostoevsky*.

Bibliography

Alena Adlerová, exhib. cat. *Česká secese. Užité umění* (Czech Secession Style. Applied Art), Prague (Uměleckoprůmyslové museum v Praze) 1981.

Alena Adlerová, 'Bohemian Glass at the World Exhibition in Paris, 1900, and Saint Louis in 1904', *Glassreview* 47 (1992), nos. 78, pp. 15-22.

Jaroslav Anděl and Emmanuel Starcky (ed.), exhib. cat. *Prague 1900–1938. Capitale secrète des avant-gardes*, Dijon (Musée des Beaux-Arts) 1997.

Sigrun Bielfeldt, *Die Tschechische Moderne im Frühwerk Šaldas. Zur synchronen Darstellung einer Epochenschwelle*, Munich 1978.

Otokar Březina, *Hudba pramenů a jiné eseje* (Music of sources and other essays), Prague 1989 (orig. 1903).

Jarmila Brožová, exhib. cat. *Historismus. Umělecké řemeslo* (Historicism. Traditional art) 1860–1900, Prague (Uměleckoprůmyslové museum v Praze) 1976.

Jarmila Brožová, 'Český interiér na Světové výstavě v Paříži 1900' (The Czech interior at the 1900 Paris World Fair) *Umění* (Art) 29 (1981), pp. 38-42.

Peter Cannon-Brookes, *Czech sculpture 1800-1938*, London 1983.

Květoslav Chvatík, *Die Prager Moderne: Erzählungen, Gedichte, Manifeste*, Frankfurt am Main 1992.

Gary B. Cohen, *The politics of ethnic survival: Germans in Prague, 1861–1914*, New Jersey 1981.

Gary B. Cohen, 'Ethnicity and urban population growth: the decline of the Prague Germans, 1880–1920', in Keith Hitchins (ed.), *Studies in East-European social history*, Leiden 1981, pp. 3-26.

Michel Décaudin and Étienne-Alain Hubert, 'Petit historique d'une appelation: "Cubisme littéraire"', *Europe* (1982), pp. 7-25.

Bohuslav Fischer, *Český interiér na světové výstavě pařížské 1900* (The Czech interior at the 1900 Paris World Fair), Prague 1900.

Otokar Fischer, *Duše - slovo - svět* (Soul - word - world), Prague 1965.

Alfred French (ed.), *Anthology of Czech poetry*, Ann Arbor (Michigan) 1973.

Donald E. Gordon, *Expressionism: art and idea*, New Haven 1987.

Mojmír Grygar, 'L'art nouveau dans la peinture et la littérature', *Innsbrucker Beiträge zur Kulturwissenschaft* (1981), no. 51, special number 'Literature and the other arts'.

Jeroen B. Van Heerde, *Staat und Kunst. Staatliche Kunstförderung 1895–1918*, Vienna, Cologne & Weimar 1993.

Zdeněk Hojda and Roman Prahl (ed.), *Český lev a rakouský orel v 19. století* (The Czech lion and the Austrian eagle in the nineteenth century), Prague 1996.

Manfred Jähnichen, *Der Weg zur Anerkennung. Tschechische Literatur im deutschen Sprachgebiet 1861–1918*, Berlin 1972.

Hanuš Jelínek, *Histoire de la littérature tchèque*, 3 vols., Paris 1930-35.

Robert Kann, *The multinational empire. Nationalism and national reform in the Habsburg monarchy 1848–1918*, New York 1950.

Robert Kann, *A history of the Habsburg empire 1526–1918*, Los Angeles & London 1977.

Jiří Kotalík (ed.), exhib. cat. *Tschechische Kunst 1878–1914. Auf dem Weg in die Moderne*, 2 vols., Darmstadt (Mathildenhöhe) 1984.

Karel Krejčí, *Český fin de siècle. Česká literatura a kulturní proudy evropské* (The Czech fin de siècle. Czech literature and European cultural trends), Prague 1975.

Josef Kroutvor and Monika Faber (ed.), exhib. cat. *Photographie der Moderne in Prag 1900–1925*, Linz (Neue Galerie der Stadt Linz), Vienna (Museum Moderner Kunst Stiftung Ludwig) & Frankfurt (Frankfurter Kunstverein) 1991/92.

Jiří Kudrnáč, *Úvod do české secesní literatury. Z času Moderní revue - Literární archiv* (Introduction to Czech Secession literature. From the age of Moderní revue - Literární archive), Prague (National Literary Museum) 1997.

Heinrich Kunstmann, *Tschechische Erzählkunst im 20. Jahrhundert*, Cologne & Vienna 1974.

Miroslav Lamač, *Osma a Skupina výtvarných umělců 1907–1917* (The Eight and the Group of Fine Artists 1907–1917), Prague 1992.

Hana Larvová (ed.), exhib. cat. *Umělecké sdružení Sursum 1910–1912* ('Sursum' Society of Artists 1910–1912), Prague (Gallery of the City of Prague and National Literary Museum) 1996.

Lexikon české literatury. Osobnosti, díla, instituce (Lexicon of Czech literature. People, works, institutions), 3 vols., Prague 1985-99.

Zdeněk Lukeš, 'K výročí pražských výstav 1898–1908' (On the jubilee of the Prague exhibitions 1898–1908), *Ročenka technického magazínu* (Technical Journal Yearbook), pp. 182-93.

Jaroslav Marek, *Česká moderní kultura* (Czech modern culture), Prague 1998.

Anna Masaryková, 'Cizí umělci na výstavách Krasoumné jednoty v Praze' (Foreign artists at the exhibitions of the Art Society in Prague), in *Sborník k sedmdesátinám Jana Květa* (Collection to mark the 70th birthday of Jan Květ), Prague 1965, pp. 199-205.

Luboš Merhaut, *Cesty stylizace. Stylizace, 'okraj' a mystifikace v české literatuře přelomu devatenáctého a dvacátého století* (Manners of stylisation. Stylisation, 'peripherals' and mystification in Czech literature around the turn of the century), Ústav pro českou literaturu, Akademie věd ČR (Institute for Czech literature, Academy of Sciences of the Czech Republic), Prague 1994.

Jan Mukařovský, 'Mezi poezií a výtvarnictvím (Between poetry and fine art), *Kapitoly z české poetiky* (Topics from Czech poetry) 1, Prague 1948.

Roman Musil (ed.), exhib. cat. *Felix Jenewein 1857–1905*, Prague (Národní galerie v Praze) 1996.

Nils Åke Nilsson (ed.), *The Slavic Literature and Modernism*, a Nobel symposium (1985), Stockholm 1987.

C. Nolte, 'Art in the service of the nation. Miroslav Tyrš as art historian and critic', *Bohemia* 34 (1993), pp. 47-62.

Arne Novák, *Czech Literature*, Ann Arbor (Michigan) 1986.

Miloslav Novotný, 'Kreslíři a malíři mezi našimi spisovateli' (Draughtsmen and painters amongst our writers), *Literární noviny* (Literairy Newspaper) 12 (1939), pp. 3235.

Jiří Opelík and Jaroslav Slavík, *Josef Čapek*, Prague 1996.

Piotr Paszkiewicz (ed.), *Totenmesse. Modernism in the Culture of Northern and Central Europe*, Warsaw 1996.

László Péter and Robert B. Pynsent (ed.), *Intellectuals and the future in the Habsburg Monarchy: 1890–1914*, London 1998.

Sylva Petrová and Jean-Luc Olivié, *Bohemian Glass*, Paris 1989.

Miroslav Petříček jr., 'Krajiny duše' (Landscapes of the soul), *Umění* (Art) 44 (1996), pp. 915.

Cathrin Pichler and Tomáš Vlček (ed.), exhib. cat. *Vergangene Zukunft. Tschechische Moderne 1890 bis 1918*, Vienna (Künstlerhaus) 1993 & Kassel (Fridericianum) 1994.

Alena Pomajzlová (ed.), exhib. cat. *Expresionismus a české umění 1905–1927* (Expressionism and Czech art 1905–1927), Prague (Národní galerie v Praze) 1994/95.

Exhib. cat. *Prager Jugendstil*, Dortmund (Museum der Stadt Dortmund) 1992.

Exhib. cat. *Prague Art Nouveau. Métamorphoses d'un style*, Brussels (Palais des Beaux Arts) 1998/99.

Prague, une capitale au coeur de l'Europe, Acte du colloque de la Société des Amis des Musées de Dijon, Dijon 1997.

Roman Prahl, 'Václav Brožíks "Ferdinand I. among his artists". History of the painting and artistic patronage in Bohemia around 1900', *Bulletin of the National Gallery in Prague* 1 (1991), pp. 87-91.

Roman Prahl, 'Plakát první výstavy Mánesa: mezi protestem a utopií / The poster of the 1st Mánes exhibition: between protest and utopia', *Umění* (Art) 40 (1991), pp. 23-36.

Roman Prahl (ed.), ten. cat. *Umění na Jubilejní výstavě před sto lety* (Art at the Jubilee exhibition 100 years ago), Prague (Národní galerie v Praze) 1991.

Roman Prahl, 'Tschechische Secessionisten und ihre Aufnahme in Wien um 1900', *Umění* (Art) 41 (1993), pp. 1-25.

Roman Prahl and Lenka Bydžovská, *Volné směry. Časopis secese a moderny / Freie Richtungen: Die Zeitschrift der Prager Secession und Moderne*, Prague 1993.

Robert B. Pynsent, *Czech prose and verse*, London 1979.

Robert B. Pynsent (ed.), *Decadence and innovation. Austro-Hungarian life and art at the turn of the century*, London 1989.

Hana Rousová (ed.), exhib. cat. *Mezery v historii 1890–1938. Polemický duch střední Evropy. Němci, Židé, Češi*, Prague (Gallery of the City of Prague) 1994. Also in German, exhib. cat. *Lücken in der Geschichte*, Eisenstadt (Museum Österreichischer Kultur) & Regensburg (Ostdeutsche Galerie) 1994/95.

František Xaver Šalda, *Boje o zítřek* (Struggle for tomorrow), 2nd edition, Prague 1915.

Herta Schmid, 'Básnická a malířská obraznost v poezii Jaroslava Vrchlického' (Poetic and painterly metaphors in the poetry of Jaroslav Vrchlický), *Česká literatura* (Czech literature) 46 (1998) pp. 86-104.

Ferdinand Seibt (ed.), *Böhmen im 19. Jahrhundert. Vom Klassizismus zur Moderne*, Frankfurt am Main 1995.

František Šmejkal, 'Symbolika sfingy v umění přelomu století' (Sphinx symbols in art around the turn of the century), *Umění* (Art) 27 (1979), pp. 401-26.

Rostislav Švácha, *Od moderny k funkcionalismu. Proměny pražské architektury první poloviny 20. století* (From Modernism to Functionalism. Changes in Prague architecture during the first half of the twentieth century), Prague 1994.

Karel Teige, *Osvobozování života a poezie* (Emancipation of life and poetry), Prague 1994.

Otto Urban, *Die tschechische Gesellschaft 1848 bis 1918*, 2 vols., Vienna, Cologne & Weimar 1994.

Otto M. Urban and Luboš Merhaut (ed.), *Moderní revue 1894–1925*, Prague 1995.

Otto M. Urban, 'Na cestě k věčnému ideálu: Výtvarná kritika a esejistika na stránkách Moderní revue' (On the road to an eternal ideal: art criticism and essays in the pages of Moderní revue), *Umění* (Art) 44 (1996), pp. 391-410.

Otto M. Urban, 'Procházkovo Prostibolo a Hlaváčkova Duše' (Procházka's 'Brothel' and Hlaváčeks 'Of the soul'), *Umění* (Art) 45 (1997), pp. 430 ff.

Pascal Varejka, 'Les artistes tchèques et les Salons officiels parisiens avant 1914', *Umění* (Art) 32 (1984), pp. 155-69.

Tomáš Vlček, exhib. cat. *Světlo v českém malířství generace 80. a 90. let 19. století* (Light in Czech painting of the 1880s' and 1890s' generation), Prague (Gallery of the City of Prague) 1982.

Tomáš Vlček, *Praha 1900. Studie k dějinám kultury a umění Prahy v letech 1890–1914* (Articles on the history of art and culture in Prague during the years 1890–1914), Prague 1986.

Tomáš Vlček, *Julius Zeyer. Texty, sny, obrazy* (Julius Zeyer. Texts, dreams, images), Prague 1997.

Tomáš Vlček (ed.), *Dějiny českého výtvarného umění 1890–1938* (History of Czech Fine Art, 1890–1938) vol. IV/4, Prague 1998.

Vít Vlnas (ed.), exhib. cat. *Obrazárna v Čechách 1796–1918* (The painting gallery in Bohemia 1796–1918), Prague (Národní galerie v Praze) 1996.

René Wellek, *Essays on Czech literature*, The Hague 1963.

Petr Wittlich, *Česká secese* (The Czech Secession movement), Prague 1982.

Petr Wittlich, *Prague. Fin de siècle*, Paris 1992.

Petr Wittlich (ed.), exhib. cat. *Důvěrný prostor/nová dálka. Umění pražské secese* (Intimate space/new distance. Art of the Prague Secession movement), Prague (Obecní dům - Municipal House) 1997.

Index

Colophon

This catalogue has been published to accompany the exhibition *Prague 1900. Poetry and ecstasy* in the Van Gogh Museum, Amsterdam (17 December 1999 – 26 March 2000), and the Museum of Applied Art, Frankfurt am Main (11 May – 27 August 2000).

The exhibition has been organized in close cooperation with the Národní galerie v Praze, Prague and the Uměleckoprůmyslové museum v Praze, Prague.

Concept and editing
Edwin Becker
Roman Prahl
Petr Wittlich

Editing of English translation
Michèle Hendricks
Annabel Howland
Robert Ordish

Translators
Donald Gardner
Michèle Hendricks
Jennifer Kilian
Katy Kist
Robert Ordish
John Rudge
Jean Vaughan
Kate Williams

Art history adviser
Michael Huig

Picture captions have been written by the authors of the relevant chapter unless otherwise stated below:
Iva Janáková, fig. 17
Daniela Karasová, figs. 147, 160, 164, 173, 187, 188
Roman Prahl, figs. 3, 15, 16, 20, 99, 123, 124

Van Gogh Museum project supervisors
Edwin Becker
Andreas Blühm

Coordination
Martine Kilburn
Aly Noordermeer

Administration
Marianne Nieuwenhuizen
Sara Verboven

Exhibition design
Peter de Kimpe

Lighting
Henk van der Geest

Museum of Applied Art project supervisors
James Bradburne
Margrit Bauer

Project supervisors in Prague
Iva Janáková
Alena Pomajzlová
Roman Prahl
Petr Wittlich

Design
Studio Roozen, Amsterdam

Printing
Waanders Printers, Zwolle

Photographs
All photographs were supplied with the permission of the owners of the works reproduced. With special thanks to Alena Urbánková (Moravian Gallery, Brno), Ateliér Roudnička (Gallery of Modern Art, Hradec Králové), Ms. Ducháčková (North Bohemian Museum, Liberec), Jiří Jirout (Regional Museum, Liberec), Jan Brodský (Art Gallery, Litoměřice), Ivo Přeček (Museum of Art, Olomouc), F. Řezníček Photo Studio (Museum of Fine Art, Ostrava), Hana Hamplová (Museum of the City of Prague), Jan Diviš, Karel Probošt, Otto Palán, Milan Posselt, Čestmír Šíla, M. Sošková (all of whom work for the Národní galerie v Praze, Prague), Miloslav Šebek, Gabriel Urbánek (Uměleckoprůmyslové museum v Praze, Prague), © Mucha Trust 1999, Ateliér Paul (figs. 1, 4, 5, 6, 11), Jan Malý (figs. 10, 153, 169, 170, 175, 192, 200), Thijs Quispel.

Frontispiece: Vladimír Jindřich Bufka, *The Charles Bridge and Prague Castle at eventide*, photograph, 1914, Moravian Gallery, Brno
Front cover: fig. 20
Back cover: figs. 139, 154, 212

© 1999 Van Gogh Museum, Amsterdam
 Uitgeverij Waanders b.v., Zwolle

ISBN 90 400 9391 1 (hb)
ISBN 90 400 9390 3 (pb)
NUGI 921, 911